THE
TRAGEDY
OF THE
TEMPLARS

THE
TRAGEDY
OF THE
TEMPLARS

The Rise and Fall of the Crusader States

MICHAEL HAAG

HARPER

NEW YORK • LONDON • TORONTO • SYDNEY

HARPER

All images are author's own.

Originally published in Great Britain in 2012 by Profile Books, Ltd.

THE TRAGEDY OF THE TEMPLARS. Copyright © 2013 by Michael Haag. All rights reserved. Printed in the United States of America. No part of this book may be used or reproduced in any manner whatsoever without written permission except in the case of brief quotations embodied in critical articles and reviews. For information address HarperCollins Publishers, 10 East 53rd Street, New York, NY 10022.

HarperCollins books may be purchased for educational, business, or sales promotional use. For information please e-mail the Special Markets Department at SPsales@harpercollins.com.

FIRST U.S. EDITION

Library of Congress Cataloging-in-Publication Data is available upon request.

ISBN 978-0-06-205975-8

13 14 15 16 17 /RRD 10 9 8 7 6 5 4 3 2 1

To Neville Lewis
Chevalier of the Inner Temple
and friend of many years

Contents

The Mediterranean on the Eve of the Crusades

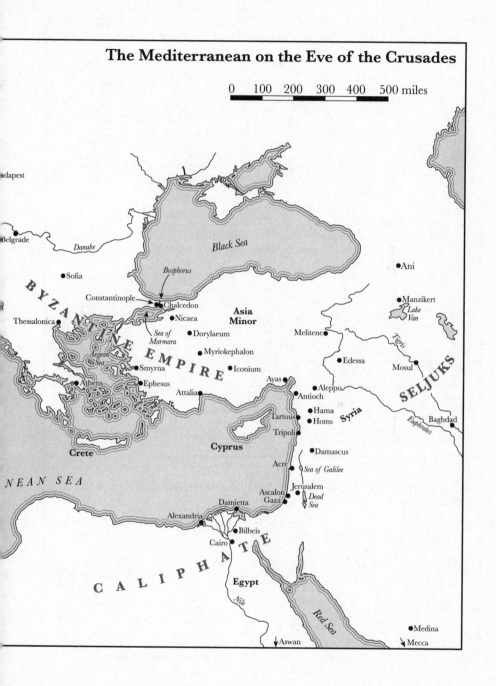

0 100 200 300 400 500 miles

Budapest

Belgrade

Danube

Black Sea

Sofia

Bosphorus

BYZANTINE EMPIRE

Constantinople

Chalcedon

Thessalonica

Nicaea

Asia Minor

Sea of Marmara

Dorylaeum

Myriokephalon

Aegean Sea

Smyrna

Iconium

Athens

Ephesus

Attalia

Ayas

Ani

Manzikert

Lake Van

Melitene

Edessa

Mosul

SELJUKS

Tigris

Aleppo

Antioch

Hama

Syria

Baghdad

Euphrates

Tartous

Homs

Tripoli

Crete

Cyprus

Damascus

Acre

Sea of Galilee

Ascalon

Jerusalem

Gaza

Dead Sea

NEAN SEA

Damietta

Alexandria

Cairo

Bilbeis

CALIPHATE

Egypt

Nile

Red Sea

Medina

Aswan

Mecca

Outremer – Crusader territory in the Holy Land

Cilicia

County of Edessa

Tarsus

Ayas

Edessa

Baghras

Antioch

Aleppo

Orontes

Euphrates

Principality of Antioch

Latakia

Shaizar

Hama

Cyprus

Famagusta

Margat

Masyaf

Tortosa

Chastel Blanc

Limassol

Ruad

Homs

Tripoli

Krak des Chevaliers

Gibelet

Baalbek

MEDITERRANEAN SEA

Beirut

County of Tripoli

Sidon

Litani

Château de Mer

Damascus

Beaufort

Tyre

Jacob's Ford

Saphet

Tiberias

Acre

Hattin

Sea of Galilee

Chastel Pelerin

La Feve

Caesarea

Nazereth

Jordan

Nablus

Kingdom of Jerusalem

Jaffa

Jericho

Ascalon

Ramla

Ahamant (Amman)

Gaza

Dead Sea

Damietta

Bethgibelin

Jerusalem

Hebron

Bethlehem

Kerak

Egypt

N

Crusader territory

Territory lost in 1144

0 20 40 60 80 100 miles

Gulf of Suez

Gulf of Aqaba

Crusader Jerusalem

N

Breach point
(15 July 1099)

St Stephen's
Gate

St Mary
Magdalene's

St Ann's
Church

To Mount
of Olives,
Bethany &
Jericho

St Lazar's
Leper Hospital

Church of
the Holy
Sepulchre

Sorrowful
Gate

Golden
Gate

Garden of
Gethsemane

Temple Mount

Templum
Domini
(Dome of the
Rock)

St Mary
Latin

Hospital of the
Knights of St John

Tancred's
Tower

Grain
Market

Solomon's
Stables

David's
Gate

Markets

Tower of
David

Templum Solominus
(Templar's headquarters,
formerly the Aqsa Mosque)

Palace

Tanners'
Gate

St James's

Mount
Zion Gate

St Mary of
Mount Zion

St Peter's
Church

Siloam
Pool

Kidron Valley

Cemetery

0 300 yards

Jerusalem 1187

O N FRIDAY 2 OCTOBER 1187, after a twelve-day siege, and less than a century after the victorious climax of the First Crusade, the inhabitants of Jerusalem surrendered their city under the terms allowed them by Saladin. Those who could afford to pay their ransom were free to walk towards the coast; those who could not pay were to be taken away as slaves. A few Knights Hospitaller were permitted to remain to run their hospital for pilgrims located in the heart of the city adjacent to the Church of the Holy Sepulchre. The knights of the Poor Fellow-Soldiers of Christ were driven out altogether – their headquarters had been the Aqsa mosque on the Temple Mount. The Franks believed that the Aqsa mosque had been built on the very site of the Templum Solomonis, as they called it in Latin, and it was not long before the knights became known as the Poor Fellow-Soldiers of Christ and of the Temple of Solomon; or, simply and most famously, the Templars.

Saladin's order to purify Jerusalem 'of the filth of the hellish Franks',[1] in the words of his secretary Imad al-Din, began with the Aqsa mosque, for the Templars had been 'overflowing with impurities' so that 'slackness in purifying it is forbidden to us'.[2] The walls and floors of the Aqsa mosque and the

nearby Dome of the Rock were cleansed with rosewater and incense; then Saladin's soldiers went about the city tearing down churches or stripping them of their decorations and converting them to mosques and madrasas, 'to purify Jerusalem of the pollution of those races, of the filth of the dregs of humanity, to reduce the minds to silence by silencing the bells'.[3] Only the Church of the Holy Sepulchre was spared, Saladin saying that it would pay its way by charging Christian pilgrims an extortionate entrance fee.[4]

To the Franks of Outremer – 'the land across the sea', as the crusader states were called – the fall of Jerusalem was seen as the terrible judgement of God. Saladin's capture of the city even suggested to some that Christianity was an inferior belief to Islam. 'Our people held the city of Jerusalem for some eighty-nine years', wrote the anonymous author of the *De Expugnatione Terrae Sanctae per Saladinum*. 'Within a short time, Saladin had conquered almost the whole Kingdom of Jerusalem. He exalted the grandeur of Mohammed's law and showed that, in the event, its might exceeded that of the Christian religion.'[5]

Frankish misery was more than matched by Muslim exultation. 'The victory of Islam was clear, and so was the death of Unbelief',[6] wrote Imad al-Din, as though Christianity itself was destroyed that day. For maximum effect, Saladin had waited until Friday 27 Rajab in the Muslim calendar, the anniversary of Mohammed's Night Journey from Jerusalem into Heaven, to take possession of the city. 'What a wonderful coincidence!' exclaimed Ibn Shaddad, Saladin's biographer and friend.[7] Saladin radiated the triumph of jihad as he entered the city, sat upon a throne 'which seemed as if surrounded by a lunar halo' and gave an audience to receive congratulations. 'His carpet was kissed, his face glowed, his perfume was sweet, his affection all-embracing, his authority intimidating.'[8] Saladin carefully presented his capture of Jerusalem as a great victory for the jihad for, like the

'propagandistic posing'[9] of purifying the Aqsa mosque and the Dome of the Rock, it gave out the message that he and his family, the Ayyubids (from his father, Ayyub), were the effective rulers and the protectors of Islam, not the caliph in Baghdad. To hammer home the point, Saladin ordered that gold coins be struck describing him as 'the sultan of Islam and the Muslims'.[10]

Yet since 1174, when Saladin became sultan of Egypt and began his independent career, though notionally subject to the Abbasid caliph in Baghdad, he had campaigned against the Franks for barely more than a year; all the rest of his campaigns were directed against his fellow Muslims, whom he defamed as heretics and hypocrites, and who in turn saw him as 'a dynast who used Islam for his own purposes'.[11] Indeed right up until 1187, Saladin's reputation in Muslim eyes amounted to nothing more than 'a record of unscrupulous schemes and campaigns aimed at personal and family aggrandisement'. [12] Not surprisingly, when the news of Saladin's capture of Jerusalem reached Baghdad, the caliph was less than happy, for he had been counting on the Franks to limit Saladin's ambitions, and the caliph let it be known through his advisers that 'this man [Saladin] thinks that he will overturn the Abbasid dynasty'.[13] As the caliph understood, by his conquest of Jerusalem, though it had no strategic value, Saladin had won what he most needed to further his dynastic ambitions, the acquiescence of Muslims to his rule; as Saladin's adviser Al-Qadi al-Fadil wrote, he 'has become my master and the master of every Muslim'.[14]

As well as using the propaganda of jihad to make his Muslim rivals submit to his authority or to eliminate them altogether, Saladin also used jihad as an excuse for imposing Muslim rule on Christians, who even at this time were still the majority of the population in Syria, Palestine and Egypt.[15] Jihad has its origins in the Koran, which enjoins Muslims to

'proclaim a woeful punishment to the unbelievers'[16] and to 'make war upon them: God will chastise them at your hands and humble them'.[17] Defined as a 'divine institution of warfare', the purpose of jihad is to extend Islam into the *dar al-harb* – that is, the abode of struggle or disbelief (as opposed to the *dar al-Islam*, the abode of peace, where Islam and sharia law prevail); and jihad ends only when 'the unbelievers have accepted either Islam or a protected status within Islam'.[18] Jihad is also fought when Islam is in danger, so that when Christians reclaim Christian territory from Muslim occupation, that too can be a reason for jihad. It was a concept that perfectly suited Saladin's ambitions, providing religious justification for his imperialist war against Outremer.

Saladin and his army conquered Jerusalem and made war in the Middle East as an alien power – alien in religion from the Christian majority and both ethnically and culturally alien from the indigenous Greek-, Armenian-, Syriac- (that is, Aramaic-) and Arabic-speaking population. Saladin himself was a Turkified Kurd who began his career serving the Seljuk Turks, who were invaders from Central Asia, and his army at Jerusalem was Turkish, though with a Kurdish element.[19] The Turks looked down on the Arabs whose rule in the Middle East they had replaced, and the Arabs viewed the Turks with bitter contempt; nor is there much evidence 'of the Arab knights learning Turkish, the language of their military overlords, nor that the Turks learned much Arabic'.[20] Being alien also meant being indifferent, so that after his capture of the city Saladin acknowledged that the Franks had 'turned Jerusalem into a garden of paradise';[21] yet he himself neglected Jerusalem and caused it to decline,[22] just as he destroyed everything he could along the coast, regardless of the welfare of the native population. This was no war of liberation, of reclaiming lost lands; it was the continuance of previous aggression, of Islamic imperialism driven by Saladin's dynastic ambitions.

The disaster had been anticipated by the Frankish chroni-
cler William of Tyre, who died in 1186, the year before Jeru-
salem fell, but who, in recounting how Saladin had begun
tightening the noose round the kingdom of Jerusalem with his
seizure of Damascus in 1174, analysed why the Franks seemed
unable to rise to the threat. 'The question is often asked, and
quite justly, why it was that our fathers, though less in num-
ber, so often bravely withstood in battle the far larger forces
of the enemy. […] In contrast to this, the men of our times too
often have been conquered by inferior forces.' William gave
three reasons for this situation. First, 'our forefathers were
religious men and feared God. Now in their places a wicked
generation has grown up.' The second reason was that, until
the advent of Saladin, the Franks in Outremer had enjoyed
a 'long-continued peace' with their Muslim neighbours, so
that now 'they were unused to the art of war, unfamiliar with
the rules of battle, and gloried in their state of inactivity'. But
only with his third reason did William of Tyre identify what
in fact was the fundamental problem. 'In former times almost
every city had its own ruler', but now 'all the kingdoms round
about us obey one ruler, they do the will of one man, and at
his command alone, however reluctantly, they are ready, as a
unit, to take up arms for our injury. Not one among them is
free to indulge any inclination of his own or may with impu-
nity disregard the commands of his overlord.'[23]

But in those autumn days of 1187 after Jerusalem had
fallen, neither the faith nor the fighting spirit of the Franks
was entirely overwhelmed. The kingdom of Jerusalem had
suffered a comprehensive defeat from which no feudal mon-
archy could have emerged with its powers unimpaired, but
the military orders survived and became more important
than before. This was particularly true of the Templars,
whose single-minded policy and purpose was to preserve, to
defend and now to regain Jerusalem and Outremer from the
full might of the Turks.

PART I

The Middle East before the Crusades

HICROSOLIMA

*W*HEN THE TURKS EMERGED *from the steppes of Central Asia and captured Baghdad, they became the masters of what had been an Arab empire. The Turks also became the new champions of Islam, the religion brought by the Arabs when they stormed out from the deserts of Arabia to invade and occupy the fertile lands of the Middle East in the seventh century AD, lands that had been part of the Graeco-Roman world for a thousand years and in the case of Palestine had been home to the Jews for twice as long.*

Already since the second millennium BC the Middle East had known the rule of successive rival empires, including the Egyptians, Hittites, Assyrians and Persians. In the early fifth century BC, when the Persians also tried to extend their empire into Europe, they were famously repulsed by the Greeks at Marathon, Salamis and Plataea, and a century and a half later, in 333 BC, when Alexander the Great carried the war into Asia

and defeated the Persian king Darius III at the battle of Issus, near the present-day Turkish–Syrian border, the entire Middle East came under the rule and cultural influence of the Greeks. By the end of the first century BC the Greeks in turn had been superseded by the Romans, whose empire embraced all the lands round the Mediterranean. This was the world that gave rise to Christian civilisation.

1

The Christian World

THE ROMANS RULED PALESTINE through Herod the Great, king of Judea, who constructed the vast platform known as the Temple Mount over a rocky hill to support his gigantic Temple built around 25-10 BC on the site of Solomon's original Temple of nearly a thousand years earlier. It is Herod's Temple that is referred to in the Gospel of Mark 13:1-2, when a disciple says to Jesus, 'Master, see what manner of stones and what buildings are here!', to which Jesus replies, 'Seest thou these great buildings? There shall not be left one stone upon another, that shall not be thrown down.' And it was this temple that, duly bearing out the prophecy, was destroyed by the Roman emperor Titus in AD 70 in the course of putting down a Jewish rebellion. During a second Jewish revolt the rebels occupied Jerusalem in AD 132 and intended to rebuild the Temple, even striking coins bearing its image. But the Romans returned in force and crushed the revolt completely. Jerusalem became a pagan city, Colonia Aelia Capitolina. All traces of the Temple were obliterated in AD 135, and statues of Hadrian the conqueror and of Jupiter were erected on the site. Thereafter Jews were forbidden by official Roman decree to enter Jerusalem, although from time to time tacit permission was given for them to enter

the precincts of the former Temple. Nothing remained, only the desolate rock, and here the Jews poured libations of oil, offered their prayers and tore their clothes in lamentation.

Meanwhile, starting in the Middle East during the first century AD and extending across North Africa and Europe, Christianity took hold throughout the Roman Empire, not by force of arms nor because it was imposed or even encouraged by the state, but rather in the teeth of the most ferocious imperial opposition. Despite suffering terrible persecutions for their faith, Christians numbered about one-seventh of the population by the early fourth century, and their influence went far wider. The Christian doctrine of equality of the individual soul gave it a universal appeal, it was well organised, and it attracted some of the best minds of the time, who in rooting its theology in Greek philosophy made it intellectually acceptable. By promulgating in AD 313 the Edict of Milan, which tolerated Christianity and gave it rights in law, Constantine won the support of the strongest single group in the Roman world. Constantine was baptised only on his deathbed in 337, but his conversion had already occurred in 312, when his vision of the Cross accompanied by the words εν τούτῳ νίκα, usually rendered in Latin as *in hoc signo vinces* – 'in this sign you will conquer' – preceded his victory against the rival emperor Maxentius at the battle of the Milvian Bridge outside Rome, a battle in which he had the Cross emblazoned on the shields of his soldiers and carried aloft as their standard.[1] During Constantine's lifetime and in the reigns of his successors, Christianity flourished under imperial patronage, and by the end of the fourth century dominated the empire. In 392 the Emperor Theodosius I declared Christianity the official religion of the Roman Empire: henceforth paganism was proscribed. During his reign temples throughout the empire were in whole or in part destroyed and churches built, so that in Damascus, for example, the great temple of Jupiter was rebuilt as the Church of St John the Baptist, and

throughout Egypt churches were built within the temples of the pharaonic gods.

In what had already been the universal Roman Empire, Christianity added a new dimension of unity between the diversity of local cultures. Christian ideas and images were shared from the Thames to the Euphrates, from the Rhine to the Nile. The word 'catholic' means universal and all-embracing and was the word used to describe the original Christian Church. It was a universal Church, and the faithful travelled freely from one end of Christendom to the other. Tens of thousands of pilgrims travelled to the lands of the Gospels, to visit the holy sites and to obtain the blessings of monks and other holy ascetics there. And they came not only from the West but also from the East. 'Not only do the inhabitants of our part of the world flock together', wrote the fifth-century Syrian monk Theodoret of Cyrrhus, 'but also Ishmaelites, Persians, Armenians subject to them, Iberians, Homerites, and men even more distant than these; and there came many inhabitants of the extreme west, Spaniards, Britons, and the Gauls who live between them. Of Italy it is superfluous to speak.'[2]

Pilgrimages are practised among all the world's religions, but during its first three centuries Christianity was a persecuted faith and it was not safe or practical to go on a pilgrimage. Yet despite the danger to their lives, Christians did go on pilgrimages from an early date. Already in the early second century a 'cave of the Nativity' was being shown at Bethlehem; people wanted to see sites associated with the life and death of Jesus.

The era of pilgrimages really got under way with the end of persecutions following Constantine's Edict of Toleration in 313. The pace was set by the emperor's own mother, the

empress Helena, who visited Palestine in 326–8. That she
was a woman was typical of pilgrimages, for the truth about
women in pagan societies was that their worth was judged
almost exclusively on their success as sexual and reproduc-
tive beings, whereas Christianity, once it had been legitimised
by Constantine, was liberating for women in numerous ways,
not least in providing them with an excuse for going on long
journeys away from home. As his mother travelled from site
to site, Constantine ordered and financed the construction of
churches to celebrate the central events of Christian belief.
In Bethlehem, Constantine built the Church of the Nativity,
and in Jerusalem he built the Church of the Holy Sepulchre
on the spot, discovered by Helena herself, where Jesus was
entombed and then rose again on the third day.

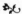

But exactly who was this risen Jesus? No sooner had Con-
stantine tolerated Christianity than competing answers to
this question threatened to split the universal church. The
argument was not over whether Jesus was divine – his divin-
ity was almost universally agreed – rather, it was over the
nature of that divinity, and it was during Constantine's reign
that the first great heresy emerged – Arianism, named after a
priest of Alexandria.

Arius argued that, as Jesus was the Son of God, then surely
he was younger than God: an appealing notion that brought
Jesus closer to mankind and emphasised his human nature.
But another Alexandrian, a bishop called Athanasius, saw a
danger. If Jesus was younger than God, so there must have
been a time when Jesus was not. This challenged the unity of
the godhead – the Father, the Son and the Holy Spirit – and
opened the way to regarding the nature of Jesus as being not
of the same substance as God's. Indeed in time Jesus might
be seen merely as a good man, while God would become less

accessible and more remote. The counter-argument of Athanasius was that no distinction could be made between Christ and God, for they were of the same substance.

Seeing the Christians within his empire divided between the arguments of Arius and Athanasius, in 325 Constantine summoned the First General Council of the Church at Nicaea, a Greek city of north-west Asia Minor in what is now Turkey. Two hundred and twenty bishops were in attendance, from Egypt and Syria in the East to Italy and Spain in the West. The divine nature of Jesus Christ was argued from both the Arian and the Athanasian points of view, and when the bishops balloted on the issue, it was decided in favour of Athanasius by 218 votes to two. This Nicene Creed became the official position of the universal Church, but although it is the creed of both the Roman and Orthodox Churches in our own day, Arianism flourished in various parts of the Roman Empire for many centuries to come and allowed many Christians in the East to mistake the advent of Islam as nothing more than a version of their own belief.

Constantine also faced a problem brought about by the great size and diversity of the Roman Empire. The separate military threats it faced across the Rhine–Danube frontier in the West and the Euphrates in the East made its governance unwieldy. Constantine's solution was to establish a new imperial capital at the ancient city of Byzantium on the Bosphorus, the strategic meeting point of Europe and Asia. Beautifying the city and enlarging the circuit of its walls, in 330 he dedicated Nova Roma, as he called Byzantium, to Jesus Christ – although it quickly became known as the city of Constantine, Constantinople.

On the death of the emperor Theodosius I in 395 a more radical step was taken, and the Roman Empire was formally divided into a western empire ruled from Rome and an eastern empire ruled from Constantinople. Greek culture and language increasingly reasserted themselves in the East

Roman Empire, which, taken together with its Christian foundations, has led historians to give it a different name, the Byzantine Empire. But long after Rome fell to Germanic invaders in 476, and throughout its struggle in the Middle Ages against Islam, and indeed right up to the last when Constantinople fell to the Ottoman Turks in 1453, the emperors and their subjects in the East called themselves Romans and spoke of their empire as the Roman Empire.

Palestine was part of this Christian empire. Jews in significant numbers inhabited lower and upper Galilee and the Golan as well as Caesarea on the coast, but Christians became the majority during the Byzantine period.[3] And not only was Palestine predominantly Christian, but for people all over Europe, North Africa and the Middle East, Palestine was a shared Christian landscape. 'All we, the faithful, worship the cross of Christ as his staff: his all-holy tomb as his throne and couch: the manger and Bethlehem, and the holy places where he lived as his house [...] we reverence Jerusalem as his city; we embrace Nazareth as his country; we embrace the river Jordan as his divine bath', wrote Leontius of Byzantium, who travelled to Palestine in the early 500s.[4]

This feeling for Palestine contributed to the social and economic well-being it enjoyed during the Byzantine period, reflected in the tremendous growth of population, which in numbers and density reached a peak it would not see again until the twentieth century.[5] Just as Palestine was central to Christian sentiment, so it figured favourably in the imperial concerns and attentions of Constantinople and of people throughout the Christian world. Emperors, ecclesiastics and wealthy believers invested enormous funds in the country to take care of the spiritual and material needs of pilgrims, monks and the local inhabitants, so that its cities expanded,

agriculture flourished and even the Negev desert was irrigated and brought under cultivation. Syria and Lebanon also enjoyed prosperity under Byzantine rule, reflected especially in the profusion of both secular and religious buildings in the northern highlands, in the Hauran in the south and in Damascus too, all rich in variety and innovation, drawing on both metropolitan and local architectural styles. Peace and security contributed to this well-being and growth. Under Byzantine protection Palestine and its neighbours were free from wars and their destruction; no foreign armies crossed the country causing damage on their way. But then came the titanic struggle with the Persians, followed by the Arabs afire with the faith of Islam.

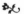

After the fall of Rome to the barbarians in 476 the Byzantines managed to recover a great deal of Roman territory in the West, so that by the mid-sixth century their empire included almost all of Mediterranean Europe except for France and the interior of Spain, nearly all of northern Africa, as well as Asia Minor and the Middle East. But in 568 northern Italy was invaded by a new German tribe, the Lombards. The empire managed to hold no more than Ravenna, while Rome was preserved only by the energy of its pope, Gregory I, who in the process established the temporal power of the papacy. As its Western links dissolved, the Byzantine Empire became a decidedly Greek empire. Instead of taking the Latin title of *imperator* when he came to the imperial throne at Constantinople in 610, Heraclius took the Greek *basileus*, and it was Heraclius also who decreed that Greek, for centuries the language of the educated class, was to replace Latin as the official language of the empire. Roman in conception, Greek in language and culture, Christian in faith, the empire was also composed of people of many backgrounds. Heraclius

himself was of Armenian descent, and his rise was part of the pattern of increasing Armenian prominence in Byzantine society, a consequence of their homeland serving since the second half of the sixth century as the battleground between the empire and Persia.

The Persian state religion was Zoroastrianism, and wherever it spread Christianity was persecuted. In 611 the Persians launched their conquest of Syria; Antioch fell to them in the same year, and in 613 they sacked Damascus, decimating its people by murder and captivity. The Persians captured Jerusalem in 614 and advanced into Egypt, taking Alexandria in 619. At Jerusalem, after a three-week siege, the Persians rushed into the city 'like infuriated wild beasts' and slaughtered the entire Christian population, wrote Antiochus Strategos, a monk at the Greek Orthodox monastery of St Saba outside Jerusalem, who was an eyewitness to the events. When the walls were breached, the defenders

> hid themselves in caverns, fosses, and cisterns in order to save themselves; and the people in crowds fled into churches and altars; and there [the Persians] destroyed them. [...] Like mad dogs they tore with their teeth the flesh of the faithful, and respected none at all, neither male nor female, neither young nor old, neither child nor baby, neither priest nor monk, neither virgin nor widow.

In the midst of this horrific slaughter the Persians set fire to the Church of the Holy Sepulchre and looted the city of its treasures, including the True Cross, discovered by the empress Helena and Christendom's holiest relic. The death toll was 66,509 Christians, a figure given by Antiochus on the authority of a fellow monk who kept a count as he searched for corpses and helped bury them. The litany is long, and this is just a sample:

> In the church of Saints Cosmas and Damian we found 2212 souls. [...] In the lane of St Kiriakos we found 1449 souls. [...] And we found at the spring of Siloam 2818 souls. [...] In the monastery of Saint John we found 4219 souls. [...] We found in the grottos, fosses, cisterns, gardens, 6917 souls. At the Tower of David we found 2210. [...] Just where the enemy overthrew the wall of the city we found 9809 souls

and so on.[6] According to the contemporary Armenian historian Sebeos, the Persians themselves arranged for the dead to be counted, and he gives a hardly less appalling figure of 57,000.[7] Archaeologists have discovered mass graves confirming that a great massacre did take place.[8]

From 622 Heraclius launched a series of counter-attacks against the Persians which 'assumed the form of a crusade'.[9] His remarkable expeditions required that he leave Constantinople unprotected except by its geography, its walls and divine providence, and in this his trust was sound; in 626, while Heraclius was attempting to outflank the Persians via the Caucasus, the Persians advanced across Asia Minor to Chalcedon on the Bosphorus in concert with a land and sea assault on Constantinople from the north and west by Avars and Slavs. But the crusading zeal that Heraclius had instilled in the city's inhabitants kept them loyal to him in his absence, and they resisted stoutly. Although the Slavs at one point breached the Theodosian land walls, they were repelled, it was believed, by the miraculous intervention of the Blessed Virgin, while the Slav ships were destroyed in the Golden Horn and the Persians were never able to cross the Bosphorus.

The following year, as Heraclius advanced deep into Persia, its king was overthrown by revolution and his successor sued for peace. Syria, Palestine and Egypt were restored to the Byzantine Empire, and Heraclius himself with his wife, Martina, travelled to Jerusalem, where the True Cross

was restored to its former place amid scenes of great joy, described by Sebeos:

> There was much joy at their entrance to Jerusalem: sounds of weeping and sighs, abundant tears, burning flames in hearts, extreme exaltation of the emperor, of the princes, of all the soldiers and inhabitants of the city; and nobody could sing the hymns of our Lord on account of the great and poignant emotion of the emperor and of the whole multitude.[10]

2

The Arab Conquests

B OTH THE BYZANTINES in their victory and the Persians
in defeat lay exhausted when, in 633, the sounds of war
were heard again. This time it was an Arab army, the follow-
ers of the new religion of Islam, whose prophet Mohammed
had died the year before. The Byzantines did not feel greatly
threatened, failing to recognise the approaching Bedouins
as a significant military force. This story of conquest, one of
the most far-reaching and rapid in history, had its beginnings
in Arabia in 622, when Mohammed began to unite the Arab
tribes into a powerful fighting force through his preaching
of a single god. Despite being largely barren and uninhab-
ited, Arabia occupied an important position between Egypt,
Abyssinia, Persia, Syria, Palestine and Mesopotamia, whose
trade with one another relied to some considerable extent on
the Arab caravans that carried their goods across the perilous
wastes. Mecca stood at an important crossroads of this desert
trade, and the authority of the Arab nomadic tribal sheikhs
was in some measure supplanted at Mecca by an oligarchy of
ruling commercial families whose religious beliefs and prac-
tises transcended narrow tribal allegiances. The Meccans
ensured that their rock-shrine, the Kaaba, contained not one
but several venerated tribal stones, each symbolising a local

god, so that tribesmen visiting the market fairs could wor-
ship their favourite deity during their stay in the city. The
Meccans also worshipped Manat, Uzza and Allat, goddesses
of fertility and fate, who in turn were subordinate to a yet
higher god, called Allah.

Such material as we have about the early days of Islam
comes mainly from the Koran and from the hadith, the
traditions relating to the actions and sayings of Moham-
med as recounted by his Companions. Born in about 570,
Mohammed was the son of a poor merchant of Mecca who
was nevertheless a member of the powerful Quraysh tribe,
the hereditary guardians of the Kaaba. While working as a
trader, he was exposed not only to the flow of foreign goods
but also to the currents of Jewish and Christian ideas. In par-
ticular, through conversing with Jews and Christians he met
in Mecca and elsewhere in Arabia, Mohammed had become
acquainted with the stories of the Old and New Testaments,
with the main elements of Jewish and Christian popular
custom and belief, and above all with the concept of mono-
theism. Drawn into a life of religious contemplation, in about
610 he began to receive revelations via the angel Gabriel of
the word of Allah, who announced himself to Mohammed
as the one and only God. Other gods were mere inventions,
announced the revelation, and their idols at the Kaaba were
to be destroyed.

This message provoked a great deal of antagonism among
the Meccans, but slowly Mohammed began making some
converts among pilgrims from Yathrib, an agricultural com-
munity about 250 miles to the north which had a mixed pop-
ulation of Arabs, Jews and Judaised Arabs and was therefore
already familiar with monotheism and other features of his
teaching. In 622 the hostility of the pagan Meccans towards
Mohammed reached such a pitch that he and his small band
of followers were obliged to accept an invitation to settle in
Yathrib. This migration, or Hegira, marked the beginning of

the Muslim era, and in time Yathrib was renamed Medinat al-Nabi – 'City of the Prophet' – or Medina for short.

Mohammed's understanding of Jewish and Christian concepts led him to believe that they were basically identical to the revelations, later gathered in the Koran, that he had received, and therefore he expected that Jews and Christians would agree with his teaching and recognise him as a prophet standing in the line of Abraham, Moses, David, Solomon, Jesus and others. But whereas remnants of Arianism, a familiar Christian heresy which depreciated the divinity of Jesus, may have allowed Mohammed to believe that Christianity could dispense with the divinity of Jesus, the Jews were uncompromising: they told him that his revelations were a distortion and a misunderstanding of their tradition, and they drew attention to the numerous contradictions in his revelations on Old Testament themes.

Mohammed's answer was to turn against the Jews, saying they had deliberately falsified their traditions, while he presented himself as the restorer of the religion of Abraham, who he said was the founder of the Kaaba and its cult. He abandoned the Muslim fast corresponding to Yom Kuppur, the Jewish Day of Atonement, the one day of the year when the High Priest at the Temple in Jerusalem entered the Holy of Holies where he made atonement for all the Jews in the world. In place of a day of fasting, Mohammed instituted the month-long fast of Ramadan. And at the same time, according to tradition, he instructed Muslims to pray towards the Kaaba in Mecca; until then he and his followers had prayed towards Jerusalem.

But one of Mohammed's most important acts during his early years in Medina was to announce the revelation giving permission to his followers to go to war against those identified as their enemies. 'Permission to take up arms', goes the Koranic verse, 'is hereby given to those who are attacked, because they have been wronged. God has power to grant

them victory: those who have been unjustly driven from their homes, only because they said: "Our Lord is God".'[1] According to Muslim scholars this concept of jihad, or holy war, can legitimately be applied against injustice and oppression, or against the rejectors of the truth – that is, the truth of Islam – after it has been made evident to them. In the immediate circumstances it was used against the Meccans. After provoking several clashes with the Meccans, including raids on their caravans, which provided the Muslims with considerable booty, Mohammed conquered Mecca in 629. Extending his wars against the Bedouin tribes, he gained control over much of Arabia the following year. But many tribes who allied themselves with Mohammed saw him as a war leader, not as a religious prophet, and at his death in 632 they thought of their alliance as dissolved. When Abu Bakir was made caliph – that is, successor to Mohammed (Khalifat Rasul Allah, Successor to the Apostle of God) – he went to war against these 'apostates', for he understood that Islam would survive only if the momentum of war was continued. And so what began as the wars of the Ridda, wars against apostasy among the tribes, soon broadened into a war of plunder and conquest beyond the Arabian peninsula, each triumph winning new followers and confirming the new faith.

Arabia's limited natural resources presented a constant threat of poverty and hunger to its inhabitants and were a major factor in why the Arabs 'erupted from the hot prison of the desert'.[2] But material need alone would not have sustained the campaigns of conquest that followed. Religious fervour and the promise of Paradise for those who died in the course of making the supreme effort to go the way of Allah, which is the meaning of jihad, turned the Arabs into a united force, courageous and unafraid of death. Moreover, Islam gave the Arabs an imperialist ideology that demanded the submission of their enemies and justified Muslims as

the ruling class. The first forays, under the caliph Abu Bakr (632–4), pushed up through the Syrian desert and into the lower reaches of the Euphrates in Mesopotamia (modern-day Iraq), to which the raiding Arabs were attracted by booty, ransom and abundant pasturage, while others penetrated into Palestine. Under his successor, the caliph Umar (634–44), Arab armies overran all of the Byzantine Middle East, including Syria, Palestine and Egypt, and won an important initial victory over the Persians, leaving the final destruction of Persia's Sassanian Empire to Uthman (644–56), the third caliph. When the Persian king Yazdegerd III asked, 'Why has your nation taken up arms against us?', the Arab emissary had the answer: 'Allah commanded us, by the mouth of His Prophet, to extend the dominion of Islam over all nations.'[3]

The Arab invasion began in February 634, Thomas the Presbyter recording 'a battle between the Romans and the Arabs of Mohammad in Palestine twelve miles east of Gaza. The Romans fled, leaving behind the patrician Bryrdn, whom the Arabs killed. Some 4000 poor villagers of Palestine were killed there, Christians, Jews and Samaritans. The Arabs ravaged the whole region.'[4] Then in July that year an Arab army 20,000-strong overwhelmed a Byzantine force half that size at the battle of Ajnadayn, 16 miles west of Jerusalem, leaving Palestine and Syria vulnerable to further advances.

Damascus was the first major Byzantine city to face the Arab onslaught. In March 635 a Muslim army arrived at the walls of the city, fell to its knees in prayer, then put the population under siege. After months of growing desperation within the city, the commander of its garrison, Thomas, the son-in-law of the emperor Heraclius, launched a counterattack. As he led his men out to battle, Thomas placed his

hand on the Bible and called to God: 'If our faith be true, aid us, and deliver us not into the hands of its enemies.' The Muslim chroniclers to whom this account is owed recorded great feats of heroism on both sides. Many Muslim commanders were killed, but Thomas was shot through the eye with an arrow, the Christians were forced back within the walls, and Damascus fell a few days later (in 635 or 636, the sources giving various durations for the siege, from six months to over a year). Those Christians who wanted to leave the city were given three days' safe passage, and among these were Thomas and his wife, the emperor's daughter. The refugees made for the mountains of Lebanon, but after the third day they were hunted down and were slaughtered in the meadows. Thomas was struck to the ground, and his head was cut off and raised on the cross of a captured Byzantine standard. Only one Christian escaped to carry the news of the disaster to Constantinople, while Thomas' wife, after being offered up to one of her captors, was instead released to a deputation from her father.[5]

These events were followed anxiously in Jerusalem, which by the summer of 636 was itself under siege. The Arabs began with an ultimatum:

> Health and happiness to every one that follows the right way! We require of you to testify that there is but one God, and that Mohammed is his apostle. If you refuse this, consent to pay tribute, and be under us forthwith. Otherwise I shall bring men against you who love death better than you do the drinking of wine or eating hogs flesh. Nor will I ever stir from you, if it please God, till I have destroyed those that fight for you, and made slaves of your children.[6]

But the ultimatum was refused.

The defence of Jerusalem was in the hands of a Byzantine garrison supported by armed units of local inhabitants and

was organised by Sophronius, the city's eighty-six-year-old Greek Orthodox patriarch. After sending the True Cross to Constantinople for safety, Sophronius did what he could to prevent Jerusalem suffering the same fate as Damascus, the city of his birth. But any hopes of relief were dashed when the Arabs, thanks largely to the agility of their fast-moving cavalry, won a decisive victory over the Byzantines in August 636 at the Yarmuk river, a tributary of the Jordan east of the Sea of Galilee; from that moment Jerusalem was entirely cut off from the outside world, while the Arabs 'plunder cities, devastate fields, burn down villages, set on fire the holy churches, overturn the sacred monasteries', as Sophronius told his congregation.[7] Although sometimes described as 'bloodless', the Arab siege necessarily meant great suffering for Jerusalem's inhabitants, some dying of starvation, others killed in defending the walls or making sorties against the encircling enemy. Finally, in the spring of 638, after Jerusalem had endured the siege for nearly two years, Sophronius was forced to surrender.[8]

There are several accounts of the fall of Jerusalem by Muslim writers, short on detail and contradictory, and all written at least a century after the event. But generally they speak of Jerusalem refusing to surrender to anyone other than the caliph, and so Umar rode up from the Muslim capital at Medina and received its capitulation on terms agreed with Sophronius. Provided the inhabitants paid the *jizya*, a tax imposed on non-Muslims, they were free to remain within the city, and the security of their lives, their property and their churches would be assured. Then Umar entered the city, not on horseback but more humbly on a camel, or according to another version he dismounted from his camel and entered on foot.

The caliph asked to be taken to the Temple Mount, the site of Solomon's Temple and powerful for its associations with the Jewish prophets, claimed by the Koran as

forerunners of Islam.[9] Since the destruction of Herod's Temple by the Romans the Mount had been left ruinous and abandoned and, according to some sources, had become a rubbish dump. The site meant little to the Christians, and to build a mosque there would avoid Umar's undertaking not to interfere with Christian places of worship. Summoning his men to clear a space amidst the debris, Umar ordered the construction of a mosque, later described by the Gallic pilgrim Arculf, who visited Jerusalem in about 670: 'In that renowned place where once the Temple had been magnificently constructed [...] the Saracens now frequent a four-sided house of prayer, which they have built rudely, constructing it by raising boards and great beams on some remains of ruins'[10] – probably the remains of Herod's Royal Stoa along the south retaining wall of the Temple area. The mosque was large enough, Arculf was told, to house three thousand men at once.

Umar's greatest concern when building his mosque was that there should be no mistaking its direction of prayer. In this he was recalling that Mohammed had first prayed towards Jerusalem but had received a revelation that he should turn his back upon the city and pray instead to Mecca. This change of *qibla*, the direction of prayer, is mentioned in the Koran, where, after saying that fools will taunt believers for their sudden turnabout, the instruction is given to 'Turn your face towards the Holy Mosque; wherever you be, turn your faces towards it', the Holy Mosque being the mosque built round the Kaaba at Mecca.[11] Umar followed this admonition on the Temple Mount, where he was emphatic about the position for his mosque: 'We are not directed about the Rock', he said, referring to the outcrop that was believed to mark the Holy of Holies of the Jewish Temple 'but about the Kaaba', speaking of Islam's most sacred site in Mecca.[12] Instead of placing his mosque somewhere at the northern part of the Temple Mount, where the *qibla* would point

towards both the rock and the Kaaba, he built his mosque at the southern end of the Mount so that it turned its back on Jerusalem and the site of Solomon's Temple but had an unimpeded line of prayer to Mecca. For all the respect Umar paid to Jerusalem and its prophets, there was nothing in his acts which signified that the city or the Temple Mount or its rocky outcrop was holy to Muslims.

But Muslim attitudes would begin to change after a new dynasty of caliphs, the Umayyads, redeveloped the Temple Mount, building the Dome of the Rock and replacing Umar's nameless mosque with the one that stands there to this day and is known as the Aqsa mosque – *aqsa* meaning 'the furthest', a name that would link the Temple Mount to the Night Journey of the Prophet Mohammed and would eventually transform Jerusalem into a Muslim holy place.

Meanwhile Palestine was organised into military districts, *junds*, which more or less followed the Byzantine provinces of Palestina Prima and Palestina Secunda. Jund Filastin (Palestine) extended from the Mediterranean to the Dead Sea; at first its capital was at Ludd (Lod), later at Ramla, both cities inland from the Byzantine capital of Caesarea on the coast but on the overland trade route between Egypt and Damascus. Jund Urdunn (Jordan), centred on Galilee, extended eastwards beyond the Jordan river, and had its capital at Tiberias.

3
Palestine under the Umayyads and the Arab Tribes

FOR ALL THAT ISLAM was meant to transcend the ancient tribal loyalties of the Arabs, the tribes still survived, and with them tribal jealousies and feuds. Moreover, rivalry between the tribes and their component clans and families went right to the very heart of the caliphate. In 656 insurgent Arab troops murdered Uthman, the third caliph, who was a member of the powerful Umayyad family of Mecca. Ali put himself forward as the natural inheritor of the caliphate, basing his claim on his marriage to Mohammed's daughter Fatima, as well as on his considerable religious learning. But Ali was opposed by Aisha - Mohammed's favourite wife and the daughter of Abu Bakr, the first caliph - along with many of Mohammed's surviving companions, the very people who had stirred up the murderous rebellion against Uthman. Ali took to arms and won his first battle, but opposition against him only hardened when he dismissed many of those whom Uthman had appointed. Among these was Muawiya, Uthman's nephew and governor of Syria, who demanded vengeance for his uncle's murder. In 657 Ali and Muawiya met in battle at Siffin, near Raqqa, on the Euphrates, which ended in negotiations that weakened Ali's position and ultimately led to his assassination by a disaffected follower in 661.

Muawiya's brother had commanded the Arab tribes that conquered much of Palestine and Syria; they subsequently gave their loyalty to Muawiya as governor of Syria and received many rewards from him, and now they were his power base when Muawiya was acclaimed caliph in Jerusalem, made Damascus his capital and established the Umayyad dynasty as masters of the growing Arab empire.

After consolidating his authority, Muawiya turned his attention to new wars of territorial expansion with their rewards of plunder, expropriation and taxation, and which also had the benefit of diverting tribal frictions into struggles for the faith. Attacks against the Byzantine Empire were resumed. Arab armies ravaged Asia Minor nearly every summer, Cyprus and the Aegean islands were laid waste, and in 670 an Umayyad fleet landed at Cyzicus, on the Sea of Marmara, from where the Arabs launched annual summer sieges of Constantinople for seven years. Under the energetic resistance of the emperor Constantine IV the city repelled the Arab attacks. The most potent weapon in the Byzantine armoury was Greek Fire, a secret compound of sulphur, naphtha and quicklime which burst into flames on impact with enemy ships and could burn even under water, the invention of a Christian Syrian refugee. Eventually the Byzantines drove the Arab army out of Asia Minor and forced Muawiya into paying a tribute in return for a negotiated peace. Not for the last time a Byzantine victory saved not only themselves but all Europe from Muslim domination.

But elsewhere the Umayyads had greater success. In North Africa the last outpost of Byzantine rule in the region of Carthage was destroyed by the Arabs in 667. The resistance of the Berbers, who were Christians, to the Arab armies was repaid with terrible raids and devastation. Those who eventually submitted to Islam became part of the further expansion of the Muslim armies towards the Atlantic, while the more Latinised population of North Africa, heirs of a

classical and Christian civilisation that had produced such figures as the theologian Augustine of Hippo, author of *The Confessions* and *The City of God*, and himself of Berber origin,[1] emigrated to Italy and Gaul.

The wave of Muslim expansion was checked by the outbreak of prolonged and savage warfare between the Arab tribes. In 684 Ibn al-Zubayr, the nephew of Aisha and the grandson through his mother of the first caliph, Abu Bakr, rejected the Umayyad claim to the caliphate and declared himself caliph at Mecca, winning the support of tribes in Arabia and those occupying Egypt and Mesopotamia and, most worrying of all, even some in Palestine and Syria. A battle at Marj Rahit, east of Damascus, secured Syria for the Umayyads in that same year, but the wider struggle was inherited by Abd al-Malik, who succeeded to the Umayyad caliphate in 685, and was decided only in 692 with the defeat of al-Zubayr at Mecca.

Abd al-Malik countered these disorders not only on the battlefield but also with a variety of administrative measures aimed at asserting the unity of the empire, the authority of his caliphate and the supremacy of Islam. In the years following their conquests the Arabs could not have administered Syria, Palestine, Mesopotamia or Egypt, and most importantly could not have collected taxes, without the services of experienced officials drawn from the local populations, which meant leaving Christian officials at their posts, just as Zoroastrians were left in place in Persia. In Syria and Palestine the language of administration had been Greek, while the everyday language of the population was Syriac, a dialect of Aramaic, the lingua franca of the Middle East for over a thousand years. The administration of Egypt was carried on in Greek by its native Christian population, the Copts (from 'Aegyptos', the Greek for Egypt), whose demotic language,

Coptic, had evolved from ancient Egyptian; they also continued to manage the country's vital irrigation system. But now Abd al-Malik made Arabic the mandatory language of government affairs throughout his empire. Likewise the coinage, which had continued to bear Christian and Zoroastrian symbols, was replaced by redesigned pieces inscribed in Arabic with the Profession of Faith ('There is no God but Allah and Mohammed is his Prophet'). The message of Muslim domination was perfectly suited to the system, for the economy was predominantly monetary and depended on exactions from the conquered people who paid their taxes in coin. Very few Arabs were productive settlers on the land, an activity they despised; a few were great landlords who used native tenants to cultivate their estates; but generally they were nomadic tribesmen, soldiers or officials, all of whom lived off the *jizya* (or poll tax) and the *kharaj* (or land tax) paid by the occupied peoples in return for the protection of their lives and property and for the right to practise their own religion. Because the *jizya* and the *kharaj* could be imposed only on non-Muslims, the Arabs had little interest in making converts to Islam, a contributory reason why Syria, Palestine and Egypt would remain overwhelmingly Christian for centuries to come.

As Abd al-Malik Arabised and Islamised his administration, so he also turned to dominating the religious landscape of Jerusalem with the construction, starting in 688, of the Dome of the Rock atop the Temple Mount. Recent archaeological excavations suggest that the Dome of the Rock was the centrepiece of an ambitious plan to redevelop the eastern part of Jerusalem. The exterior of the Dome of the Rock is in the form of an octagon, its four portals facing the cardinal points and giving access to a domed circular interior enclosing the rocky outcrop like a shrine. Archaeologists think that the Dome of the Rock was meant as a tetrapylon, a four-gated monumental structure common in Roman and Byzantine cities, in this case marking the crossroads of a new Muslim city

centred on the Temple Mount, while a new mosque, replacing the wooden structure built by Umar at the southern end of the Temple Mount, was part of this plan.[2]

As for the religious significance of the works atop the Temple Mount, early Muslim writers give various accounts. According to Ahmad al-Yaqubi, a Muslim chronicler and geographer writing two hundred years after these events, the rebellion of al-Zubayr was the spur to Abd al-Malik to build an alternative shrine of pilgrimage at Jerusalem, and certainly the Dome of the Rock, with its inner and outer ambulatories, suggests that it may have been intended to rival the Kaaba at Mecca, where walking round the shrine is part of the ritual. It follows from this argument that the Umayyads wanted to glorify their power base in Syria and Palestine at the expense of Mecca and Arabia, and certainly they devoted a great deal of effort and expense to glorifying Damascus and even more to exalting Jerusalem. But in the view of Mohammed ibn Ahmed Muqaddasi, a tenth-century Arab geographer born in Jerusalem, the Dome of the Rock was built to put the Church of the Holy Sepulchre in the shade: 'Abd al-Malik, noting the greatness of the Dome of the Kumamah and its magnificence, was moved lest it should dazzle the minds of the Muslims, and hence erected, above the Rock, the Dome which now is seen there.'[3] Early Islam was haunted by the fear that its adherents would abandon their faith for the attractions of Christianity, and such was the need to depreciate the Church of the Holy Sepulchre, or the Anastasis as it is called in Greek, meaning the Resurrection, that the Muslims deliberately corrupted the Arabic for 'Resurrection', which is Kayamah (*al-qiyamah*), and commonly called the Church of the Holy Sepulchre the Kumamah (*al-qumamah*), or 'the Dunghill',[4] as Muqaddasi has done in his description.

But there was the even greater need for the caliphs to impress their Christian subjects. When criticised for his shameless imitation of the Byzantine emperors, the first

Umayyad caliph, Muawiya, had retorted that 'Damascus was full of Greeks and that none would believe in his power if he did not behave and look like an emperor'.[5] Not surprisingly, Abd al-Malik made a point of building the Dome of the Rock along familiar Christian lines, his borrowing so complete that it has been called 'a purely Byzantine work'.[6] One obvious model for the Dome of the Rock was the 'Dunghill' itself, the Anastasis, the domed rotunda of the Church of the Holy Sepulchre; the dimensions of its inner circle of piers and columns and their alternating pattern are exactly reproduced in the Dome of the Rock. Other Byzantine churches too were of this circular type, among them the church of St Simeon Stylites in northern Syria, the church of San Vitale in Ravenna, and interestingly the church of the Ascension on the Mount of Olives overlooking Jerusalem, built round the spot identified by tradition as where Jesus ascended into heaven, leaving his footprint in the rock, where it can still be seen today – just as Muslim tradition later claimed that the rock beneath the Dome of the Rock bears the footprint of Mohammed from the time he was taken by the angel Gabriel for a glimpse of heaven during the Night Journey.

The tradition of the Night Journey tells of the *isra*, the journey itself, and the *miraj*, meaning 'the ascent'. According to the account, when Mohammed was still at Mecca, and before the Hegira to Medina, he was miraculously conveyed by the angel Gabriel to the site of the Furthest Mosque (*al-masjid al-aqsa*) in Jerusalem, where he encountered various prophets before ascending from the Temple Mount through successive heavens until finally entering into the presence of God himself. But nothing in the Koran identifies the Furthest Mosque with the Temple Mount, nor is there any mention of Jerusalem: 'Glory be to Him, who carried His servant by night from the Holy Mosque to the Further Mosque the precincts of which We have blessed that We might show him some of Our signs.'[7] The Holy Mosque means the Kaaba at

Mecca, but nothing in the Koran indicates the location of the Further Mosque – with some arguing that the Further Mosque most certainly refers not to Jerusalem but to the mosque which at that time was furthest from Mecca: that is, the mosque at Medina.[8] Moreover the Koranic verse is about the journey but says nothing about an ascent, for which there are traditions that Mohammed ascended to heaven from the roof of his own house in Mecca, not from Jerusalem.[9]

The earliest source for the story of the Night Journey is Mohammed's biographer Mohammed Ibn Ishaq, who died in about 767, although his original work is lost and survives only in various later edited versions, most notably that of Abdul-Malik Ibn Hisham, who died in about 833. What is more, Ibn Ishaq may never have written down his biography, so that what reached Ibn Hisham and others was an oral version. In other words, something like one or two centuries had passed since the death of Mohammed before the first known appearance of the story of the Night Journey. Had the tradition of Mohammed's journey to Jerusalem and his ascent from there to heaven already been in place when Abd al-Malik built the Dome of the Rock, one would expect it to be commemorated among the shrine's many inscriptions, yet the inscriptions make no mention of the Night Journey at all. Instead, the evidence suggests that the tradition of the Night Journey and its connection with Jerusalem arose some time after the construction of the Dome of the Rock, and that the tradition specifically connecting the *isra* and *miraj* with the Dome of the Rock is very much later still and was 'perhaps not fully established until Mamluk times'[10] – that is, after Saladin and the demise of his dynasty. In fact, far from commemorating the Night Journey, the Dome of the Rock seems to have generated the tradition.

Abd al-Malik himself announced his purpose in building his shrine atop the Temple Mount, leaving no doubt over its meaning or date. In what is the earliest surviving written

Islamic text, his founder's dedication was inscribed in gold mosaic along the arcade inside the Dome of the Rock. 'This dome was built by the servant of God, Abd al-Malik Ibn Marwan, the Prince of the Believers, in the year 72' – that being the year since the Hegira and corresponding to AD 691 or 692 – 'May God accept it and be pleased with him. Amen.' Then, borrowing from the Koran, the inscription continues with an emphatic warning to Christians and their belief in Christ and the Trinity:

> People of the Book, do not transgress the bounds of your religion. Speak nothing but the truth about God. The Messiah, Jesus the son of Mary, was no more than God's apostle and His Word which he cast to Mary: a spirit from Him. So believe in God and his apostles and do not say: 'Three'. Forebear, and it shall be better for you. God is but one God. God forbid that he should have a son! His is all that the heavens and the earth contain. God is the all-sufficient protector.[11]

Muqaddasi would write proudly in the tenth century: 'At dawn, when the light of the sun first strikes the dome and the drum catches the rays, then is this edifice a marvellous sight to behold, and one such that in all of Islam I have not seen the equal; neither have I heard tell of anything built in pagan times that could rival in grace this Dome of the Rock.'[12] By its location on the site of the Temple the Dome of the Rock announced that Judaism had been succeeded by the prophet of Islam just as its inscription and the magnificence of its architecture announced the triumph and dominance of Islam over the Christian East. As Abd al-Malik intended, the building acted like a magnet, attracting visitors from the expanding Muslim world who conferred a sense of Islamic veneration on the Mount. Chroniclers and Koranic commentators also made their contribution by elaborating an entire

tradition of the Night Journey round the Dome of the Rock and also the nearby Aqsa mosque, completed in 715 but only much later acquiring its name, 'the Furthest', which linked it to the Koranic verse.[13] So began the process of sanctification that over the coming centuries would turn Jerusalem, after Mecca and Medina, into the third most holy city in Islam.

☙

By the time Abd al-Malik died, in 705, he had succeeded in imposing order on the Arab tribes and had concentrated yet further powers in the caliphate; and during the reign of his son Walid the wars of aggression in the name of Islam were resumed, raising the Umayyads to the high point of their power. In the East, the Arabs advanced beyond the Oxus into Central Asia, where they captured Bukhara and Samarkand in 715 and first encountered the Turks. Another army crossed the Indus and invaded Sind, beginning the long process of Islamisation in India. In North Africa the Arabs reached the Atlantic and in 711 crossed via Gibraltar into Spain, and within a decade they stood at the foot of the Pyrenees and occupied Languedoc.

The jihad against the great Christian enemy, the Byzantine Empire, began again, starting with seasonal raids into Asia Minor. Under Walid's successor Sulaiman a massive combined naval and land force beleaguered Constantinople in 717-18. But the city did not fall, nor Asia Minor, that indispensable reservoir of men and resources, thanks to Heraclius, who a century earlier had created a system of defence in depth that would preserve the empire's heartland for another four hundred years. He had organised Asia Minor into 'themes' - that is, regions in which inheritable land was given in exchange for hereditary military service - and the system proved successful: except in the border areas south of the Taurus mountains round Tarsus and eastwards round

Edessa (present-day Urfa), Arab raids almost never led to Arab occupation. Defended by its farmer-soldiers, Byzantine Asia Minor maintained the continuity of its Graeco-Roman traditions and protected Europe long enough for it to reorganise after the barbarian invasions and the collapse of the Roman Empire in the West.

The commander of one of these themes in Asia Minor was Leo, who had been born in northern Syria. In 716 he fought a rearguard campaign from the Taurus mountains to the Sea of Marmara against the invading Arab army, arriving at Constantinople in time to impose himself as emperor and to stock the city's granaries and arsenals in anticipation of the siege to come. Before the invention of gunpowder, Constantinople was impregnable as long as it could be supplied by sea. By daring sea and land sallies Leo III wore out the Arab army and hurled Greek fire at the Arab fleet – or rather a fleet constructed and manned by Syrians and Egyptians, as the Arabs had little knowledge of seafaring[14] – and finally inflicted such a disaster upon the besiegers that out of the 2,560 galleys and the 200,000 men directed against Constantinople, only 5 galleys and no more than 30,000 men returned to Syria. The event has been compared to the failed Persian invasion of ancient Greece and Leo compared to Miltiades, the victor at Marathon.

In Western Europe an echo of the Byzantine victory came fourteen years later, in 732, during the caliphate of Hisham, when the Arab armies, after advancing deep into France from Spain, were hammered by Charles Martel between Poitiers and Tours, only 160 miles short of the English Channel. Charles Martel then went on to clear the Muslims from southern France, in the process establishing the Franks as the dominant people in Western Europe; his grandson Charlemagne laid the foundations for the Holy Roman Empire and was the first European leader to join the Reconquista against the Muslims in Spain.

These defeats brought Umayyad internal problems to a

head. The cost of the expeditions had been enormous and was not recovered by tributes and taxes from newly conquered peoples. At Constantinople the complete destruction of the Umayyad fleet and army deprived the caliphate of the military basis of its power and undermined the perception of the Arabs as a legitimate ruling elite.

During this first century of Islam the terms Muslim and Arab were all but synonymous. To be an Arab was to be an Arabic-speaking, desert-dwelling tribesman, a nomad or of nomadic ancestry, which is the meaning of 'Bedouin', whose life centred on the camel. Some Arabs had become townsmen and engaged in trade, just as Mohammed had been a merchant, but their tribal relationships remained. These Arabs were now conquerors, members of the ruling class and recipients of its privileges, which included regular pensions as well as a share in the booty from newly conquered lands. Neither settlers nor farmers, they were a military aristocracy who lived deliberately apart from native populations and whose only obligation was to fight for their religion, the organising faith that justified their dominance and made them masters of an empire.

But somewhat disconcertingly to the Umayyad leadership, Islam began to attract converts, mostly to escape the oppressive restrictions imposed on non-Muslims. Such was the identity, however, between being a Muslim and an Arab that would-be converts had to be adopted as clients of an Arab tribe, at the same time severing themselves from their previous social, economic and national connections. Even then the Arabs treated these converts, *mawali*, as their social and economic inferiors. For an Arab woman to marry a convert brought shame upon her family; converts could serve in the army only as infantry and received less pay than Arabs; and *mawalis* who settled round the *ansari*, the Arab garrison towns, where they served as artisans and the like, were periodically driven away. Furthermore they were still subject to

the same poll tax imposed on non-Muslims. But the *mawalis* were becoming increasingly conscious of their growing numbers, their political and military importance, their cultural superiority – and now they were demanding social and economic equality with the Arabs.

Following the Constantinople disaster, the caliph Umar II tried to appease rising discontent by decreeing that converts were exempt from the *jizya* and that they should receive equal soldier's pay. But the effect was to reduce the revenue coming into the treasury, and the shortfall was made up by treating the non-Muslim population, the *dhimmis*, all the more severely. Umar II is usually credited with formalising decrees determining the legal and social position of *dhimmis*. The basic position was that *dhimmis* were the People of the Book – that is, Christians and Jews whose prophets handed down the message that in its essence and its perfected form was recorded in the Koran. Therefore a certain tolerance and protection were owed to these people, to whom the Koran promised that the Muslims would not fight them on condition that they paid the *jizya*, a form of tribute. Christians and Jews stood outside the community; they were not allowed to carry weapons, or to bear witness against Muslims in courts of law, or to marry Muslim women. A *dhimmi* who attempted to convert a Muslim to his own religion paid with his life, as did any Muslim who apostasised. But a Muslim who killed a Christian or a Jew was subject not to the death penalty, only to a fine at most. *Dhimmis* had to be submissive and consider themselves inferior to Muslims and act and dress accordingly; they could not resemble Muslims in their clothing or the way they wore their hair. Christians and Jews were free to practise their religion, but in a subdued manner so as not to disturb Muslims; festivals and public expressions of faith were curtailed. They were not allowed to build new churches or synagogues, or to keep them in repair. If a place of worship was damaged or destroyed for any reason – earthquake,

fire or mob action – it could not be rebuilt. After a time Zoro-
astrians of Persia and pagan Berbers of North Africa were
also accepted as People of the Book. But no toleration was
extended to those who were not People of the Book; to them
the choice was Islam or the sword.

Despite these onerous and humiliating regulations, many
Christians found an advantage in their condition. If the tri-
umph of Islam had been enabled by the Byzantine Empire's
long and exhausting conflict with Persia, it had also been
helped by the fierce theological disputes that for hundreds
of years had disturbed the unity of the Christian world. And
so it is fitting, if ironic, that an effect of the Muslim conquests
was to protect and preserve a considerable variety of Chris-
tian beliefs considered unorthodox and even heretical under
Byzantine rule. To the Muslims these controversies were of
little account; Islam was the revealed and perfected faith,
and as for the Christians, and also the Jews, as long as they
submitted to Muslim rule and paid their taxes, they were
permitted to conduct their own affairs according to their own
laws, customs and beliefs.

Christian heresy therefore flourished in the Middle East
under Muslim rule, or rather, what was regarded as heresy by
the authorities in Constantinople and by the popes in Rome.
But here in the Middle East all Christian sects were treated
alike, so that heterodox and heretic Christians were now
freed from persecution by Christian orthodoxy or the state.
For example, at the Council of Chalcedon in 451 a major-
ity decided that Jesus had two natures, the human and the
divine, adding that these were unmixed and unchangeable
but at the same time indistinguishable and inseparable. This
is the view of almost all Christian churches to this day. But
Nestorius, a fifth-century archbishop of Constantinople who
had been born in Syria and was trained at Antioch, held that
the human and divine natures of Christ were entirely sepa-
rate, and for this he was called a dyophysite (from the Greek

for 'two natures') and declared a heretic. Yet his adherents, who formed the Nestorian Church and were active missionaries, enjoyed a considerable following in the East, especially in Persia, where they contended against Zoroastrianism. In reaction to Nestorianism, and also in opposition to the orthodoxy put forward at the Council of Chalcedon, members of the Syrian Church, known as the Jacobites, and of the Egyptian Church, that is the Copts, while not denying the two natures, put emphasis on their unity at the Incarnation. For this the Syrians and Egyptians were called monophysites (from the Greek for 'single nature'), and were charged with the heretical belief that Jesus' human nature had been entirely absorbed in the divine.

These arguments were of supreme importance, quite literally a matter of life and death, for the nature of Jesus was directly relevant to the salvation of man. Pope Leo I, 'the Great', advanced the orthodox position that prevailed at the Council of Chalcedon: 'God is believed to be both almighty and Father; it follows that the Son is shown to be co-eternal with him, differing in no respect from the Father. For he was born God of God, almighty of almighty, co-eternal of eternal; not later in time, not inferior in power, not dissimilar in glory, not divided in essence.' Having asserted the divine and timeless nature of Jesus, he argued that being born of the Virgin Mary, 'this birth in time has taken nothing from, and added nothing to, that divine eternal nativity, but has bestowed itself wholly on the restoration of man'. Man is the beneficiary of the divine Jesus also taking on the nature of man, 'For we could not overcome the author of sin and death, unless he had taken our nature, and made it his own'.[15]

What exactly the parties to these disputes meant when they talked of the nature of Jesus Christ was affected by shades of language and culture as well as by ultimate principles. While the various Church councils hammered out the theological positions that became the orthodoxy of Rome

and Constantinople, Christians in Syria, Palestine, Egypt and elsewhere often held to their views and found themselves in conflict with, and felt oppressed by, the universal Church. Sometimes it was more local than that, with the rural population of, say, Palestine following monophysite beliefs while the established clergy in Jerusalem was soundly orthodox. The arguments could be bitter and had a divisive effect within the Byzantine Empire and helped prepare the way for the coming of Islam. As one figure of the Jacobite Church said of the Muslim conquest: 'The God of vengeance delivered us out of the hands of the Romans by means of the Arabs. It profited us not a little to be saved from the cruelty of the Romans and their bitter hatred towards us.'[16]

But soon Christians were regretting the welcome they gave the Arab invaders. Umar saw the danger of abusing the *dhimmis*, the source of Arab income, whom he compared to domesticated animals, as when he warned one of his governors:

> Do not destroy a synagogue or church nor a house of Zoroastrians whose existence has been ensured by the peace treaty; but also no synagogue [or church] or house of Zoroastrians shall be built anew. The sheep should not be dragged to the slaughter and one must not sharpen the slaughtering knife on the head of the cattle that is being slaughtered.[17]

But there were troubles nevertheless, as in 725-6, when Egypt's native population, still overwhelmingly Christian, revolted against discrimination and the burden of taxation under Muslim rule. In one incident, after a census of the Egyptian monasteries the monks were taxed for the first time. But that was not enough, as the medieval Egyptian historian Al-Maqrizi wrote:

> Usama ibn Zaid al-Tanukhi, commissioner of revenues, oppressed the Christians still more, for he

fell upon them, robbed them of their possessions, and branded with an iron ring the name of every monk on the monk's own hand, and the name of his convent, as well as his number; and whosoever of them was found without this brand, had his hand cut off [...] He then attacked the convents, where he found a number of monks without the brand on their hands, of whom he beheaded some, and others he beat so long that they died under the lash. He then pulled down the churches, broke the crosses, rubbed off the pictures, broke up all the images.[18]

Sometimes the Arab tribes took matters into their own hands to compensate for the fall in their subsidies and pensions. Objecting to the tribes' extortion of non-Muslims, the caliph Yazid III told them in 744, 'I will not tolerate your behaviour which causes the poll-tax payers to exile themselves from their country and see no future ahead of them'[19] – to which the tribes responded by accusing the caliph of being a heretic under the influence of Christianity. His successor Marwan II once again singled out the tribes of Palestine, saying, 'You only want to rob the property of every dhimmi you encounter.'[20]

Towards the end of 744 the disaffection among the Arab tribes grew into a widespread rebellion that extended across Palestine and Syria. Damascus became unsafe, and Marwan II made Harran in northern Syria his capital instead. Edessa, Homs, Heliopolis (Baalbek in present-day Lebanon) and Damascus all rose in revolt and shut their gates to the caliph, who during the winter and summer of 745 sent his armies against them and drowned the rebellions in rivers of blood. Marwan himself commanded the bitter four-month siege of Homs, and afterwards, in the words of Theophanes

the Byzantine chronicler, 'he destroyed the walls of Heliopolis, Damascus and Jerusalem, killed many important people, and mutilated the people who remained in those cities'.[21]

The problems faced by the Umayyad caliphs with the tribes, the *mawalis* and the *dhimmis* were particularly acute in Persia and Mesopotamia, where other resentments had long been stirring. In 680 Hussein, the son of Ali, the assassinated fourth caliph, had led an uprising against Damascus, but he and his followers were massacred by the Umayyad forces at Karbala, in present-day Iraq. His supporters saw his death as a wound at the heart of Islam, for Hussein was Ali's son by Fatima, the daughter of Mohammed, and so in a sense the Prophet's own blood had been shed at Karbala. For the partisans, or Shia, of Ali, Hussein's death was a martyrdom and also a stain on the Sunni, the orthodox Muslims, who constituted the greater part of Islam. From then on the Shia refused to accept as caliph any but Ali's descendants, while the Sunni barred the caliphate to the Prophet's descendants for all time. Although this issue was originally a theological and tribal dispute among the Arabs, it soon attracted disaffected *mawalis*, especially Persians, a proud and cultured people who resented being treated as inferiors.

Their sense of grievance, along with that of the Shia, was nurtured by the Arab family of Abbas, which claimed descent from an uncle of the Prophet Mohammed. In 746 rebellion broke out in eastern Persia; by 749 Mesopotamia had erupted in civil war; and in 750 the caliph Marwan II was defeated by the Abbasid leader Abu al-Abbas al-Saffah at the battle of the Zab, a tributary of the Tigris in northern Iraq, and was relentlessly pursued through Syria, Palestine and Egypt, where he was captured and beheaded. Other members of the Umayyad house were hunted down and murdered. Only one scion of the family, Abd al-Rahman, escaped the destruction of his dynasty by fleeing to Spain, where he established the Emirate of Cordoba.

4

The Abbasids and the Arab Eclipse

WITH THE OVERTHROW of the Umayyads, Palestine and Syria would never again be the centre of the Muslim world. The Abbasids settled in Mesopotamia and in 762 established their capital on the site of a small Christian village called Baghdad[1] at a strategic location on the Tigris river, where it was linked by a navigable canal to the Euphrates, which curved close by. The place was a natural crossroads for caravans across the desert from Syria and Egypt, for Byzantine products carried down the Tigris, and for shipments from India and China brought upriver from the Persian Gulf. 'This island between the Tigris in the East and the Euphrates in the West is a market place for the world', said caliph Mansur, the founder of the city,[2] and indeed within a generation the seat of the Abbasid caliphate had become the mercantile and cultural capital of Islam in the East. In contrast, 'the Abbasids ground Damascus underheel.'[3] Its walls were demolished, its population collapsed, and for a century the city disappeared from written records altogether. The whole of Palestine and Syria went into decline, and their populations fell; Muslims and *dhimmis* alike found themselves 'oppressed by their new rulers and would more than once revolt against them'.[4] The Umayyad caliphate had been

a time of relative order for Palestine and Syria compared with what was to come, 'the enervating process of repeated military movements, internal revolt, and political instability producing chronic anarchy and cultural decline'.[5]

In abandoning Damascus in favour of Baghdad, the Abbasids moved the Muslim empire into the orbit of Persian influence. The Umayyad caliphs had ruled in the patriarchal style of Arab chiefs, cajoling tribal leaders and sometimes enforcing their will upon them, but they were always approachable by their peers and consulted with them on significant matters. In contrast, the Abbasid caliphs increasingly adopted the manners and methods of Persia's Sassanian kings, whom the Arabs had overthrown a century earlier. Whereas Umayyad caliphs styled themselves the Deputy of the Prophet of God, Abbasid caliphs bore the awesome title of Shadow of God on Earth. They derived their authority directly from Allah and ruled as absolute autocrats. Dispensing with the Arab tribal militia and discontinuing their pensions, the Abbasids exercised power through a regular army of Turkish slaves called Mamelukes. Also they created a salaried civil service staffed mostly by Persian converts.

At the time of the Arab conquest most Persians were Zoroastrians, towards whom Muslims had an ambivalent attitude. The Prophet Mohammed regarded the Jewish and Christian prophets as his precursors, but he did not count the Zoroastrians as a people with a revealed scripture.[6] The Koran is explicit that Jews and Christians are People of the Book and therefore free to follow their own beliefs,[7] but the position of the Zoroastrians depended on the interpretation of a Koranic passage in which the Magians, as Muslims called the Zoroastrians, are mentioned in the same breath as Jews and Christians but also pagans.[8] While it came to be accepted that Zoroastrians should be accorded protected *dhimmi* status, their treatment at the hands of Muslims in the Umayyad period was 'contemptuous and intolerable',[9] and under the

Abbasids it was worse. The Abbasids proved deadly foes of Zoroastrianism, meting out harsh persecution on the one hand and lavishing patronage on converts with the other. The process began in the cities and towns where Arab garrisons were settled and where Zoroastrian fire temples were turned into mosques and populations forced to convert or flee. The work of mass conversion was extended to the countryside during the eighth century and was complete, except in pockets, a century later.[10]

But for those Persians who did convert to Islam there were rich rewards. Having gained the caliphate by relying largely on Persians who had already converted to Islam, the Abbasids continued to favour Persians in their regime. With the doors of advancement wide open to Persian converts, the disadvantages of remaining Zoroastrian were all too apparent. A new class of Persian merchants, landowners and government officials – people whose activities were fundamental to settled life – ousted the old Arab tribal aristocracy. The Abbasid caliphs might claim pure Arab descent (overlooking dilution in the female line) with its racial pretensions of natural superiority, but the Persians dominated the workings of the empire at every level, so that one caliph was reported to have said, 'The Persians ruled for a thousand years and did not need us Arabs even for a day; we have been ruling for one or two centuries and cannot do without them for an hour.'[11]

The Arabs had always been a small minority imposed on the conquered peoples, but with the move to Baghdad they ceased to be the ruling elite and became one element among many, with the Persian element dominant. The effect was not only political; both in religion and culture the Abbasid Empire became Persianised. Islam was no longer bound 'solely to the Arabic language and Arab norms of behaviour'.[12] To this day the golden age of the Abbasids, particularly the reign of the caliph Harun al-Rashid, is defined in the public imagination by the fabulous stories of *A Thousand and*

One Nights, which, drawing on old Indian and Persian tales, began to take shape in Abbasid Baghdad. Although Harun al-Rashid appears in legendary form in several of the tales, significantly the main protagonists – King Shahryar and the storyteller herself, the vizier's daughter Scheherazade – have Persian names. And even as the tales of *A Thousand and One Nights* were being translated into Arabic, the language of the Koran and of high culture at the court, the Persian language was being carried far beyond the borders of the old Sassanian kingdom by the armies of Islam and became the lingua franca of the Muslim East.[13]

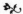

Under the Abbasids the governors of Palestine and Syria and other important officials were at first members of the caliph's own family. The Umayyads were calumnied as heretics and those who had served under them were treated as hated collaborators. Over time these western provinces were placed under the control of the central administration in Baghdad, staffed largely by Persian bureaucrats subject to the will of the caliph. The Arab tribes of Palestine and Syria, who were gradually deprived of their privileges and their role in political affairs, were heard from only when they rose in revolt. The first erupted in 754 and was met with a crushing defeat at the hands of an army under the command of the caliph's uncle, which returned to its base in Egypt bearing as trophies three thousand severed heads. It was the beginning of a long period of insecurity and decline caused by warfare between Muslims that would see the destruction of agriculture and the depopulation of villages in Palestine. Civil war broke out among the Arab tribes in Palestine in 788, devastating Gaza and Ascalon, as well as towns in Judaea and Galilee; while outside Jerusalem the Mar Saba Greek Orthodox monastery was attacked. Tribal warfare broke out again in

792, particularly in the Jordan valley and around Jerusalem, and erupted once more in 796, when several towns in western Palestine were sacked. When the fighting turned into an uprising against the Abbasids, Harun al-Rashid, who was caliph at this time, despatched an imperial army under the command of the son of his Persian vizier, who 'put down the rebels with an iron hand and much blood was spilled'.[14]

But the chief victims of this mayhem were the natives of the country, the townspeople and the farmers, who were overwhelmingly Christian.[15] *Dhimmis* also suffered persecution by the Abbasid regime despite the Muslim obligation, in exchange for their submission and payment of the *jizya*, to protect their lives, their property and their holy places and their right to practise their own religion. In the 750s Christians were ordered to remove crosses from over their churches and were forbidden to teach the scriptures and hold midnight masses. In 772, when caliph Mansur visited Jerusalem, he ordered that Christians and Jews should have their hands stamped with a special mark, at which many Christians fled to Byzantine territory. Harun al-Rashid, who reigned as caliph from 786 to 809, decreed that all churches and synagogues built after the conquest be demolished; he also imposed prohibitions on Christian and Jewish dress, forcing both to wear yellow clothing, forbidding silk to women and obliging *dhimmis* visiting bath houses to have their bodies marked.[16]

When Harun al-Rashid died in 809, war broke out between two of his sons leading to anarchy and a collapse of security, so that 'Palestine was the scene of violence, rape and murder'.[17] Christians abandoned many of their monasteries and churches in and about Jerusalem, and as matters got worse they fled to Cyprus and Constantinople. When Mamun, Harun al-Rashid's son by a Persian woman, established himself as unchallenged caliph in 813, a degree of stability returned, though at the price of fierce repressions. In 831 he launched a 'murderous'[18] expedition against a

widespread revolt in Egypt, the twelfth since the Muslim conquest, breaking Christian resistance by massacres and deportations, killing all the men, plundering their belongings and selling their women and children into slavery – the standard response to insurrection as prescribed by sharia law.[19] Mamun afterwards came to Jerusalem, where in hatred of the Umayyads he falsely claimed credit for building the Dome of the Rock by having Abd al-Malik's name hacked out from the founder's dedication and replaced with his own.

Harun al-Rashid's oppressive decrees against the *dhimmis* were renewed in 850 by his grandson the caliph Mutawakkil, who as well as requiring that they identify themselves by wearing yellow – 'unpleasantly reminiscent of the anti-Jewish legislation of Nazi Germany'[20] – added new measures in 854, among them that any place of Christian or Jewish worship that had been renovated should be demolished or turned into a mosque, that the gravestones of Jews and Christians should be levelled so as not to stand higher than those of Muslims, that they ride only on donkeys or asses, that no testimony of a Jew or Christian was admissible in court, and that one in ten of their homes should be confiscated by Muslims. The purpose of these abuses was to proclaim the superiority of Islam and to humiliate and demoralise Christians and Jews, although the intent could be more sinister than that, as when Mutawakkil demanded that they attach wooden images of devils to the doors of their homes.[21] These new decrees provoked an uprising in Homs, a predominantly Christian city in central Syria, which was brutally put down in 855, all its churches demolished except for that of St John, which was added to the Great Mosque, its leaders decapitated or flogged to death and then crucified at the city gate, and the entire Christian population driven from their homes.

These same persecuted Christians were responsible for creating the cultural golden age of Islam. Greek civilisation had flourished round the shores of the Eastern Mediterranean long before the advent of Alexander the Great; the origins of philosophy, science, mathematics, astronomy, geography and medicine can be traced back as far as the eighth century BC in the Greek islands of the Aegean and in the Greek cities of Ionia along the Aegean coast of Asia Minor. The empires of Alexander, the Romans and the Byzantines extended and perpetuated that culture throughout the Middle East; for several hundred years Alexandria in Egypt, founded by Alexander, was the capital of Western civilisation, its great Library a vast treasure house of knowledge.

The Christians of Syria, Palestine and Egypt were the heirs to this Greek culture. Until the reign of the Umayyad caliph Abd al-Malik at the end of the seventh century, Greek had been the language of administration and learning throughout the Middle East; now the Abbasids were keen to know those works of Greek learning that they thought would be useful to translate into Arabic; not poetry, drama or history, which they ignored, but mathematics, astronomy and medicine, and also the practical aspects of philosophy, especially logic.

The demand for Greek knowledge came from a very narrow base, essentially from the elite society surrounding the Abbasid court in Baghdad, for whom patronage of Christian translators became a fashionable cultural activity, stimulated by the caliph Mamun's own enthusiasm for translations into Arabic. Wealthy families vied with one another to establish themselves as discerning patrons of translations in specific fields, and in some cases we know their names, such as the Banu Musa brothers, Persians whose father had been a highway robber, who had themselves probably made their fortune from the abusive practice of tax farming and whose patronage may have been part of a money-laundering operation.[22]

Their speciality was scientific and medical texts, and they paid vast sums to attract the best translators. Nor was translating a passive activity; Christian translators themselves, imbued with Greek culture, hunted for valuable works to render into Arabic, some travelling round the Byzantine Empire in search of manuscripts for their patrons. This period of intellectual curiosity and effervescence did not last, however, and was replaced in the eleventh century by madrasas, Islamic schools whose chief concern was with religious dogma. But the texts survived and found their way to southern Italy and Spain, where the Arabic was translated into Latin and the legacy of Greece was transmitted to a medieval Europe that was emerging from the disorder of the barbarian invasions.

On Christmas day 800 Charlemagne was crowned emperor of the Romans by Pope Leo III in Rome. Charlemagne was the grandson of Charles Martel, victor over the Muslims at the battle of Poitiers, and by his coronation his Frankish kingdom was transformed into the successor state of the Roman Empire in the West, from which the Holy Roman Empire would evolve in the tenth century. Attending Charlemagne's coronation were two monks from Jerusalem – one from the monastery of Mar Saba, the other from a monastery on the Mount of Olives – and with them they brought the blessings of the patriarch and the keys of the Church of the Holy Sepulchre. This had followed several exchanges of delegations between Charlemagne and Harun al-Rashid, the pre-eminent rulers in the West and East, who may have felt that they shared common rivals in the Byzantine Empire and the Umayyads of Spain. According to Eginhard, Charlemagne's biographer who was writing about twenty years after these events, Harun had approved the gift of keys from Jerusalem, telling Charlemagne's embassy that he 'conceded

that that sacred and saving place (meaning the Holy Sepulchre) should be assigned to his jurisdiction'.[23] Harun's concession would have been in response to protests made by Charlemagne's embassy to Baghdad against the recent disorders and persecutions in Palestine and Syria, but although it is probably incorrect to interpret Harun's gesture as conferring on Charlemagne a protectorate over the holy places in Jerusalem, the keys do indicate the granting of a real if limited power over the Holy Sepulchre.[24] But behind all this, and initiating these exchanges, was the figure of the patriarch of Jerusalem, who on behalf of the indigenous Christians of Palestine was actively seeking the protection of the West.

The West had now become involved in Eastern events, and its influence and its resources were increasingly called on by Christians in need. In Palestine and Syria the Christians were unbowed by the persecutions they suffered at the hands of the Muslims. In theory they were a 'protected people' and were permitted to practice there own faith, but in reality the destruction of their churches and the restrictions on maintaining and rebuilding them, or on building new ones, was effectively aimed at destroying their culture and their faith. In the face of that, Christians made remarkable and persistent efforts to preserve and reconstruct their places of worship, raising money within their communities and seeking financial assistance from abroad. In one case, after the dome of the Church of the Holy Sepulchre had been damaged during the disorders following the death of Harun al-Rashid, the Christians of Jerusalem were able to restore it with money received from a wealthy Egyptian Christian. They completed their work in 820, but seven years later Muslims complained that the dome had been enlarged, making it higher than the Dome of the Rock, and demanded that it be pulled down. The patriarch Thomas was jailed and threatened with flogging but managed to save himself and his church by paying a

considerable bribe. The exorbitant costs of keeping churches in repair, including obtaining permission and paying bribes, put a severe strain on an already oppressed community, obliging the Christians of the East to look abroad for financial help, so that from the ninth century they won support not only from Constantinople but also from Rome, from bishops, princes and the nobility in the West, and even received large donations from as far away as England. Moreover the Abbasids encouraged the Latin Church of Rome, using it to reduce the influence of the Greek Church of the Byzantines; the Byzantines were close and a real threat, but the Latins and the Franks seemed very far away.

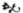

Bernard the Monk, who arrived as a pilgrim in Jerusalem in 870, was an eyewitness to the attentions bestowed on the city by Charlemagne and left an account of what he saw. But, like other pilgrims in the ninth century, he took his life in his hands to reach Jerusalem at all.[25] His journey took him across Europe from Mont St Michel in northern France to Bari in the heel of Italy, which since 847 had been a Muslim emirate, captured from the Byzantines by the Aghlabids, an Arab dynasty that ruled North Africa nominally in the name of the Abbasid caliphate in Baghdad. As well as capturing parts of southern Italy, the Aghlabids had also begun the conquest of Sicily, from where in 846 an Arab fleet of seventy-three ships set out to attack Rome. At Ostia the fleet landed a force of eleven thousand men and five hundred cavalry, which marched up the Tiber, plundered the Vatican and St Peter's basilica and desecrated all the holiest shrines. This was the first time Rome had been attacked since the barbarian invasions of the fifth century, 'and they at least had respected shrines and churches'. All Europe was appalled by what was seen as 'a calculated demonstration of Muslim contempt for

Christianity'.[26] The city's defences were improved, and three years later, when the Arabs attacked again, they were driven off and Rome was never threatened by Muslims again. But Italy south of Naples was another matter.

At Bari, Bernard obtained papers from the emir permitting him to travel to the East, then continued to Taranto, also at the time under Muslim occupation. The principal commercial activity of Bari and Taranto was raiding the coasts and countryside of Italy for Christian slaves. At the port of Taranto, Bernard saw nine thousand captives from the principality of Benevento, near Naples, who were put aboard ships bound for Tripoli and Egypt – some of the millions of men, women and children who throughout the centuries were captured by Muslim corsairs along the Mediterranean and Atlantic coasts of Europe, even in the English Channel, and were transported to a grim existence in North Africa and the Middle East, leaving depopulated and devastated homelands behind.[27] Bernard boarded a ship packed with slaves bound for Egypt, and after thirty days he arrived at Alexandria. But no one in Egypt was impressed with his travel papers from Bari. The captain of his ship would not allow him to disembark without a bribe; the governor of Alexandria likewise demanded money before allowing Bernard to continue to Fustat, the capital founded by the Arabs near the future site of Cairo. There again Bernard showed his papers, both those from Bari and those from Alexandria, but was immediately clapped in jail until he paid the further sum of 13 dinars. This was apparently the *jizya*, for Bernard goes on to say that 13 dinars was the least a Christian had to pay 'to have the right to live in freedom and security. [...] And any one who cannot pay the thirteen dinars, whether he is a native Christian or a stranger, is imprisoned either till such time as God in his love sends an angel to set him free, or else until some other good Christians pay for his freedom.'[28] Even then, every time Bernard entered another city on his

itinerary through Egypt and Palestine he had to pay a further dinar or two for permission to leave.

From Fustat, Bernard travelled through the Delta along an eastern branch of the Nile, arriving at Tanis, 'where the Christians are very conscientious, welcoming and hospitable. Indeed there is nowhere in the district belonging to this city which lacks a church.' After Tanis, Bernard went to Pelusium, at the eastern edge of the delta, where 'at the place to which the angel told Joseph to flee with his son and the mother, is a church in honour of Blessed Mary'. Hiring a camel at Pelusium, Bernard rode for six days through the desert to Palestine and so to 'the holy city of Jerusalem, where we stayed in the hospice of the Most Glorious Emperor Charles [Charlemagne]. All who come to Jerusalem for reasons of devotion and who speak the Roman language are given hospitality there.' Bernard also mentions the Church of St Mary, with its 'splendid library' built with Charlemagne's help, as was the church's pious foundation of twelve dwellings with fields, vineyards and a grove in the Valley of Jehoshaphat (the Kidron valley) between the city and the Mount of Olives. These fruits of Charlemagne's generosity, also the many monasteries he founded throughout Palestine and the great sums of money he sent to the Christians there, were widely recorded and long remembered not only in the East but throughout both the Latin and the Byzantine worlds.[29]

Given the difficulties, dangers and expense of travelling to the East, it is a wonder that Bernard and others like him should have gone on pilgrimage at all. But by the beginning of the tenth century the Byzantines and the Holy Roman Empire had driven the Muslims out of southern Italy, and soon they would be prised from their pirate lairs in southern France, while half-way through the century the Byzantines would recover Crete and their naval patrols would ensure the safety of travellers and trade in the Eastern Mediterranean. But although travelling by sea was more comfortable and

cooler, it was cheaper to travel overland. Most pilgrims from the West first made their way to Constantinople, visited the great churches and famous relics there, and then continued through Asia Minor on the excellent Byzantine roads. But Western pilgrims were always the minority, a small stream compared to the great flow of travellers from the Byzantine Empire, from Egypt, from all over Palestine, Syria and beyond.[30] Although much of the East was under Muslim domination, most of the millions who lived there were Christians inhabiting a Christian world.

5

Byzantine Crusades

THE AGHLABIDS, who made themselves the masters of
North Africa in 800 and who dominated the Medi-
terranean during the travels of Bernard the Monk, were a
symptom of the weakening authority of the Abbasids in the
western reaches of their empire, which was partly a conse-
quence of moving the caliphate eastwards from Damascus
to Baghdad. Spain became effectively independent of the
Abbasids already in 756, right after the fall of the Umayy-
ads; while Ibn Tulun, a Turk who was sent from Baghdad
to Egypt as governor in 868, was busy creating a powerful
black and Turkish slave army when Bernard passed through
the country, and used it to make himself autonomous of the
caliphate, although he maintained a nominal allegiance. Tak-
ing advantage of declining Abbasid authority in Palestine
and Syria, the Arab tribes again rose in revolt in the 860s and
were only suppressed in 878, when Ibn Tulun took control of
the region. From then on, with only occasional interruptions,
Palestine and Syria ceased to be ruled from Baghdad and
would fall within the orbit of whoever ruled Egypt.

Persian ambitions had a similar fragmenting effect in
the eastern lands of the caliphate, where a number of local
dynasties were established during the ninth century. Soon

the caliphs' writ hardly ran beyond Iraq. As their revenues declined, they resorted to tax farming, turning over tax collection to local governors who remitted an agreed sum to the central government, keeping any surplus for themselves. Increasingly the real power in the Abbasid empire rested with these governors, mostly Persian, and with the army commanders, usually Turkish Mamelukes, who served as their enforcers. These same Mamelukes formed the palace guard, which was supposed to protect the caliph. But in 861, when the caliph Mutawakkil tried to counter the growing power of the Mamelukes by recruiting troops from Armenia and North Africa, he was murdered by a palace conspiracy, and thereafter it was clear that any caliph who did not answer to the demands of the Mamelukes would not last long. The caliphs became figureheads, the symbolic representatives of Islam and the state; often they were merely puppets in the hands of one warlord or another who over the coming centuries fought one another incessantly with the result that the Abbasid heartlands of Persia and Mesopotamia, once the most flourishing part of the Islamic world, were laid waste.

But internal upheavals did not stop the Baghdad regime from launching its almost annual attacks against the Byzantines along the eastern borders of Asia Minor; in fact, Muntasir, who succeeded the murdered Mutawakkil, understood well enough that the call to jihad could distract from internal ailments when he declared holy war against the Byzantines in 862. In a letter broadcast from the mosques during Friday prayers, he proclaimed the excellence of Islam, quoted from Koranic texts which justified jihad, and promised the joys of paradise to all those who gathered at the frontier to wage war against the Byzantines: 'The Commander of the Faithful desires to come close to God by waging Holy War against his enemy, by carrying out His obligations in the religion that He entrusted him with and seeking closeness to Him by strengthening his friends and permitting injury and revenge

against those who deviate from His religion, deny His messengers and disobey Him.'[1]

But the answer to continued Muslim aggression came in the tenth century, when the Byzantines, after three centuries of keeping on the defensive, began to advance and triumph under the emperor Romanus Lecapenus and his general John Curcuas, 'the most brilliant soldier that the Empire had produced for generations. He infused a new spirit into the imperial armies, and led them victorious deep into the country of the infidels.'[2] In 933 Curcuas won an important victory when he captured Melitene (present-day Malatya, in Turkey) at the foot of the Anti-Taurus mountains. The fall of Melitene was a profound shock to Muslims. The city had been taken during the initial Arab conquests in 638 and had remained a base for Umayyad and Abbasid raids into Byzantine territory ever since, but now its reconquest was the first major recovery of Byzantine territory and opened the way for the even more dramatic reconquests later in the century.

But in 923, even before the start of Curcuas' eastern campaigns, a year-long wave of persecutions by Muslims against Christians swept through the Middle East. Atrocities were committed in Egypt, Syria and Palestine; in Ascalon, Caesarea and Jerusalem churches were destroyed. The fall of Melitene, followed by further Byzantine victories, aroused still greater Muslim violence; on Palm Sunday 937 in Jerusalem a mob attacked the Church of the Holy Sepulchre, robbed it of its treasures and set it alight, causing large sections of the church to collapse, including the Rotunda or Anastasis enclosing the tomb of Jesus.

Again in 966, towards the end of May, severe anti-Christian riots took place in Jerusalem. The Byzantines had reconquered Crete in 961, releasing the island from 135 years of Muslim occupation and clearing out the pirates whose slave raids had terrorised the coasts and islands of the Aegean; and another expedition drove the Muslims out of

Cyprus in 965. But these events had nothing to do with the disturbances in Jerusalem, which were caused by Mohammed al-Sinaji, the governor of the city, in revenge against the Christians because they would not submit to his demands for bribes beyond the normal level of taxation. When the patriarch John VII dared complain to the governor's superiors in Egypt – the short-lived Ikhshidid dynasty, a Turkish military dictatorship like the earlier Tulunids – al-Sinaji directed a mob against the patriarch, who took refuge in the Church of the Holy Sepulchre. The mob looted and set fire to the church, causing its dome to collapse, and the patriarch, who had hidden in a vat of oil, was tied to a pillar and set alight. The Muslims set their seal on these acts by seizing part of the entrance to the Church of the Holy Sepulchre, where they constructed the mosque of Umar. But the Ikhshidids in Egypt also attempted to appease the Byzantine emperor by saying they would rebuild the Church of the Holy Sepulchre and make it lovelier than it had been before. Back came the reply from Nicophorus Phocas: 'No, I shall build it, with the sword.'[3]

In the aftermath of these events Nicophorus Phocas, the victor of Crete and Cyprus who had been crowned Byzantine emperor in 963, made it his mission to liberate Jerusalem after more than three hundred years of Muslim occupation – to launch 'a sort of tenth-century crusade'.[4] In 968 he breached the Abbasid defences along the Taurus mountains and captured Tarsus, followed by the whole of Cilicia; and crossing into Syria in 969 he recovered the ancient Greek city of Antioch, the cradle of gentile Christianity. Shortly afterwards his armies took Aleppo and Latakia along with a coastal strip extending down through Syria nearly to Tripoli, in northern Lebanon. Cilicia and Antioch, with much of northern Syria, were restored to the Byzantine Empire. Aleppo was left under Muslim control but made a Byzantine vassal state, the treaty terms allowing the Muslim inhabitants to remain

undisturbed, but now they were to pay taxes from which the Christians were exempt, the revenue going towards rebuilding churches that had been destroyed, while the freedom to convert from Islam to Christianity (previously punishable by death) or from Christianity to Islam was guaranteed.

Nicophorus Phocas was assassinated in the same year he took Antioch, but his successor, Emperor John Tzimisces, continued the Byzantine campaign, 'a real crusade',[5] to wrest Jerusalem from Muslim control. Marching south from Antioch, John Tzimisces took Damascus, the first Byzantine city to have been conquered by the Arabs, which left open the way to Baghdad. But the Abbasid capital was hardly worth taking. Throughout Mesopotamia and Persia military disorders and financial crises had taken their toll. Incessant fighting between warlords had laid waste to what had only recently been the flourishing centre of the Muslim world. Agriculture was devastated, irrigation canals ruined beyond repair, and much of Baghdad had been pillaged and abandoned. Security throughout the caliphate had collapsed, and Bedouin adherents of the Qaramatian sect had even stolen the sacred black stone from the Kaaba in Mecca.[6] Instead John Tzimisces advanced into Palestine, where Nazareth and Caesarea opened their gates to him and the Muslim authorities at Jerusalem pleaded for terms. But first the emperor turned towards the Mediterranean to clear the enemy from the coast – only to die suddenly, possibly of typhoid, in 976, before he could return his attention to Jerusalem. For the next century the Byzantines remained in control of northern Syria, but their attempts to liberate Jerusalem were frustrated by a new regime in Egypt, the Fatimids.

6

Muslim Wars and the Destruction of Palestine

THE FATIMID DYNASTY came originally from Syria and claimed descent from the third caliph, Ali, and his wife, Fatima – hence their name – and after migrating across North Africa they established their own caliphate centred on Tunisia in 909. Sixty years later they returned eastwards and invaded Egypt, where they founded 'The Victorious City of the Exalter of the Divine Religion', or 'Victorious' for short, *al-Qahira* in Arabic – that is Cairo, just north of Fustat – and immediately built the great mosque and theological school of al-Azhar to propagate their version of Islam among Egypt's Sunni Muslims. The Fatimids were Ismailis, a dualist offshoot of Shia Islam; they believed that the universe contains both good and evil because God himself is made up of good and evil, light and darkness. This set them apart from orthodox Islam (or for that matter from orthodox Christianity), which believes that God is wholly good and that evil has its origins elsewhere. Dualism is an ancient belief that can be traced back to Manichaeanism in Persia and to Hellenistic Gnosticism, and which, without altering its fundamental outlook, cloaked itself in later religions such as Islam and Christianity in order to survive and propagate.

The Fatimids may have picked up their dualism from Persian influences while still in Syria or from the Berbers of North Africa, many of whom had been Christian Gnostics and now constituted the bulk of the army. The Fatimids' caliphs were also the Fatimids' imams, which according to Ismaili doctrine meant they were the infallible essence of the divine on earth. By establishing a caliphate the Fatimids were laying claim to universal political and spiritual dominion, and the conquest of Egypt was their first step towards their ambition of overthrowing the Abbasids' Sunni caliphate in Baghdad and imposing themselves and their beliefs on the entire Islamic world. The Templars would later encounter Ismaili dualists in the form of the Assassins, who would descend from their Syrian mountain eyrie to commit acts of terror against all sides.

The Fatimid victory over the Ikhshidids in Egypt was helped by a terrible famine caused by the failure of the Nile to rise sufficiently in 967; the land was still in the grip of starvation and plague, six hundred thousand people were said to have died in the region of Fustat alone, and many thousands more were abandoning their homes to seek salvation elsewhere.[1] Less than a year later, in the spring of 970, with Egypt still suffering from hunger and disease, the Fatimids resumed their campaign against the Abbasid caliphate and marched northwards into Palestine. But this was no easy conquest; their arrival marked the start of a series of wars against a succession of enemies, including Arab tribes, Turkish warlords and a terrorist sect called the Qarmatians, who like the Fatimids were Ismailis but refused to accept their imams as their spiritual overlords. 'A state bordering on anarchy prevailed. Pillage, fire and slaughter marched in the wake of the invaders', while cities such as Jerusalem and Damascus were 'tossed like a ball from one alien hand to another',[2] usually with much slaughter. Throughout the Umayyad period the Muslims of Syria and Palestine had followed the orthodox

Sunni line, but their growing hatred for the distant Abbasid regime opened the way for many to adopt the apocalyptic and communistic outlook of the Qarmatians. Sectarian divisions between the various Muslim forces made the fighting all the more vicious. 'Atrocities, the like of which had never been seen in the lands of Islam, were committed by them.'[3] The people who most suffered were those who were the majority of the population in Palestine, the Christians and the Jews, but who played no part in this long catalogue of violence, this 'almost unceasing war which destroyed Palestine'.[4]

The Fatimids did what they could to impose their Shia beliefs on Egypt, but whether Shia or Sunni, Egypt's Muslims were outnumbered by the Copts, the native Christians of the country.[5] To bolster their position against the recalcitrant Sunni, the Fatimids put special emphasis on good relations with Egypt's Christians and Jews. Anxious to preserve the expertise that came with continuity, the Fatimids showed a preference for Copts in their administration, especially in the irrigation department, where traditional techniques going back to ancient times and exact knowledge were essential; and in the closely linked revenue department, where the Copts' carefully devised system of record-keeping was indispensable. In financial matters and international trade the Fatimids relied on Jews and their well-developed knowledge of Mediterranean commerce. Egyptian foreign trade during the preceding Muslim regimes had been negligible, but under the Fatimids Egypt was at the centre of a flourishing network of mercantile relations extending from India to Spain, and its harbour at Alexandria was alive with ships bound for Amalfi, Pisa and Venice. With their initiative and experience, and their readiness to adapt to the Arabic cultural environment, Jews served the Fatimids loyally and well.

The third Fatimid caliph to take the throne in Cairo, and the first to be born in Egypt, bore the sonorous name of al-Hakim bi Amr al-Lah, meaning 'ruler by Allah's command'. The year was 996, and al-Hakim was only eleven years old. The youthful al-Hakim looked set to continue the Fatimid policy of fostering good relations with *dhimmis*; his step-mother was a Greek Orthodox Christian, as were her two brothers, one of whom was patriarch of Alexandria, the other patriarch of Jerusalem. Also he seemed to have an open and curious mind. He showed a keen interest in mathematics and the sciences, and endowed Cairo with an astronomical observatory and a great scientific library which attracted such figures as the polymath Ibn al-Haytham, famous for his contributions to optics, ophthalmology, astronomy and physics, and his commentaries on Aristotle, Euclid and Ptolemy. But al-Hakim's true fascination seems to have been with astrology and mysticism, and he would spend hours walking in the Moqattam Hills overlooking Cairo, where he looked for portents in the stars.

The dark side of al-Hakim was revealed when he began persecuting Christians and Jews in 1003. It began with the claim that the church of St Mark in Fustat had been built without permission; al-Hakim ordered it to be pulled down and a mosque built in its place and even extended so that the mosque covered Jewish and Christian cemeteries in the area. A continuous series of oppressions followed. A few years later he was throwing scientists into prison, al-Haytham feigning madness to escape what he feared would be his execution. In 1016 al-Hakim had himself publicly proclaimed God at Friday prayers in Cairo, a claim he was obliged by the resultant uproar from his Sunni subjects to retract. Some have said he was insane, others that he was merely eccentric, but his own grandfather the caliph al-Muizz had also declared himself God, though more discreetly. As Ismaili imams, the Fatimid caliphs were absolute and infallible monarchs ruling by

hereditary right as determined by divine will. Moreover the
imams possessed the key to cosmic salvation, and al-Hakim
would have been seen, and would have seen himself, as the
redeeming mahdi, who appears on earth before the Day of
Judgement and rids the world of evil.

Among al-Hakim's redeeming acts, as he would have seen
them, was to order that Christians must wear round their
necks a wooden cross a foot and a half long and weighing
five pounds,[6] while Jews had to wear an equally weighty
frame of wood with jingling bells. Later he demanded that
Christians and Jews convert to Islam, which many did to
save their lives, although some Christians were able to escape
into Byzantine territory. Conversion meant little under these
circumstances, however, as many resorted to what has been
called the 'single-generation conversion ruse',[7] by which a
man would shield himself and his family from persecution
and discrimination by converting to Islam while ensuring
that his wife and children remained Christian or Jewish. By
repeating this ruse from generation to generation the appear-
ance was given of a family having converted to Islam when in
fact it remained steadfastly rooted in its true faith. Also there
were those who after the death of al-Hakim quietly resumed
their old religion. In the event there were no mass conver-
sions to Islam among Christians or among Jews.[8] Al-Hakim's
further ordinances demanded the confiscation of Christian
property, the burning of crosses and the building of small
mosques on the roofs of churches. At first these various meas-
ures were applied only to Egypt, but soon they were applied
throughout the Fatimid empire, including Palestine.

Al-Hakim's most infamous act was in 1009, when he gave
the order for the destruction of the Church of the Holy Sep-
ulchre in Jerusalem, 'to destroy, undermine, and remove all
traces of the holy Church of the Resurrection'. The work was
thoroughly done by Abu Dhahir, the governor at Ramla,
who, recorded the Christian chronicler Yahya Ibn Said, 'did

all he could to uproot the Sepulchre and to remove all trace of it, and to this effect he dug away most of it and broke it up'.[9] The church was razed to its foundations, its graves were dug up, church property was taken, furnishings and treasures were seized, and the tomb of Jesus was hacked to pieces with pickaxes and hammers and utterly obliterated. Nothing remained but a few portions of the Rotunda, which, according to Ibn Said, 'proved too difficult to demolish' and have been incorporated into the church that stands there today.[10] Muslim sources saw the destruction as a reaction to the magnificence of the church and to the fact that it drew pilgrims from all over the world, among them many Christians from Egypt. Christianity and its symbols had to be destroyed and its churches too; over the next few years thirty thousand churches throughout Egypt, Palestine and Syria were pillaged or torn down or converted into mosques.[11]

That these were not simply the acts of a madman is evidenced by the fact that the devastations continued into the early years of al-Hakim's son and successor the caliph al-Zahir.[12] In fact, the destruction of the Church of the Holy Sepulchre was 'one of the most popular acts of al-Hakim's administration' so far as the Muslims of Palestine and Syria were concerned.[13] Also it seems to have been part of a deliberate Fatimid policy to enhance the Islamic sanctity of Jerusalem, a city about which Muslims held ambivalent views, some believing that it was tainted by Christian and Jewish associations and that the true focus for Islamic sanctity should be Mecca and Medina. Obliterating the Holy Sepulchre went some way towards erasing that Christian contamination of Jerusalem. In contrast, enhancing the city's Islamic sanctity was the purpose of al-Zahir's act when he rebuilt the mosque at the southern end of the Temple Mount and added a mosaic inscription, the first in Jerusalem to begin with Koranic verse 17:1, about the Night Journey, which Muslims have come to interpret as Mohammed travelling

to Jerusalem and ascending from there into heaven: 'Glory be to Him, who carried His servant by night from the Holy Mosque to the Further Mosque the precincts of which We have blessed that We might show him some of Our signs.'[14] From this moment the mosque became known as the Furthest, al-Aqsa, contributing to the story that would further Saladin's jihad.

Reports by returning pilgrims of Muslim sacrilege against the Church of the Holy Sepulchre and the cruel persecution of Christians in the East travelled rapidly through the Byzantine Empire, throughout the Mediterranean, and into Western Europe, causing astonishment and pain. With the reports also came rumours that Jews in western Europe and Muslims in Spain had been sending secret letters to al-Hakim encouraging him to destroy the Holy Sepulchre.[15] But there is no evidence for these claims. Yahya Ibn Said, the Christian chronicler based in Antioch, while making no mention in his history of Jewish involvement in al-Hakim's outrage in 1009, did write that Jews had been among the mob that attacked the Church of the Holy Sepulchre over forty years earlier in 966, saying 'The Jews have overtaken the Muslims in their acts of destruction and ruination'.[16] Certainly there were severe communal tensions between Jews and Christians in Palestine at that time; as Abbasid Baghdad collapsed, the Jews of Iraq moved westwards, many of them into Palestine, where they found themselves at a disadvantage to the well-established Christian community. But if Jews were among the anti-Christian mobs in 966, there are no accounts, apart from those generated in Western Europe, of Jews having been involved in al-Hakim's destruction of the Holy Sepulchre in 1009. As for Western Europe, Jews prospered there until well into the eleventh century and were generally free from discrimination.[17] But al-Hakim's outrage changed the situation. Most Western Europeans hardly knew the difference between Muslims and Jews,[18] so that the acts of one

were readily attributed to the other; but whereas Muslims were far away, Jews lived close at hand, scattered throughout Christian Europe, where the first serious anti-Semitic incidents now broke out.

The destruction of the Holy Sepulchre also gave new impetus to the belief that the West should move to the aid of the East, and new versions of the story of Charlemagne now appeared, among them that the emperor himself had journeyed to Jerusalem after receiving a letter from the patriarch of Jerusalem telling him that the Muslims were desecrating the very tomb of Christ. But still no armies were raised in the West, not for many decades yet, not until Europe was confronted with the very real and terrifying threat of a Muslim invasion from the East in the form of the Seljuk Turks.

PART II

The Turkish Invasion and the First Crusade

'*As the most of you have heard ...': so Pope Urban II introduced the subject of the Turkish menace to a vast crowd at Clermont in central France in 1095, for all the talk in Europe was of the Turks. He recounted to his listeners that the Turks were advancing into the heart of Christian lands, killing and mistreating many of the population and destroying their churches; and he added that the emperor of Byzantium had called for help and it was the duty of the West to respond.[1] Urban was rousing his audience to a great cause, the liberation of the lands and churches and peoples of the East, what we now call the First Crusade.*

Little had been known about the Turks in the West until 1071, when reports of an extraordinary military victory began to reach Europe. The Turks had defeated the army of the Byzantine Empire at Manzikert, opening the whole of Asia Minor to conquest and threatening Constantinople

itself. In that same year the Turks also turned south, taking northern Syria from the Byzantines and Jerusalem from the Fatimids of Egypt.

The Byzantines had known the Turks for a long time. They had fought Turkish tribesmen when they appeared in the ranks of the Abbasid armies and had even employed them as mercenaries in their own. But these were a new Turkish people, the Seljuks, whom the Byzantines encountered only in the eleventh century, when they announced themselves on the empire's eastern border with the invasion of Armenia and the destruction of Ani.

7

The Turkish Invasion

ANI, IN THE EXTREME EAST of present-day Turkey, is not a city many people have visited or even know about. Yet this once famous city of 'a thousand and one churches' was the capital of a medieval Armenian kingdom and was comparable to Constantinople in the magnificence of its architecture and the size of its population. As though on a promontory, the city stood within the sharp angle of two conjoining river canyons, a two-mile line of walls closing the triangle – an outline rather like that of Constantinople itself. The massive ruins of these walls is all you see today as you approach from Kars across a bleak landscape with a handful of blighted villages of stone-built houses en route. The road goes nowhere now, not since the First World War, when the Turks murdered a million and a half Armenians,[1] the first great genocide of modern times, or since the Armenian Soviet Socialist Republic, now the Republic of Armenia, was established across the river just ahead. But what has long been a no-man's-land was once a major route of east–west trade, and Ani grew wealthy on the flow of caravans.

In 1045 the Armenian kingdom was annexed by the Byzantine Empire, and Ani became a forward position against the new enemy who had erupted from their heartlands in

Central Asia. The Seljuks were a clan of the nomadic Orguz Turks who in the early tenth century inhabited the steppes north of Lake Balkhash in present-day Kazakhstan. In about 985 they split off from the Orguz and migrated southwards into a remote region of the Abbasid empire. There on the banks of the Jaxartes river (the present-day Syr Darya), east of the Aral Sea, they converted to Islam. Quick and agile mounted archers, the Seljuks were forged into a devastating strike force under their leader, Tughril. They fought their way westwards across Persia and into Mesopotamia, where Tughril captured Baghdad in 1055, reduced the caliph to his puppet, made himself sultan and replaced the ruling aristocracy with Seljuk Turks. The sultan's court adopted in some degree the Persian language and the trappings of Persian culture, 'but the body of the Turkish nation, and more especially the pastoral tribes, still breathed the fierceness of the desert'.[2]

Nothing stopped the onward rush of the Seljuks, who under Tughril's nephew and successor Alp Arslan overran most of Armenia and in 1064, less than a century after leaving their homeland 3,000 miles away, stood before the walls of Ani. The Arab historian Sibt ibn al-Jawzi quoted an eyewitness to what took place when after a twenty-five-day siege Ani finally surrendered to the Turks:

> The army entered the city, massacred its inhabitants, pillaged and burned it, leaving it in ruins and taking prisoner all those who remained alive. The dead bodies were so many that they blocked all the streets; one could not go anywhere without stepping over them. And the number of prisoners was not less than fifty thousand souls. I was determined to enter the city and see the destruction with my own eyes. I tried to find a street in which I would not have to walk over the corpses; but that was impossible.[3]

After the Seljuks sacked the city, earthquakes and Mongol raids would do the rest. Passing through the main double gate into Ani today is like entering a storm-wrecked harbour where broken churches have run aground. The circular Chapel of the Redeemer stands amid flowers and rolling grassland like an upright hull, half of it torn away as though by some dreadful whirlwind and spat on the ground. One of the few structurally intact monuments is the cathedral, begun in 988 and completed twelve years later; its architect was Trdat, who also restored the dome of Constantinople's Haghia Sophia after its partial collapse in 989. As the Seljuks looted Ani, one of them clambered up the conical roof of the great church and tore down its cross; the cathedral was then converted to the Fethiye Cami, the Victory Mosque.

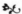

Alp Arslan is portrayed in Muslim sources as a fervent jihadist. His own chief minister, Nizam al-Mulk, called him 'earnest and fanatical in his beliefs'.[4] But for the time being, his policy towards the Byzantine Empire was defensive; his concern was to secure his north-west frontier while he turned his attentions southwards to Egypt. As the military arm of the Abbasid caliphate in Baghdad and the champion of Sunni Islam, Alp Arslan's great enemy was the Shia regime in Cairo, and his immediate aim was to make war against the Fatimid caliphate. But in 1071, just as he was moving against Fatimid territory in Syria, he received word that 500 miles to the north-east a large army led by the Byzantine emperor Romanus IV Diogenes was advancing deep into Asia Minor with the intention of reconquering Armenia.

About 100 miles south of Ani and just north of Lake Van, the Byzantine army entered a broad steppe-like plain broken by volcanic outcrops and bounded to the right by the great shoulder of the Suphan Dagi massif, even in summer

gleaming with snow, and to the left by the dun bare line of lesser mountains. Nowadays a monument like a huge pair of goalposts rises into the vast sky at the western end of the plain, where it falls off into a cultivated river valley green with orchards. A village stands close by, built round an ancient Armenian fortress tower, black and squat. This is Malazgirt – once Manzikert – where the monument erected by the Turkish government in 1990 commemorates what the Byzantines called that 'dreadful day' when Asia Minor, Christian and culturally Greek, began the long and violent process of being remade from the East. Here at Manzikert, on 26 August 1071, a Friday, Romanus was surprised by Alp Arslan's fast-moving forces, his army was destroyed, and the emperor himself was taken prisoner – and then at once set free against promise of a tribute. On his return to Constantinople, Romanus was overthrown, blinded and exiled; he died a year later, the same year that Alp Arslan was himself killed by a Turkish rebel.

The catastrophe was greater than the defeat of the imperial army. Asia Minor was left doubly defenceless because the old theme system established by Heraclius had broken down. The security of the frontiers had made land a good investment and led to the emergence of a landed aristocracy that bought out the smallholders, those independent farmer-soldiers on whom the defence of Asia Minor depended. Now after Manzikert the empire lay open before bands of Turkish tribesmen, who looted, murdered and destroyed as they marauded westwards until in 1073 they were standing on the Bosphorus opposite Constantinople. In the words of a Byzantine chronicler, 'Almost the whole world, on land and sea, occupied by the impious barbarians, has been destroyed and has become empty of population, for all Christians have been slain by them and all houses and settlements with their churches have been devastated by them in the whole East, completely crushed and reduced to nothing.'[5] In fact, the

Turks were as yet only thinly spread across the newly invaded territory and by no means replaced the existing population, but the dislocation to settled society was ruinous, not least because of the rapacity and strife as one tribe fought against another. The tragedy that had overtaken Armenia had now overtaken Asia Minor, and an Armenian refugee writing in Constantinople struck a note of grim foreboding:

> The voices and the sermons of the priests are silent now. The chandeliers are extinguished now and the lamps dimmed, the sweet fragrance of incense is gone, the altar of Our Lord is covered with dust and ashes. [...] Tell heaven and all that abide in it, tell the mountains and the hills, the trees of the dense woodlands, that they too may weep over our destruction.[6]

The warfare that had overtaken Palestine after the Fatimid invasion in 970 lasted for generations, and the country continued to suffer from Bedouin depredations throughout the eleventh century. Ramla, which the Arabs founded on the plain as the capital of Jund Filastin, was all but abandoned owing to earthquake damage and continuous Bedouin attacks; instead from the 1160s Jerusalem, lodged in the highlands of Judaea, became the centre of Fatimid rule in Palestine and its walls were strengthened.

Even during these perilous times pilgrims journeyed to Jerusalem, where they made an important contribution to such prosperity as the city enjoyed. Their chief goal was the Church of the Holy Sepulchre, where al-Hakim's successor had allowed the Byzantine emperor to rebuild the Rotunda at his own expense. But pilgrimages were unpredictable and required considerable courage and faith to pursue. In 1065 a large pilgrimage of seven to twelve thousand Germans, led by Gunther, bishop of Bamberg, travelled across Asia Minor

and arrived at Latakia in northern Syria, still within the Byzantine Empire then. But in Latakia, according to a chronicler,

> they began to meet each day many people returning from Jerusalem. The returning parties told of the deaths of an uncounted number of their companions. They also shouted about and displayed their own recent and still bloody wounds. They bore witness publicly that no one could pass along that route because the whole land was occupied by a most ferocious tribe of Arabs who thirsted for human blood.

The pilgrims gathered to discuss what to do and quickly decided 'to put all hope in the Lord. They knew that, living or dying, they belonged to the Lord and so, with all their wits about them, they set out through the pagan territory towards the holy city'. On Good Friday, within a day's walk of Jerusalem, the pilgrims were attacked by Bedouin, 'who leaped on them like famished wolves on long awaited prey. They slaughtered the first pilgrims pitiably, tearing them to pieces.' Taking refuge in a village, the pilgrims defended themselves as best they could until on Easter Monday they were saved by the Fatimid governor at the head of a large body of men who drove the Bedouin off. The governor, 'who had heard what the Arabs, like heathen, were doing, had calculated that if these pilgrims were to perish such a miserable death, then no one would come through this territory for religious purposes and thus he and his people would suffer seriously'.[7] After thirteen days visiting the holy sites in Jerusalem the pilgrims departed for the coast but again were attacked by Bedouin before boarding ships to Byzantine territory. Only two thousand pilgrims out of the original number survived the journey and returned safely home.[8]

The experience of the German pilgrims was far from unusual. Muslim pirates operated against pilgrims at sea, either attacking them outright or exacting charges, bargains and

gifts. Pilgrims were obliged to pay protection money, known as *khafara*, along the roads. Also the sensibilities and prejudices of Muslims had to be borne in mind: pilgrims could not enter mosques, they could not enter towns or cities except on foot, they could not dress in certain ways, they should not look at Muslim women, and they should not laugh or be merry lest the Muslims thought the Christians' behaviour was directed at them. The oppressions borne by *dhimmis* were forced upon pilgrims too.

Pilgrimage depended on the Muslim authorities maintaining orderly conditions so that the unarmed and defenceless Christian traveller could move about and worship in safety, but the Muslim East was wracked by misgovernment, division, exploitation, fanaticism and aggression, which undermined that guarantee. And now after Manzikert the appearance of the Turks in Palestine made matters even worse.

ॐ

While Turkish tribesmen were overrunning Asia Minor, other Turkish forces, led by Atsiz bin Uwaq, a freebooting warlord, were swarming over Syria and Palestine, adding to the already chaotic conditions existing there. They captured Ramla and put Jerusalem under siege in 1071, leaving the Fatimids clinging to the coast at Acre. Jerusalem fell in 1073, and when Acre was taken the following year, Fatimid control was reduced to Damascus, which Atsiz conquered in 1075. But when Atsiz carried the war into Egypt he was defeated at Cairo, and, falling back on Palestine, he was met with Muslim uprisings in Gaza, Ramla and Jerusalem, forcing him to retreat to Damascus.

The revolt against the Turks was a revolt against disruptive aliens who had imposed themselves on the Middle East. The Fatimids were alien too, their armies made up mostly

of Berbers and Sudanese, but at least they spoke Arabic and employed Arabic-speakers, including the native Jews and Christians of Palestine, in their administration. But the Turks, to the extent that they were civilised at all, inclined towards Persian culture and looked down on the Arabs. If they spoke a language other than Turkish, it was more likely to be Persian than Arabic. The arrival of the Turks in Syria and Palestine marked the end of Arab domination there. Turkish chiefs dispossessed Arab landlords of their estates; Turkish nomads encroached on Bedouin pastures and hunting grounds; Turkish wars and Turkish administration dislocated trade; and everyone complained at the very heavy taxes imposed by the Turks on the entire population.

In 1077 Atsiz began his campaign to reconquer Palestine by attacking Jerusalem, destroying its surrounding vineyards and orchards as he placed it under siege a second time. On his promise of protection if they surrendered, the inhabitants opened the city gates; but reneging on his pledge, Atsiz led his soldiers on a rampage through the city, slaughtering three thousand of its Muslim population, including those who sought sanctuary in the Aqsa mosque atop the Temple Mount.[9] The Christians, safe within their walled quarter of the city, escaped harm; the fate of Jerusalem's Jews is less certain; but certainly numbers of both Jews and Christians abandoned Jerusalem, not daring to return, and together with fleeing Muslims they settled in coastal towns like Tyre.

Everywhere in Palestine, Atsiz punished the rebellions with a reign of terror, burning harvests, razing plantations, desecrating cemeteries, raping women and men alike, killing and maiming people – 'they cut off the ears and even the noses are finished off', reported an eyewitness.[10] He annihilated Ramla and hastened on to Gaza, where he murdered the entire population. Damascus fared no better in the havoc; its population collapsed to three thousand due to the scarcity and starvation that followed in his wake. From al-Arish on

the Egyptian border to Antioch in northern Syria the Turks continued the slaughter, taking people captive, pillaging their homes and setting them on fire, destroying monasteries and churches, and desolating entire villages and towns. Arab nomadic tribes were the allies of the Turks in this chaos and made a kind of living by kidnapping and looting. The Fatimids launched two campaigns against Atsiz in an effort to reclaim Palestine and Syria, but instead his end came at the hands of the Seljuk hierarchy itself when, in 1078, Atsiz was invited to Damascus for consultation with the brother of the Seljuk sultan, where he was arrested and put to death.

The Byzantines were all but helpless against the Seljuks. After Manzikert they lost their regained territories in Syria and, more importantly, lost the manpower and resources of Asia Minor, the richest part of the empire. Making matters worse, the new emperor was the incompetent Michael VII Ducas, who spent lavishly on luxuries while starving the army of money even as the empire was collapsing all about him. But finally, in 1074, with the Turks standing across the Bosphorus within sight of Constantinople, the emperor appealed to the West for aid. In doing so the Byzantines had to overcome their pride, not least in putting aside the Great Schism of 1054, that dramatic rupture between the Eastern and Western parts of the universal Church. A growing estrangement, accentuated by the use of Latin in the West and Greek in the East, had developed between the Churches, and when the Greek patriarch caused offence over matters of custom, rite and theological emphasis during delicate negotiations in Constantinople, the papal legate furiously threw down a bull of excommunication against the patriarch in the great church of Haghia Sophia and was excommunicated in turn. Nevertheless, no fundamental dogmas separated

the two Churches, and the dispute remained something of which ordinary Christians in the East and West were largely unaware. But the Greek hierarchy in Constantinople, who counted the schism a great victory as it freed the patriarchate from having to acknowledge the traditional supremacy of the papacy at Rome, now had to endure the sight of Michael VII appealing to Pope Gregory VII for the very survival of their empire.

Gregory VII was heir in name, office and disposition to an earlier bishop of Rome, Pope Gregory I, who after the collapse of the Roman Empire in the West had marshalled resistance against the barbarian invaders and in the process established the papacy as a temporal and military power. When Michael VII's appeal reached Rome, it fell on ready ears, for not only was Gregory eager to heal the rift between the Churches but he also saw a role for the papacy in striking at the new barbarian invasions in the East. Gregory circulated a letter to leading figures throughout the West, explaining that he had just been visited by an emissary who 'repeated what we had heard from many others, that a pagan race had overcome the Christians and with horrible cruelty had devastated everything almost to the walls of Constantinople, and were now governing the conquered lands with tyrannical violence, and that they had slain many thousands of Christians as if they were but sheep'. Gregory continued that it was not enough to grieve at the misfortunes of the Greek empire and of Christians in the East, but that 'we should lay down our lives to liberate them'.[11]

Gregory's concern with the oppression of fellow Christians had much to do with his hopes for reuniting the Church, which, like his call to help the faltering Byzantine Empire, was practical and strategic. For more than the East was at stake. Europe had slowly reconstructed itself after the disorders of the barbarian invasions in the West and after centuries of Muslim devastation round the Mediterranean;

if Byzantium was overwhelmed by the Turks, then Europe would again be plunged into a dark age. Gregory sought to recruit knights to join a fighting force fifty thousand strong, the Militia Sancti Petri, the army of St Peter, which he would lead personally to relieve the East.

But this was not the moment when Gregory could call on the secular powers of Europe to march eastwards under his command, for within a year he became embroiled with many of those same secular authorities in the Investiture Controversy, over whether it was they or the Church who had the right to appoint high church officials and thereby control the great wealth and powers such officials could command. The Holy Roman emperors in particular, now represented by the incumbent Henry IV, claimed to rule by divine right, by which they justified exercising authority over Church appointments and sacraments, including penances and pardons. The reformers, led by Gregory, rejected lay interference in Church affairs, saying it led to severe abuses such as simony, the buying and selling of those same offices and sacraments, which they declared a heresy. But Gregory went further; not only did the Church have the right to appoint bishops, but also, he argued, spiritual authority was superior to temporal authority, and it was for the Church to dominate kings. But even this was only an aspect of a far greater revolution. Devout men and women who strongly felt the call to immerse themselves in the religious life had withdrawn from the world and had become monks and nuns within the growing Benedictine order. But for a century the Benedictines were swept with a great reform which redirected their spiritual energies outwards, transforming their monastic concern for liturgy and prayer into help for the poor, into artistic creation, into the sacralisation of everyday life. As society became increasingly pious, so every faithful Christian was a microcosm of the whole. As one of the reformers, the one-time Benedictine monk Cardinal Peter Damiani, remarked,

'Each of the faithful seems to be, as it were, a lesser church'.[12] Although the Investiture Controversy deflected Gregory from pursuing a military campaign in the East, his assertion of a unified and spiritualised world view under the authority of the papacy would dominate medieval Europe for the next two centuries and would provide an underpinning for the crusades.

Anxiety about Islam had long ago worked its way into Christian prophetic literature, which after the Bible and the works of the Church Fathers was the most influential body of writing circulating in Europe during the Middle Ages. Uncanonical, unorthodox and infinitely adaptable to the preoccupations of the moment, these concoctions followed a common theme derived from the New Testament's Book of Revelation – that of the divine warrior who will come and save the world. An early candidate for this role was the Emperor Constantine, who had legalised Christianity and was then expected to bring about the Second Coming. Another was Charlemagne, who by the second half of the eleventh century was almost universally believed to have led a crusade to Jerusalem, where he reinstated the Christians whom the Muslims had driven out. In prophecy after prophecy the role of holy warrior passed from one emperor or king or prince to another while the story took on fantastical dimensions in relating the final triumph of Christianity.

One famous example that would reverberate throughout the Middle Ages was the Apocalypse of Pseudo-Methodius. Written in the seventh century, it was made to look as though it had been written in the fourth century as a prediction of the Muslim invasion of the Middle East, its author supposedly Bishop Methodius of Patara, who was martyred in 311 at Tyre in Lebanon during the Roman persecutions. Its original

purpose was to console the Christians of Palestine and Syria for suffering under Muslim domination, but it was soon translated from Syriac into Greek and Latin and became known throughout the Christian world. It relates how the Ishmaelites – that is, the Arabs – emerge from the desert and ravage the land from the Nile to the Euphrates. The Christians are punished for their sins by being subjected for a time to the Ishmaelites, who kill Christian priests, desecrate the holy places, take the Christians' land and force or seduce many Christians from their faith.

But just when all seems lost, a mighty emperor, whom many had thought long dead, rises up and defeats the Ishmaelites, lays waste their lands with fire and sword, and rages against those Christians who had denied Jesus as their lord. Now under this great emperor a golden age begins, a time of peace and joy, when the world flourishes as never before. This is shattered, however, when fearsome peoples known collectively as Gog and Magog, whom Alexander the Great had imprisoned in the far north, break out and bring universal terror and destruction until God sends a captain of the heavenly host who destroys them in a flash. The emperor journeys to Jerusalem, where he hands over Christendom to the care of God by going to Golgotha and placing his crown on the Cross, which soars up to heaven. But the emperor dies and the Antichrist appears, installing himself in the Temple in Jerusalem, where he inaugurates a reign of trials and tribulations, deceiving people with his miracles and persecuting those he cannot deceive. Before long, however, the Cross reappears in the heavens and Jesus Christ himself comes on clouds in power and glory to kill the Antichrist with the breath of his mouth and to carry out the Last Judgement.

In the event the story was reinforced by the reality. The persecutions of al-Hakim and the barbarities of the Seljuk Turks were all too real and gave an intensity and immediacy to the cosmic drama. The Last Days were not a fantasy about

some remote and indefinite future but an infallible prophecy which at almost any given moment was felt to be on the point of fulfilment. The lawless chaos experienced by Christians in the East and the threat of Turkish attack directed against Christians in the West could be seen as the expected prelude to the universal salvation of the Second Coming.

After the execution of Atsiz in 1078 Palestine was put under direct Seljuk rule, but conditions hardly improved. An atmosphere of the Last Days flourished amid the devastation and havoc caused by the endless wars between the Seljuks and the Fatimids, and there were rumours that the world would come to an end in 1092 or 1093. Jerusalem suffered from depopulation as Christians, Muslims and Jews continued to leave the city. Significantly, the Aqsa mosque, which had been damaged by an earthquake in 1033, was restored to only half its size, the original fourteen aisles reduced to seven, demonstrating a considerable fall in the Muslim population that was never made good. In 1086 a new and additional use was found for the Temple Mount; the Seljuks established their garrison there.

Yet throughout these unsettled times the pilgrim traffic never entirely ceased, although the journey was now far more difficult than it had been before. Asia Minor, which had offered secure passage when it was in Byzantine hands, could no longer be traversed without an armed escort owing to marauding Turkish tribesmen, and even then it was not safe. In Syria and Palestine pilgrims chanced brigands on the roads, and at small towns along the way petty headman tried to extort money from passers-by. Then, arriving at the holy city, there were more sufferings to endure, as described by Edward Gibbon:

> The pilgrims who, through innumerable perils, had reached the gates of Jerusalem were the victims of private rapine or public oppression, and often sunk under the pressure of famine and disease, before they were permitted to salute the holy sepulchre. A spirit of native barbarism, or recent zeal, prompted the Turkmans to insult the clergy of every sect: the patriarch was dragged by the hair along the pavement, and cast into a dungeon, to extort a ransom from the sympathy of his flock; and the divine worship in the church of the resurrection was often disturbed by the savage rudeness of its masters.[13]

The pilgrims who succeeded in overcoming all these harassments and dangers returned impoverished and weary to the West with tales to tell of the appalling conditions in the East. The consequences of such reports are set out by the Syrian Muslim chronicler Ibn al-Azimi, who gave an account of the very last pilgrimage we know about before the crusades. In 1093, al-Azimi wrote, Christian pilgrims, both Byzantines and 'al-Franj' as he called them – that is, Franks, a term that included anyone from Western Europe – were prevented by people living on the coast from going to Jerusalem, and 'those who survived' – implying there had been a massacre – spread the news of what had happened in their own countries. This, wrote al-Azimi, and he was the only Muslim chronicler to make such a connection, was why the Christians began their preparations for the campaign that was to become the First Crusade.[14]

Almost the last glimpse we have of Palestine before the crusades comes from Ibn al-Arabi, a young Islamic scholar from Seville, not yet twenty, who along with his father was forced to leave Andalusia when almost all of Muslim Spain was overrun by the Almoravids, puritanical fundamentalist Berbers whose aim was 'a return to the doctrines of primitive Islam'.[15] From 1093 to 1096 al-Arabi stayed at Jerusalem,

mainly in the neighbourhood of the Temple Mount, where he remarked on the lively activities at the madrasas and conversed with Muslim, Jewish and Christian religious figures. The imposition of Shia beliefs and teachings under the Fatimids had meant something of a spiritual drought for Sunni Muslims and others, who found themselves pressed to the margins, but in the few years since the Seljuk re-occupation of the city in 1073 there was something of an effervescence. Jerusalem was an idyll for al-Arabi. 'We entered the Holy Land', he wrote, 'and reached the Aqsa mosque. The full moon of knowledge shone for me and I was illuminated by it for more than three years.' Yet al-Arabi could not ignore that, even four and a half centuries after the Muslim conquest, Jerusalem was still a predominantly Christian city and that the same was true of Palestine generally.[16] 'The country is theirs', al-Arabi observed about the Christians, 'because it is they who work its soil, nurture its monasteries and maintain its churches.'[17]

8

The Call

Alexius I Comnenus, who became Byzantine emperor in 1081, began the fight-back against the Seljuks, reclaiming territory along the Black Sea and round the shores of the Sea of Marmara. But a new danger arose in 1090–91, when Tzachas, a Turkish pirate based on the Aegean coast of Asia Minor, moved his fleet against Constantinople, intending to combine with the Seljuks in Nicaea and with another Turkish people, the Pechenegs, who had rounded the top of the Black Sea and now stood outside the Land Walls of Constantinople to the west. During these desperate days when the Byzantine Empire was 'drowning in the Turkish invasion', Alexius appealed to the West for help. 'In 1091, from the shores of the Bosphorus', one historian has written, 'there broke upon western Europe a real wail of despair, a real cry of a drowning man.'[1] Alexius addressed his appeal to his friend Count Robert of Flanders, and according to Anna Comnena, the daughter of Alexius, who wrote a history of her father's reign, Alexius also expected troops 'from Rome', which can only mean that he was in touch with the new pope, Urban II, who had been raised to the throne of St Peter in 1088.[2] Count Robert did send help, but before Urban raised any forces Alexius succeeded in setting his enemies against one another and then, with some

well-placed blows, routed both the Pechenegs and Tzachas' navy. The crisis had passed, but the problem remained.

In March 1095, following renewed pressure from the Turks, Alexius again sought assistance from the West, this time sending emissaries to the Council of Piacenza, in northern Italy, where Urban had summoned a synod to pass decrees against simony, the marriage of clergy and schism within the Church. Thousands of ecclesiastics, including two hundred bishops, as well as thirty thousand laymen, were reported to have attended the council,[3] so vast a congregation that it had to be held in the open air outside the city, the numbers a tribute to the increased authority of the Church follow-ing Gregory VII's triumph in the Investiture Controversy. The synod was also a supreme court which heard appeals from royalty. The chronicler Bernold of Constance recorded that emissaries came from King Philip I of France, who had been excommunicated for his illegal divorce and adulterous remarriage, asking for more time to put the matter right. And Queen Praxedis, the separated twenty-four-year-old wife of Henry IV, the Holy Roman emperor, 'complained to the lord pope and the holy synod about her husband, regarding the unheard-of filth of fornication that she suffered at his hands', for which she was absolved of any sin as 'she had not initi-ated such filthiness and also had endured it unwillingly'.

Bernold then went on to describe the appearance of a legation from the Byzantine emperor 'who humbly implored the lord pope and all the faithful of Christ that they offer help to him against the pagans for the defence of the holy church which they already had almost annihilated in these parts, occupying those regions up to the walls of the city of Constantinople'. The Byzantines made a deep impression on the gathering, and Urban 'induced many men to offer this help, so that they promised indeed by oath that they will journey there with God's help and, to the best of their ability, will provide help to the same emperor'.[4] But this was

hardly a large-scale military venture, and Bernold, who is the only source for the Byzantine appeal at Piacenza, does not say how deep into Asia Minor the campaign was meant to go, or whether the intention was to advance into Syria and Palestine. These were matters that Urban turned over in his mind before crossing over the Alps into France to meet with various lords and bishops and summon another council, this time at Clermont.

Another chronicler, Albert of Aachen, provides a different version of how Urban was spurred to support military action against the Turks. He writes of an itinerant French monk popularly known as Peter the Hermit who made a pilgrimage to Jerusalem, where he was shocked at the behaviour of the Turks at the Church of the Holy Sepulchre. Peter sought out the patriarch and asked him why he allowed these 'wicked men to defile the holy places, and let the offerings of the faithful be carried off, churches be used as stables, Christians beaten up, holy pilgrims robbed by excessive fees and distressed by the many violent acts of the infidels'. The patriarch replied:

> Why do you reproach me about these things and make things difficult for our fatherly care, when our strength and power may not be reckoned more than a poor ant's against the tyranny of so many? The fact is, either we have to ransom our life by constant payments, or it will be cut short by fatal executions, and we expect the dangers to be greater from one day to the next unless there should be aid from the Christians, which we summon with you as our envoy.

Peter promised the patriarch, 'I shall return and seek out first of all the pope, then all the leaders of Christian peoples,

kings, dukes, counts, and those holding the chief places in the kingdom, and I shall make known to them all the wretchedness of your servitude and the unendurable nature of your difficulties.'[5]

Peter then 'crossed the sea again with considerable anxiety', continues Albert of Aachen, 'and when he was back on dry land he set out for Rome without delay'. There he found the pope and told him of the 'outrages against the holy places and the pilgrims', so that Urban was 'stirred into action because of this' and crossed the Alps into France, where he summoned a council at Clermont.[6] As we shall see, Peter the Hermit certainly gathered a vast and myriad following for a crusade, but whether he and not the pope was the 'first instigator'[7] of the crusade is another matter. Jonathan Riley-Smith accepts that 'Peter must have been preaching some kind of religious expedition to Jerusalem before the council of Clermont', although only in the context of the 'waves of rumour' that preceded the papal announcement;[8] but it would not be surprising, given the Turkish outrages in Palestine and their threat to Byzantium, if a call for action arose from several sources. The real significance of Albert of Aachen's account is that it presents the crusade as answering not only the call of a Byzantine emperor and a Roman pope but also the call of the patriarch of Jerusalem and his fellow Christians in Palestine. In the words of a present-day historian, 'Far from being passive spectators of the events of 1095–9, the indigenous Christians surely understood the First Crusade as a forceful response to the perceived crisis of Christianity under Seljuk rule'.[9]

Between the Council of Piacenza in March and the Council of Clermont in November, Pope Urban gave his thoughts to the menacing situation in the East, but he did so in the wider

context of the centuries-long assault by Islam against a Christian civilisation that had once embraced the whole of the Mediterranean. The tide had seemed to turn with the Byzantine victories in Syria and the Eastern Mediterranean in the tenth century and with the slow but steady advance of the Reconquista in Spain, culminating with the recovery of Toledo in 1085. In the Western Mediterranean, Pisa, Genoa and Catalonia had fought campaigns throughout the eleventh century to free Sardinia and Majorca from Arab rule, and Sicily fell to the Normans in 1090. But now these advances were threatened or reversed by the sudden resurgence of militant Islam. The Seljuks had overrun the Middle East and Asia Minor, threatening the very existence of the Byzantine Empire, the bulwark of the West, while the fundamentalist Almoravids struck back after Toledo with a victory at Zalaca in 1086 that cost the Christians large swathes of eastern Spain, including Valencia and Saragossa, and carried Muslim armies within striking distance of France. Confronted with aggression on two fronts, Urban mounted his response, not driven by religion, but rather summoning religion to the cause of the survival of the civilisation shared by East and West.

When Urban arrived in France, he had not yet summoned the Council of Clermont. Instead, he said his main reason for his journey was to do honour to the Benedictine abbey of Cluny in Burgundy, where he had been a monk and where now he dedicated an altar at its new church, the largest in Europe, built with funds provided by Ferdinand I of León and Castile. The reforms that swept the monastic order of Benedictines had begun at Cluny, which was both engine and beneficiary of the growing piety of society. The abbey was at the forefront of generating the architecture, the art and the liturgical music that defined and expressed the sacralised culture of the Middle Ages. Cluny, which was subject only to the pope, was the best-endowed monastery in Christendom, and through its priories, nearly a thousand in France

and northern Spain, it wielded great influence. It was also a firm supporter of Gregory VII in the Investiture Controversy and of the consolidation of papal authority under Urban; another of its sons, Pope Alexander II, had given his blessing to the Reconquista and in 1064 declared that those who fell in battle would receive remission from their sins.

After Cluny, and accompanied by its abbot, Urban visited a number of Cluniac priories along the pilgrims' way which ran through southern France to its destination, Santiago de Compostela, in a corner of north-west Spain never overrun by the Arabs. Charlemagne himself was said to have discovered the bones of Jesus' cousin St James the Apostle at Compostela not long after the Great Mosque at Cordoba announced that it possessed a bone from the body of the Prophet Mohammed. Soon St James was being identified with the Reconquista and was seen fighting alongside the Christians in numerous battles against the occupying Arabs. The pilgrimage to the saint's relics at Compostela quickly caught the imagination of Christian Europe, and at the height of its popularity in the eleventh and twelfth centuries the city received over half a million pilgrims each year. After Jerusalem and Rome, Compostela was regarded as the third holiest site in Christendom, and completion of a pilgrimage to its relics ensured the remission of half one's time in Purgatory. Cluny was a great proponent of pilgrimages to the East, and likewise its priories in France gave encouragement and support to pilgrims bound for Compostela as well as to young French knights who crossed the border into Spain and played their part in the Reconquista.

Urban's visit to Cluny and its priories along the way to Compostela brought him among people who well understood that the reconquest of the East was a second front in the struggle to restore the Mediterranean to its Christian roots and to the unity that it had enjoyed before the Muslim conquests. Since Piacenza, Urban had matured his plan for

a campaign for the defence and recovery of the Christian East; his visit to Cluny and its priories was to gain support, for Urban's aim was to rouse every church and monastery to his great venture and have his message broadcast from every pulpit, so that all of Western Christendom should reverberate with his call. The full weight of Christianity would be brought to bear, but neither Christianity nor the West was the cause of the crusades. As the historian Paul Chevveden has written,

> Scholars have been asking themselves, 'What devotional religious climate or religious innovation caused the emergence of the Crusades?' when they should have been asking, 'What ongoing conflict intensified to the point where it received the highest and most expansive religious warrant?' [...] The prolonged struggle between Islam and Christianity in the Mediterranean world, rather than the religion of the Latin West, is the central issue and must be the real focus of inquiry.[10]

The Council of Clermont in central France was convened by Pope Urban II during the second half of November 1095. It was largely concerned with ecclesiastical business similar to that at Piacenza; even King Philip's persistent adultery came up again. But Urban had let it be known that in response to the appeal from Eastern Christendom he would make a speech on the penultimate day of the council, Tuesday 27 November. Three hundred clerics had been attending the council within the cathedral at Clermont, but the crowds, both clerical and lay, that assembled on that Tuesday were huge, and so the papal throne was set up on a platform in an open field outside the eastern gate of the city, and there, when the multitudes were gathered, Urban rose to address

them. The reports of four contemporary chroniclers survive but differ greatly from one another; all were written years later, were coloured by their authors' points of view and by subsequent events, so that we can have only a very approximate idea of what Urban actually said.

According to one of these chroniclers, Fulcher of Chartres, Urban began by referring to the Truce of God, the device by which the Church had for half a century been trying to limit feudal warfare which was creating anarchy and abuses across the land. 'You have seen for a long time the great disorder in the world caused by these crimes. It is so bad in some of your provinces, I am told, and you are so weak in the administration of justice, that one can hardly go along the road by day or night without being attacked by robbers; and whether at home or abroad one is in danger of being despoiled either by force or fraud.' Truces had been imposed from time to time in one region or another, but now Urban threw the full weight of his universal and newly empowered Church behind the Truce of God. 'I exhort and demand that you, each, try hard to have the truce kept in your diocese. And if anyone shall be led by his cupidity or arrogance to break this truce, by the authority of God and with the sanction of this council he shall be anathematised.'

But however bad the disorders in the West, continued the pope, the Christians in the East were suffering under conditions far worse:

> As the most of you have heard, the Turks and Arabs have attacked them and have conquered the territory of Romania [the Byzantine Empire] as far west as the shore of the Mediterranean and the Hellespont, which is called the Arm of St. George. They have occupied more and more of the lands of those Christians, and have overcome them in seven battles. They have killed and captured many, and have destroyed the churches and devastated the empire.

Nowhere in Fulcher's account does Urban say that the object of the expedition is Jerusalem; rather, as the pope explains, 'your brethren who live in the East are in urgent need of your help' – the cause is the defence of Christians in the East and their Church. And the cause is also the defence of the West, for 'if you permit [the Turks] to continue thus for a while with impunity, the faithful of God will be much more widely attacked by them'.

Then Urban made his great appeal. Let the West go to the rescue of the East. The nobility should stop fighting one another and instead fight a righteous war. For those who died in battle there would be remission of sins:

> Let those who have been accustomed unjustly to wage private warfare against the faithful now go against the infidels and end with victory this war which should have been begun long ago. Let those who for a long time have been robbers now become knights. Let those who have been fighting against their brothers and relatives now fight in a proper way against the barbarians. Let those who have been serving as mercenaries for small pay now obtain the eternal reward. Let those who have been wearing themselves out in both body and soul now work for a double honour.[11]

Urban's speech at Clermont, as conveyed by Fulcher of Chartres, was entirely in line with the realities of Muslim oppression in the East, the advancing Turkish threat and the dangers posed to the Christian world in those parts of the Mediterranean and Europe that had not fallen victim to Muslim aggression or had recently been liberated from alien rule. If Urban mentioned Jerusalem, Fulcher does not say so; instead the pope speaks of rescuing the Christians of the East and their Church, which effectively meant joining with the Byzantines in recovering their lands – certainly Asia Minor,

invaded just twenty-five years earlier, and perhaps also Syria and Palestine, occupied by the Turks at the same time.

Fulcher's is the earliest of the four accounts we have of what happened at Clermont. He is thought to have trained as a priest, probably at Chartres, and during the crusade he would serve as personal chaplain to Baldwin of Boulogne, who established a crusader state centred on the Armenian city of Edessa (present-day Urfa in Turkey) and later became the first Frankish king of Jerusalem. Fulcher was the only chronicler actually to take part in the crusade and he wrote about it immediately afterwards, in 1100–01, although, as he followed Baldwin to Edessa, he was not at the siege of Jerusalem, or at Antioch or Ma'arra, where his accounts are second-hand. But he was at Clermont, where he presents Urban as a pragmatic strategist with a global grasp of the situation besetting Byzantium and the West.

The other three chroniclers – Baldric of Dol, Robert the Monk and Guibert de Nogent, all of them Benedictine monks – give strikingly different accounts of Clermont from that of Fulcher of Chartres. Baldric of Dol wrote his account soon after the First Crusade, but he was not a participant, although he does give the impression that he was at Clermont. His version is a theological rewriting of Urban's speech; its references to the Old and New Testaments underline the pope's call for a holy war of liberation, with Jerusalem itself as the very image of heaven.

> Let us bewail the most monstrous devastation of the Holy Land! This land we have deservedly called holy in which there is not even a footstep that the body or spirit of the Saviour did not render glorious and blessed which embraced the holy presence of the mother of God, and the meetings of the apostles, and drank up the blood of the martyrs shed there. How blessed are the stones which crowned you Stephen, the first martyr! How happy, O John

the Baptist, the waters of the Jordan which served
you in baptising the Saviour! The children of Israel,
who were led out of Egypt; they have driven out the
Jebusites and other inhabitants and have themselves
inhabited earthly Jerusalem, the image of celestial
Jerusalem. You should shudder at raising a violent
hand against Christians; it is less wicked to brandish
your sword against Saracens.[12]

According to Baldric of Dol, the multitude listening to
Urban that day were swept with emotions of overwhelming
power, with many bursting into tears and others seized with
convulsive trembling.

Robert the Monk was not on the First Crusade, and
although he is the one chronicler explicitly to claim that he
was at Clermont, that is questionable. Certainly he was slow
to produce his account, completing it only in 1106, eleven
years after Pope Urban's speech, which Robert presents in
the most lurid terms. Although Urban certainly spoke of the
persecution of Christians in the East, the atrocities of which
Robert accuses the Turks are not recorded in other versions
of the speech.

They circumcise the Christians, and the blood of the
circumcision they either spread upon the altars or
pour into the vases of the baptismal font. When they
wish to torture people by a base death, they perfo-
rate their navels, and dragging forth the extremity of
the intestines, bind it to a stake; then with flogging
they lead the victim around until the viscera hav-
ing gushed forth the victim falls prostrate upon the
ground. Others they bind to a post and pierce with
arrows. Others they compel to extend their necks and
then, attacking them with naked swords, attempt to
cut through the neck with a single blow. What shall I
say of the abominable rape of the women? To speak
of it is worse than to be silent.[13]

In Robert the Monk's version, as Urban delivered these words and called for a great army to march against the Turks, cries of 'Deus le volt!' – 'God wills it!' – filled the air.

Guibert de Nogent, who was neither at Clermont nor went on the crusade, finished his account in 1108. His tone is apocalyptic, and he has the pope playing to the popular medieval drama of the Antichrist and the Last Days:

> With the end of the world already near, it is first necessary, according to the prophecy, that the Christian sway be renewed in those regions either through you, or others, whom it shall please God to send before the coming of Antichrist, so that the head of all evil, who is to occupy there the throne of the kingdom, shall find some support of the faith to fight against him.[14]

But it is most unlikely that Urban would have seen the issue in apocalyptic terms, nor is it likely that he would have stooped to lurid rabble-rousing. In fact, the best indication of what Urban said that late November day in a field outside Clermont comes in the form of a sober letter of instruction written a month later, at Christmas 1095, by the pope himself to a gathering of knights in Flanders:

> Your brotherhood, we believe, has long since learned from many accounts that a barbaric fury has deplorably afflicted and laid waste the churches of God in the regions of the East. More than this, blasphemous to say, it has even grasped in intolerable servitude its churches and the Holy City of Christ, glorified by his passion and resurrection. Grieving with pious concern at this calamity, we visited the regions of France and devoted ourselves largely to urging the princes of the land and their subjects to free the churches of the East. We solemnly enjoined upon them at the

council of Clermont such an undertaking, as a prepa-
ration for the remission of all their sins.

Here Urban repeats the information he has received of
Seljuk destruction and abuse in the East, and this time he
mentions Jerusalem as an instance, but the aim of the expe-
dition remains the same, 'to free the churches of the East'.
This assessment is confirmed by Peter Frankopan in *The
First Crusade: The Call from the East*, where he writes:

> By the time of Urban's speech at Clermont, the
> Turks had demolished the provincial and military
> administration of Anatolia that had stood intact for
> centuries and captured some of the most important
> towns of early Christianity: places like Ephesus,
> home of St John the Evangelist, Nicaea, the location
> of the famous early church council, and Antioch, the
> original see of St Peter himself, were all lost to the
> Turks in the years before the Crusade. Little won-
> der, then, that the Pope pleaded for the salvation of
> the church in the East in his speech and letters in
> the mid-1090s. [...] The knights who set out in high
> expectation in 1096 were reacting to a developing cri-
> sis on the other side of the Mediterranean. Military
> collapse, civil war and attempted coups had brought
> the Byzantine Empire to the edge. It was to the west
> that Alexios I Komenneos was forced to turn, and
> his appeal to Pope Urban II became the catalyst for
> all that followed.[15]

The First Crusade

CHRISTIANITY WAS FOUNDED on a pacifist ideal, and strong voices within the Church continued to be raised against the use of violence in any circumstances. But the use of force against a deadly enemy and in the service of Christ had already been justified in the fifth century by no less a figure than St Augustine of Hippo, who in *The City of God* described the necessity of repelling the pagan barbarian invasion of Italy, writing that 'it is the injustice of the opposing side that lays on the wise man the duty of waging wars'.[1] Similarly Christians saw Urban's call to rescue the Christians of the East from Turkish violence and oppression as an entirely just war.

When Urban finished his speech at Clermont, Adhemar, the bishop of Le Puy, immediately knelt before the papal throne and begged permission to join the expedition. This apparently spontaneous gesture was probably prearranged, as Urban had stayed at Le Puy in August. Urban then commanded all those marching to the rescue of the East to obey Adhemar as his representative on the expedition and its spiritual leader. Urban also directed those who took the vow to sew cloth crosses on their shoulders as a symbol of their decision to follow Christ, who had said, 'If any man

wishes to come after me, let him deny himself, and take up his cross, and follow me.'[2]

Taking the cross was Urban's innovation; never before had laymen adopted a distinctive emblem for their clothing, and the symbolism made a deep impression. By means of these crosses Urban broadcast the cause, for as one person sewed the cross on his clothes, so it was seen by others, and the idea caught fire. The effect was described in the *Gesta Francorum*, that is *The Deeds of the Franks*, written in 1100–01 by an unknown soldier in the service of Bohemond, one of the leaders of the crusade:

> And when this speech had already begun to be noised abroad, little by little, through all the regions and countries of Gaul, the Franks, upon hearing such reports, forthwith caused crosses to be sewed on their right shoulders, saying that they followed with one accord the footsteps of Christ, by which they had been redeemed from the hand of hell.[3]

But only much later did this piece of red cloth in the form of a cross, *crux* in Latin, give a name to the great venture to the East. The term 'crusade' is a late one; it came into use only in the thirteenth century, after the Holy Land was lost and the crusades were over. The people we now call crusaders were known by various names, such as knights of Christ, and they saw themselves as taking a pilgrimage, except that pilgrims were normally forbidden to carry arms. The word 'pilgrim' originally meant a stranger or a traveller, and for Christians life itself was seen as a pilgrimage in an estranged world far from their homeland in heaven. This 'taking of the cross' eventually gave the name crusade to these journeys – *croisade* in French, *crociata* in Italian, *Kreuzzug* in German, and *cruzada* in Spanish and Portuguese. But although the word 'crusade' would not come into use until after the crusades were over, the cross when worn as

a symbol had a powerful effect. 'The cross was the first army insignia that was common to a whole army and gave external expression to its unity; it was the first step in the direction of a uniform.'[4]

The first great secular lord to join the expedition was Count Raymond of Toulouse, who led the knights of Provence, and others soon joined. Robert, the duke of Normandy, who was the son of William the Conqueror, led the knights of northern France; Bohemond, prince of Taranto, led the Norman knights of southern Italy, among them his nephew Tancred; and Godfrey of Bouillon led the knights of Lorraine. Subject in theory to Adhemar, who represented the pope, these barons became the secular leaders of the campaign, and together with their followers, family and friends, they brought to the expedition many of the most enterprising, experienced and formidable fighting men of Europe.

The way was long, but not as long as it had been for the Turks on their migration from Central Asia to the Middle East. Not only did France and the rest of Europe lie closer to Palestine, but Europe shared a cultural and religious background with the inhabitants of the Middle East, the majority of whom were still Christians, and for centuries a steady stream of Western pilgrims had kept the relationship alive. The Turks were aliens; the crusaders were not.[5]

Although Pope Urban had asked his bishops to preach the crusade, the most effective preaching was done by humble evangelicals who inflamed the poor of France and Germany with their version of the pope's message. A populist wave of enthusiasm for going to the rescue of the East had been building independently, fed by reports from returning pilgrims and by itinerant preachers. In fact, part of Urban's thinking in rousing the Church to a crusade would have

been the desire to channel popular energy along constructive lines. Outstanding among these populist preachers was Peter the Hermit. He went about barefoot, and his clothes were filthy, but he had the power to move men. As Guibert de Nogent, who knew him personally, wrote, 'Whatever he said or did, it seemed like something half-divine.'[6]

While Adhemar and the princely armies of knights were still preparing for their expedition, Peter's preachings had roused fifteen thousand French men and women, who left their homes to follow him into Germany, where the numbers continued to swell. Many among this multitude of peasants, artisans and other ordinary people took the cross in the belief that the apocalypse was at hand. The atmosphere was heightened by the very real fear of Turkish aggression, fuelled by the stories of returning pilgrims and of terrified refugees whose lands and towns had suffered devastation and whose people had been killed or sold into slavery. European Jews had become the victims of these fears already at the time of al-Hakim's outrages, and over fifty years later, in 1063, Pope Alexander II found it necessary to condemn the identification of Jews with Muslims, declaring that war was permissible against the latter, who were attacking Christians everywhere, but that Jews were loyal subjects and must be protected.[7] But now Christians turned on Jews again.

The worst violence came when Peter's crusade appeared along the Rhine, one of Europe's major trade routes, where Jews had lived for centuries in large numbers, their economic usefulness recognised by the encouragement and protection they had always received from the bishops in the cathedral towns. During May and June 1096 Jewish quarters were attacked, synagogues were sacked, houses were looted and entire communities were massacred. The bishops and the burghers did what they could to protect the Jews but were often overwhelmed. At Worms, for example, the bishop sheltered Jews in his castle, but he could not resist the combined

force of Peter's mob and his own poorer townsfolk, who demanded their death or conversion; and when the bishop offered to baptise the Jews to save their lives, the entire Jewish community chose suicide instead. During that May and June as many as eight thousand Jews were massacred or took their own lives as the crusading rabble marched through Germany.

Far removed from the spirit and the intentions of Clermont, tributaries of this popular crusade passed across Europe, through France, Germany and Hungary, but only the chaotic stream led by Peter the Hermit and known in history as the People's Crusade got as far as Asia Minor, where in October 1096 it was annihilated by the Seljuks, although Peter, who had hung behind in Constantinople, lived to preach another day.

The official crusading army led by Adhemar and the great secular lords had no part in these massacres. Assembling their forces in the West, in France especially, they made their preparations. Setting off in groups after the summer harvest, the army arrived at Constantinople between October 1096 and April 1097. But of the forty thousand crusaders who approached the city, no more than four thousand five hundred were nobles or knights. Travelling in their wake was yet another mass of poor and humble people, artisans and peasants, not unlike the rabble that had caused so much death and devastation the previous year along the Rhine. This untrained and undisciplined horde, which included women and other non-combatants, filled the leaders of the crusade with anxiety, as they did Alexius, the Byzantine emperor, because they were unpredictable and needed to be fed. But as the crusade was also a pilgrimage, there was little that could be done to prevent them joining in the march, and now their

numbers were increased by Greeks and Armenians, refugees from the Muslim occupation of their lands.

Alexius ferried the crusaders across the Bosphorus, and in May they had laid siege to Nicaea, the Seljuk capital. Making clear what he saw as their purpose in Asia Minor, the emperor had the crusader leaders swear an oath that 'whatever cities, countries or forts he might in future subdue, which had in the first place belonged to the Roman [Byzantine] Empire, he would hand over to the officer appointed by the emperor for this very purpose';[8] and when Nicaea fell, in June 1097, Alexius took care that his imperial forces and not the crusaders received the surrender.

From Nicaea the First Crusade marched southwards to Dorylaeum (present-day Eskisehir). The crusaders had taken the precaution of dividing their forces in two, Bohemond and several other nobles leading the first group, while Godfrey of Bouillon and Raymond of Toulouse followed with the second group a day behind. This tactic proved itself when the Seljuks under the command of Kilij Arslan, the sultan of Rum, attacked the advance force, thinking it was the entire army. Bohemond was able to hold out until Raymond and Godfrey arrived, catching the Turks unaware. Faced with the full force of the crusader army, the Turks fled the field of battle in a panic. The crusaders had won a great victory, and as they advanced towards Philomelion (Aksehir) and on to Iconium (Konya), it seemed that all Asia Minor lay open before them.

But it was not an easy march, for Kilij Arslan opposed the crusaders with a ruthless campaign of destruction that took no account of the lives or welfare of the native Christian population, destroying their crops and poisoning their wells to deny succour to the relieving army. Fulcher describes the terrible conditions the crusaders endured as they advanced eastwards through the punishing summer heat:

Then, indeed, we continued our journey quietly, one day suffering such extreme thirst that many men and women died from its torments. [...] In these regions we very often were in need of bread and other foods. For we found Romania [Asia Minor], a land which is good and very rich in all products, thoroughly devastated and ravished by the Turks. Still, you would often see this multitude of people well refreshed by whatever little vegetation we found at intervals on this journey throughout barren regions.

Fulcher then goes on to describe the remarkable variety of the crusader army, composed of peoples from the farthest reaches of Europe, from the Mediterranean and from the beleaguered East, all marching as one against the alien oppressor.

But who ever heard such a mixture of languages in one army? There were Franks, Flemish, Frisians, Gauls, Allobroges, Lotharingians, Alemanni, Bavarians, Normans, Angles, Scots, Aquitanians, Italians, Dacians, Apulians, Iberians, Bretons, Greeks and Armenians. If a Breton or Teuton questioned me, I would not know how to answer either. But though we spoke diverse languages, we were, however, brothers in the love of God and seemed to be nearest kin. For if one lost any of his possessions, whoever found it kept it carefully a long time, until, by enquiry, he found the loser and returned it to him. This was indeed the proper way for those who were making this holy pilgrimage in a right spirit.[9]

The crusade was beginning to redefine itself through its own remarkable successes. For many the conviction grew that they were under divine protection; in the eyes of contemporary chroniclers, the crusade became 'a military monastery on the move'.[10] Whatever the strategic objectives originally

envisioned by Urban, the crusaders were after all pilgrims, for whom Jerusalem was now their goal.

❧

After traversing Asia Minor the crusaders turned southwards into Syria, marching along the eastern flanks of the Amanus mountains. By autumn they stood before the walls of Antioch, founded by one of Alexander's generals and later famous as the place where the followers of Jesus were first called Christians. The population of the city was almost entirely Greek and Armenian but was garrisoned by the Turks; throughout the bitter winter months and well into 1098 the crusaders laid siege to Antioch, which finally fell in June, when Bohemond and his men, after bribing one of the guards, clambered over the walls and opened the gates of the city to the crusaders.

Meanwhile Baldwin of Boulogne, who had taken a different route, found himself warmly welcomed by Armenians who had settled in Cilicia, and was urged to continue eastwards to the Armenian city of Edessa, which had been reduced to vassalage under the Turks. Entering the city among cheering throngs of people, Baldwin established himself as ruler of the county of Edessa, the first crusader state founded in the East.

But the taking of Antioch and Edessa marked the parting of the ways between the crusaders and the Byzantines. Under their oath to Alexius the crusaders were obliged to hand over to Alexius any cities and lands that had previously been under Byzantine rule. But the Armenians, who had a long history of theological and territorial disputes with the Byzantines, preferred to remain under Frankish rule. As for Antioch, after it was captured by Bohemond it was invested in turn by Kerbogha, the Turkish atabeg, or governor, of Mosul; but when the crusaders sent to Constantinople

asking for help against the siege, Alexius ignored them, convinced that theirs was a lost cause. Relying on their own force of spirit, the crusaders emerged from the city, threw themselves against the Turks and sent them fleeing in panic. From that moment the crusaders repudiated their oaths to Alexius, whom they branded a faithless coward, and Bohemond made Antioch a principality of his own, the second state established by the crusaders in the East.

The knights and the nobility may have thought that they were leading the crusade, but the poor who marched in their wake regarded themselves as the elite, a people chosen by God. Most of the common people who had joined the first wave of the crusade perished on the long journey across Europe or were cut to ribbons by the Seljuks no sooner than they had crossed the Bosphorus. Many of those who survived and had joined the second wave of the crusade, the one led by Adhemar, bishop of Le Puy, and the great French, Norman and Provençal lords, were known as Tafurs.

A modern historian has described the Tafurs as 'a hard-core of poor men organised under their own leaders, whose name may be derived from the big light wooden shield which many of them carried, the talevart or talevas. These desperadoes seem to have been pre-eminently North French and Fleming in origin and to have represented a quasi-autonomous force within the army.'[11] Stories describe them as barefoot, wearing sackcloth, being covered in sores and filth, and living on roots and grass and sometimes the roasted corpses of their enemies. Wherever they went, they left a trail of devastation. Too poor to afford swords, they fought with clubs, knives, shovels, hatchets, catapults and pointed sticks. Although the Tafurs made a virtue of their poverty, they looted cities captured by the crusaders; they also raped Muslim women

and committed massacres. Their ferocity was legendary; the leaders of the crusade were unable to control them and never went among them without being armed.

After Antioch, as the crusaders advanced deeper into Syria, the Tafurs were said to have resorted to cannibalism at the siege of Ma'arra, according to Raymond of Aguilers, although other chroniclers of the crusade make no mention of the incident and modern scholars have their doubts. 'It is tempting to deduce that they were accused of this crime because they were poor warriors, even peasants, despised and feared by the more noble warriors who regarded them of being capable of any depravity. In other words, the accusation reflects fear and distrust between classes, rather than what actually happened.'[12] Certainly the Muslims were terrified of the Tafurs, but that may have been the point. The Tafurs may have invented the story of cannibalism themselves to so terrify their enemies that they would fear to fight them and instead would flee.

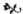

The pilgrim army marched along the coast as far as Jaffa, which they reached on 3 June. Taking the inland road that wound into the Judaean Hills, they were welcomed as liberators at Bethlehem, which they entered on the 6th, the whole town turning out in celebration with relics and crosses from the Church of the Nativity and to kiss the crusaders' hands. That night the crusaders were amazed to see a lunar eclipse, which they took as a sign from God that the crescent of Islam was on the wane. Early the next morning, on 7 June 1099, after journeying nearly three years and over 2,000 miles, the pilgrims climbed the hill which they named Montjoie and gained their first sight of Jerusalem. Many of them wept. It seemed a miracle that they had survived. They had fought and beaten the Seljuks and had restored Asia Minor

to the Byzantine Empire, and they had liberated Antioch and Edessa from Muslim rule. But they had suffered greatly along the line of march; many had fallen in battle, and many more had succumbed to starvation and disease, among them the papal legate Adhemar, bishop of Puy, who died during an epidemic, probably typhoid, at the siege of Antioch. Yet now, as in a vision, the earthly Jerusalem rose before them; for many it was the key to the heavenly city.

The Fatimids had lost Jerusalem to the Seljuks in 1073, but in July 1098 they had recovered it once more. Marching up from Cairo, the Fatimid vizier al-Afdal had laid siege to the city, 'bombarding it from forty catapults during forty days', according to the Arab chronicler Ibn Khaldun. The vizier then returned to Cairo, leaving a large garrison of well-trained Arab and Sudanese troops in Jerusalem.[13] With the destruction done to the city and the killing and menacing of its population by Atsiz and then al-Afdal, it is a wonder it had any inhabitants at all.

Nevertheless Jerusalem was one of the great fortresses of the medieval world, and despite everything its population is estimated to have been between twenty and thirty thousand.[14] The Fatimid governor prepared for the arrival of the crusaders by augmenting his forces with four hundred elite cavalrymen from Egypt and by strengthening the city walls. After extorting all the money and goods in the possession of the Christian inhabitants, he expelled them from the city, fearing that, as at Edessa, Antioch, Bethlehem and elsewhere, they would welcome the approaching army as liberators; then, after bringing the Muslim inhabitants of the outlying villages within the walls, he poisoned all the surrounding wells, secure that within Jerusalem's formidable defences he could rely on its numerous underground cisterns for good water. He knew that the crusaders were hundreds of miles from any relief from Antioch, and in their haste they had not even attempted to take the port of Jaffa. Moreover, as both he and the crusader

leaders knew, an army was mustering in Egypt. Isolated and unsupplied in the face of a gathering enemy, the crusaders' complete destruction seemed just a matter of time.

By now the crusaders had only about 1,200 knights and 15,000 able-bodied men; their force was insufficient to surround the city effectively; but they had an unshakeable conviction that under divine protection their moment of victory had come. On 13 June they launched a general attack with great fervour and overran the outer defences, but they had too few ladders to scale the walls in several places simultaneously, and after a long morning of desperate fighting they withdrew. They needed siege engines and more ladders, but the crusaders lacked the bolts and ropes and mangonels, and the area around Jerusalem had few trees. But then they had a stroke of luck: the Fatimids had left Jaffa unprotected, and six ships had sailed into the port – two from Genoa, four from England – carrying arms and food supplies and all the equipment necessary for building siege machines.

On the night of 13–14 July the attack resumed, simultaneously from north and south. The fighting continued throughout the day and on into the following night as, against terrific resistance, the crusaders managed to move their machines closer to the walls. Around noon on 15 July Godfrey of Bouillon forced his way onto the northern battlements, and soon Tancred and his men surged deep into the city's streets towards the Temple Mount surmounted by the Dome of the Rock and the Aqsa mosque, where the Muslims were retreating, intending it as their last redoubt. To the south the Fatimid governor paid Raymond of Toulouse an immense treasure in return for sparing his life and that of his bodyguard; they were escorted out of the walls and rode to safety at Ascalon. Those on the Temple Mount surrendered to Tancred, who accepted and gave them his banner for protection, but the next morning the Tafurs killed a great number, which outraged Tancred when he found out, and

they set alight the synagogue, burning many Jews who had taken refuge within in reprisal for their having been allies of the Fatimids.

<p style="text-align:center">⁂</p>

In a letter sent by the crusade leaders to the pope in September, just two months after the city was taken, they wrote: 'If you wish to know what was done unto the enemies found there, rest assured that in Solomon's portico and in his Temple [as the crusaders believed the Aqsa mosque to be] our men rode in the Saracens' blood up to the knees of the horses.'[15] In an age when victory was seen as a sign of divine favour and defeat as a punishment for sins, exaggeration served the purposes of both papal authority and of the crusade itself. The chroniclers followed suit, for example Raymond of Aguilers, Robert the Monk and Fulcher of Chartres, all of whom strongly favoured the reformist programme of Gregory VII and Urban II. The greater the victory, the more it justified the pope's ability to raise armies and fight wars, an authority opposed by the papacy's great adversary in the Investiture Controversy, the Holy Roman emperor and his allies.

And so Raymond of Aguilers, who was attached to Raymond of Toulouse and entered Jerusalem with the crusaders, does not hesitate to embellish the victory with exaggerated gore as in these often quoted lines:

> Piles of heads, hands, and feet were to be seen in the streets of the city. It was necessary to pick one's way over the bodies of men and horses. But these were small matters compared to what happened at the Temple of Solomon, a place where religious services are ordinarily chanted. What happened there? If I tell the truth, it will exceed your powers of belief. So let it suffice to say this much, at least, that in the Temple and porch of Solomon, men rode in blood up to

<p style="text-align:center">114</p>

An early 1930s aerial view of the Temple Mount from the south. The Dome of the Rock rises at the centre, on the site of the Jewish Temple, while in the foreground is the Asqa mosque, the headquarters of the Templars for much of the twelfth century.

A nineteenth century photograph of the Aqsa mosque seen from the north. The three central arches of the facade are very fine Templar work.

Covered in marble and mosaics, the Dome of the Rock has been described as 'a purely Byzantine work'; in plan it was closely modelled after the domed Rotunda of the Church of the Holy Sepulchre.

The dome of the Rotunda of the Church of the Holy Sepulchre, in the left foreground, stands high on the western hill of Jerusalem and overlooks the Dome of the Rock. The Mount of Olives rises in the distance.

Bethlehem welcomed the First Crusade as liberators. Palestine in the eleventh century was overwhelmingly Christian.

The interior of the Church of the Nativity at Bethlehem; a grotto beneath the altar is the traditional birthplace of Jesus. The church was rebuilt in the sixth century during the reign of the Emperor Justinian, reusing columns and capitals from the fourth century church built on this spot by the Emperor Constantine.

A nineteenth century photograph of Bethany, on the far side of the Mount of Olives from Jerusalem. Here, according to the gospels, Jesus raised Lazarus from the dead. A great monastery was built at Bethany by Queen Melisende and King Fulk in the twelfth century; its remains can be seen above the village to the right.

The ancient road from Jerusalem to the traditional baptismal place of Jesus in the River Jordan near Jericho. A massacre of pilgrims along this road at Easter 1119 led to the formation of the Templars. A castle from the crusader period stands on the hill to the right.

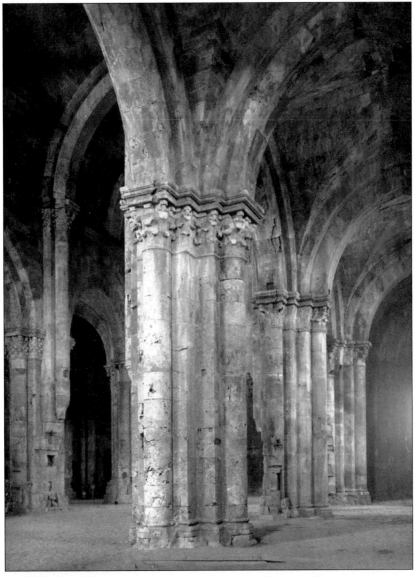

The Church of Our Lady at Tortosa, present-day Tartus in Syria. An elegant cathedral built in 1123, it marks the transition from the Romanesque to the Gothic. Tortosa was a Templar stronghold until the Franks were driven from the East in 1291.

The great concentric castle of Krak des Chevaliers was a Hospitaller fortress standing guard over the Homs gap.

Chastel Blanc at Safita was a Templar castle in the Jebel al-Sariya, not far from the Assassins' fortress at Masyaf. Like nearby Krak des Chevaliers, Chastel Blanc also defended the Homs gap. The pattern of houses round the central keep traces the pattern of the long vanished concentric walls.

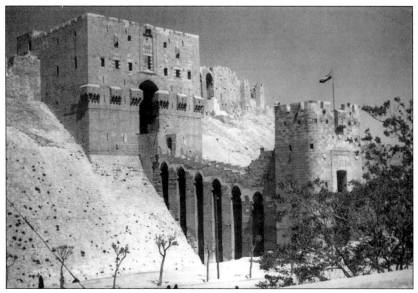

The Citadel at Aleppo. The monumental gateway and entrance bridge were built by one of Saladin's sons.

The Templar fortress of Chastel Pelerin was so strong that, according to an awed pilgrim, 'the whole world should not be able to conquer it'. The last foothold of the Templars in the East, Chastel Pelerin was afterwards destroyed by the Mamelukes along with every castle, town and village along the coast.

their knees and bridle reins. Indeed, it was a just and splendid judgment of God that this place should be filled with the blood of the unbelievers, since it had suffered so long from their blasphemies.[16]

Where the crusade leaders had written of blood up to their horses' knees, here Raymond of Aguilers goes one better and mentions the bridle reins, thereby raising the level of the blood by at least a foot. But Raymond was something of a credulous apocalyptic and described all sorts of visions and miracles, and his accounts of slaughter at Jerusalem had more to do with his notions of the Last Days than with what actually happened.

Robert the Monk, who was not there, envisages waves of blood that drive dead bodies across the floor, while dismembered arms and hands float on this sea of blood until they haphazardly join up with some corpse. And Fulcher of Chartres, who had been with Baldwin at Edessa and came to Jerusalem only in December to celebrate Christmas, makes up for not being an eyewitness to the siege by making himself a nose-witness to the aftermath, remarking that such were the numbers of dead still lying both inside and outside the city walls that he had to hold his nose against the stench – a patent nonsense, as a body left unburied in July would have been reduced by rats, dogs, birds, flies and beetles to a fleshless and odourless skeleton within a month – that is, if any bones would have been left at all.[17]

By the standards of the time, and adhered to by Christians and Muslims alike, if a city resisted conquest the lives of its inhabitants were forfeit when it fell. But despite exaggerated reports that Jerusalem's entire population was put to the sword – 10,000, 20,000, 30,000, even over 60,000 killed, depending on the source – this is not what happened. The killing was never as massive or as indiscriminate as certain medieval historians have alleged, or as many modern

historians have chosen to accept. Exaggeration was due to misinformation, or to a desire to praise the crusaders, or to assert the power of the papacy, or to captivate an audience; exaggeration was also due to ideology, the belief that tales of massive and indiscriminate bloodshed conferred a kind of purification on its perpetrators and the city. Yet no less a figure than Steven Runciman has written that 'the Crusaders rushed through the streets and into the houses slaying everyone that they saw, man, woman, and child', and that 'the only survivors' were the few hundred troops of the garrison who surrendered to Raymond of Toulouse; yet he contradicts himself by noting that the city was cleared of corpses after the siege by the surviving inhabitants.[18] Which raises the question of Runciman's motives and bias in distorting history, and the motives and bias of those who repeat the distortions to this day.[19]

The anonymous *Gesta Francorum* mentions that prisoners, men and women, were taken at the Aqsa mosque, which the crusaders, referring to King Solomon, called the Templum Solomonis. The *Gesta* also says that it was the surviving inhabitants who cleared the corpses. Moreover, letters sent to the Jewish community in Cairo and throughout the Eastern Mediterranean by Jews of Jerusalem at the time tell of Jewish survivors, Jews held for ransom, and captive Jews sold in such numbers that they depressed the price of slaves. Quite apart from the Fatimid governor and his forces who were set free, Muslim captives are known to have survived, many later turning up in Damascus. None of which means that there was not a massacre when Jerusalem was captured. But one should also listen to Ibn al-Arabi, that young Islamic scholar from Seville who had lived in Jerusalem until only three years before the arrival of the crusade and knew it well. In 1099 he was in Egypt, mostly in Alexandria, where he followed events in Jerusalem with an intimate knowledge of the setting and its people. Certainly there was a massacre, for al-Arabi writes of

3,000 men and women, 'including God-fearing and learned worshippers', being killed on Friday morning 16 July in the Aqsa mosque, and he also mentions several women who were killed near the Dome of the Rock.[20] Against this informed account we have the rhetoric of Fulcher of Chartres, who says ten thousand were killed at the mosque, or Matthew of Edessa who puts the figure at sixty-five thousand. But as one eminent historian of the crusades has written, 'stories of the streets of Jerusalem coursing with knee-high rivers of blood were never meant to be taken seriously. Medieval people knew such a thing to be an impossibility. Modern people, unfortunately, often do not.'[21]

On one point all the chroniclers agree. When the killing was over, the knights went 'rejoicing and weeping'[22] to the Church of the Holy Sepulchre to give thanks to God at the site of the death and resurrection of Jesus.

PART III

The Founding of the Templars and the Crusader States

*P*OPE URBAN II DIED *on 29 July 1099, two weeks after the recovery of Jerusalem but before the news reached Rome. He had no plans for ruling in the East; his object was to liberate its indigenous Christians from Arab and Turkish occupation and to restore Asia Minor and Syria to Byzantine rule. Carried forward by their courage and their faith, the crusaders had also captured Jerusalem. Their leaders established a feudal system and a hierarchy of self-governing states, the county of Edessa, the principality of Antioch, the county of Tripoli and the kingdom of Jerusalem, which was paramount.*

Divisions in the Islamic world – not only the rivalry between the Arab Fatimid dynasty in Egypt and the Baghdad caliphate, which had been taken over by the Seljuk Turks, but also local divisions in Syria and Palestine, Arab against Arab, Turk against Turk – meant that the Middle East was fragmented into numerous Muslim emirates. The crusader

states fitted into this mosaic and were accepted in the wider scheme of things. Rather than reacting to the fall of Jerusalem with a call to arms, local Muslim rulers sought accommodation with the Franks – the Franj as they were known in Arabic, meaning not only Franks but anyone from Western Europe.

The Franks were welcomed among the indigenous Christian population, as the celebrations at Bethlehem, Edessa and elsewhere showed. Moreover the Franks were welcomed by Muslims too, who valued the protection they offered against the depredations of the Turks. At first the Franks regarded the Muslims as the enemy, but gradually their attitude changed, partly as some among the Franks began to learn Arabic, and partly because in making allies among the Muslims they came to respect Islamic society. Outremer, the land across the sea, as the crusader states were collectively known, became a successful and progressive society and a source of fruitful exchange of goods and ideas between Latin Europe and the Muslim East.

The Templars were established to maintain security for pilgrims against marauding brigands, successors to those tribesmen who lived by plunder and had caused trouble throughout the days of Muslim rule. But apart from these local disturbances, the lands of Outremer were at peace. Only later, in the face of renewed Turkish aggression, did the Templars' moment come, when they fought to the death for the defence and survival of the Holy Land.

10

The Origins of
the Templars

O N 17 JULY 1099, two days after the reconquest of Jeru-
salem, the crusader barons met to choose a leader.
This was against the wishes of the Tafurs, who hourly
awaited the Second Coming and wanted no government at
all. The favourite choice among the barons would have been
Adhemar, the papal legate, but he had died a year earlier at
Antioch. In his stead, the crown was offered to Raymond
of Toulouse; his age, wealth, experience and his closeness
to both Adhemar and the Byzantine emperor Alexius made
him the almost necessary choice. But Raymond knew he was
unpopular, and his own soldiers wanted to return home, so
reluctantly he refused. Of the other candidates, Bohemond
had already made himself prince of Antioch after leading
the attack on that city, his nephew Tancred was regarded as
merely an appendage of his uncle, and Robert of Normandy
had let it be known that he wanted to return to Europe. And
so on 22 July the crown was offered to Godfrey of Bouillon,
who delicately replied that he would wear no crown where
Jesus had worn the crown of thorns, nor would he presume
to bear the title of king in Christ's holy city, but he would
accept kingly powers under the title of *Advocatus Sancti Sepul-
chri*, the Defender of the Holy Sepulchre.

There were some, in particular the Latin patriarch of the city, who wanted Jerusalem to be governed as a theocracy under patriarchal rule and subject to the pope at Rome. But the papacy had never seen the crusade as an imperial venture. Moreover within a year the pious Godfrey was dead and the crown passed to his brother, Baldwin of Boulogne, who had no qualms about ruling over a secular kingdom of Jerusalem as Baldwin I. After granting the county of Edessa to his cousin Baldwin of Bourcq, Baldwin I took up residence at Jerusalem. The Seljuks had turned the Temple Mount into a militarised acropolis, garrisoning their troops there. The crusaders were attracted by its biblical associations. For his palace Baldwin used the Aqsa mosque, which was assumed to stand on the site of Solomon's Temple, as it is confusingly phrased in English; the Greeks called it the Ναός του Σολομώντα, where naos means both 'temple' and 'palace', while in Latin it was called Templum Solomonis, where again *templum* can mean 'palace'; Christians at the time understood the meaning to be 'palace'.[1] The Dome of the Rock, which the crusaders not surprisingly mistook for a Byzantine building, was understood to occupy the site of the Jewish Temple. Known to Christians throughout the Muslim occupation of Jerusalem as the Holy of Holies, it became a Christian church, the *Templum Domini*, the Temple of the Lord, under the guardianship of the Augustinian canons of the Holy Sepulchre, although only much later was a cross placed atop the dome.

The stage was being set for restoring Jerusalem to the status of a great city, a royal capital. Except under the Umayyads, when Jerusalem was promoted and embellished, the Muslims had reduced the city to a provincial town subordinate to their administrative and military headquarters at Ramla and to their imperial capitals at Cairo and Baghdad. Over the coming decades the Franks would replace all the churches the Muslims had destroyed and build many more;

they would construct monasteries, libraries, hospitals, bath houses, covered markets and other institutions; and they would build a royal palace and strengthen the city walls. The increased flow of pilgrims since the Frankish liberation of the holy sites was central to this great revival in the fortunes of Jerusalem and of the whole of Outremer.

※

Saewulf of Canterbury, who travelled to the Holy Land in 1102, described the perils facing pilgrims along the way. Arriving at the port of Jaffa as a storm was coming up, he quickly got ashore; but of thirty ships standing in the harbour, only seven survived the battering of the winds and waves.

> Some people were consumed with terror and drowned there and then. Some people were – it seemed unbelievable to many – clutching to the wooden parts of the ship, but as I saw they were cut to pieces or, being snatched off the timber of the ship, were taken off to deep water. [...] Of human beings of either sex more than a thousand died that day.[2]

Such catastrophes explain why altars were set up in both the Church of the Holy Sepulchre and the Dome of the Rock to St Nicholas, patron saint of sailors, where prayers were received from pilgrims for safety at sea.

But a safe landfall for pilgrims was merely the prelude to new dangers. Bedouin had brought havoc to Palestine ever since the Arab conquest, and Turkish tribesmen had more recently added to the violence and disorder. Saewulf told how parties of pilgrims landing at Jaffa were exposed to attack as they journeyed along the hard mountain road to Jerusalem. Pilgrims who wearied and fell behind, or groups that were vulnerably small, were prey to bands of Bedouin who lived in the surrounding wilderness. The bandits did

not hesitate to kill to get at the money sewn into travellers' clothes. Corpses were left to rot along the route up to Jerusalem because it was too dangerous for their companions to leave their party to give them a proper burial. 'Anyone who has taken that road', Saewulf wrote,

> can see how many human bodies there are in the road and next to the road, and there are countless corpses which have been torn up by wild beasts. It might be questioned why so many Christian corpses should lie there unburied, but it is in fact no surprise. There is little soil there, and the rocks are not easy to move. Even if the soil were there, who would be stupid enough to leave his brethren and be alone digging a grave! Anybody who did this would dig a grave not for his fellow Christian but for himself![3]

Daniel, a Russian abbot, needed all his courage when his pilgrimage through the Holy Land in 1106-7 brought him near the town of Basham in Galilee. 'In this pool Christ himself bathed with his disciples and one may see to this day the place where Christ sat on a rock.' But there was menace in the scene, where tall palms stood about the town like a dense forest and great reeds grew along the streams and in the water meadows. 'This place is terrible and difficult of access for here live fierce pagan Saracens who attack travellers at the fords on these rivers.'[4] The tribes were not the only problem. An especially shocking attack took place at Easter 1119, when a party of seven hundred unarmed pilgrims, both men and women, set out from Jerusalem for the traditional baptism site of Jesus in the river Jordan, east of Jericho. They were travelling, in the words of the German chronicler Albert of Aachen, 'with joyfulness, and with gladness of heart'[5] when they were set upon by a Fatimid sortie from Ascalon, on the coast south of Jaffa. Three hundred pilgrims were slaughtered, and another sixty were captured to be sold as slaves.

The formation of the Templars arose out of these conditions of insecurity on the roads and the murder, rape, enslavement and robbery of unarmed pilgrims. Only recently a group of nine French knights, most prominently Hugh of Payns, a knight from Champagne who had fought in the First Crusade, and Godfrey of Saint-Omer in Picardy, had proposed to the patriarch of Jerusalem, Warmund of Picquigny, and King Baldwin II, who had succeeded his cousin in 1118, that for the salvation of their souls they form a lay community or perhaps even withdraw into the contemplative life of a monastery. Instead Baldwin, alive to the urgent dangers confronting travellers in his kingdom, persuaded Hugh of Payns and his companions to save their souls by defending pilgrims against brigands on the roads. The Easter massacre along the way to the River Jordan persuasively drove home the king's view, and on Christmas Day 1119 Hugh and his companions took their vows before the patriarch in the Church of the Holy Sepulchre, calling themselves in Latin the *Pauperes commilitones Christi*, the Poor Fellow-Soldiers of Christ.

The king and patriarch probably saw the creation of a permanent guard for travellers as complementary to the work of the Hospitallers, who were providing care for pilgrims arriving at Jerusalem. The Hospital was located immediately south of the Church of the Holy Sepulchre. Its ruins could still be seen there in the late nineteenth century until finally they were cleared away by the Ottomans to create the network of market streets seen today – still called the Muristan, meaning 'hospital'. Already in 600 Pope Gregory the Great had commissioned the building of a hospital at Jerusalem to treat and care for pilgrims, and two hundred years later Charlemagne, emperor of the Holy Roman Empire, enlarged it to include a hostel and a library. This was where Bernard the Monk stayed during his visit to Jerusalem in 870. But in 1009 it was destroyed as part of the Fatimid caliph al-Hakim's violent anti-Christian persecutions. In about 1070

merchants from Amalfi obtained permission from the Fatimids to rebuild the Hospital, which was run by Benedictine monks and dedicated to St John the Baptist.[6] But after the First Crusade the Hospital was released from Benedictine control and raised an order of its own, the Hospitallers of St John, which was recognised by the pope in 1113 and came under his sole jurisdiction. Recent research on the origins of the Templars suggests that the knights were probably first associated with the Augustinian canons, the guardians of the Holy Sepulchre, who housed them in the Hospital until the knights received permission to form a separate group.[7]

Official acceptance of the new order of Templars came at Nablus in January 1120, when the nine members of the Poor Fellow-Soldiers of Christ were formally introduced to an assembly of lay and spiritual leaders from throughout the lands of Outremer. In this year too they first attracted the attention of a powerful visitor to Outremer, Fulk V, count of Anjou, who on his return home granted them an annual revenue, an example that was soon followed by other French nobles, and which added to the allowance they were already receiving from the canons of the Church of the Holy Sepulchre. Yet altogether these amounted to only a modest income, and individually the Poor Fellow-Soldiers were genuinely poor and dressed only in donated clothes, meaning they had no distinctive uniform – the white tunic emblazoned with a red cross came later. Their seal alludes to this brotherhood in poverty by depicting two knights, perhaps Hugh of Payns and Godfrey of Saint-Omer, having to share a single horse.

The Templars were also given the use of another hand-me-down. After the conquest of Jerusalem in 1099, the king had made do with the Aqsa mosque for his palace, but now he was building a new royal palace south of the Tower of David to the west. As gradually he moved from one to the other, he gave up the successive portions of what had been the mosque to the Poor Fellow-Soldiers. Because the Aqsa mosque was

known as the Templum Solomonis, it was not long before the knights had encompassed the association in their name. They became known as the *Pauperes commilitones Christi Templique Solomonici* – the Poor Fellow-Soldiers of Christ and of the Temple of Solomon; or, in a word, the Templars.

॰॰

Even now, however, the Templars' role was modest, and throughout the 1120s they remained in close association with the Hospital, sharing in the task of looking after pilgrims by acting as a gendarmerie, a police force on the roads. Had the archives of the Templars survived, there might be more to say; these were taken to Cyprus after the fall of Outremer at the end of the thirteenth century, and they were probably destroyed when the Ottomans overran the island in 1571. That explains why almost everything we know about the Templars comes from sources other than themselves – from bodies such as the canons of the Holy Sepulchre, the Italian trading communities, the Hospitallers and the various chroniclers and pilgrims in the Holy Land, from the Vatican archives and from the French trial documents of the early 1300s, when the Templars were convicted of heresy and their leaders burned at the stake. Nevertheless these numerous sources should have been sufficient to give some clear indication of Templar activity during the first half of the twelfth century in Outremer, but until the coming of the Second Crusade in 1148 the Templars rarely figure in the historical record, and then only in a minor way.

This fits with the reality of the situation; Outremer was largely at peace with its Muslim neighbours. According to Ibn al Jawzi, the Muslim scholar and chronicler, when the qadi – that is, judge – of Damascus travelled to Baghdad in August 1099 and gave an emotional account at the Abbasid court of the fall of Jerusalem to the crusaders a month earlier,

many who were listening were reduced to tears, but no concrete proposals were forthcoming and 'the people remained aloof'.[8] The Muslim inhabitants of Syria and Palestine, wrote the Arab chronicler al-Muqaddasi, 'have no enthusiasm for jihad'.[9] Instead pragmatism prevailed. In 1108 the Damascus atabeg Tughtigin, a Turk who had made himself independent of Seljuk rule, signed an armistice agreement with the kingdom of Jerusalem, which made the Golan Heights a demilitarised zone and divided the revenues from their fertile agricultural lands: one-third to Damascus, one-third to the crusaders and one-third to the local peasants who tilled the land. The following year a similar agreement was signed with regard to the Bekaa valley in Lebanon. These arrangements remained in force until Saladin's capture of Jerusalem in 1187 and were not disturbed even when the signatories attacked one another elsewhere from time to time. As for the coast, the view taken in Cairo, according to the Egyptian-Syrian chronicler Ibn Zafir, was that it was preferable that the Franks should occupy the ports of Syria and Palestine 'so that they could prevent the spread of the influence of the Turks to the lands of Egypt'.[10]

The greatest danger to the crusader states came from the Turks in Aleppo, who twice, in 1119 and 1122, inflicted heavy defeats on the Christian armies of Antioch and Edessa and put the cities under threat. But Muslim aggression was sporadic, and so far as the kingdom of Jerusalem was concerned, it was easily rebuffed. Before Saladin began his campaigns against the Franks in the late 1170s, the mountain area of Jerusalem was raided only twice, in 1124 and then in 1152, the second assault feebler than the first. Ascalon was the base for Fatimid attacks, but in 1118 its garrison lacked the strength to prevent a small expedition against Egypt led by King Baldwin I; and Ascalon's raid against Jerusalem in 1124 was possible only because the entire Frankish army was engaged in the siege of Tyre. The coastal plain north of Jaffa was free

of menace until the late 1180s, and well before then, in 1153, Ascalon's power was broken and the city was taken by the Franks. The district round Nablus, 40 miles north of Jerusalem, twice suffered incursions from Damascus, in 1113 and 1137; on the second occasion the Turks killed many of Nablus' Christians and burned down their churches, but they were driven out again.

This was the sum of the disturbances that afflicted Palestine for the first eighty years or so after the First Crusade. There were great lapses of time between these incursions, sometimes as long as a generation, during which the Franks established themselves in the country, mixed with its inhabitants, and developed the security and the political structure of the kingdom of Jerusalem and the rest of Outremer. Conditions soon became settled in the East; the security of travellers and farmers in the kingdom of Jerusalem was 'not much different from the state of security on the roads and in the rural areas of contemporary Europe'.[11] Thanks to the Franks, Palestine enjoyed a period of peace and prosperity throughout most of the twelfth century that contrasted sharply with the violence and destruction of the previous century, when it was under Muslim rule.

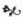

By 1128 the Franks had liberated all the places of pilgrimage associated in the gospels with the life of Jesus. They had established themselves militarily and politically in Outremer, where the landscape was still marked by Christian shrines and carried Christian associations, but there was much to recover and rebuild.

The Temple Mount was the centre of the universe for Jews and the centre of the universe for Muslims too, and because it stood in an open position and was crowned by the gilded Dome of the Rock it could seem to dominate the Jerusalem

skyline. But to the west another and higher hill rose above the city, and well up its eastern slope stood the Church of the Holy Sepulchre, the dome of its Rotunda, or Anastasis, meaning 'Resurrection' in Greek, rising high above the press of surrounding buildings. Here the Templars had taken their founding vows on Christmas Day 1119; thereafter Templar churches would often be round, like the Anastasis. For medieval Christians the Church of the Holy Sepulchre was the centre of the world, the exact spot being in the court between the chapel of Golgotha, marking the site of the Crucifixion, and the tomb beneath the dome marking the place of Resurrection.[12] Higher still was the Mount of Olives, east of the city across the Kidron valley (the biblical valley of Jehoshaphat); it was topped by the Church of the Ascension, built in 392, and enclosed a pair of Jesus' footprints, marking the spot where he ascended to heaven forty days after the Resurrection (Acts 1:2-9).[13] Now after the crusaders recovered Jerusalem, pilgrims discovered other footprints of Jesus, this time within the Temple of the Lord, the church that had been the Dome of the Rock, footprints pressed into the Rock itself, a reminder of Jesus' many visits to the Temple Mount.

The crusaders' enthusiasm for identifying the Temple Mount with various biblical events was shared with the Christians of Palestine generally and with pilgrims throughout Christendom, for since Umar's conquest of Jerusalem Christians had been forbidden access to the Mount and it had become a place of confusion and mystery. Now in a burst of discovery wonderful associations were revealed. Abraham's sacrifice of Isaac (Genesis 22:1-19; Chronicles 3:1) and David's encounter with the angel and his purchase of the threshing floor of Araunah (2 Samuel 24:15-25; 1 Chronicles 21:15-28) both took place on the Temple Mount. The Dome of the Rock, converted to a church, sanctified the spot where Jesus had driven the moneychangers from the Temple (Matthew 21:12; John 2:14-16), the very same Temple that had

been built and dedicated by Solomon (1 Kings 6–8). Here took place the Presentation of Christ, where Jesus, soon after his birth, was presented by his parents to the Lord, and the aged Simeon prophesied that the child would be 'a light to lighten the Gentiles, and the glory of the people of Israel' (Luke 2:22–32). Moreover Simeon's own house, where the Holy Family had stayed, and which contained the bed of the Virgin Mary and the cradle and bath of the infant Jesus, was identified as having stood at the south-east corner of the Mount, a stone's throw from the Templars' quarters. In the Temple too the young Jesus was remembered for conversing with the doctors (Luke 2:46). In the cave below the Dome of the Rock the angel Gabriel announced that Zachariah would have a son, John the Baptist (Luke 1:5–23); and in the same cave Jesus forgave the adulterous woman (John 8:2–11), making it a suitable place for pilgrims to come for confession.

Headquartered on the Temple Mount, the Templars were daily in touch with these places and as aware as anyone of their holy associations. And in protecting bands of pilgrims on their journeys from the ports up to Jerusalem and on to Bethlehem and to the River Jordan, the Templars were more familiar than most with the holy sites. Pilgrims would ask them for information and explanations, and the Templars found themselves providing answers and serving as guides. They also began interpreting the holy landscape for themselves: for example, routing the Via Dolorosa through the Temple Mount, the way previously forbidden to Christians by the Muslims. According to the Templars, after Jesus had been before Pilate at the praetorium, identified as against the northern side of the Temple Mount, and was beaten, spat upon, mocked and made to wear the crown of thorns, he was led up through the Mount where he briefly rested with his cross, the spot marked by a dome within the north-west quadrant and called the Throne of Jesus. Here Simon of Cyrene helped bear the cross (Matthew 27:32, Mark 15:21,

Luke 23:26) as Jesus passed through what the Templars renamed the Sorrowful Gate, today's Bab el Nazir, on the western side of the Mount, and so slowly upwards through the city to Golgotha, the site occupied by the Church of the Holy Sepulchre, where he was crucified, buried and rose again on the third day. The most sacred procession in the Christian Church, the goal of every pilgrim, the Stations of the Cross along Jerusalem's Via Dolorosa, was reinterpreted, developed and enshrined by the Templars – until 1187, when Saladin swept everything Christian from the Temple Mount, and the Via Dolorosa was re-routed again.

In the autumn of 1127 or early in 1128 Baldwin II sent emissaries to the West with the aim of bolstering the foundations of his kingdom. When Baldwin was count of Edessa, he had married an Armenian princess by whom he had four daughters but no male heir, and to secure the succession he and his barons decided to offer the hand of Melisende, his oldest daughter, to a suitable candidate in France. The French king recommended Fulk V, count of the wealthy and formidable house of Anjou, the same Fulk who became an early backer of the Templars after his pilgrimage to Jerusalem in 1120. The count, who was a widower, felt the time had come to devote the remainder of his life to the Christian cause in the East, and so handing Anjou to his son, Fulk agreed to return to Outremer and marry Melisende. In this respect Baldwin's mission to the West was entirely successful; in due course the couple would succeed jointly to the throne, and meanwhile their union strengthened the kingdom's ties with the West.

But there was more to the mission than that. Among the emissaries sent by Baldwin to the West was Hugh of Payns. Certainly the Master of the Temple was involved in the arrangements that brought Fulk to Jerusalem, but he was

also sent to raise funds and as many knights as possible for Baldwin's long-cherished ambition of conquering Damascus. Despite a treaty with Jerusalem, Damascus remained a constant threat, as shown by the attack against Nablus in 1113. Also, as Outremer was hardly more than a long, thin strip along the Mediterranean coast from the Amanus mountains in the north to the Gulf of Aqaba to the south, capturing Damascus would give the crusader lands strategic depth.

Yet at the same time there was disaffection among the Templars, a crisis of confidence or an apparent loss of faith in the direction they were taking. A letter written in about 1128 reveals the turmoil within the order. The author signed himself Hugh Peccator – that is Hugh the Sinner, who is thought to have been Hugh of Payns. Whoever wrote the letter, it was addressed directly to the Templars.

> We have heard that certain of your number have been troubled by some people of no wisdom, as though your profession, by which you have dedicated your life to carrying arms against the enemies of the faith and peace in defence of Christians, as though, I say, that profession were illicit or harmful, that is either a sin or an obstacle to greater advancement.

It goes on to say that this is the tempting of the devil who

> under the pretence of piety tries to lead you into the pitfall of error. [...] He tells the knights of Christ to lay down their arms, not to wage war, to flee tumults, to seek out the wilderness, so that when he shows the appearance of humility he takes away true humility. What is pride if not to disobey what God has imposed on one?

Clearly there were voices who argued against the notion of an order of monks that used the sword, and agreement with

those voices was heard within the Templars themselves. The Templars had at first been asked to play a defensive role, to act as a protective militia for pilgrims travelling from one holy place to another along the roads. But Baldwin's plan to attack Damascus meant that the Templars were being asked not to recover or protect but to take the offensive against the enemy in order to secure strategic goals necessary for the survival of Outremer. 'In time of peace by abstinence and fasting you fight against your own flesh [...] but in war you fight with arms against the enemies of peace who harm or wish to harm.'[14] Templars, warned Hugh Peccator, must not surrender to the argument of bogus piety or humility; they must accept that what they do is no sin, that they act in accordance with the will of God. The letter was written at a decisive moment for the future direction of the order and was meant to silence doubts and to stiffen resolve while Hugh of Payns was on his mission to the West to secure resources and support.

According to *The Anglo-Saxon Chronicle*, Hugh of Payns' recruiting drive was fantastically successful: 'He summoned people out to Jerusalem, and then there went with him and after him so large a number of people as never had done since the first expedition in the days of Pope Urban.'[15] Whatever the reality, Baldwin acquired the wherewithal to mount his assault against Damascus in late 1129.

As Baldwin marched his army towards Damascus he sent out detachments, mostly men recently arrived from the West, to gather food and supplies; but they lacked discipline and wandered widely, distracted by opportunities for grabbing booty for themselves, and were caught off-guard by the Turkish cavalry and were overwhelmed; only forty-six escaped. Nevertheless Baldwin with the main force of his army, which included numbers of Templars, pressed forward to attack; but then the skies opened, rain fell in torrents, the ground turned to mud, the way became impassable, and Baldwin

could do nothing but retreat in good order to Jerusalem. The records do not say whether the foragers cut down by the Turkish cavalry were men specifically recruited for the Templars by Hugh of Payns; we know only that some Templars were with the main army. And that is almost the last that is heard of the Templars until the arrival of the Second Crusade in 1148.

The silence about the Templars is all the more surprising because it was precisely at this time that they burst into the historical record in the West. Baldwin II had sent Hugh of Payns sailing westwards not only in the service of the kingdom of Jerusalem but also with the intention of gaining support and recognition for the Templars from the highest ranks of the Church and states in Europe. The king had prepared the ground for Hugh by writing to Bernard, the abbot of the Cistercian monastery of Clairvaux, explaining that the Templars were seeking approval of their order from the pope, who they hoped would also initiate a subsidy that would help fund the battle against the enemies of the faith who were threatening the very existence of the kingdom of Jerusalem. Baldwin knew his man: Bernard had already written to the pope objecting to a proposal put forward by a fellow abbot to lead a mission of Cistercians to the East, saying that what the Holy Land really needed was 'fighting knights not singing and wailing monks'.[16]

Bernard of Clairvaux, who was made a saint within twenty years of his death, was one of the most influential and charismatic figures of the medieval Church. A volatile and passionate young man of an aristocratic family, he was devoted to the Virgin Mary; once in the later years of his life, as he stood before a statue of the Virgin imploring that she might be a mother to him, the statue came to life and offered him

her breasts to suck. Bernard deliberately sought out the Cistercian order, a stricter form of the Benedictines and known for its austerity, and in 1113 joined its monastery at Cîteaux. Three years later, at the age of twenty-six, he founded a new Cistercian house and became its abbot, calling the monastery Clairvaux, meaning the 'Valley of Light'. By the time Pope Honorius II was elected in 1124, Bernard was already regarded as one of the most outstanding churchmen of France; he attended important ecclesiastical assemblies, and his opinion was regularly sought by papal legates.

Significantly Clairvaux was built on land given to Bernard by Hugh, the count of Champagne, whose vassal was Hugh of Payns, the future founding Grand Master of the Templars. By the time Hugh of Payns sailed westwards in 1127 or 1128, Bernard was already well informed about the East and what was needed there; his mother's brother was André of Montbard, one of the original nine Templars, and Bernard's early patron the count of Champagne had three times gone on pilgrimage to the Holy Land, and on the last occasion, in 1125, he too renounced his worldly possessions and joined the Templars.

Grants of land as well as silver, horses and armour were made to the Templars almost as soon as Hugh of Payns landed in France in the autumn of 1127. The following summer the Grand Master was in England, where he was received with great honour by King Henry I, who donated gold and silver to the order. Hugh established the first Templar house in London, at the north end of Chancery Lane, and he was given several other sites round the country. More donations followed when Hugh travelled north to Scotland. In September, Hugh of Payns had returned across the Channel, where he was met by Godfrey of Saint-Omer, and together they received further grants and treasures, all these given for the defence of the Holy Land and for the salvation of their donors' souls.

The climax of Hugh of Payns' tour came in January 1129 at Troyes, the capital of the counts of Champagne, where Theobold, Hugh of Champagne's successor, hosted a convocation of Church leaders, among them seven abbots, ten bishops and two archbishops. They were presided over by a cardinal who was the papal legate, but dominating the assembly was one of the seven abbots, Bernard of Clairvaux. Clearly the Council of Troyes had been convened on the prior understanding that the Templars were to be accepted as a religious order. Hugh addressed the council and described the founding of the Templars and presented their Rule, adapted from the precepts followed by the canons of the Church of the Holy Sepulchre. This stipulated attendance at services together with the canons, communal meals, plain clothing, simple appearance and no contact with women. Because their duties carried them away from the church, they could replace attendance with the recitation of paternosters, and they were also allowed a horse and a small number of servants, and while the order was under the jurisdiction of the patriarch of Jerusalem they owed their individual obedience to the Grand Master. These regulations formed the raw material from which, after considerable discussion and scrutiny by the gathered churchmen, Bernard drew up the Latin Rule of seventy-one clauses.

Bernard's Latin Rule enjoined the Templars to renounce their wills, to hold worldly matters cheap and not be afraid to fight but always to be prepared for death and for the crown of salvation and eternal life. But Bernard was more than codifying existing practice and custom among the Templars; he was creating new conditions, imposing an ethos that had not entirely been in place before.

The evidence is in the Rule itself, which makes it clear that the Templars had at first been following a somewhat different life. For example, there was the rule on how married brothers were to be treated, making it clear that chastity was not

originally required, but 'we consider it unfair that this sort of brother should live in one and the same house with brothers who promise chastity to God'. Also in the early days there had been female members of the order, but Bernard put an end to this. 'It is dangerous to add more sisters to the order because the ancient enemy has expelled many men from the straight path of Paradise on account of their consorting with women. Therefore, dearest brothers, in order that the flower of chastity should always be evident among you, it shall not be permissible henceforth to continue this custom.'

But chastity in relations with women might encourage homosexual activity, and this too was suppressed, through a series of oblique prohibitions. Pointed shoes and laces were 'an abomination', as were 'excess hair or immoderately long clothes' - that is, anything that might smack of femininity. The hair on their heads was to be cut short, but all Templar knights wore beards as they were not permitted to shave.

The knights were to dress in white, symbolising that they had put the dark life behind them and had entered a state of perpetual chastity. Foul language and displays of anger were forbidden, as were reminiscences about past sexual conquests. Property, casual discussion with outsiders, and letters and gifts given or received were subject to the approval of the master. Discipline was enforced by a system of penances, with expulsion the punishment in extreme cases.

In all this the Templars were regulated like monks, but when it came to guidance in military matters Bernard offered few practical injunctions, although he did understand that in creating 'a new type of Order in the holy places', one that combined knighthood with religion, the Templars needed to possess land, buildings, serfs and tithes, and were entitled to legal protection against what the Latin Rule called 'the innumerable persecutors of the holy Church'.[17]

The endorsement of the Templars by the Council of Troyes was subsequently confirmed by Pope Honorius II. These successes had come largely through the efforts of Bernard of Clairvaux, who was now urged by Hugh of Payns to write a robust defence of the Templars for general distribution.

De Laude Novae Militae was the name of Bernard's panegyric, *In Praise of the New Knighthood*, in which he announced the Templars as the champions of a higher struggle in which homicide, which was evil in Christian eyes, was really malicide – that is, the killing of evil itself – which was good. The Holy Land, wrote Bernard, bore the impress of Jesus' life – Bethlehem, Nazareth, the River Jordan, the Temple Mount, and the Church of the Holy Sepulchre, which encompassed the places of Jesus' crucifixion, burial and resurrection. The Templars were the protectors of these holy sites and even acted as pilgrim guides, but by their proximity and daily familiarity with these footsteps in the life of Jesus, the Templars also had the advantage and the duty to search for the deeper truth, the inner spiritual meaning of the holy places. The implication of Bernard's *De Laude* was that by understanding the full meaning of their role the Templars would be fortified in their mission, which had gone beyond policing the pilgrimage routes and now embraced the defence of the Holy Land itself.

Following the death of Hugh of Payns in 1136, his successor Robert of Craon, the second Grand Master, consolidated the gains made at Troyes by securing for the Templars a string of papal bulls (from *bullum*, the Latin for 'seal', and so meaning an official decree). In 1139 Pope Innocent II issued *Omne Datum Optimum*, which had the effect of establishing the Templars as an independent and permanent order within the Catholic Church answerable to no one but the pope and sanctioned their role as defenders of the Church and attackers of the enemies of Christ. The Grand Master was to be chosen from among the ranks of the Templar knights free from

outside interference. The Templars were also given their own priesthood answerable to the Grand Master even though he was not ordained, which made the order independent of the diocesan bishops in Outremer and the West, and they were allowed their own oratories and cemeteries. The Templars were exempted from all tithes, but they were free to collect tithes on their own properties; all spoils of battle against the infidel were theirs by right; and donations made to the Templars were put under the protection of the Holy See.

These privileges were confirmed and extended by two further bulls: *Milites Templi*, issued by Pope Celestine II in 1144, and *Militia Dei* issued by Pope Eugenius III in 1145, which taken together with *Omne Datum Optimum* put the Templars beyond reproach and formed the foundation for their future wealth and success. It was also under Eugenius III that the Templars were granted the right to wear their famous habit of a red cross over a white tunic, symbolising their readiness to suffer martyrdom in the defence of the Holy Land.

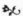

The Knights Templar would in time become one of the wealthiest and most powerful financial and military organisations in the medieval world, yet there are holes in the historical record about their origins, and there are contradictions too. When were they founded? How many were there? Why do we hear so little about them during the first three decades of their existence? What accounts for their meteoric rise? Part of the problem in finding the answers to these questions lies in the nature of the sources themselves.

The earliest chronicler of Templar history was William, archbishop of Tyre. Born into a French or Italian family at Jerusalem in about 1130, he studied Latin, Greek and Arabic there before continuing his education at Paris and Bologna from about 1146 to 1165. After returning to Outremer he wrote,

among other works, a twenty-three-volume history of the Middle East from the conquest of Jerusalem by Umar, based on Arabic sources. This *Historia Rerum in Partibus Transmarinis Gestarum*, or *History of Deeds Done Beyond the Sea*, was begun around 1175 and remained unfinished at the time of William of Tyre's death in about 1186. Most of it concentrated on the First Crusade and subsequent political events within the kingdom of Jerusalem – events from which William was not entirely detached, for he was involved in the highest affairs of both the kingdom and the Church, and as archbishop and contender for the office of Patriarch of Jerusalem he was naturally jealous of any diminution of ecclesiastical authority – and therefore resentful of the Templars' independence and their rise to wealth and power.

Two other early chroniclers were Michael the Syrian, Jacobite Patriarch of Antioch, who died in 1199, and Walter Map, archdeacon of Oxford, who died in about 1209. But Michael was weak on matters outside his own experience and times, while Walter preferred a good story to sound historical inquiry, and moreover his prejudice against the Templars was fundamental, for he objected to the entire concept of an order of fighting monks. Despite his own bias against the Templars, William of Tyre is considered the most reliable of the three; he diligently sifted through sources to glean the facts about events that occurred before his time, and he made a point of interviewing surviving first-hand witnesses.

All the same, William of Tyre did not even begin writing his history until the mid-1170s – that is, fifty-five years after the founding of the Templars – and there is no earlier source. The chroniclers of the First Crusade – men such as Fulcher of Chartres, Baldric of Dol, Robert the Monk and Guibert de Nogent – had all completed their works within a decade of the reconquest of Jerusalem in 1099 and long before the foundation of the Templars in 1119 – or was it 1118? According to William of Tyre, it was the latter, but he was notoriously

poor on dates even if careful in other things, and the balance of scholarly opinion has the Templars established in 1119. In whatever year it was, it does not seem to have occurred to anyone to write a first-hand account of the founding ceremony of the Templars in the Church of the Holy Sepulchre on Christmas Day – at the time it did not register as a significant event.

We do not even know how many founding members there really were. William of Tyre says that there were nine and names the two most prominent as Hugh of Payns and Godfrey of Saint-Omer. Other sources also name Archambaud of Saint-Aignan, Payen of Montdidier, André of Montbard, Geoffrey Bissot, a knight called Rossal or possibly Roland, another called Gondemar, and two more whose names have not survived. Moreover, William of Tyre maintains that even as late as the Council of Troyes in 1129 there were still only nine Knights Templar. But why would only nine men command such attention from the Council and the pope, and why would Bernard of Clairvaux devote so much effort to praising their worth and propagating their fame? Indeed in this case Michael the Syrian seems to be more reliable, for he says there were thirty founding Templar knights, and most likely there were very many more a decade later.

Nevertheless the notion that the Templars began with nine members and continued at that strength for a decade may have less to do with factual accuracy than with medieval number symbolism. Nine was considered an incorruptible number because no matter how many times it is multiplied it continues to reproduce itself in the sum of its digits. This symbolism would have enshrined nine in the founding myth of the Templars, a myth that was repeated by later generations from whom William of Tyre collected his information.

Just as we owe it to William of Tyre that the Templars comprised only nine members right up to 1129, so we also owe to him the claim that they were a poor and simple order

throughout the early decades of their foundation. Certainly the Templars looked back on themselves in this idealistic way, so that in 1167, when they were very rich indeed, they adopted as their seal the two knights astride one horse, a self-image perhaps also derived from their ascetic Cistercian promoter in the West, Bernard of Clairvaux. Yet however humble the lives of the individual knights, the order itself was never indigent, not even at the start when already it was receiving an income from the canons of the Church of the Holy Sepulchre as well as significant donations from powerful French barons.

But to portray the Templars as poor and humble and few in numbers in their early years gave William of Tyre a handy stick with which to beat them in his critical history. By the 1170s, according to William of Tyre, the Templars 'are said to have immense possessions both here and overseas, so that there is now not a province in the Christian world which has not bestowed upon the aforesaid brothers a portion of its goods. It is said today that their wealth is equal to the treasures of kings.' William contrasts this state of affairs with the Templars' earlier simplicity, suggesting they have somehow betrayed themselves. But it seems that his real complaint is that their support in the West made them independent of any power in Outremer, particularly that of the Church as represented by William, the archbishop of Tyre and would-be patriarch of Jerusalem:

> Although they maintained their establishment honourably for a long time and fulfilled their vocation with sufficient prudence, later, because of the neglect of humility, they withdrew from the Patriarch of Jerusalem, by whom their order was founded and from whom they received their first benefices and to whom they denied the obedience which their predecessors rendered. They have also taken away tithes and first fruits from God's churches, have disturbed their

possessions, and have made themselves exceedingly troublesome.[18]

This was the beginning of the criticism the Templars would receive from sources whose interests they crossed. Some would call them saviours of the East and defenders of all Christendom; others would find them 'troublesome' and accuse them of arrogance, greed, secrecy and deceit. Their destruction lay in their beginning; when there was no more East to save, the Templars would be doomed.

Outremer

FULCHER OF CHARTRES, who chronicled Pope Urban's speech at Clermont in 1095 and travelled east with the First Crusade, eventually became canon of the Church of the Holy Sepulchre and remained in Jerusalem for the rest of his life. Before he died in 1127[1] Fulcher recorded the great changes he had witnessed in Outremer, years when soldiers, traders, settlers and pilgrims mingled and intermarried with the indigenous inhabitants to form a revitalised society and culture in the East.

> We who were Occidentals now have been made Orientals. He who was a Roman or a Frank is now a Galilaean, or an inhabitant of Palestine. One who was a citizen of Rheims or of Chartres now has been made a citizen of Tyre or of Antioch. We have already forgotten the places of our birth; already they have become unknown to many of us, or, at least, are unmentioned. Some already possess here homes and servants which they have received through inheritance. Some have taken wives not merely of their own people, but Syrians, or Armenians, or even Saracens who have received the grace of baptism. Some have with them father-in-law, or daughter-in-law, or son-in-law,

or stepson, or stepfather. There are here, too, grand-
children and great-grandchildren. One cultivates
vines, another the fields. The one and the other use
mutually the speech and the idioms of the different
languages. Different languages, now made common,
become known to both races, and faith unites those
whose forefathers were strangers. As it is written,
'The lion and the ox shall eat straw together'.[2] Those
who were strangers are now natives; and he who was
a sojourner now has become a resident.[3]

It is noteworthy that Fulcher of Chartres specifically men-
tions that the Franks were engaged in rural activities such
as cultivating vines and fields. This is testimony to the set-
tled conditions in Outremer and to the way Franks lived
and worked among the indigenous population. It also con-
tradicts the assertions of certain present-day historians that
the Franks enjoyed no security and kept themselves apart, for
example Jonathan Riley-Smith, who has written: 'In the king-
dom of Jerusalem, most of the immigrant Frankish popula-
tion lived in towns or castles; the countryside was populated
and worked almost exclusively by native Syrians, both Chris-
tians and Muslims.'[4] As we shall see there is plenty of solid
evidence, quite apart from Fulcher of Chartres, to demon-
strate that this view is wrong.

Fulcher also mentions that the Franks learned the local
languages, which meant Greek, Armenian, Syriac and Ara-
bic; this stood in contrast to the Arabs and the Turks, for
whom there is very little evidence that they could speak the
others' language or troubled to learn the languages of the
people they had conquered and oppressed.

Intermarriage occurred throughout all levels of society, not
least among the aristocracy. At the same time as Fulcher of
Chartres was describing the mixing of East and West, the first
generation of Franks in Outremer was dying off, and with the
death of Baldwin II in 1131 they were gone. Baldwin was now

succeeded by Fulk and Melisende, who was half Armenian and ruled as queen in her own right. Like her, Melisende's younger sisters were powerful and influential women: Alice was princess of Antioch; Hodierna was countess of Tripoli; and through Melisende's influence Ioveta became abbess of the richly endowed convent of St Lazarus in Bethany, not far from Jerusalem, a pilgrimage site famous for its gospel associations with Lazarus and Mary Magdalene. Outremer was passing into the hands of a new home-grown generation.

The Aqsa mosque had already become dilapidated under Seljuk rule, and by the time Baldwin II came to the throne in 1118, the Temple of Solomon, as the crusaders knew it, that is the Templum Solomonis, was in a sorry state. Although the king was using the building as his palace and would soon hand over a wing to the Templars, Fulcher of Chartres remarked that 'the fabric of the roof needs repairing [...] This is due to our lack of resources.' Things were so bad that the previous king, Baldwin I, would sell off any lead that fell from the roof and was even known to order the roof to be stripped so that he could sell the lead to merchants.[5] But after the Council of Troyes in 1129, Baldwin II or his successors King Fulk and Queen Melisende, moved into their newly built palace near the Tower of David to the west and put the Templars in full possession of the Temple of Solomon as well as the entire southern end of the Temple Mount.

With the lands, tithes and other donations the Templars were beginning to acquire and develop in the West following Hugh of Payns' mission, their numbers were increasing, and they also had the funds to repair, enlarge and embellish the Templum Solomonis. The former palace was the headquarters not only of their administration but also of their daily lives; they resided there and used it to store arms, clothing

and food, and they stabled their horses in a great underground vault at the south-east corner of the Mount.

The Temple was also a place of prayer. For all their later reputation as warriors, the Templars were very much monks and lived the monastic life in accordance with the canonical hours. Rising at 4 a.m. for Matins, they then attended to their horses before returning to bed. Services began at 6 a.m. with Prime and continued with Tierce at 9 a.m. and Sext towards noon, the intervals in between devoted to training and grooming their horses. At noon the knights had a dinner of cooked meats, maintaining complete silence throughout the meal while the chaplain read from the Bible. Nones, the afternoon service, fell at 3 p.m., followed by Vespers at 6 p.m. and then supper. At 9 p.m. the Templars attended Compline, after which they received a glass of wine and water, were given their instructions for the following day, and went to see after their horses. At midnight they were in bed, keeping complete silence in their dormitories until rising again at 4 a.m.

But the Templars were not alone in praying on the Temple Mount, nor the Canons of the Temple, who were quartered near the Templum Domini, the Dome of the Rock. Unlike the Muslims, who during their occupation of Jerusalem forbade entry to the Temple Mount to all non-Muslims, the Franks made the platform of the Dome of the Rock available to Muslim worship, the pilgrim John of Würzburg remarking in about 1170 that 'very many Saracens even today come to this altar to pray'.[6] The Jews, forbidden by their laws to stand within what had been the Holy of Holies, the innermost shrine of their Temple, and not being sure exactly where it had stood, preferred to keep off the Mount and prayed at the Western Wall, as they do today.

While the Templars on the Mount were still acting as guides and guardians to pilgrims on the roads in the kingdom of Jerusalem, they were playing an altogether more military role in the Iberian peninsula.

In Spain, King Alfonso I of Aragon had reconquered large territories from the Muslims and was attracted to the concept of military orders as a means to safeguard them, rather than let them be taken by his barons, who might build up power bases independent from the crown. When he died childless, in 1134, he willed his entire kingdom to the Templars, the Hospitallers and the Church of the Holy Sepulchre in equal measures. But although the will was contested and adjusted, a settlement was reached with the Templars in 1143 which gave them six major castles in Aragon, a tenth of royal revenues and a fifth of any lands in future conquered from the Muslims, turning the Templars into a major force in the Reconquista against the forces of Islam. The Templars were the first; the Hospitallers followed them into the Iberian peninsula around 1150.

The Templars played a similar role in the west of the Iberian peninsula, where in the struggle against the Muslims a new nation was emerging, the independent kingdom of Portugal. The Templars' commitment to the cause of the crusade against Islam made them perfect allies; at no cost to existing Portuguese resources they were given anticipatory grants, so that, as the frontier was extended against the Muslims during the 1130s and 1140s, the Templars acquired a share in newly recovered lands and were given control of border castles.

In Outremer, by contrast, the Templars are reported in medieval sources to have been involved in only three military engagements between 1119 and the arrival of the Second Crusade in 1148. The Templars were at the failed siege of Damascus in 1129, they took part in a campaign to defend an eastern outpost of the county of Tripoli which met with defeat in

1137, and they were worsted in a skirmish at Hebron in 1139. The Templars did take over responsibility for guarding the passes into Antioch from Asia Minor through the Amanus mountains in about 1136. Otherwise the surviving record is silent on the early decades of the Templars in the East.

For that matter nothing much is heard of the Hospitallers' military exploits in the East during these early decades, despite the survival of their archives. Both the Templars and the Hospitallers were religious orders, but whereas the Templars had been founded by secular knights whose mission was to protect pilgrims by force of arms, the Hospitallers, who included both monks and nuns, were monastics from the start and their purpose remained primarily the care of the needy and the sick. Nevertheless in 1128 the Hospitallers were given the village and tower of Calansue (now Qalansuwa) on the plain between Jaffa and Caesarea, and in 1136, the same year that the Templars were sent to guard the passes in the north, the Hospitallers took charge of the village and fortress at Bethgibelin, one of several new settlements built in the vicinity of Fatimid-held Ascalon.

Yet these beginnings were less dramatically military than they might seem. The three castles built by the Templars in the Amanus range were poorly constructed affairs, all relying on the craggy mountainous terrain for their defences; they were hardly meant for sustained warfare. Two routes pass through the mountains, one north of Alexandretta (present-day Iskenderun), where the Templars built the castles of Trapesac and La Roche de Roissol, the latter actually on a mountain peak, the other route south of Alexandretta, the famous Belen Pass, through which Alexander chased the Persian king Darius after the battle of Issus, where the Templars built the castle of Baghras. These castles did not mark a frontier between the Christian states and the Seljuk Turks; rather, the passes were connecting avenues between the principality of Antioch and the new Armenian homeland in

Cilicia, established after the catastrophe of Ani. In particular the Belen Pass, also known as the Syrian Gates, led directly south to the city of Antioch itself. It is not surprising that the castles were built soon after Queen Melisende came to the throne; being half Armenian and with her sister married to the prince of Antioch, her concern was naturally with the alliance between Outremer and the Armenians. The Templars' castles in the Amanus mountains did not directly block the passes – rather, they could serve as secure bases for attacking any Turkish forces attempting to cross the range – but more immediately and importantly they protected the two routes along which trade and pilgrimage traffic, as well as military assistance, passed between the Armenian and Frankish allies. The Templars' role in the Amanus mountains, therefore, at least initially, was an extension of their role as a gendarmerie along the roads in the kingdom of Jerusalem.

The Hospitallers' activities at Calansue and Bethgibelin were humbler yet. Calansue was an estate founded by Geoffrey of Flujeac on the Plain of Sharon, north of Jaffa and west of Nablus. In the village stood a stone tower, two storeys high, thought to have been built by Geoffrey before he granted the Hospitallers his estate, and near it a hall and three other vaulted structures added later. But the tower and other buildings were not enclosed and can hardly be said to have amounted to a fortress; but even if they were, their primary purpose would not have been defensive, for Calansue was far from any danger. Frankish landowners commonly built towers or other structures that might be described as fortifications not so much for defence as to attract settlement to their estates. The same was going on in Europe, where fortified settlements had been widespread since the tenth century despite the lack of an external or internal threat. Quite the opposite; fortified settlements followed on the heels of improved security and rising prosperity. As the historical geographer Ronnie Ellenblum has written, in *Frankish Rural*

Settlement in the Latin Kingdom of Jerusalem, 'The fortress, it is now commonly argued, was designed to be more of a power symbol and a nucleus for a new settlement rather than an answer to acute security requirements. The construction of new settlements as well as the construction of fortresses are considered to be the result of an improvement in the security and economic situation and not of its deterioration.'[7]

Bethgibelin, built in rolling countryside 25 miles inland from Ascalon and granted to the Hospitallers by King Fulk and Queen Melisende in 1136, was an altogether more impressively fortified settlement. The city of Eleutheropolis had stood on the site in Roman times; when the Frankish settlement was established here, the remains of the ancient amphitheatre were used to construct a concentric fortress with an inner and outer circuit of walls, towers and a moat. Significantly, Bethgibelin was built only after Ascalon ceased to be a serious threat to the Franks. It was not a defensive outpost to guard the frontier; rather, it supported attacks against the Fatimid garrison at Ascalon. During a period of disorder in Egypt, the Franks were pressing home their military superiority. Meanwhile all of southern Palestine was enjoying a period of security, and Bethgibelin was primarily an agricultural community.[8]

The loss of the Templar archives means that there is less evidence for their settlement activities, but archaeological excavations are helping to fill the gap, as at Wadi al-Haramiya, along the road from Jerusalem to Nablus, where the Templars had possession of a spring and built a tower and established an agricultural settlement, suggesting that 'the Templars may have been acting here as property developers, in the same way as [...] the Hospitallers at Bait Jibrin [Bethgibelin] and Qalansuwa [Calansue]'.[9]

From these small beginnings the Templars and the Hospitallers not only became wealthy developers in the East but also developed their military careers. When Thoros II,

prince of Armenia, was travelling through the kingdom of Jerusalem in the 1160s, he remarked to Baldwin III, 'When I came to your land and enquired to whom the castles belonged, I sometimes received the reply, "This belongs to the Temple"; elsewhere I was told, "It is the Hospital's". I found no castle or city or town which was said to be yours except three.'[10] This was no exaggeration. The Templars and the Hospitallers owed direct responsibility only to the pope while enjoying the favour of all strata of society, and they transcended not only local feudal quarrels but also the antagonisms of nations and their kings. As corporate bodies, the military orders were everlasting, their numbers undiminished by disease or death, and they were able to draw on a continuous supply of young men of noble families in Europe seeking to fulfil the moral and religious obligations of knighthood. Also the Templars and the Hospitallers received donations of property in Europe which together with their development ventures in Outremer soon made them wealthy. Very quickly the lords of Outremer were selling or giving fortresses to the orders, and by 1166 there were only three castles in the kingdom of Jerusalem that the military orders did not control.

Mythology rather than history tells us that the East was settled by crusaders. The truth is that three-quarters of those who set out on the First Crusade never made it to Jerusalem but fell along the way, victims of battles or disease. And many of the survivors returned home, where news of their deeds was wildly celebrated in epic songs such as the *Chanson d'Antioche* and the *Chanson de Jerusalem* – which fostered the mythology that attached itself to the crusader states and is remembered to this day. But the settlement of Outremer depended on a very different people.

Outremer was ultimately swept away, and almost all the local records that would have provided a social history were destroyed. But here and there documents have survived, including lists of the inhabitants of Bethgibelin of the Hospitallers and the settlement of Magna Mahomeria (al-Bira), 10 miles north of Jerusalem, founded by the Church of the Holy Sepulchre in about 1128. The lists indicate the settlers' places of origins and their occupations,[11] and they are striking first of all for showing that not a single settler at either place came from northern France, the origin of the greater number of crusaders. Instead the Frankish settlers at Bethgibelin and Magna Mahomeria came from central and southern France, Italy and Spain. They were peoples of southern Europe and the Mediterranean, familiar with the environment, bringing their enthusiasm and skills to bear in Outremer just as they had been doing in the West, where their ancient lands were being liberated from Muslim occupation. The First Crusade established the boundaries for Frankish settlement, but it did not determine the demographic composition of Outremer; that was left to a wider process of migration which was occurring also in Europe, where enterprising people travelled far afield in search of places offering better social and economic conditions. There may have been those who ventured to the East as much to satisfy their souls as to seek opportunities, but otherwise they were very much the same people who were settling in Sicily or Spain, newly recovered from Muslim occupation, or in any other area of European settlement, and who came almost by chance, who might have settled elsewhere but came to the Levant. 'It is doubtful', Ronnie Ellenblum has stated, 'whether in the minds of the Lombards or Burgundians there was any great difference between settlement in Languedoc and Catalonia or the Frankish East.'[12]

There was a difference, however, between the settlers in Outremer and in comparable places in the West. Compared

to villagers in Languedoc, for example, the lists show that the inhabitants of Bethgibelin and Magna Mahomeria were highly skilled and specialised. This was probably true of the Templars' settlement at Wadi al-Haramiya, 3 miles north of Magna Mahomeria, and indeed throughout Outremer. As well as the usual butchers, bakers and shoemakers, the settlers in the East counted among their number an unusually large number of builders, carpenters and blacksmiths, as well as a concentration of expertise in such areas as vegetable gardening, vineyards, grain cultivation and also rearing pigs, goats and camels. After centuries during which native Christians were forbidden by their Muslim masters to build churches or even keep them in repair, the locals had lost much of their experience in large-scale construction. The need to restore lost skills meant there was a particular demand for Frankish masons, carpenters and metalworkers, who also found themselves engaged in military activities such as building fortresses and siege engines and shoeing horses. Pig-breeding and wine-making served the requirements of the indigenous Christian and Frankish population, and the increase in olive oil production at least partly reflected its use in the growing number of new churches, while Frankish experts succeeded in the husbandry of animals such as goats and camels, previously largely the preserve of Muslims.

The Frankish achievement in the rural development of the kingdom of Jerusalem was considerable. Recent archaeological investigations reveal that they founded over two hundred new settlements; they interconnected their sites with a network of roads, constructed bridges and renovated ancient aqueducts, built watermills and windmills, and in a hard and drought-prone environment mastered the complicated traditional techniques of irrigation. The military orders played a leading part; as well as founding settlements, both the Templars and the Hospitallers developed the rural economy by building watermills and granaries; the Hospitallers also

engaged in the sugar industry and the Templars in the glass-making industry in the countryside.

The Franks numbered about a quarter of the population of Palestine, over 100,000 out of an estimated 400,000 to 500,000 inhabitants in all,[13] further bolstering the Christian character of Palestine, whose rural population was 'still Christian on the eve of the Crusaders' conquest' and whose major city, Jerusalem, 'was certainly inhabited mainly by Christians during the entire period [of the Muslim occupation]'.[14] But during the Arab period some parts of Palestine – eastern Galilee, for example, and also the region on the west bank of the River Jordan around Nablus – had suffered from frequent nomad attacks and depredations, forcing the sedentary farming population to abandon their lands, which were eventually settled by Muslims. The pattern of Frankish settlement was affected by these conditions, the Franks preferring to establish themselves among fellow Christians, founding new sites in Christian neighbourhoods and marrying local Christian women, or even living in the same villages with Eastern Christians and sharing the same churches, but staying away from areas where the population was Muslim and largely intrusive, invaders rather than indigenous converts to Islam.

The Muslims had long failed to involve themselves in the daily lives and culture of the people they regarded as their chattel, the Christians and the Jews who had been 'tolerated' as *dhimmis* under Islamic rule; and they felt the same, even more so, about the Franks. Very few Muslims troubled to learn the languages of the Franks, or indeed were aware that the Franks spoke a variety of languages; instead they lumped them all together as speaking one Frankish tongue. The Arab writer and diplomat Usamah ibn Munqidh contemptuously dismissed them with the remark, 'These people speak nothing but Frankish; we do not understand what they say.'[15] Not that the Arabs chose to understand the Turks, nor

the Turks the Arabs; there is very little evidence that they learned the other's language. Usamah ibn Munqidh underlined the point when he added for good measure that he did not understand Turkish either. As Carole Hillenbrand, one of the leading scholars of the Turkish imperium admits, the effect of this linguistic haughtiness, or ignorance, is to cast doubt on Muslim chronicles of the time in which 'dialogues in high-sounding Arabic' are put in the mouths of Turkish commanders and sultans but 'could never have actually taken place'.[16]

To the extent that the Muslims verbally acknowledged the Franks, it was to hurl abuse, calling them devils, dogs and pigs, while the Muslim chroniclers could barely write a page about the Franks without resorting to some invective, calling them 'accursed' or 'enemies of God'. Abusive phrases such as 'may God curse them' and 'may God send them to perdition' run like a litany through Muslim writings about the Franks,[17] but the chronicles of those Franks who knew the East are generally free of such abuse towards Muslims. As Fulcher of Chartres observed, Franks did learn Arabic, and Syriac and Armenian too: 'the one and the other use mutually the speech and the idioms of the different languages'.[18] Knowledge of the local languages facilitated trade and allowed the Franks to work with the indigenous population in developing the country through agriculture, roadmaking, construction works and so on, and also to share in their lives as neighbours and to intermarry. The Franks were successfully establishing a political, social and cultural environment based on the local Christian population, accruing along the way a tolerance and breadth of view that Muslim society ignored. After several hundred years of alien occupation, Outremer was being restored to the Mediterranean world.

12

Zengi's Jihad

I N 1138 THE ARAB DIPLOMAT Usamah ibn Munqidh was
sent to Jerusalem by the independent Turkish ruler of
Damascus, Muin al-Din Unur. His purpose was to discuss
with King Fulk the possibility of an alliance against Imad al-
Din Zengi, who a decade earlier had been confirmed by the
Seljuk sultan as the atabeg, or governor, of Mosul in north-
ern Iraq and of Aleppo in northern Syria. But the Seljuk
dynasty was in decline and exercised only the loosest control
over its minions, or over the Abbassid caliph in Baghdad or
over anyone else, leaving Turkish strongmen like Zengi to
vie for power in the region. William of Tyre called Zengi 'a
vicious man',[1] and the inhabitants of Damascus agreed: they
had learned something of his brutality during his unsuccess-
ful siege of their city in 1135, and Usamah ibn Munqidh's
mission to Jerusalem was sent with popular support. For two
years Usamah travelled back and forth, negotiating an alli-
ance and making friends. Zengi threatened Damascus again
in 1140, but his fear of being caught in a pincer movement
forced him to withdraw, an event celebrated later that year
when Usamah accompanied Muin al-Din Unur on a state
visit to Jerusalem.

During the times Usamah spent in Jerusalem and

elsewhere in the kingdom he became a close observer of the Franks and their ways, and he described his encounters in his memoirs, though often in a tone of self-congratulation at what he saw as the superiority of his own culture over theirs. He was shocked, for example, by the lack of restriction placed on their women by Frankish men.

> The Franks are without any vestige of a sense of honour and jealousy. If one of them goes along the street with his wife and meets a friend, this man will take the woman's hand and lead her aside to talk, while the husband stands by waiting until she has finished her conversation. If she takes too long about it he leaves her with the other man and goes on his way.[2]

On a visit to Acre, Usamah met an important Frankish knight who had come on a pilgrimage. 'He was of my intimate fellowship and kept such constant company with me that he began to call me "my brother". Between us were mutual bonds of amity and friendship.' But when the knight was about to embark for home and offered to take Usamah's teenage son into his household for some time, a form of tutelage that was common among the nobility of Europe, Usamah declined, remarking in his memoirs that 'even if my son were to be taken captive, his captivity could not bring him a worse misfortune than carrying him into the lands of the Franks'.[3]

Usamah was an Arab, born at Shaizar in Syria in 1095, the year that launched the First Crusade. He was a widely read and cultivated man; he was also raised as a hunter and a warrior, and as a young man he helped defend Shaizar against all comers. He fought against the Franks at Tripoli and Antioch as well as against the Turks at Hama and Homs, and also against the Assassins who built their castle of Masyaf within view of Shaizar across the valley of the Orontes river. But in 1131 he was exiled by his uncle the emir of Shaizar,

who feared that Usamah was plotting against him. Thereafter Usamah wandered the Middle East in the service of one ruler or another and developed a reputation as an unscrupulous political intriguer. He was accused of arranging the assassination of a Fatimid caliph and his vizier, as well as scheming against Muin al-Din Unur, the ruler of Damascus, whom he nevertheless served as diplomatic envoy. But his abilities and charm opened many doors, and he was befriended by numerous figures in the East, among them the Templars and King Fulk; Usamah died at Damascus in 1188, the year after the fall of Jerusalem to Saladin, another of his friends.

Usamah came to know the Templars particularly well and told how they made a point of providing him with a place to pray in their headquarters on the Temple Mount, although inevitably in his memoirs he turned the tale against the Franks.

> This is an example of Frankish barbarism, God damn them! When I was in Jerusalem I used to go to the Masjid al-Aqsa, beside which is a small oratory which the Franks have made into a church. Whenever I went into the mosque, which was in the hands of Templars who were friends of mine, they would put the little oratory at my disposal, so that I could say my prayers there.

Usamah would then arrange himself to pray towards Mecca, which is south of Jerusalem, whereas Christian churches were usually oriented to the east. But on one occasion a Frank noticed Usamah's direction of prayer and roughly pointed him towards the east, saying 'That is the way to pray!' Usamah's Templar friends rushed forward and led the man away, but when their attention was diverted the man accosted Usamah again, repeating 'That is the way to pray!' Again the Templars intervened and led the Frank away,

apologising to their Muslim friend, saying the man had just arrived from the West and had never seen anyone pray as Usamah had done.[4] All in all, decided Usamah, 'There are some Franks who have settled in our land and taken to living like Muslims. These are better than those who have just arrived from their homelands, but they are the exception'.[5]

During the Muslim occupation Christians were not permitted on the Temple Mount at all, whereas Usamah was treated royally by the Franks. But the Franks were 'animals', he wrote, 'possessing the virtues of courage and fighting, but nothing else; just as animals have only the virtues of strength and carrying loads'.[6] It was that old familiar contempt that Muslims had for *dhimmis*, which went back hundreds of years. As for his remark that the Franks 'have settled in our land', it comes oddly from Usamah, whose family, ensconced in Shaizar, were aliens to the place, which had only recently been in Byzantine hands and had been the seat of a bishop. Known to the Byzantines as Cezer, it had been part of Graeco-Roman Syria for a thousand years until it fell to the Arabs in 638, although it was recovered in 999. But in 1081, almost on the eve of the First Crusade and just fourteen years before Usamah was born, Cezer was lost to the Banu Munqidh, Usamah's clan. It was not so much the Franks who had 'settled in our land' as the Banu Munqidh who had taken the land from the indigenous population.

Early in 1099, after the First Crusade had captured Antioch and was marching south towards Jerusalem, the army at first followed the valley of the Orontes river, where the crusaders were welcomed by the Banu Munqidh clan of Shaizar, who were delighted to help any enemy of the Turks. The emir of Shaizar, the uncle of Usamah ibn Munqidh, provided them with horses and food and other provisions and gave them

guides to show the way along the valley and through the Homs gap, where the army emerged on the Mediterranean just north of Tripoli. There another Arab clan, the Banu Ammar, gave the crusaders further help as they marched along the coast as far as Fatimid territory, where from Jaffa they ascended through the highlands to Jerusalem.

Yet within Usamah's own lifetime the attitude of local Muslim rulers, whether Arab or Turk, towards Turkish imperial domination went from resistance to acceptance, mostly because they were beaten into submission in the cause of dynastic ambition by successive warriors, Imad al-Din Zengi, his son Nur al-Din, and Nur al-Din's successor Salah al-Din, famous in the West as Saladin. One historian has succinctly explained Zengi's technique as a 'policy of deliberately refraining from serious attack on the Latin states and concentrating his assaults on his Muslim rivals. His programme of the status quo in respect to the Franks was of course designed to give him a free hand in his endeavours to best his Muslim foes.'[7]

Zengi was a Turk who in 1127 prevailed on the weakened Seljuk sultan in Baghdad to appoint him atabeg, or governor, of Mosul in northern Iraq. A year later, after agreeing a truce with the Frankish count of Edessa, Zengi marched into northern Syria and made himself atabeg of Aleppo as well. By means of war and intimidation Zengi soon extended his authority over much of Muslim Syria, and he would have taken Damascus too but for the alliance negotiated in 1139 by Usamah ibn Munqidh between its Turkish ruler, Muin al-Din Unur, and King Fulk and Queen Melisende of Jerusalem.

Zengi's ambition to take Damascus had already brought him into conflict with the Franks and also with the Templars. In 1137 Zengi laid siege to the Syrian city of Homs, which was a dependency of Damascus, but Raymond II, the count of Tripoli, went to its defence if only to keep Zengi in check and to prevent him from gaining too much power. As the Franks

approached, Zengi abandoned his siege and withdrew north into the Orontes valley, where he invested the castle of Montferrand, an outpost of the county of Tripoli. Raymond followed Zengi north, meanwhile calling on Jerusalem for assistance. King Fulk answered by dashing to Tripoli and through the Homs gap at the head of a small army which included a number of Templars.[8] For all that the Templars were beholden to no authority other than the pope, they had from the beginning enjoyed a close relationship with the ruling family of Jerusalem, were prominent at court and played an important role in the political as well as the military affairs of the kingdom. The Templars' participation in the failed assault against Damascus in 1129 and now this march north to the Orontes are the first recorded instances of the order being involved in outright warfare in the East rather than policing actions, and in both cases the Templars were lending their services to the king. But like the Damascus debacle, this adventure also ended in ignominious disaster.

As Raymond and Fulk marched against Zengi at Montferrand, Zengi quit his encirclement of the castle and fell upon the Franks, taking them by surprise, decimating their infantry and taking Raymond and a number of knights captive. Fulk and his forces, including the Templars, abandoned their supplies and sought refuge at Montferrand, where Zengi quickly put them under siege. Help was on the way; a mass conscription of fighting men from Jerusalem, Antioch and Edessa rushed towards the Orontes, so numerous that it seemed to the Muslims like a fresh crusade. This was the usual form of Frankish defence in the early years of Outremer; rather than relying on massive castles and static warfare, the Franks rapidly deployed their forces to relieve the town or fortress that was under attack or siege, which had only to hold out for a few days until overwhelming help arrived. But the Franks had dashed inside the castle of Montferrand without their supplies, and they were starving now and eating their own

horses. Isolated and unaware of the approaching forces, they sued for terms. Zengi agreed to let them go for nothing more than the surrender of Montferrand; at first astonished at his generosity, the Franks soon learned of the relieving army and reproached themselves for giving in too soon. Among those who went free were eighteen humiliated Templars. As for Zengi, he had avoided a major battle with the Franks, which, had he suffered a loss, would have played to the advantage of his true enemy, Damascus; but he had acquired Montferrand, which would prevent the Franks from pushing through the Homs gap into the Orontes valley and which gave him control of Homs and the nearby city of Hama, a gain that the Franks would never succeed in taking back. A year later, in not dissimilar circumstances, Zengi would show how he dealt less favourably with his fellow Muslims; while besieging Baalbek, a dependency of Damascus, he guaranteed the safety of its garrison if they would surrender; when they did so, he skinned their commander alive and crucified the rest.

Yet just three years later, still without any serious campaign against the Franks, Zengi was proclaiming his jihadist prowess with a series of inscriptions on public buildings in Aleppo: 'Tamer of the infidels and the polytheists, leader of those who fight the Holy War, helper of the armies, protector of the territory of the Muslims'.[9] The inscriptions were probably composed by Muslim clerics, who also talked up jihad in the marketplace and the mosque; it was the beginning of the alliance between the Turkish commanders and the religious authorities, whose mutual interests would be bolstered by whipping up public opinion against the Franks. But Zengi, Nur al-Din and Saladin were primarily driven by an ambition to build up their own imperial domains; fighting against the Franks was incidental to that goal. All three applied the call for jihad not only to their occasional campaigns against the Franks but also to their far more numerous and violent wars against their Muslim rivals, using the

excuse that a jihad against the Franks was not possible until wrongdoing, heretical or foot-dragging Muslims were got out of the way – excuses that disguised the fact that neither Zengi nor Nur al-Din nor Saladin enjoyed the support of all Muslim rulers, let alone the Muslim population at large, many of whom fought alongside the Franks against these self-described holy warriors.[10]

Fear is the most common word associated with Zengi in the Muslim chronicles. He was 'a chillingly ruthless personality who literally inspired terror in his army and subjects alike',[11] writes Carole Hillenbrand in *The Crusades: Islamic Perspectives*. According to the Persian chronicler Imad al-Din al-Isfahani, who later saw service with Nur al-Din and Saladin, 'Zengi was tyrannical and he would strike with indiscriminate reck-lessness. He was like a leopard in character, like a lion in fury, not renouncing any severity, not knowing any kindness.'[12] Oppressive, perfidious and murderous towards his fellow Muslims, he was nevertheless pardoned for his brutality by the Muslim chroniclers because of one act, his conquest of Edessa. 'This was truly the victory of victories and the one of them most similar to Badr', exulted the Kurdish chronicler Ibn al-Athir, comparing Zengi's taking of the city to a deci-sive early battle in the career of Mohammed, adding that those who witnessed it became 'devoted to jihad with the firmest conviction'.[13]

Thwarted in his great goal of conquering Damascus, Zengi turned his attention to lesser Muslim enemies elsewhere. Kara Arslan, of the Turkish Artuqid dynasty of the Diyabi-kar region in eastern Asia Minor, was one of those Muslim princes whom Zengi was determined to destroy. With Zengi ravaging his lands, Kara Arslan made an alliance with Josce-lin II, the half-Armenian, half-Frankish count of Edessa, who

in the autumn of 1144 marched northwards with the greater part of his soldiery, leaving Edessa lightly garrisoned and protected only by its walls. When reports reached Zengi that the city lay exposed, he immediately turned south and by a series of forced marches stood before Edessa, which he encircled with his vast army.

Zengi understood the strategic importance of Edessa; the city was a bulwark of the Frankish states against Muslim aggression. The other states of Outremer fringed the Mediterranean, but Edessa was landlocked; it lay beyond the Euphrates, a day's ride east of the river, where it commanded the trade route from Mosul to Aleppo and separated the Muslims of Iraq from the Seljuks of Rum in Asia Minor. Westerners rarely visited the city, and only a small number of its citizens were Franks, who, like the ruling family from which Queen Melisende of Jerusalem had sprung, were mostly intermarried with the local people; otherwise the greater part of the population were Armenians, and also Syrian Orthodox. Edessa was famous as an early centre of Christianity; the gospels were translated into Syriac there in about AD 150, and by the tenth century it had as many as three hundred churches, including a cathedral with a vaulted ceiling covered in mosaics rated among the wonders of the world. Architects from Edessa were sought all over the East, including by the Fatimids, for whom they built the great gates of Bab al-Futuh and Bab al-Nasr at Cairo. And so when Zengi laid siege to the city, he came up against its formidable walls. But William of Tyre was dismissive of the Edessans, complaining that they were more devoted to trade than skilled in the use of arms.

> All these defences could be of use against the enemy only if there were men willing to fight for their freedom, men who would resist the foe valiantly. The defences would be useless, however, if there were

none among the besieged who were willing to serve as defenders. Towers, walls, and earthworks are of little value to a city unless there are defenders to man them. Zengi found the town bereft of defenders and was much encouraged.[14]

But the Edessans showed no lack of courage, and when Zengi called on them to surrender they defiantly answered through their leaders, Bishop Papios, a Latin, Basilius Bar Shumanna, a Syrian, and Iwannis (John), an Armenian; trusting in the Franks, to whom they remained loyal, they refused Zengi's demand, and at the end of November the siege began.

Joscelin appealed for help from the other Frankish states of Outremer, but he had long been at odds with the prince of Antioch, who now ignored him, while relief forces sent from Tripoli and Jerusalem arrived too late. Meanwhile Zengi's men showered the city walls with stones propelled by catapults, while others tunnelled beneath the walls to bring them down. According to the Syriac chroniclers, and contrary to the dismissive remarks of William of Tyre, the people of Edessa fought heroically and tried to counter the mining of the walls. Everyone was busy; women, girls and boys, weary and exhausted, carried stones and water and other materials to the labourers who were trying to shore up the foundations. Even when a section of wall collapsed, the people worked frantically to rebuild it, but Zengi's men drove through the breach and rushed into the streets and houses of the city. The day was Christmas Eve, 1144.

'They slew with their swords the citizens whom they encountered, sparing neither age, condition nor sex',[15] wrote William of Tyre, and they enslaved any who survived. The Syriac chroniclers went into greater detail. Six thousand people lost their lives on that day alone, and for three days in all Zengi allowed the violence to go unchecked. According to

the account of Michael Rabo, the Syrian Orthodox patriarch of Antioch,

> You could see the priests killed and the deacons slaughtered, the sub-deacons mangled, the churches looted and the altars turned upside down. What a calamity! Fathers deserted their own children and mothers lost compassion for their children. Some fled to the mountain, while others gathered their children as the hen does to the chicks, waiting to die or be taken captive.[16]

The Turks, he added, left a few Armenians, Syrians and Greeks alive, but they were merciless towards the Franks. First they robbed the Franks of all they had, then they separated the priests and dignitaries from the rest, stripped off their clothes and sent them naked to captivity in Aleppo. They also separated the craftsmen from the prisoners, each according to his trade, before enslaving them too. As for the others, some were tortured, some were used as targets for Turkish arrows, and some were despatched outright by the sword; one way or another, all were killed.

The Muslim chroniclers agreed with the Syriac sources that great numbers of Armenians and Franks perished and churches were destroyed and defiled, some turned into granaries and stables. Ibn al-Athir wrote that Zengi captured Edessa by the sword, and that his men went on killing and looting. 'He declared the city open to the carnage wrought by his men. They turned crosses upside down, annihilated its priests and monks, killed its knights and brave men, and filled their hands with booty.' Ibn al-Athir also quoted the Koran, 11:102: 'Such was the scourge which your Lord has visited upon the sinful nations. His punishment is stern and harrowing.'[17]

Some inhabitants of the city fled to Jerusalem, where they found refuge at convents which with much difficulty provided

them with food and shelter. Others stayed at Edessa, where over a hundred young women married Turks and converted to Islam.

Zengi's conquest of Edessa excited panegyrics from contemporary Muslim poets, one writing that Zengi 'will turn tomorrow towards Jerusalem', another likewise directing the future course of jihad towards Jerusalem, writing: 'If the conquest of Edessa is the high sea, Jerusalem and the Sahil [the coast of Palestine and Syria] are its shore.' And the caliph at Baghdad honoured Zengi with a garland of titles, among them 'the adornment of Islam, the king helped by God, the helper of the believers'.[18]

The following year, as Zengi was laying siege to the Frankish fortress of Jabar, on the Euphrates, he was murdered in his tent. Accounts of his death vary, but according to several Muslim sources, Zengi was in a drunken stupor when he was killed by a Frankish slave. In the ensuing chaos, and as Zengi's sons battled for the succession, local Muslim rulers reclaimed what they could from Zengi's domains; Muin al-Din Unur, the atabeg of Damascus, recovered Baalbek, Homs and Hama, while the Artuqids repossessed their territories round Diyarbikir. Edessa also yearned to throw off the Turkish yoke. Its native Christians sent secret word to Joscelin, then at Turbessel, his capital of what remained of the county of Edessa west of the Euphrates, reporting that the Turks had all but abandoned Edessa and saying they would open the gates to him. But by now the succession had been won by Zengi's son Nur al-Din, who, on receiving word that Joscelin had taken Edessa, marched from Mosul at the head of an enormous army. Joscelin was unable to dislodge the Turkish garrison from the city's citadel, and fearing being trapped between the Turks within and the Turks approaching from Mosul, he rode out from the city to face the Turks on open ground. But as the Franks charged, the Turkish lines gave way, then closed ranks again and attacked Joscelin and

his army from the rear. Thrown into confusion, the Franks fled. Joscelin was wounded by an arrow but managed to escape.

On 3 November 1146 the Muslims once again became masters of Edessa. First the Armenians and other Christians were annihilated by the sword, in some cases tortured and their bellies cut open. Then the looting began. When Zengi had taken the city in 1144 it was pillaged for three days; this time the looting went on for a whole year. The Turks went about the city searching through secret places, digging into foundations, tearing open roofs. Churches, houses, monasteries were stripped bare and destroyed. Edessa was reduced to a scene of desolation and horror; the city became the abode of jackals, who picked over the corpses of its people, and no one entered except those searching for treasures. The Muslim chroniclers, however, avoided giving details about the attack on Edessa; Ibn al-Qalanisi said that Muslim hearts were strengthened as they rejoiced in their victory. The Christian chroniclers told a different story. Michael Rabo, the Syrian Orthodox patriarch of Antioch, wrote of the

> night of death and the morn of hell and the day of desolation which stunned the sons of the wretched city. [...] The corpses of priests, deacons, monks, dignitaries, and poor people were piled up. Those who died were luckier than those who remained alive. Those who were still alive suffered incredible torment. They fell into the midst of the fire of the Turks' wrath. The Turks made them shed their clothes and shoes. They tied their hands behind them, beating them and forcing them, men and women, to walk naked alongside their horses. The Turks flayed the bellies of those who fell due to fatigue and torture, then left them dead to stink and become food for birds of prey.[19]

Michael Rabo estimated that in the two Turkish occupa-
tions of Edessa, in 1144 and 1146, some 30,000 of its people
were slaughtered and 16,000 were taken captive, while only
1,000 men made it to safety. No women or children remained;
some were killed, and the rest were driven to Aleppo, where
they were sold into slavery and scattered throughout the
lands of the East. It was Ani all over again.

The Second Crusade

MUSLIM CHRONICLERS later looked back on the destruction of Edessa as the start of the jihad that would drive the Franks from the East. In the West the loss of Edessa touched off the Second Crusade, a huge campaign by sea and land, this time led by two European kings. But the crusade might never have reached the Holy Land at all had it not been for the Templars, which did not stop them being made scapegoats when the expedition unexpectedly failed. Yet against the gathering forces of the Muslim jihad Outremer could not have survived, as it did, for another hundred and fifty years without the conviction, sacrifice and military prowess of the Knights Templar.

All through 1145 pilgrims had been returning from the East with news of the fall of Edessa, and emissaries had been sent to the West from Armenia, Antioch and Jerusalem. Pope Eugenius III was moved by the terrible events and on 1 December issued a call to arms in the form of a papal bull known from its opening words as *Quantum Praedecessores*: 'How much our predecessors the Roman pontiffs did labour

for the deliverance of the oriental church ...'.[1] The bull went on to grant the remission of sins to all who took part in the crusade. Yet there is no record of a response to it from any quarter; the pope's call seems to have fallen on deaf ears.

Whether King Louis VII of France knew of the bull is not clear, but he too would have had news from the East, and at Christmas 1145 he summoned his barons and told them of his desire to go to the aid of the Christians in the East. But he made no reference to the pope nor to a crusade with its various inducements, including the remission of sins; instead Louis was saying nothing more than had been said sixteen years earlier, when the first Grand Master of the Templars, Hugh of Payns, came to France to raise fighting men for the attack on Damascus. In the event Louis' barons were indifferent to his call, and Abbot Suger of St Denis, the senior statesman in Louis' court, opposed the venture outright, arguing that the king's business was at home.

Louis hardly had the makings of a war leader. Following the death of his older brother, he had come unexpectedly to the throne seven years earlier, when he was only seventeen. As the younger son of Louis VI he had been intended for the Church; he was austere and pious, and the high-spirited Eleanor of Aquitaine, whom he married when she was fifteen, complained that she had expected to marry a king but found she was married to a monk. Louis and his barons agreed to put the matter to Bernard of Clairvaux and then convene again at Easter 1146 at Vézelay in Burgundy.

Bernard refused to decide for Louis and his nobles, saying that it was a matter for the pope, and so Louis sent an embassy to Eugenius, who gladly enlisted the young king in the papal crusade. Eugenius authorised Bernard to preach the crusade in his place, but at the same time, on 1 March 1146, the pope underlined the papal role by reissuing *Quantum Praedecessores*, repeating what it had said before.

> How much our predecessors the Roman pontiffs did
> labour for the deliverance of the oriental church, we
> have learned from the accounts of the ancients and
> have found it written in their acts. For our predeces-
> sor of blessed memory, pope Urban, did sound, as it
> were, a celestial trump and did take care to arouse for
> its deliverance the sons of the holy Roman church
> from the different parts of the earth.[2]

In summoning the memory of Urban, the bull deliber-
ately looked back for inspiration to the First Crusade.

Meanwhile Eugenius and Louis arranged that Bernard of
Clairvaux should speak at the great abbey church of Véze-
lay, powerful for harbouring the bones of Mary Magdalene.
The abbey, refounded in the ninth century after an Arab raid
had destroyed an earlier convent on the spot, stood astride
a major pilgrimage route across France to Santiago de Com-
postela in north-western Spain, a forward station in the war
against the Muslim occupation of the Iberian peninsula. Not
only was Bernard the friend of popes and kings (Eugenius
had been a monk at Clairvaux, and the king's brother had
recently joined the Cistercians there), but his asceticism,
conviction and eloquence combined to make him the most
formidable spiritual figure of the age. At word that Bernard
would speak, such a crowd of aristocrats and admirers from
all over France was drawn to Vézelay that, as at Clermont
when Pope Urban had called for the First Crusade, the vast
basilica of St Mary Magdalene was not big enough to con-
tain the throng and a platform was erected in the fields out-
side the town.

Bernard's speech has not been handed down, but his let-
ters, which he circulated immediately afterwards, undoubt-
edly catch the passion and repeat the themes of what he said
that day. This was an age like no other, Bernard told the
crowd. God had found new ways to save the faithful. The
fall of Edessa was a gift from God. It was an opportunity

created by God to save men's souls. 'Look at the skill he is using to save you. Consider the depth of his love and be astonished, sinners. [...] This is a plan not made by man, but coming from heaven and proceeding from the heart of divine love.'[3] Amid the roars of 'Deus le volt!' so many came forward to take the cross that Bernard had to tear his own habit into strips. King Louis, who was beside him as he spoke, was the first among them, followed by his barons, many of whom were the sons and grandsons of original crusaders. Bernard was able to write a few days later to the pope: 'You ordered; I obeyed. I opened my mouth; I spoke; and at once the crusaders have multiplied to infinity. Villages and towns are now deserted. You will scarcely find one man for every seven women. Everywhere you see widows whose husbands are still alive.'[4]

Bernard broadcast his message farther, travelling into the north of France and to Flanders, and addressing a letter to the people of England, explaining that Jesus, the Son of God, was losing the land in which he had walked among men for more than thirty years. 'Your land', Bernard told the English, 'is well known to be rich in young and vigorous men. The world is full of their praises, and the renown of their courage is on the lips of all.' Do not miss this opportunity, he implored. 'Take up the sign of the Cross and you will find indulgence for all the sins which you humbly confess. The cost is small; the reward is great. Venture with devotion and the gain will be God's kingdom.'[5]

Among those who pledged themselves to the crusade were Louis' own wife, Eleanor of Aquitaine (whose uncle was Raymond of Antioch), several bishops and numerous nobles and knights from France, Flanders and England, and also a group of Templars led by Everard des Barres, master of the Knights Templar in France and future Grand Master. A year was then allowed for preparations and for advising foreign rulers of the approach of the crusade.

As news of the crusade spread among the populace of northern France and Germany, it touched off anti-Semitic pogroms, but nothing on the scale of the First Crusade, thanks largely to the efforts of Bernard, who hastened through France and along the Rhine to condemn the atrocities on the spot. 'The Jews', he said, 'are not to be persecuted, killed or even put to flight.' His reason for protecting Jews, however, was to throw into relief the triumph of Christian salvation. The Jews 'are living signs to us, representing the Lord's passion. For this reason they are dispersed into all regions, that now they may pay the just penalty of so great a crime, and that they may be witnesses of our redemption.'[6]

Redemption was the key to the Second Crusade. The First Crusade had successfully liberated great numbers of Christians in the East as well as the holy places from Muslim occupation. For all the emotional response to the fall of Edessa, the city was not a particularly holy spot in Western eyes, and all the rest of the Holy Land was still safely in the hands of the Franks. And so the purpose of the Second Crusade, from the very beginning, was not so much liberation of lands across the sea as redemption of Christians' souls. As Bernard himself expressed it, 'I call blessed the generation that can seize an opportunity of such rich indulgence as this, blessed to be alive in this year of jubilee, this year of God's choice. The blessing is spread throughout the whole world, and all the world is flocking to receive this badge of immortality.'[7] There was no doubt in Bernard's mind that the expedition would succeed, that God would perform miracles for its soldiers just as he had done for the heroes of the First Crusade. But this emphasis on redemption would mean that when the incomprehensible happened, when the Second Crusade failed, the fault could only be explained as a punishment from God for man's spiritual poverty and his sins.

To control and give direction to popular feeling along the Rhine, Bernard made a point of preaching the crusade to

the reluctant King Conrad III of Germany himself. Bernard had already asked the king in November 1146, but Conrad had flatly refused. Yet now a month later, on 27 December, Bernard was at the king's court, where during daily Mass he unexpectedly insisted on delivering a sermon, directing its final words to Conrad not as a king but as a man. Dramatically he presented Conrad standing in judgement before Christ, who enumerates all the king's pieces of good fortune: his wealth, wisdom, courage, his bodily vigour, and the kingship itself. And then Christ says to Conrad, 'O man, what is there that I should have done for you and did not do?' Shamed at his own ingratitude, Conrad cried out, 'I am ready to serve Him', and those with him cried out the same, whereupon Bernard gave the king the banner from the altar to lead his army to the Holy Land.[8] But Conrad's conversion to the crusade may not have been as sudden as it seemed. Diplomatic exchanges between Germany and Constantinople had been going on throughout 1146, ever since Manuel I Comnenus, the Byzantine emperor, had sent an emissary to Conrad imploring his help against the revived Turkish threat in the East. By the same route Conrad may also have received news of the second fall of Edessa on 3 November, confirming Bernard's warning that this was just a prelude to an attack on Jerusalem.

But the East was not the only objective of the crusade. In the spring of 1147 Eugenius gave his blessing to the campaign of Alfonso VII of Castile against the Muslim occupation of Spain, declaring it a crusade. In May crusaders from Flanders, Normandy and Germany joined Scottish and English crusaders at Dartmouth, from where they made for the Mediterranean, but during stormy weather they put in at Oporto, where they were told that the king of Portugal was warring against the Almoravids, a fundamentalist Berber dynasty that occupied all of southern Portugal and Spain, and that he had just laid siege to Lisbon farther down the coast. On

1 July the northerners joined the siege and on 24 October the city fell. Some of the crusaders remained in Portugal, but the others, after wintering there, continued their voyage to the East. The Second Crusade had rapidly become an international campaign against the forces of Islam on both the eastern and western fronts.

Owing to the destruction of the Templars' archives their earliest activities in Outremer are only very sketchily known, but perhaps that reflects a truth – that until the resurgent Turkish threat the Templars in the East were hardly more than a mounted police force for the protection of pilgrims and others on the roads. But the Templars had been fighting in the Iberian peninsula, and their numbers were strong in the adjacent recruiting ground of France. Certainly the importance of the Templars in the West can be measured by the fact that on 27 April 1147 King Louis VII and Pope Eugenius III came to the Paris Temple – which had become the European headquarters of the order – to discuss plans for the Second Crusade. Also in attendance were four archbishops and 130 Templar knights, with at least as many sergeants and squires.

This was in contrast to Templar numbers in the East. Between 1129, when Hugh of Payns returned from France to Jerusalem, and 1148, when the Second Crusade arrived in Outremer, only nine Templars are mentioned in the surviving charters of the crusader states: Robert of Craon, Grand Master of the order, and William, the order's senechal, and the brothers William Falco, Geoffrey Fulcher, Osto of St Omer and Ralph of Patingy, all based at Jerusalem, and Goscelin and Drogo at Antioch and Ralph Caslan at Tripoli. Another two can perhaps be added to this list: Odo of Montfaucon, whom William of Tyre recorded as dying in the skirmish near

Hebron in 1139, and Andrew of Montbard, probably an uncle of Bernard of Clairvaux, who mentions him in his letters. Set against these few, 210 Templars can be identified in the West during the same period. Possibly more written evidence of the Templars was lost in the East than in the West, but it is also true that the need for warrior Templars was greater in Spain and Portugal than in those early years of peace in Outremer. The Templars' power base was also in the West, the source of their wealth coming from tithes and grants of land and other donations, especially in Spain, France and England. Now the Templars were called on to project their energy and resources against the renewed Turkish aggression by joining the Second Crusade.

In Paris it was agreed that the Templars would accompany the French army to the East, and it was probably on this occasion that the pope conferred on the Templars the right to emblazon their white robes with the red cross. The pope also appointed the Templar treasurer to receive the tax that had been imposed on all Church goods to finance the crusade. It was the start of a fateful relationship that would last for over a century and a half, with the Paris Temple serving in effect as the treasury of France.

Everard des Barres, the master of the Temple in France, was sent ahead to Constantinople by King Louis to arrange with the Byzantine emperor Manuel I Comnenus for the passage of the French and German armies. Everything seemed set fair in September 1147, when Conrad's army arrived in Constantinople and was ferried across the Bosphorus, to be followed by Louis' army a month later.

The first disaster struck in late October. Conrad led his army on the direct route across Asia Minor and straight up against the border of Seljuk territory, where at Dorylaeum on

25 October the Germans were attacked by the Turks. Unlike the First Crusade, which had won a victory over the Seljuks at this same spot, the Germans were almost completely wiped out. The survivors, including Conrad himself, retreated to Nicaea, where they awaited the French and joined them in following the safer coastal route via Smyrna and Ephesus on the Aegean.

But the crusade had no sooner reached Ephesus than Conrad fell ill and returned with the remnants of his forces to Constantinople, while the French, inadequately provisioned by the Byzantines, marched up the Maeander valley and eastwards against the advancing winter. Toiling through the narrow defiles of the Cadmus mountains in early January 1148, the heavily armoured French knights were easy prey for the Seljuks' light cavalry, with their talent for firing off arrows at full gallop. Rumours spread among the French that Manuel was deliberately trying to weaken the crusade, fed by the knowledge that the Byzantines, who were at war with Roger II, the Norman king of Sicily, had recently agreed a treaty with the Seljuks to cover their backs. To the minds of many of those on the crusade this accommodation with the infidel seemed treacherous, and Louis himself sent letters back to France blaming the Byzantines for many of his problems.

With his army on the verge of disintegration, Louis surrendered his responsibilities to Everard des Barres, who divided the French forces into units of fifty, each under the command of a Templar knight whom they swore to obey absolutely. The Templars arranged the army into an organised formation which reined in knightly impetuosity and protected against Turkish attacks. To keep order in the ranks and not waste energy on fruitless pursuits, the army was taught to attack only when ordered to do so and to return from pursuits the moment the signal was given; also they were taught to maintain an order of march in which each man kept the

position given him. The archers on foot were drawn up at the rear to combat the Turkish bowmen, and nobles who had lost their horses and equipment joined this group. On this march through Asia Minor the Templars established the pattern that was to characterise the order's approach to battle; theirs would become the first institutionalised army in Western Christendom, permanent and disciplined in a way known until then only in the monasteries.

Thanks to the boldness and organisational skills of the Templars, towards the end of January the army was led to safety at Attalia (present-day Antalya) on the Mediterranean. But the Templars could only do so much; the ordeal of the French army was far from over, for the expected Byzantine fleet was too small to take them all to the Holy Land, and storms prevented the arrival of further vessels. Attalia was in Byzantine possession, but the Turks stood beyond its gates; the French were unable to obtain new horses or to pasture the ones they had. The town was crowded with the army; food became short, prices rose, disease set in. Finally Louis decided to embark with his barons on what ships were available, leaving the greater number of his army behind. There the French succumbed to plague or were killed when they tried to break out and march overland to Antioch.

When Louis arrived at St Simeon, the port for Antioch, early in March 1148, he and Eleanor of Aquitaine were warmly and grandly received by Prince Raymond of Antioch, who was Eleanor's uncle. Raymond had been one of the earliest to send messages to the West calling for aid against the mounting menace from the Turks, and for three years now he had been looking forward to the arrival of Louis' army. But Raymond's plan was not to recover Edessa, which had been thoroughly destroyed; rather, he counted on French support for

a campaign against Nur al-Din's strongholds of Aleppo and Shaizar. If these cities could be taken, it would alleviate the Turkish pressure against the northern boundaries of the crusader states. But Louis was not enthusiastic. His forces were depleted, and the cost of supplies and shipping had been so great that he needed to borrow if he was to continue with the crusade. Despatching Everard des Barres to Acre, where he raised enough money from Templar resources to cover the cost of the French expedition – a sum that was more than half the annual tax revenue of the French state – Louis had no immediate thought other than to journey as a pilgrim to Jerusalem.

Finances and piety may have been sufficient for Louis to turn his back on Raymond's plans and hasten to Jerusalem. But Eleanor of Aquitaine may have been another reason. Raymond had been entertaining his lively young niece with the pleasures and diversions of Antioch. Flamboyant, handsome and cosmopolitan, Raymond was everything that Eleanor's husband Louis was not. Casting a willing spell upon her, Raymond drew her into his schemes for capturing Aleppo and Shaizar, and also, so the rumours grew, drew her into a passionate and incestuous affair. When Louis rejected Raymond's Aleppo campaign and announced he would go to Jerusalem instead, Eleanor refused to go and said she would have their marriage annulled on the grounds of consanguinity, of all things (she and Louis were fourth cousins, once removed), to which Louis replied by seizing his wife at her uncle's palace and taking her by force to Jerusalem.

William of Tyre called Eleanor of Aquitaine a fatuous woman – not that he ever met her when she came to Outremer, as he was studying at Paris and Bologna at the time. Other accounts suggest she was strong-willed and outspoken, and

more intelligent than her husband, and that her argument with Louis at Antioch had as much to do with politics and strategy as with a dalliance with her uncle. Eleanor did eventually divorce Louis when the crusade was over and married Henry Plantagenet, duke of Normandy and count of Anjou, her cousin in the third degree and nine years younger. He soon became Henry II, king of England, and to him she bore five sons, three of them future kings of England, among them Richard the Lionheart, the great challenger of Saladin during the Third Crusade. As duchess of Aquitaine in her own right, she was one of the wealthiest and most influential women in Europe; as queen first of France and then of England, she acted as the patron of troubadours and poets. The earliest epic poetry centring on King Arthur and his Round Table emerged at Eleanor's court. An exciting and passionate woman, her presence lies behind two of the greatest stories to come out of the Middle Ages: the legend of the Holy Grail and the romance of the Knights Templar.

Although the first mention of the Templars in literature came in about 1220, in *Parzival*, by the German knight and poet Wolfram von Eschenbach, its origins can be traced back to Eleanor of Aquitaine. Eschenbach based his work on Chrétien des Troyes' romance *Perceval, The Story of the Grail*, begun in 1181 and left unfinished at his death in 1190. Chrétien's association with Troyes is significant: it was the capital of the counts of Champagne who played an important role in the founding of the Templars and also in promoting their great champion Bernard of Clairvaux. Certainly Troyes represented a link with the East through Chrétien's patroness, the countess Marie of Champagne, who was the daughter of Eleanor of Aquitaine, the adventurous queen who had risked the hazards of travelling to the East with the Second Crusade and had stories to tell.

Bernard of Clairvaux, like William of Tyre, did not much approve of the free-spirited Eleanor, whom he found flighty

and indecorous. But for a poet she made good copy, and it is not hard to imagine her inspiring Chrétien when he invented the character of Guinevere in his earlier work *Lancelot, the Knight of the Cart*, which he wrote specifically at Marie's request.

The Grail was invented in the late twelfth century by Chrétien de Troyes: no mention of a Grail had ever been made before. Curiously, there was nothing explicitly religious about Chrétien's Grail; he did not write about it as the cup or chalice at the Last Supper. For that matter he did not describe it as a cup or chalice at all, but rather as a serving dish, which is the usual and original meaning of the Old French word *graal*. But there is something wonderful about the Grail's first appearance in the pages of Chrétien's story at the beginning of a rich man's feast, and all the more wonderful and strange because Chrétien never finished his story. This is how it makes its first appearance on the page.

> Then two other squires entered holding in their hands candelabra of pure gold, crafted with enamel inlays. The young men carrying the candelabra were extremely handsome. In each of the candelabra there were at least ten candles burning. A maiden accompanying the two young men was carrying a grail with her two hands; she was beautiful, noble, and richly attired. After she had entered the hall carrying the grail the room was so brightly illumined that the candles lost their brilliance like stars and the moon when the sun rises.[9]

What is tantalising about this appearance of the Grail is that Perceval, the hero of the romance, knows exactly what it is, but he fails to tell us before the story breaks off (when Chrétien dies). Is the story allegorical? People have argued over that point for more than eight hundred years. And if allegorical, is the allegory religious? That too has never been

resolved. But this haunting image was soon inspiring writers to complete the tale – among them Wolfram von Eschenbach, who in *Parzival*, his thirteenth-century German adaptation, introduced the Knights Templar to literature by making them guardians of the Grail.

Chrétien de Troyes was writing when medieval Western society was opening onto a wider world, the world of the Mediterranean, the world of the East, to worlds of ideas and beliefs that it was discovering or rediscovering, not least on account of the crusades. Writing about the Grail meant writing about this cultural and spiritual quest, and yet, strangely, it has been a genre, regardless of its religious overtones, that has always belonged to secular writers, never to the Church. William of Tyre and Bernard of Clairvaux would most certainly have disapproved – as they disapproved of Eleanor of Aquitaine. But free from doctrine and canon, the Grail and the story of Guinevere, her lovers and her knights, have been endlessly reinvented down to the present time.

Despite the French losses in Asia Minor, the crusading forces that finally assembled in Outremer were far from negligible. The French forces were augmented by the late arrival of crusaders from Provence; the crusading fleet that had helped take Lisbon had also arrived, and added to these were the survivors of the German army, which had arrived by sea from Constantinople with Conrad. In fact, this was the largest army deployed by the Franks in the East since the First Crusade.

On 24 June 1148 the lords and military leaders then in Outremer attended a great council at Acre. King Fulk had died in a hunting accident in 1143, and Baldwin III, his seventeen-year-old son by Melisende, presided over the gathering, which included the kings of France and England, the

Hospitallers and the Templars, and the barons and lead-
ing clergy of the kingdom of Jerusalem. Not surprisingly
Melisende, with her Armenian ancestry and sympathies, sup-
ported Raymond of Antioch's plan to strike at Aleppo, Nur
al-Din's base in northern Syria astride the route to Edessa,
and her general Mannassas agreed. Nor was it a matter of
sentiment; despite William of Tyre's dismissal of the fighting
abilities of Edessa's merchant class, the Armenian popula-
tion of the county of Edessa had provided many of the best
auxiliaries to the Frankish forces, and the loss of this recruit-
ing ground was serious; and although Edessa itself was now
ruinous, the capture of Aleppo would extend the north-east-
ern borders of Outremer against the Turks, perhaps hold-
ing them back beyond the Euphrates. But Louis remained
adamantly opposed to Raymond's plan.

Others spoke of Egypt as an objective, but the road south
was blocked by Ascalon, still in the hands of the Fatimids
and powerfully fortified. The third possibility was Damas-
cus, which, though a sometime ally of the Franks, had long
before King Baldwin II's expedition of 1129 attracted the
attention of the Franks. For the states of Outremer, peril-
ously clinging to the Mediterranean seaboard, it was always
a strategic necessity to extend their depth, to conquer
Aleppo, Damascus or Cairo. Damascus was a venerable and
wealthy city whose capture would give the Franks control
over the crossroads of commerce and communications in
the East, and would separate the Muslim forces in northern
Syria and Iraq from those in Egypt, while the vastness of
the desert opening up eastwards beyond Damascus would
provide the Frankish states with a natural frontier. The cap-
ture of either Damascus or Aleppo offered similar strategic
advantages, but Damascus was nearer, provided greater
defence for Jerusalem, would be easier to hold – and in hav-
ing biblical associations, which Aleppo did not, Damascus
was a more appealing cause for the crusaders from the West.

As William of Tyre wrote, quoting Isaiah 7:8: 'Damascus is the largest city of lesser Syria and is its metropolis, for as it is said, "Damascus is the head of Syria".'[10] If there was an argument that going to war against Damascus would drive it into the arms of Nur al-Din, the answer was that Damascus was already moving in that direction without Frankish help. Since Zengi had demonstrated his destructive powers at Edessa, Muin al-Din Unur, the atabeg of Damascus, had warmed to Nur al-Din, to whom he had married off his daughter; the growing might of Zengi and Nur al-Din and the propaganda of jihad ensured that Damascus was no longer the ally of the Franks it had once been. After vigorous discussion of the various plans of action the assembly came to 'a unanimous decision'.[11] King Louis was in favour, Conrad was in favour, Baldwin was in favour, the barony of Outremer was in favour, and the Templars were in favour of an expedition against Damascus.

The army of the Second Crusade, the largest assembled in Outremer since 1099, some fifty thousand cavalry and infantry according to Ibn al-Qalanisi, an Arab chronicler who was an eyewitness,[12] marched out from Galilee for Damascus in late July 1148. The army camped in a well-supplied position amid orchards and fresh-flowing water in front of the western walls and prepared for the siege. But the orchards also served detachments of Damascenes, who used their cover to make repeated sorties against the crusaders. Louis and Conrad responded by switching their attack to the eastern walls, where there was open ground and they could deploy their heavy cavalry to greater effect. But the city walls were higher on this waterless desert side, and the siege dragged on as meanwhile Turkish cavalry and infantry from elsewhere in Syria made their way towards Damascus. 'News reached the

Franks from many sources that the Muslims were bearing down on them to attack them and wipe them out,' wrote Ibn al-Qalanisi, 'and they felt that their defeat was certain. They consulted among themselves, and decided that the only escape from the trap or abyss that loomed ahead of them was to take flight.' At dawn after only four days they retreated in 'miserable confusion and disorder', pursued by the Turks, who showered them with arrows and killed many of their rearguard and their horses and pack animals as well. 'Innumerable corpses of men and their splendid mounts were found in their bivouacs and along the route of their flight, the bodies stinking so powerfully that the birds almost fell out of the sky.' Without even fighting a battle the Second Crusade was defeated, ending in a whimpering fiasco and adding to the Muslim conviction, arising after Edessa, that the Franks could be beaten. 'This gracious sign of God's favour brought rejoicing to Muslim hearts, and they gave thanks to the Most High for hearing the prayers raised unceasingly to Him in the days of their distress. For which let God be praised and blessed!'[13] Six years later Damascus fell to Nur al-Din, and the encirclement of Outremer by a united Muslim power began.

The withdrawal from Damascus caused a bitterness in relations between Outremer and the West that lasted for a generation. Seen from the perspective of the East, kings Louis and Conrad had neither recovered Edessa nor offset its loss by taking Damascus or anything else; indeed, their bungling placed Outremer in greater peril than before the crusade began.

In the West the failure of the crusade came as a shock and turned large numbers of Western Europeans against the whole notion of crusading; both the papacy and the West as a

whole had suffered a setback. In the event the Second Crusade was destined to be the last crusade in which the armies were accompanied by large groups of pilgrims and other non-combatants. In future the crusades would be more strictly military expeditions, like the successful campaigns in Portugal and Spain. The shock was all the greater because the crusade had been led by the powerful kings of Germany and France and had been preached by Bernard of Clairvaux, the outstanding spiritual figure of the age. Some blamed the Franks of the East, supposedly corrupted for previously having been in alliance with the ruler of Damascus. Some German chroniclers, anxious to protect Conrad, blamed the Templars, saying that they had deliberately engineered the retreat; indeed Conrad himself, without naming names, wrote that 'from a source we did not suspect treachery arrived, for "they" assured us that that side of the city could not be taken. They purposely led us to another side where there was no water for the army and no obvious access';[14] while the anonymous Würzburg chronicler wrote of Templar greed, and of betrayal by taking a massive bribe. The French blamed the Byzantines for letting down the crusaders as they crossed Asia Minor, and Louis felt 'betrayed and deceived' at Damascus, wrote John of Salisbury, who may have heard the words at first hand; he was resident at the papal court when Louis visited the pope on his return from Outremer. 'Some impute the treachery to the Templars, others to those who were moved by a desire to return home: certainly the king himself always endeavoured to exonerate the brothers of the Temple'[15] – which stands to reason, as it was the Templars who had supported the French expedition throughout. As John of Salisbury makes clear after hearing Louis' account, it was Conrad himself who early on lent his weight to those who wanted to abandon the siege, and Louis went along with it only later and reluctantly. While there is a strong case for royal bumbling, there is no evidence at all of Templar treachery.

In reality the notion of treachery was born out of incomprehension. The crusade had been undertaken to achieve redemption; it had been guided by God, so how could it fail? No one was more disappointed than Bernard, who would be made a saint within twenty years of his death. The question that he and all Europe asked was, why? Why would God call his knights to the Holy Land to be butchered by the infidels? Why would he bring blame and dishonour on kings attempting to do his will? Bernard's answer was that the armies of Christendom had failed because of the sins of Europe. The fault was not his nor the pope's; rather, it was that of every man and woman in Europe who had to cleanse themselves of sin. If the crusades were to succeed, then Europe must purify itself.

The need for moral regeneration had been a theme of the papacy and monastic reformers since at least the mid-eleventh century, as well as proponents of the First and Second Crusades; it was also a chief attraction of the order of the Templars, which offered young knights the chance to seek salvation within a monastic order without turning their backs on a life of action. In this the Templars and the spiritual mood in Europe were at one.

PART IV

The Templars and the Defence of Outremer

*W*HILE THE KINGS *of Germany and France blamed others for their failure at Damascus, and St Bernard blamed Europe for its sins, the burden of dealing with the Turkish threat fell squarely on the Franks of Outremer, particularly on the military orders, and most especially on the Templars. From the 1160s onwards, when it became clear that Outremer could not fight wars on several fronts at once, the call went out again and again to Europe for support in the form of manpower, finance and supplies, made necessary to defend against the almost limitless resources of the Turks, which they were able to draw from the vast areas of their conquests.*

The problem was that the more the Franks of Outremer relied on Western subsidy and military aid, the more critical the West became if things went wrong; the enthusiasm was there, but defeat could mean a high

price, not least in the morale of the West and the sense of having failed in God's eyes.

Bernard of Clairvaux described the Templars as men whose bodies were protected by iron and whose souls were clothed in the breastplate of faith. Certainly the moral and spiritual strength of the Templars, let alone their ferocity in battle, was tested to the extreme as the jihads of Nur al-Din and then Saladin closed the ring round Outremer.

But meanwhile in Jerusalem the Turks still seemed far off. Confidence and optimism were greater than any sense of threat or doom, and Jerusalem celebrated its rebirth as the great goal of Christian pilgrimage with a series of remarkable building works.

14

The View from the Temple Mount

THE KINGS of France and Germany had sailed for home, and the Second Crusade was over when, late in 1149, Andrew of Montbard, the seneschal of the Temple, wrote to Everard des Barres, who had been raised to Grand Master of the Templars earlier that year but had since travelled back to Europe with Louis to rouse fresh support for Outremer. 'After you left us our sins were such that they caused us to lose the prince of Antioch, killed in a battle with all his barons and men'. Nur al-Din had laid siege to the fortress of Inab, north of Antioch, on 29 June 1149, and Prince Raymond, the uncle of Eleanor of Aquitaine, had ridden to its defence with a small mounted force of Franks and their allies the Assassins.

Raymond's boldness almost worked; believing that they were part of a much larger army, Nur al-Din at first retreated, but when he realised the truth he attacked. Greatly outnumbered, Raymond's force was destroyed, Raymond himself was killed, and Antioch lay open to capture by the Turks. The situation was only saved, as Andrew of Montbard explained, by the rapid action of the Templars. 'Our brothers joined up with the King of Jerusalem to go to the immediate help of Antioch, forming an army of 120 knights and up

to a thousand well-armed squires and sergeants', and now they were holding the city against the enemy, but 'many of those who were in our army are dead [...] No matter how quickly you come we do not think you will find us alive, but come without delay; that is our wish, our message and our request.' Calling on Everard des Barres to return to Outremer with knights, sergeants, arms and money, Andrew of Montbard concluded, 'Although we understand that you will not arrive very soon, come nevertheless. It is time for us to honour our vows to God, that is sacrifice our souls for our brothers and for the defence of the Eastern Church and the Holy Sepulchre.'[1]

In the event the bravery and tenacity of the Templars saved Antioch from Nur al-Din, and in 1153 the Templars played a leading role in taking Ascalon from the Fatimids. There were voices in the West who said that without the Templars Jerusalem and all Palestine might have fallen to the Turks. Where kings and nobles gave uncertain leadership, the Templars were disciplined, experienced and determined; and they were ready to shed the last drop of their blood for the defence of the Holy Land. As it was, until the 1160s the inhabitants of the kingdom of Jerusalem were far distant from the war with the Turks. But the crisis remained as Nur al-Din continued to harass and penetrate the northern parts of Outremer, hacking away at the principality of Antioch and even making raids into the county of Tripoli.

Like his father, Zengi, before him, Nur al-Din armed himself with the cry of jihad. His triumph over the Franks at Inab, complete with the death of Prince Raymond of Antioch on the field of battle, was pumped for all it was worth. Throughout his domains Nur al-Din encouraged the founding of new mosques and madrasas where preachers, poets and teachers whipped up popular feeling and gave it unity and direction – but although the poet Ibn Munir urged Nur al-Din to fight against the Franks 'until you see

Jesus fleeing Jerusalem',[2] the force of Nur al-Din's jihad was not so much against the Franks as against Shia Muslims in Aleppo, whose co-religionists, in the form of the Assassins, had sided with Raymond against the Turks; conformity in the form of Sunni Islam was imposed. But Nur al-Din also directed his jihad against Sunni Damascus, denouncing it for the injury it had done to the cause of Islam through its alliances with the Franks. In time Nur al-Din would turn his jihad propaganda against the Fatimids in Egypt too; like the Assassins, they were Ismailis, a dualist branch of Shia Islam, but most importantly, and like Damascus, their crime was that they stood in the way of his determination to make the Muslims of the Middle East subject to his rule. Whatever the degree of personal ambition and political cynicism behind Nur al-Din's cry of jihad, over the years to come it would be used to create a growing sense of unity and even exaltation among Muslims and would justify in their eyes their attempt to impose themselves once again on the unwilling and over-whelmingly Christian population of Outremer.[3] Meanwhile Nur al-Din was content with a symbolic gesture against the Franks; he sent the skull of Prince Raymond of Antioch set in a silver case to his impotent religious overlord the caliph at Baghdad.

The conflict had now reached a new stage. Unlike the Muslim conquests, the crusades were not a drive for world mastery but a limited endeavour with specific objectives. The Franks had pushed the Turks back, had liberated the Christians of the East from an alien yoke, had recovered the holy places and had created self-ruling Christian states. The kings of Jerusalem, the counts of Edessa and Tripoli, the princes of Antioch were not attempting to implement a universal vision; rather, they were typical feudal lords, eager to protect and develop their possessions in alliance with native Christians for whom the Turks were the common enemy. There was no grand plan, nor after the Second Crusade was there

much zeal for holy war. The Turks, on the other hand, were transforming the Franco-Turkish conflict into a clash of civilisations, a war of Islam against Christianity. By uniting the Muslim world under their control the Turks were not only applying increased pressure against the Christian East; they were also turning the conflict into what it had been, under the Arabs, a renewed venture of Islamic imperialism. Throughout the twelfth century the Turks continued to press against the newly recovered Christian lands with all the gathering force of their great migration; again and again the Frankish chroniclers described the limitless hordes the enemy had at their disposal. Eventually the bewildering Turkish numbers would overwhelm the Frankish settlers in Outremer and all but destroy native Christian society as the Turks had begun doing in Asia Minor. But that time had not yet come.

Despite the setback at Damascus and the threat of Nur al-Din, as Outremer entered its third generation the mood in Jerusalem was confident and expansive. The city walls were repaired, new markets were constructed and many small churches were built to replace those destroyed during Muslim rule. The population increased to about thirty thousand, comparable to Florence or London, and was remarkably diverse. John of Würzburg remarked that the city was filled with 'Greeks, Bulgarians, Latins, Germans, Hungarians, Scots, Navarrese, Bretons, English, Franks, Ruthenians, Bohemians, Georgians, Armenians, Jacobites, Syrians, Nestorians, Indians, Egyptians, Copts, Capheturici, Maronites and very many others'. [4] The Franks were bare-headed and clean shaven, the Greeks wore their beards long and the Syrians trimmed theirs; the fashion was for pointed lace-up shoes, and in season men and women wore furs. The pilgrimage was the most important factor in the revitalisation of

Jerusalem, a revival owed principally to the military orders, to the Hospitallers who provided care and lodging for travellers and to the Templars who made the roads safe for pilgrims. Their costumes contributed to the varied scene, the Templars wearing unadorned white-hooded mantles bearing a red cross at the left breast, while the Hospitallers' mantle was black and their cross white; both wore boots instead of fancy shoes. Nothing more expressed the energy and celebration of the times than the remarkable burst of architectural activity at the Church of the Holy Sepulchre, at the Hospital of the Knights of St John and, above all, at the headquarters of the Templars atop the Temple Mount.

The vast Church of the Holy Sepulchre built by the emperor Constantine in the early fourth century had suffered numerous attacks, first by the Persians in 614 and later, several times, under Muslim rule. Each time the Rotunda rising above the tomb of Jesus was restored, and also the great basilica extending to the east, though in less imposing form. But when the Fatimid caliph al-Hakim ordered the total destruction of the church in 1009, the basilica was obliterated, the tomb of Jesus was hacked to smithereens, and the Rotunda was reduced to such a pile of rubble that any restoration was beyond the means of the impoverished and oppressed Christian community for many years. Christians had to count themselves fortunate, after al-Hakim's death, to be allowed to worship even among the ruins. But thanks to funds from the Byzantine emperor the rebuilding of the church commenced, though on a reduced scale, and was focused exclusively on the Rotunda, which was completed by 1047. And so in July 1099, when the crusaders went in thanksgiving to the spiritual heart of Christendom, they found the rebuilt Rotunda with several apses set about it, and across an open court to the east the chapel of Golgotha marking the site of Jesus' crucifixion, in all about a quarter in extent of Constantine's original church.

As a matter of prestige as well as needing to cater to the great flow of pilgrims to Jerusalem, the Franks desired to build a new fine church on the ruins of the old basilica, although several decades passed before they had the wherewithal to do so. The moment came during the reigns of King Fulk, Queen Melisende and their son Baldwin III, who were the primary patrons of the Church of the Holy Sepulchre; this was the same moment as Zengi was destroying Edessa and Nur al-Din was menacing Antioch, yet Jerusalem felt secure. In 1149 the Franks dedicated new chapels decorated with mosaics on the fissured stone outcrop sanctified as Golgotha, and by 1153 they had built the new five-storey bell tower adjacent to the magnificent entrance façade, built in Romanesque style and decorated with local Eastern motifs. Also in Romanesque style similar to the great cathedrals built along the pilgrimage route across France and into Spain – Tours, Limoges, Conques, Toulouse and Santiago de Compostela itself – the Franks began their replacement for Constantine's basilica in the 1130s, finishing it in the 1160s.

But the limited space available between the Rotunda and the chapels to the east marking various holy sites meant building to a unique plan. The nave was dispensed with, and instead the choir was built almost immediately east of the Rotunda, the two separated by a broad-aisled transept which served as a substitute nave. An ambulatory encircled the choir and was marked by the numerous chapels all the way round, allowing pilgrims in great numbers to circulate freely through the church and pause at the chapels for their prayers. The penultimate stop was Golgotha, where pilgrims left the crosses they had carried with them throughout their pilgrimage from home; then finally they prayed at the empty tomb of Christ at the centre of the Rotunda, the most important shrine of the Christian faith. Except for some depredations by Saladin and his successors, this is essentially the church one sees today.

At the same time as work was under way on the Church of the Holy Sepulchre the Hospitallers were building their new Hospital directly opposite, immediately to the south. Moreover, according to William of Tyre, it was 'far higher and more costly than the church which had been consecrated by the precious blood of our Saviour'. Like the Templars, the Hospitallers were answerable to no one but the pope, and at Jerusalem, although their Hospital was located in the Patriarch's Quarter, they maintained a strict autonomy which led to friction and eventually a rowdy dispute during which the Knights of St John rang all their bells to annoy the patriarch when he gave a sermon in the Church of the Holy Sepulchre. 'Whenever the lord patriarch went up to speak to the people, according to custom, from the place where the Saviour of mankind hung for our salvation', wrote William of Tyre, 'they endeavoured to hinder the celebration of the office entrusted to him. With intentional malice they set their many great bells ringing so loudly and persistently that the voice of the patriarch could not rise above the din, nor could the people, in spite of all his efforts, hear him.'5

Yet despite this behaviour the Hospitallers were well regarded – principally for their charitable works in the city. John of Würzburg, who visited Jerusalem in about 1165, described the Hospital 'in which are gathered in various rooms a huge number of sick people, both men and women, who are cared for and refreshed daily at very great expense'. Two thousand people were looked after by the Hospital at the time of his visit, he said, and it 'also sustains with its food as many people outside as inside', quite apart from manning castles 'for the defence of the land of the Christians against the incursions of the Saracens'.6

In writing about the Hospitallers, John of Würzburg made a significant comparison between them and the Templars, who also gave 'a considerable amount of alms to the poor in Christ, but not a tenth part of that which is done

by the Hospitallers'.[7] A succinct explanation for this came from Jacques de Molay, the last Templar Grand Master, in a memorandum from 1305: 'The Hospitallers were founded to care for the sick, and beyond that they bear arms [...] whereas the Templars were founded specifically for military service.'[8] Whereas the Hospitallers had grown out of a break-away group of Benedictine monks and continued to include sisters in their ranks, the Templars began as a company of secular knights. Initiates to both orders swore to be 'serf and slave', but for the Hospitallers that meant to the sick, while a Templar swore to be serf and slave to the order itself. For the Templars the defence of Outremer was their overriding priority, to which they gave their resources and their lives; for the Hospitallers warfare was an extension of their service to the sick and poor, and they correspondingly gave less of their resources to castle-building and military activities. As it happened, the Templars were much more representative of medieval society than the Hospitallers; membership of the Templars was open to everyone, from the richest noble to the poorest peasant, but they also drew a sharp distinction between their sergeants and their knights; unlike the Hospitallers, the Templars bestowed on their knights an elevated aura as a fighting elite, which set them apart. But the Hospitallers, in dividing their services between warfare and charitable services, kept one foot in the changing currents of medieval society, and that would help them to survive. The raison d'être for the Templars was to fight for the Holy Land, and if that battle was ever lost, the Templars too would fall.

Today nothing of the Hospital in Jerusalem survives – only the name, Muristan, meaning 'hospital', which is now applied to the late nineteenth-century Ottoman market that fills its place. After Saladin's conquest of Jerusalem in 1187 various parts of the Hospital were converted into mosques and an Islamic college. By 1868 it was a heap of ruins. Nor does much evidence survive of the Templars after Saladin's

'purification' of the Temple Mount – mostly fragments built into the Aqsa mosque and the Dome of the Rock, testimony to a workshop that stood at the southern end of the Mount, where a large quantity of exceptionally beautiful architectural sculpture was produced in a unique synthesis of Byzantine, Western European and Levantine styles.

But in the decades following the Second Crusade visitors to the Temple Mount were impressed with how it was being developed by the Templars. After prayers at the Church of the Holy Sepulchre, with its chapels associated with the crucifixion and burial of Jesus and the discovery of the True Cross, pilgrims walked to the Temple Mount, entering through the western gate near the south side of the Dome of the Rock, the Templum Domini, or Temple of the Lord, a church which, like the Holy Sepulchre, was under the guardianship of the Augustinian order. On the outer court the Augustinian canons and the Templars had built houses and planted gardens.

According to Theoderich, a German pilgrim who wrote about his visit to the Holy Land in 1172, the Temple of the Lord bore an inscription that read 'The house of the Lord is well built upon a firm rock', but as pilgrims were in the habit of chipping away bits of the holy rock, its surface had to be paved with marble and it was cordoned off by a tall and beautifully worked wrought-iron screen which was put up between the encircling columns. By choosing to identify the Dome of the Rock and also the Aqsa mosque with Solomon's Temple and palace, the Franks incorporated them into the biblical heritage of Christianity; rather than destroy them, they preserved them by turning them to Christian use.

From the Temple of the Lord, continued Theoderich, the pilgrims made their way south to the Templar headquarters at the Aqsa mosque, or rather what he called the Palace of Solomon,

which is oblong, and supported by columns within like a church, and at the end is round like a sanctuary and covered by a great round dome. This building, with all its appurtenances, has passed into the hands of the Knights Templar, who dwell in it and in the other buildings connected with it, having many magazines of arms, clothing, and food in it, and are ever on the watch to guard and protect the country. They have below them stables for horses built by King Solomon himself in the days of old, adjoining the palace, a wondrous and intricate building resting on piers and containing an endless complication of arches and vaults, which stable, we declare, according to our reckoning, could take in ten thousand horses with their grooms. No man could send an arrow from one end of their building to the other, either lengthways or crossways, at one shot with a Balearic bow. Above, it abounds with rooms, solar chambers, and buildings suitable for all manner of uses. Those who walk upon the roof of it find an abundance of gardens, courtyards, ante-chambers, vestibules and rain-water cisterns; while down below it contains a wonderful number of baths, storehouses, granaries, and magazines for the storage of wood and other needful provisions.

Clearly the Templars had considerably renovated what had been a truncated and dilapidated building. But they were doing far more.

On another side of the palace, that is to say on the western side, the Templars have erected a new building. I could give the measurements of its height, length, and breadth of its cellars, refectories, staircases, and roof, rising with a high pitch, unlike the flat roofs of that country; but even if I did so, my

hearers would hardly be able to believe me. They have built a new cloister there in addition to the old one which they had in another part of the building. Moreover, they are laying the foundations of a new church of wonderful size and workmanship in this place, by the side of the great court.[9]

The Templars had grandly transformed the southern part of the Temple Mount into the combined administrative, military and religious headquarters of their order, with a vast stable underneath. The Temple Mount was the nerve centre of the entire Templar order, not only for Outremer but for Europe too. France, England, Aragon, Poitou, Portugal, Apulia and Hungary each had a provincial master, who was responsible to the Grand Master. But the Grand Master, although he had considerable powers, did not rule as an autocrat. All major decisions taken by the Grand Master, such as whether to go to war, agree a truce, alienate lands or acquire a castle, required that he consult with the Grand Chapter, which was comprised of senior officials.

The Grand Master, who was elected by twelve senior members of the order, had his chambers here and was attended by his entourage, which included a chaplain, two knights, a clerk, a sergeant and a Muslim scribe to act as an interpreter, as well as servants and a cook. The Seneschal, the Marshal, the Draper and the Commander of the kingdom of Jerusalem were also here along with their attendants. The Seneschal was deputy and adviser to the Grand Master. The Draper was keeper of the robes; he also issued clothes and bed linen, removed items from knights who were thought to have too much and distributed gifts made to the order. The Marshal was responsible for military decisions, such as the purchase of equipment and horses, and he exercised authority over the regional commanders. These were the Commander of the Kingdom of Jerusalem, who acted as the order's treasurer and within the kingdom had the same powers as the Grand

Master; the Commander of Jerusalem, who within the city had the same powers as the Grand Master; and the commanders of Acre, Tripoli and Antioch, each with the powers of the Grand Master within their domains. In addition there were about three hundred Templar knights and a thousand sergeants on active service in the kingdom of Jerusalem, as well as the native light cavalry, called Turcopoles, who were employed by the order, and numerous auxiliaries, including grooms, blacksmiths, armourers and stonemasons, and many of these would have been quartered on the Temple Mount.

The Temple Mount was a busy place. Yet at its heart it was as silent as any monastery, for the Templars followed the canonical hours like any Cistercian or Benedictine monk, and otherwise caring for their horses. The so-called Stables of Solomon were, in fact, a substructure of vaults and arches built by Herod to extend the platform of the Mount, and later reconstruction work was undertaken by the Umayyads and the Templars. The Templars indeed used this as a stable, but Theoderich's claim that ten thousand horses could be stabled beneath the Mount is an exaggeration; other travellers estimated the capacity at about two thousand horses, and allowing space for squires, grooms and perhaps even pilgrims sleeping there, the number of horses stabled at any one time was more like five hundred. A gate constructed by the Templars in the southern wall of the Temple Mount gave direct access to their headquarters and to the stables.

These warrior monks were a powerful force in the Holy Land, whose defence since the Second Crusade fell increasingly on their shoulders. Vassals under the feudal system produced no more than 1,000 knights throughout the whole of Outremer, although the king of Jerusalem did have sufficient resources to hire mercenaries. Nevertheless, by the 1170s the Templars alone had 300 knights and another 1,000 sergeants based at Jerusalem, and a similar number distributed among Tripoli, Antioch, Tortosa and Baghras: in other words 600

knights and 2,000 sergeants in all. When the Hospitallers were included, the military orders provided the greater part of the military prowess of the Frankish states in the East.[10]

Far from being fanatics forever in search of battle with the infidel, as sometimes they are portrayed, the Templars were pragmatic and conservative in their approach to politics and warfare – if anything, more so than the counts and kings of Outremer, who were driven by personal and dynastic ambitions in the here and now. In becoming a Knight Templar each man surrendered his will to the order, as in the words of one recruit: 'I, renouncing secular life and its pomp, relinquishing everything, give myself to the Lord God and to the knighthood of the Temple of Solomon of Jerusalem, that, as long as I shall live, in accordance with my strength, I shall serve there a complete pauper for God.'[11]

Self-will was replaced with service to the order and its aims, and the Templars were playing a long game, dedicated to defending the Holy Land for all time. In any case, conflict in the Middle Ages tended to be more about sieges of cities and castles than battle in the open field, which was unpredictable and risky even under the most favourable circumstances. And in Outremer patience had its rewards, as it was usually only a matter of time before the uneasy Muslim coalitions against the Christians fell apart. And so it was with confidence that the Templars looked out from their headquarters atop the Temple Mount upon Jerusalem and the future that lay beyond.

The Defence of Outremer

S INCE THE DEATH of King Fulk in 1143, his wife and
co-ruler, Melisende, had been ruling the kingdom of
Jerusalem both in her own right and as regent for their son
Baldwin III. In this she had the support of the Templars,
owing to the boy's age, but in 1150, by when he had long
since achieved his majority, Baldwin demanded the right to
rule as joint monarch with his mother. Tensions grew during
the next two years as factions of the nobility backed Baldwin
or Melisende, and there were fears of civil war, but the mat-
ter was decided in 1152, when Baldwin made a convincing
show of force and his mother was retired to Nablus. There
is evidence that suggests the Templars may have supported
Melisende to the last, but if so, they suffered no breach with
Baldwin; although answerable to no one but the pope, the
Templars were always strong supporters of whoever wore
the crown at Jerusalem. In any case two years later, in 1152,
Melisende and Baldwin were reconciled and, although still
ensconced at Nablus, which she had been allowed to hold
for life, Melisende continued to exercise influence at court,
where her experience was valued and she also acted as Bald-
win's regent when he was away on campaigns.

Baldwin III's first major campaign was against Ascalon,

to which he laid siege in January 1153. Garrisoned by the Fatimids of Egypt, Ascalon was the last Muslim outpost along the Palestinian coast and had served as a base for raids against the kingdom of Jerusalem and acts of piracy at sea. But although Fatimid Egypt had been weakening, Ascalon was powerfully fortified, and the siege wore on well into the summer, the city finally falling only in August. The booty was enormous, and the Christian recovery of Palestine was complete. The Templars played a prominent part in this triumph, for they were first into the breach when a section of the walls came down, yet William of Tyre was predictable in turning this against them when he claimed in his chronicle that their eagerness was due to their greed for spoils, a theme he was to develop and which was taken up by others. William of Tyre's resentment towards the Templars arose from their independence, as an order responsible only to the pope and otherwise operating outside all jurisdiction of church or state. As a churchman himself, and frustrated in his ambition to become patriarch of Jerusalem, he rarely failed to find low motives underlying the Templars' successes, a view that in time would find broader support. In fact, at Ascalon there was no Templar greed, rather a great sacrifice; they lost forty or so knights in the attack, and their Grand Master lost his life.

Baldwin's siege of Ascalon would prove to have a price. Almost immediately after the failed siege of Damascus by the Second Crusade, its atabeg, Muin al-Din Unur, renewed his old alliance with Jerusalem; it was a matter of practical politics in the face of his greater enemy Nur al-Din. But in 1149 Muin al-Din Unur died; under his successor Mujin al-Din Ibn al-Sufi, Damascus suffered several attacks and sieges by Nur al-Din. In a desperate effort to maintain the

independence of the city, Mujin al-Din on the one hand rec-
ognised the suzerainty of Nur al-Din but on the other hand
maintained the alliance with Jerusalem. Meanwhile Nur al-
Din's jihad propaganda was having an effect on the Muslims
of the city. Christians had remained the majority at Damas-
cus until at least the tenth century and maybe into the elev-
enth,[1] and even now in the mid-twelfth century their numbers
approached half the population. But faced with Nur al-Din's
incessant intimidation coupled with his propaganda – and
with Baldwin's forces recently tied up at Ascalon and the
kingdom of Jerusalem lacking the resources to come to the
aid of Damascus – in April 1154 an element of the Muslim
population opened the city's gates to Nur al-Din.

Immediately after his occupation of Damascus, Nur al-Din
applied the same programme of exciting popular religious
feeling as he had done at Aleppo, founding new madrasas
and mosques to preach jihad – and just as at Aleppo, he
directed the energy of its people not against the Franks but
against Muslim states elsewhere in Syria and beyond which
still resisted submission to his authority. In fact, he renewed
the peace treaty with Jerusalem and even agreed to pay a
tribute to the Franks, meanwhile subjugating Muslim-held
Baalbek and snatching lands from the Seljuks in Asia Minor.
Never for the rest of his life did Nur al-Din pursue jihad
against the Franks. But he did now possess Syria's greatest
city, and beyond it to the south lay Egypt.

Baldwin III fell ill and died in February 1163; he had no
children and before his death he named his younger brother
Amalric his successor. But there were some among the nobil-
ity and the Church who objected to Amalric taking the
throne on the grounds of incest – arguing that he and his
wife, Agnes of Courtenay, were third cousins (they shared the

same great great grandfather) and were therefore too closely related. Agnes was the daughter of Joscelin II of Edessa, but after the destruction of the city of her birth she came to Jerusalem; there she married Amalric and bore him three children. But now in order to assume the throne Amalric agreed to an annulment of his marriage provided his children were considered legitimate; two would eventually rule, his son as Baldwin IV, the 'leper king', and his daughter Sibylla becoming queen on her brother's death. During his reign Amalric commissioned William of Tyre, who became a close friend, to write a history of Outremer.

Within months of becoming king, Amalric was challenged by the deteriorating situation in Egypt. The Fatimid regime in Cairo had grown weak and unstable, with two viziers vying with one another for control over the enfeebled caliphate. Each of the viziers reached outside Egypt for support, drawing Amalric at Jerusalem and Nur al-Din at Damascus into their quarrel. For the Franks the prize was potentially enormous: by installing a friendly government in Cairo the kingdom of Jerusalem would not only gain access to the vast resources of Egypt but would also protect its southern flank. But the prize was no less great for Nur al-Din: not only would his acquisition of Egypt give him control over the trade route from Damascus that terminated in Cairo, but he would entirely surround the Christian states. The Fatimid garrison at Ascalon had stood astride the route into the Nile Delta and to Cairo, the same line of attack taken by the Arabs when they invaded Egypt in 640 after their conquest of Syria and Palestine. Baldwin's capture of Ascalon with Templar help in 1153 likewise opened the door to Egypt for the Franks, and now in 1164, and later in 1167 and again in 1168, Amalric entered Egypt to prevent it falling to Nur al-Din.

Nur al-Din moved first when he sent his Kurdish general Shirkuh into Egypt to install the vizier Shawar in power. But Shawar soon resented Shirkuh's heavy hand, and with the

prospect of open warfare breaking out between the two, Shawar sent to Amalric for help. In 1164 Amalric led a Frankish army, including a large contingent of Templars, into Egypt, besieging Shirkuh at Bilbeis in the eastern Delta. After three months, with Bilbeis about to fall, Shirkuh's desperate situation was relieved by Nur al-Din, who laid siege to Harim, between Antioch and Aleppo; when Harim fell in August, the heads of its defending Christians were sent to Bilbeis with instructions to Shirkuh to display them on the walls to frighten his besiegers. The worst of it was that, in attempting to relieve Harim, a Frankish army was defeated by Nur al-Din, and its leaders, Bohemond III of Antioch and Raymond III of Tripoli, as well as several others, were captured and held for ransom; Bohemond was released a year later, Raymond not until 1173. To meet the emergency in the north of Outremer, Amalric agreed to withdraw from Egypt if Shirkuh would do the same, leaving the question of the failing Fatimid caliphate unresolved.

But as the Templars immediately understood, the adventure had exposed the vulnerability of Outremer. Bertrand of Blancfort, the Grand Master of the Temple, addressing himself in November 1164 to King Louis VII of France, wrote:

> Although our King Amalric is great and magnificent, thanks to God, he cannot organise a fourfold army to defend Antioch, Tripoli, Jerusalem and Babylon [as Fustat, the original Arab capital of Egypt, adjacent to Fatimid Cairo, was called in the Middle Ages].[2] [...] But Nur al-Din can attack all four at one and the same time if he so desires, so great is the number of his dogs.[3]

By sheer force of numbers the Turks threatened to overwhelm Outremer.

Nor were the Turks fighting alone. Under Nur al-Din their numbers were augmented by the Kurds, a mountain people

inhabiting parts of the Caucasus, Mesopotamia, Persia and eastern Asia Minor; Nur al-Din's generals Shirkuh and his brother Ayyub were Kurds, and their prominence in Nur al-Din's army attracted large numbers of their fellow-country-men. In contrast, Arabs played little or no role in Nur al-Din's campaigns; instead, for fear that they would revolt against their Turkish overlords, they were actively suppressed. The Kurds were Sunni Muslims, like the Turks, and fitted in well with Nur al-Din's object of conquering Fatimid Egypt. The Fatimids were not only Arabs but also Ismailis, an offshoot of Shia Islam, a heresy as far as the Sunni were concerned, and their rivals for universal domination. Although two centuries of Fatimid rule meant that Shia influences were strong among the Muslims of Egypt, Nur al-Din was determined to use the argument of jihad to bring Egypt to orthodoxy and under his control.

The rivalry between Sunni and Shia was to Amalric's advantage; the Shia had brought him into Egypt in defence against the Sunni. But Amalric had another advantage too. The Muslim ruling elite was concentrated in Cairo and the port city of Alexandria; 'elsewhere, Egypt's indigenous Coptic Christian population predominated'[4] – five hundred years after the Arab conquest Egypt was still a substantially Christian country. Indeed Christians still formed an absolute majority in Egypt, as recent research by the Egyptian historian Tamer el Leithy 'discredits the notion of large-scale conversion before the thirteenth century'.[5]

For five years the contest to control Egypt was waged between Amalric and Nur al-Din's general Shirkuh. As each side understood, Egypt's geography, resources and man-power would prove decisive for whoever gained control.

Again Nur al-Din was the first to act; in 1167 he sent Shirkuh into Egypt, and Amalric once again went to the assistance of Shawar. This time the vizier paid handsomely for the king's services; in a treaty probably drafted by Geoffrey Fulcher,

a senior Templar, Shawar agreed to pay an annual tribute in addition to 400,000 gold bezants, half of it at once, on the Frankish pledge that they would destroy Shirkuh and his army or drive them out of Egypt. With Amalric standing in Cairo, Shirkuh withdrew southwards towards Minya, where the Franks, in a desert battle at al-Babayn, cost the Turks fifteen hundred lives against a hundred of their own. Nur al-Din's forces made a last attempt to hold on, barricading themselves within the walls of Alexandria; their commander was a young Kurd, Shirkuh's nephew Salah al-Din, better known in the West as Saladin, who, after two or three months of mounting hunger in the town, surrendered to the Franks, who escorted them out of the city for their own safety as the population would have torn Saladin and his men to pieces for the misery they had made them endure. As the army of Amalric, together with the Templars, marched through the streets of the city of St Mark, their triumph meant the liberation of the last of the great patriarchal sees; and from the top of what remained of the Pharos, the ancient lighthouse that had been a wonder of the world when Alexandria had been the cultural capital of Western civilisation, they flew the banner of Jerusalem. To ensure that Nur al-Din's forces would not return, Amalric installed a garrison in Cairo and Frankish commissioners in the caliphal palace itself. Effectively Egypt was now a protectorate. And then Amalric and his army returned home.

But the fundamental weakness of the Fatimid regime remained, and it was only a matter of time before Nur al-Din or Amalric would strike the coup de grâce. In August 1167, just after his return from Egypt, Amalric married Maria Comnena, the great grandniece of Manuel Comnenus, the emperor of the Byzantine Empire. Over the following months a plan was developed for a joint Frankish–Byzantine military expedition to conquer, divide and annex Egypt, the Franks taking the interior, the Byzantines the coast. Amalric's friend and adviser

the historian William, who had recently been appointed arch-deacon of Tyre, drew up a formal treaty of alliance and was sent to Manuel with full power to ratify the agreement in the emperor's presence. But before William of Tyre could return to Jerusalem, Amalric had struck; in October 1168 he marched into Egypt. Shawar had refused to pay the tribute as agreed, and rumours reached Jerusalem that the vizier had once again turned to Nur al-Din, this time to rid himself of the Frankish garrison and commissioners in Cairo. But why Amalric would not wait for his Byzantine allies is not clear. The argument has been made that Amalric or his barons believed they could take Egypt for themselves without having to share the coun-try with the Byzantines. Also that Amalric was goaded by the Hospitallers. Whatever Amalric's reasons, the Templars were opposed and refused to join the expedition.

If urgency was the need behind Amalric's sudden deci-sion to invade, he was subsequently criticised by none other than William of Tyre for failing to pursue the conquest with purpose and energy. First, the Frankish army captured Bil-bais in the Delta and ran amok, slaughtering many of its inhabitants, including numerous Christians. Then siege was laid to Cairo, where, after the example of Bilbeis, Shawar was determined to defend his city to the end while denying Fustat to the Franks by burning it to the ground, a confla-gration that lasted fifty-four days. Throughout all this while Amalric and Shawar haggled over tribute, and as money was handed over in stages so Amalric, apparently as part of the deal, withdrew somewhat from Cairo. But now Nur al-Din's general Shirkuh appeared in the Delta, and in January 1169, after slipping round Amalric's army, he entered Cairo unop-posed, promptly decapitated Shawar and installed himself as vizier. His rule was not long; Shirkuh died in March and was succeeded as vizier by his nephew Saladin.

The capture of Egypt by Nur al-Din's forces was a strate-gic calamity for the Franks. Their protectorate over Egypt

was at an end, the strategic and economic advantages it had brought were lost, and Syria and Egypt were now effectively united under an alien Turkish hand. The final encirclement of Outremer had begun.

And why had the Templars refused to participate in so critical a venture? The question has been a matter of speculation and debate ever since. William of Tyre, who was commissioned by Amalric to write his history of the kingdom of Jerusalem, might have been expected fiercely to condemn the Templars. Yet William himself disapproved of the campaign and said that the Templars objected on moral grounds; 'it seemed against their conscience'[6] to break the treaty they had helped negotiate with Shawar in 1167. Moreover, for all the strategic importance of Egypt, there were other strategic considerations that the Templars would reasonably have taken into account. In 1164, when the bulk of Templar forces had been with Amalric on campaign in Egypt, Nur al-Din had taken advantage by striking in the north, inflicting heavy losses against the army of the prince of Antioch. 'There is no one to check their savagery', Geoffrey Fulcher, the preceptor of the Temple, wrote to Louis VII in September that year; 'of the six hundred knights and twelve thousand foot soldiers scarcely any are known to have escaped.'[7] Numbered among these captives and casualties were sixty Templar knights, all of them dead, and numerous more sergeants and Turcopoles who had met the same fate, precisely in the region of the Amanus mountains where the Templars bore responsibility for manning strategically sited castles that were part of the ultimate defence of Outremer. The experience may have impressed on the Templars the need to husband their resources and concentrate them where they were most needed.

Nevertheless William of Tyre could not let pass the opportunity to criticise the Templars. Apart from other reasons they may have had, the Templars had jibbed at the 1168

Egyptian campaign, he suggested, because they may have been jealous of the Hospitallers, who had taken the lead in urging Amalric to undertake the expedition and had already claimed Pelusium on the edge of the Egyptian Delta for themselves. The perpetual rivalry between the two orders was a problem; it was seldom that they could be induced to campaign together, and each followed its own line regardless of the official policy of the kingdom of Jerusalem. In fact, the Hospitallers could be no less independent of secular authority, but their image was softened by the alms and care they lavished on pilgrims, whereas the image of the Templars rested more exclusively on their military prowess, and then there was their involvement in financial activities. The independence of the orders was liable to provoke resentment, and in the case of the Templars it led increasingly to criticism that the order was primarily concerned with advancing and protecting its own interests.

As well as the usual monastic vows of poverty, chastity and obedience, every entrant to the Order of the Knights Templar swore 'to conserve what is acquired in the Kingdom of Jerusalem, and to conquer what is not yet acquired'.[8] To meet their obligations an iron discipline was required; its effect made a forceful impression on an unknown pilgrim visiting Jerusalem some time after the middle of the twelfth century.

> The Templars are most excellent soldiers. They wear white mantles with a red cross, and when they go to the wars a standard of two colours called balzaus is borne before them.[9] They go in silence. Their first attack is the most terrible. In going they are the first, in returning the last. They await the orders of their Master. When they think fit to make war and the trumpet has sounded, they sing in chorus the Psalm

of David, 'Not unto us, O Lord',[10] kneeling on the blood and necks of the enemy, unless they have forced the troops of the enemy to retire altogether, or utterly broken them to pieces. Should any of them for any reason turn his back to the enemy, or come forth alive [from a defeat], or bear arms against the Christians, he is severely punished; the white mantle with the red cross, which is the sign of his knighthood, is taken away with ignominy, he is cast from the society of brethren, and eats his food on the floor without a napkin for the space of one year. If the dogs molest him, he does not dare to drive them away. But at the end of the year, if the Master and brethren think his penance to have been sufficient, they restore him the belt of his former knighthood. These Templars live under a strict religious rule, obeying humbly, having no private property, eating sparingly, dressing meanly, and dwelling in tents.[11]

All this was in accordance with the Templar Rule, which stated that, if any brother leaves the field of battle without permission,

> severe punishment will be given, and he cannot keep the habit. [...] Nor should he leave the squadron because of cuts or wounds without permission; and if he is so badly hurt that he cannot obtain permission, he should send another brother to get it for him. And if it happens that the Christians are defeated, from which God save them, no brother should leave the field to return to the garrison, while there is a piebald banner raised aloft; for if he leaves he will be expelled from the house for ever.[12]

Every Templar was a highly trained and expensive mounted knight. Such a knight in the second half of twelfth-century

France required 750 acres to equip and maintain himself as a mounted warrior, and a century later that cost had quintupled to 3,750 acres.

For a Templar knight operating overseas the costs were even greater, as much had to be imported to Outremer, not least horses. Each Templar knight had three horses, and because they fell victim to warfare and disease, and had a lifespan of only twenty years, they needed to be renewed at a rate greater than local breeding allowed. The cost of horses rose six-fold from the twelfth to the thirteenth centuries. Moreover, horses consumed five or six times as much as a man and required feeding whether or not they were in use. A bad harvest in the East, and urgent food supplies had to be shipped in for men and horses alike.

Each Templar also had a squire to help look after the horses. And in addition there were sergeants, more lightly armed than knights, who each had a horse but acted as their own squires. Sergeants were often locally recruited and wore a brown or black tunic instead of white. In fact, for every Templar knight there were about nine others serving in support, whether as squires, sergeants or other forms of help. This is not much different from modern warfare, in which every frontline soldier is backed up by four or five who never see combat, not to mention the many thousands of civilians producing weapons and equipment and providing clothing, food and transport.

Growing responsibilities increased Templar costs immensely. As secular lords found themselves unable to maintain and defend their castles and their fiefs, they handed these responsibilities over to the military orders. Only their vast holdings in Outremer and, more especially, in the West permitted the Templars to operate on such a scale and recover after losses and setbacks to continue the defence of the Holy Land.

❧

Until the 1160s the Franks possessed military superiority on the battlefield and pursued a strategy of offensive warfare. Although the Turks could assemble large armies of light cavalry and archers, their forces presented little threat to even lightly defended castles, provided that the Franks could come to their defence within a few days. The arrival of a Frankish force, even the report of its approach, was usually enough for the Turks to break off their siege. Moreover, when the Franks attacked fortified Muslim positions, they had the craftsmen and engineers to transport heavy wooden beams and other materials to the site and build siege engines on the spot. Antioch, Jerusalem, Tyre, Ascalon and many other cities had fallen to the Franks in this way. But a shift became evident during the Egyptian expeditions; while Amalric was tied up at Cairo, Alexandria or the Delta, he was unable to come speedily to the rescue of cities and castles in Outremer that were attacked by Nur al-Din. The farther the Franks advanced in one direction, the more exposed they became elsewhere; and meanwhile the number of Turks was increasing all the time, a vast migration comparable to the barbarian invasions that had destroyed the Roman Empire in the West centuries before. The Turks were also learning siegecraft from the Franks.

The Frankish answer was to alter radically their military architecture, to build more powerful castles which could withstand sieges for longer periods of time. This meant building higher walls, introducing round towers, creating posterns for sorties, digging deeper and wider moats and constructing glacis – that is, smooth sloping surfaces of stone that deterred the scaling of fortifications and exposed attackers to fire. Also the Franks now built their castles with vast chambers for storing quantities of food and water capable of lasting months, even years. But above all, and most characteristic

of Frankish castles in the East, they added outer defensive walls, a ring or several rings of walls round the central keep, creating great concentric castles such as Saphet, Beaufort, Margat, Chastel Blanc, Krak des Chevaliers.

※

Castles were never just military outposts, nor did they necessarily serve a primarily military purpose. As in Europe, castles served as core developments for new settlements and as centres of production and administration – battlemented country houses, containing corn mills and olive presses, and surrounded by gardens, vineyards, orchards and fields. Their lands in some cases encompassed hundreds of villages and a peasantry numbering tens of thousands. Wood to Egypt, herbs, spices and sugar to Europe, were important exports; indeed throughout the twelfth and thirteenth centuries Europe's entire supply of sugar came from the Latin East.

But from the 1160s, as the Franks found themselves increasingly on the defensive, the military nature of castles became more important. Often large and elaborate, and continuously improved by the latest innovations in military science, the Franks built over fifty castles in Outremer, many of them standing sentinel at strategic locations along the frontiers. The crusader states were long and narrow, lacking defence in depth. The principality of Antioch, the county of Tripoli and the kingdom of Jerusalem stretched 450 miles from north to south, yet rarely were they more than 50 to 75 miles broad, the county of Tripoli perilously constricting to the width of the coastal plain, only a few miles broad, between Tortosa (present-day Tartus) and Jeble. The inland cities of Aleppo, Hama, Homs and Damascus had all been captured by the Turks, who now occupied Egypt too. The mountains were a natural defensive line for the Franks, and they built many of their greatest castles to secure the passes.

Increasingly the cost of building or remodelling these castles and garrisoning them outstripped the wherewithal of local feudal lords. In this situation the military orders came into their own. They had the resources, the independence, the dedication – the elements of their growing power. After the Second Crusade both the Hospitallers and the Templars came to provide the backbone of resistance to the Muslims, and in due course the military orders were put in possession of the great castles, a task for which they were perfectly suited. The frontier castles could be remote, isolated and lonely places; they did not appeal to the secular knighthood of Outremer. But the monastic vows of the military orders suited them to the dour life of castles, where the innermost fortifications served as monasteries for the brothers. Their members were celibate, which made them easy to control, and they had no outside private interests. Superbly trained and highly disciplined, the Hospitallers and the Templars were led by commanders of considerable military ability; the capabilities of the orders generally stood in marked contrast to those of the lay institutions of Outremer.

When the First Crusade marched into the Middle East, it came over the Belen Pass, about 16 miles north of Antioch. In 1136 the task of policing the pass was given to the Templars. Their key fortress was Baghras, built high above the pass itself, and the Templars built several others in the Amanus mountains. As the danger from Zengi and Nur al-Din grew, these castles formed a defensive screen across the northern frontier where the Templars ruled as virtually autonomous border lords, effectively independent of the principality of Antioch.

The Templars also took charge of the kingdom of Jerusalem's southern frontier with Egypt when they were made responsible for Gaza during the winter of 1149–50. Gaza

was uninhabited and ruinous at this time, but the Templars rebuilt a fortress atop a low hill and slowly the Franks revived the city around it. This was the first major castle in the kingdom of Jerusalem that the Templars are recorded as receiving, and its purpose was to complete the blockade of Ascalon 10 miles to the north, that troublesome Fatimid outpost on the Mediterranean, which thanks to a bold Templar assault fell to King Baldwin III in 1153.

Another vital strategic site as well as an important spot for pilgrims was Tortosa on the Syrian coast, said to be the place where the apostle Paul gave his first Mass. A chapel dedicated to the Virgin Mary was built there in the third century, long before Christianity was officially tolerated within the Roman Empire, and it contained an icon of the Virgin said to have been painted by St Luke. To help the pilgrims who came to pray, the Franks built on this history with the construction of Our Lady of Tortosa in 1123, an elegant cathedral that architecturally marks the transition from the Romanesque to the Gothic. But in 1152 Nur al-Din captured and burned the city, leaving it deserted and destroyed; and as the county of Tripoli lacked the means for its restoration, Tortosa was placed in the care of the Templars, who greatly improved its defences, building a massive keep and halls within a triple circuit of tower-studded walls, and with a postern in the sea-wall enabling the city to be supplied from the sea.

The strategic significance of Tortosa was that it stood at the seaward end of an opening in the range of coastal mountains that runs back into the interior towards the Muslim city of Homs. Towards the eastern end of this Homs gap, as it is called, and towering high above the route between the interior and the sea, is the great concentric castle of Krak des Chevaliers gained by the Hospitallers in 1144, while in the mountains between Krak and Tortosa is the castle of Chastel Blanc, now known as Safita, already in the hands of the Templars some time before 1152. From the roof of the massive

keep at Chastel Blanc, round which the pattern of streets and houses is the only trace of its concentric fortifications, can be seen both Krak des Chevaliers to the east and the Templar castle of al-Arimah to the west on the Mediterranean coast just south of Tortosa. In short, the Templars, together with the Hospitallers, entirely controlled the one important route between the interior of Syria and the sea. Moreover, they did so with sovereign rights within their territories, having been granted full lordship over the population of their estates, the right to share in the spoils of battle, and the freedom to have independent dealings with neighbouring Muslim powers.

In the 1160s the Templars took over further castles, this time across the River Jordan at Ahamant (present-day Amman), and in Galilee at Saphet (also called Safad), to which was added Chastellet, better known as Jacob's Ford (Vadum Iacob) in 1178, all of these granted to the Templars by the kings of Jerusalem. Gaza, Ahamant, Saphet and Jacob's Ford were all within the kingdom of Jerusalem but close to its borders, where they served defensive purposes. Jacob's Ford was the northernmost crossing point of the River Jordan, a weak point where Saladin would come down out of Damascus and make easy raids against the Christians. So alarmed was Saladin when the Templars installed themselves at Jacob's Ford that he immediately attacked, failing in his first attempt in June 1179 but two months later storming the castle and taking seven hundred prisoners, whom he then slaughtered, although the Templar commander threw himself to his death to avoid capture.

More centrally placed was La Feve, at the crossroads of the route between Jerusalem and Acre via Galilee. Acquired by the Templars in about 1170, it served as a major depot for arms, tools and food, and it housed a large garrison. It was later the launching point for the expedition that led to the disastrous defeat at the Springs of Cresson on 1 May 1187, a foreboding of the catastrophe at Hattin.

As well as fighting in the defence of the kingdom of Jerusalem, the Templars continued to fulfil their original role of protecting pilgrims coming up to the holy sites at Jerusalem from the ports of Acre, Haifa and Jaffa, or going down from Jerusalem to the River Jordan. One of the duties of the Templar commander in Jerusalem was to keep ten knights in reserve to accompany pilgrims to the Jordan and to provide a string of pack animals to carry food and exhausted travellers. The Templars had a castle overlooking the site at the River Jordan where Jesus had been baptised, to protect not only pilgrims but also the local monks after six of them were gratuitously murdered by Zengi.

The acquisition of castles was accompanied by lands which helped to support them, especially round Baghras, Tortosa and Saphet. In these areas the Templars held many villages, mills and much agricultural land. The details are lacking because of the destruction of the Templar archives on Cyprus by the Ottoman Turks in the sixteenth century. But from what can be pieced together it seems that the orders between them, the Hospitallers and the Templars, may have held nearly a fifth of the lands in Outremer by the middle of the century, and by 1187, the year of the battle of Hattin, something like a third.

16

Templar Wealth

FROM THEIR INCEPTION the Templars were an inter-
national organisation. Their purpose was in the Holy
Land, but their support came from Europe, where they held
land, collected tithes and received donations from the pious.
They organised markets and fairs, managed their estates and
traded in everything from wool and timber to olive oil and
slaves. In time they built up their own formidable Mediter-
ranean merchant fleet capable of transporting pilgrims, sol-
diers and supplies between Spain, France, Italy, Greece and
Outremer.

Although it is usual to think of the Templars as knights on
horseback charging into battle, in a very real sense the thrust
of their lances depended on a vast network of support, not
just from sergeants and Turcopoles but also from men like
Odo of Wirmis, a brother who served the Templars but had
never gone to war. Odo was among those arrested by the
agents of Philip IV, king of France, at dawn on Friday, 13
October 1307 on charges of heresy, blasphemy and other hei-
nous crimes. Sixty years old at the time of his arrest, he had
joined the order at the late age of forty-four, well beyond the
time that he could have served as a mounted knight; in fact,
he never saw battle and probably never travelled beyond his

native France. Instead Odo had been recruited to the order because he was a master carpenter, just as others manned the Templars' preceptories in the West as administrators, agricultural workers and artisans of all kinds. Already by the 1160s the Templars had arranged their European holdings, the properties donated to them by the faithful, great and small, into seven large provinces extending from England beyond the Channel to Montenegro on the eastern coast of the Adriatic. These land holdings were the foundations of their power.

One such property was Cressing Temple, on the high road between London and Colchester in Essex. It was donated to the Templars in 1137 by Queen Matilda, wife of King Stephen of England and niece of Baldwin, the first king of Jerusalem. Unlike most other Templar sites, which were built of stone, the structures at Cressing Temple were built of wood, and they still survive today: two vast wooden barns, magnificent constructions which dominate the flat alluvial landscape, their timbered interiors of cathedral-like proportions. The Wheat Barn and the Barley Barn, built between 1206 and 1256, are the two finest Templar-built barns in Europe, while the Barley Barn is the oldest timber-framed barn in the world.

Cressing Temple, originally over 14,000 acres in extent, occupied a fertile site with good transport links by road and river, and by establishing a market there the Templars developed their holding as a considerable agricultural enterprise. The property was in the charge of a preceptor, who would have been accompanied by two or three knights or sergeants, together with a chaplain, a bailiff and numerous household servants, while the land was worked by over 160 tenant farmers. In time the estate included a mansion house with associated buildings including a bakehouse, a brewhouse, a dairy, a granary and a smithy, as well as gardens, a dovecote, a chapel with cemetery, a watermill and a windmill, its entire purpose

being to produce a surplus whose profit went towards paying for the order's activities in Outremer.

⚜

The same network of European estates that funded the Templars in Outremer and in the Iberian peninsula developed naturally into an international financial system. Individual monasteries had traditionally served as secure depositories for precious documents and objects, but during an age of greater movement owing to the crusades and the growth of trade and pilgrimages the Templar network of preceptories in the West – that is, houses and estates – could offer a better service. The Templars developed a system of credit notes whereby money deposited in one Templar preceptory could be withdrawn at another upon production of the note, a procedure that required the meticulous and scrupulously honest record-keeping at which they excelled.

Disciplined, pious and independent, the Templars were trusted throughout medieval society. Whether at Paris or Acre or elsewhere, the Templars kept daily records of transactions, giving details of the name of the depositor, the name of the cashier on duty, the date and nature of the transaction, the amount involved and into whose account the credit was to be made. These daily records were then transferred to a larger register, part of a vast and permanent archive. The Templars also issued statements several times a year, giving details of credits and debits and stating the origin and destination of each item. With their branch offices, so to speak, at both ends of the Mediterranean, and with major strongholds at the Paris and London Temples, not only could they take deposits but they could also make funds internationally available where and when they were needed.

An obvious extension to guarding crusaders' documents and money was to make funds available during the

expeditions themselves. The Templars operated treasure ships offshore, from which campaigning knights and nobles and kings could make emergency withdrawals; for services such as these, as well as for the currency exchange offices they ran in Jerusalem and the ports of Outremer for crusaders, pilgrims and merchants alike, they imposed charges and from them they turned a profit. An early stimulus to their activities and recognition of their potential came from King Louis VII himself when he found himself financially embarrassed during the Second Crusade and borrowed heavily from the Templar treasury. This was the beginning of the Templars' close financial association with the French monarchy, effectively becoming its treasurers. The episode also marked the beginning of their career as Europe's bankers, a development unintended and unforeseen yet one that arose naturally out of their situation.

From financing crusades it was a small step for the Templars to become an integral part of the European financial system. King John of England borrowed from the master of the Temple in London around the time of Magna Carta, in 1215. After the Fourth Crusade, which overthrew the Byzantine emperors and put a Frenchman on the throne instead, the new Latin emperor Baldwin II borrowed an immense sum which was secured against the True Cross. Although it was not always openly stated in documents, the Templars charged interest on loans, sometimes under the name of expenses to get round medieval scruples against interest, although sometimes they felt bold enough to declare that too. In 1274, for example, Edward I of England repaid the Templars the sum of 27,974 livres tournois together with 5333 livres, 6 sous, 8 deniers for 'administration, expenses and interest' – the total cost of the loan approaching 20 per cent.[1] Italian merchants were already financing and insuring shipments in grain, but the stimulus of the crusades and the activities of the Templars created an international system

extending across Europe and the Levant on a scale unknown before.

※

In return for these services and in addition to their charges, expenses and interest the Templars received various privileges and concessions. By papal bull and the decrees of French and English kings, the Templars were given full jurisdiction over their estates and their inhabitants. They also obtained royal consent to organise weekly agricultural markets and annual fairs, which formed a focus for local trade and brought much income to the order both from the dues paid by those taking part and through boosting the local economy generally. Combining agriculture with capital, the Templars were notably successful in the commercial exploitation of their estates, as in sheep-farming in England, for example, which in combination with the Templars' ability to provide credit turned them into major suppliers of wool. Not least among the benefits they obtained was the unimpeded export of goods and funds from the West to Outremer.

As naturally as their land holdings led the Templars into the world of international finance, so they also became traders who operated their own merchant marine. Most of the Templars' imports to Outremer such as horses, iron and wheat came by sea. At first the Templars contracted with commercial shippers and agents, but early in the thirteenth century they began building up a fleet of their own. They had a substantial presence at all the important ports of Outremer - at Caesarea, Tyre, Sidon, Gibelet (ancient Byblos and present-day Jubail), Tripoli, Tortosa, Jeble and Port Bonnel, north of Antioch. But their principal port was Acre, a walled city built on a tongue of land offering good protection for its double harbour.

In 1191, after the fall of Jerusalem to Saladin, Acre became
the capital of the kingdom and the Templars' new headquar-
ters in the Holy Land. According to the thirteenth-century
chronicler known as the Templar of Tyre, 'The Temple was
the strongest place of the city, largely situated along the sea-
shore, like a castle. At its entrance it had a high and strong
tower, the wall of which was 28 feet thick.' He also men-
tioned another tower built so close to the sea that the waves
washed up against it, 'in which the Temple kept its treasure'.[2]

After 1218 the Templars supplemented their facilities at
Acre with a new fortress of their own 30 miles to the south;
known today as Atlit, the Templars called it Chastel Pelerin,
because it was built on a rocky promontory with the help
of pilgrims (*pèlerin* in French). This castle, said a German
pilgrim who visited in the early 1280s, 'is sited in the heart
of the sea, fortified with walls and ramparts and barbicans so
strong and castellated, that the whole world should not be
able to conquer it'.[3]

From their ports in Outremer the Templars' ships sailed
to the West. Their major port of call in France was Marseille,
from where they shipped pilgrims and merchants to the East.
Italy's Adriatic ports were also important, especially Brindisi,
which had the added advantage of being near Rome. Bari
and Brindisi were sources of wheat and horses, armaments
and cloth, olive oil and wine, as well as pilgrims. Messina
in Sicily acted both as a channel for exports from the island
and as an entrepôt for shipping arriving from Catalonia and
Provence. The Templars also built ships in European ports,
everywhere between Spain and the Dalmatian coast.

Another Templar cargo was white slaves. They were trans-
ported in considerable numbers from East to West, where
they were put to work helping to run Templar houses, espe-
cially in southern Italy and Aragon. The Hospitallers also
engaged in the trade and the use of slaves; indeed the trade
in white slaves was a flourishing business for everyone,

including the Italian maritime powers, especially Genoa, but most of all for the Muslim states in the East. In the last decades of Outremer, as town after town fell to the Turks, the men would usually be slaughtered but their women and children would be taken to the slave markets of Aleppo or Damascus. Many thousands of Frankish women, girls and boys must have suffered this fate, as well as great numbers of native Christians.

But otherwise the great centre of the slave trade in the late thirteenth century was the Mediterranean port of Ayas, in the Armenian kingdom of Cilicia. Marco Polo disembarked at Ayas in 1271 to begin his trip to China at about the same time that the Templars opened a wharf there. The slaves, who were Turkish, Greek, Russian and Circassian, had been acquired as a result of intertribal warfare, or because impoverished parents decided to sell their children, or because they were kidnapped, and they were brought to Ayas by Turkish and Mongol slavers.

The pick of young strong males from the south Russian steppes or the Caucasus generally went to Egypt, where they were converted to Islam and served as elite slave soldiers known as Mamelukes. In 1250 the Mamelukes seized power in Egypt for themselves – and led the final jihad that drove the Franks out of Outremer.

The Paris Temple was the Templar headquarters in France. The area was nothing more than a riverside swamp (*marais*) until the Knights Templar drained the land in the 1140s and built their headquarters in its northern part, then outside the city walls. Nothing of the Temple survives today, and it is remembered only by a street name in the Quartier du Temple, the northern part of the area known as the Marais, which is on the Right Bank just west of the Bastille. But from the

twelfth to the fourteenth century it was one of the key financial centres of north-west Europe.

The Temple was fortified with a perimeter wall and towers. Inside there was an impressive array of buildings, and in the late thirteenth century the Templars added a powerful keep about 165 feet high – nearly twice as high as the White Tower, the keep at the centre of the Tower of London. The Templar keep in Paris was the main strong-room for the Templar bank, and it was also, in effect, the treasury of the kings of France.

Half a century after the abolition of the Templars, Paris had expanded, and a new wall brought the Temple within the embrace of the growing city, where it remained standing for four and a half centuries more. During the French Revolution King Louis XVI was imprisoned in the Templar keep, and it was from there in January 1793 that he was led out to the guillotine in what is now the Place de la Concorde. In 1808 the keep was demolished by Napoleon, who was eager to eradicate anything that might become a focus of sympathy for the royal family.

The London Temple, or the New Temple as it was called, would have been comparable to that of Paris, but only Temple Church, consecrated in 1185, remains today, amid the Inns of Court off the south side of Fleet Street. The nave of Temple Church is round, as was typical with Templar churches, its plan following that of the Church of the Holy Sepulchre in Jerusalem. King John was actually resident at the New Temple at the time of Magna Carta in 1215 and was accompanied to his famous meeting with the barons at Runnymede by the master of the London Temple. But while the kings of England entrusted Templars with military, diplomatic and financial commissions, they were always careful to keep the royal treasury as part of the royal household, where it was run by royal officials, so that at most the New Temple merely served to provide additional safe-deposit space.

The Templars' experience made them useful to the French monarchy and to the papacy, both of which wanted to maximise their revenues from taxation and reform the managing of their finances. For example, during the thirty-three-year reign of Philip II, which extended from the late twelfth century well into the thirteenth, the king's revenues were increased by 120 per cent thanks to Templar management.

But Templar holdings were never entirely secure. Only the Paris Temple presented a truly formidable obstacle to a raid; Templar houses elsewhere in France were raided by the king; the London Temple was raided by kings of England in the thirteenth and fourteenth centuries when in desperate need; and in Spain the kings of Aragon did the same. But these were passing events in desperate times of need, and restitution was made. Ultimately the Templars' best protection was not the stone walls of their treasure houses but practical and moral constraints. The kings needed the Templars and their services too much to alienate them, nor could they afford to put themselves on the wrong side of a spiritual cause.

Yet in the Templars' success as bankers and financiers lay a chief cause of their fall. The Templars, like the Church and like the crusades, were international in conception, but the thirteenth and fourteenth centuries were a time when national states were being constructed by European kings, especially by the kings of France. Just as the Templars raised money to defend the Holy Land with their arms, so they also provided money for the new nationalism arising in the West. But in 1307 the nation-state of France would in turn 'nationalise' the Templars and destroy them.

PART V

Saladin and the Templars

IN 1171, AS THE FATIMID CALIPH AL-ADID *lay dying, Saladin ordered prayers to be said in the mosques of Cairo, but not for the last of Egypt's Shia rulers; instead they were for Nur al-Din's puppet, the Sunni caliph in Baghdad. Al-Adid was the last Arab ruler in the Middle East; the once imperial Arabs were now everywhere governed by Turks.*

Saladin was a Turkified Kurd; he was born in Tikrit, in northern Iraq, where his father, Ayyub, was appointed governor by the Seljuk sultan. Both Ayyub and his brother Shirkuh had cut themselves off from their Kurdish environment and wholeheartedly served as generals under Zengi and Nur al-Din. Ayyub had been put in charge of the citadel of Baalbek by Zengi and was later involved in the surrender of Damascus to Nur al-Din. Saladin grew up in Baalbek and Damascus, where, apart from studying the Koran, he is said to have learned by heart the Hamasa *of Abu Tammam, an anthology of Arabic poetry conveying the values and*

attitudes of the heroic age of the tribes when they first poured out of the Arabian peninsula and conquered Persia, the Middle East and Egypt.

But although Saladin knew Arabic, his language of command was Turkish. His army, like those of Zengi and Nur al-Din, included Kurds but was overwhelmingly Turkish; his personal bodyguard was an elite corps of Turkish Mameluke slave soldiers. On occasion he used mercenaries of other ethnic groups, and these sometimes included Arab Bedouins,[1] but that was the extent of local recruitment. As The Cambridge History of Islam explains, Saladin's army 'was as alien as the Turkish, Berber, Sudanese and other forces of his predecessors. Himself a Kurd, he established a regime and an army of the Turkish type, along the lines laid down by the Seljuks and atabegs in the East.'[2] In capturing Egypt, and in all his wars against the Muslims of Syria and the Franks of Outremer, Saladin was not a liberator; like the Seljuks and like Zengi and Nur al-Din, he was an alien leading an alien army of conquest and occupation.

17

Tolerance and Intolerance

AFTER THE DEATH of the Fatimid caliph Al-Adid, Saladin continued in the office of vizier, supposedly ruling Egypt on behalf of Nur al-Din, but in effect ruling Egypt for himself. To consolidate his position, he began constructing the Citadel of Cairo and extended the city walls, measures taken to protect himself against his overlord, who suspected that Saladin was slipping from his control, as well as against a possible invasion by the Franks and not least against the local population; in 1169 an uprising of Nubian soldiers had been joined by both Egyptian emirs and common people, and in 1172 there was widespread rioting in Cairo against the abusive Turks. 'When a Turk saw an Egyptian he took his clothes', wrote Ibn Abi Tayy, a chronicler from Aleppo, adding 'things went so far that any Turk who liked a house would drive out its owner and settle there.'[1] Saladin drove the Nubian soldiery of the Fatimid army into Upper Egypt and then sent his older brother Turanshah against them. The Nubians were Christians, as were the majority of Egyptians, and to intimidate the native population and deny the Nubians succour or refuge along the upper Nile, Turanshah tortured clergymen and destroyed the Christians' livestock, taking a religious satisfaction in killing large numbers of

pigs, and destroyed churches and monasteries, among them the monastery of St Simeon at Aswan, built in the seventh century, just before the Arab invasion, and one of the most beautiful in Egypt. An attempt at another uprising in 1174 was poised to receive help from Amalric and a fleet from the Norman kingdom of Sicily sailing off Alexandria, but Saladin discovered the plot and crucified the leaders, and the venture collapsed. Crucifixion was also Saladin's punishment for his own soldiers if they disobeyed him.

Meanwhile, although Saladin continued the fiction that he was Nur al-Din's vassal in Egypt, tensions between the two men continued to grow – but then suddenly came the news in May 1174 that Nur al-Din had died. His realm, extending over Mesopotamia and Syria, immediately disintegrated. Nur al-Din's son, facing plots against his life, fled Damascus for Aleppo, where a Turkish eunuch, acting ostensibly as the boy's guardian, put himself in charge; Nur al-Din's nephew seized Mosul and made himself independent; while Damascus itself took advantage of its sudden freedom to agree a truce with Jerusalem. Saladin's response was to declare himself sultan in Egypt and then rush to take Damascus, but when he advanced north to take Homs, Hama and Aleppo, he was resisted by the local emirs, who called on the Assassins to murder Saladin. The emirs were not impressed by Saladin's propaganda of jihad, which he now deployed; in their eyes he was simply one of them, motivated by self-interest and a lust for power. Saladin's reply, after capturing Homs, was, 'Our move was not made in order to snatch a kingdom for ourselves but to set up the standard of jihad. These men had become enemies, preventing the accomplishment of our purpose with regard to this war.'[2] In other words, Saladin justified his wars against his fellow Muslims because they were content to live in peace with Outremer. The attempted assassination had failed, but early in 1175 Saladin abandoned his attack on Aleppo and withdrew from northern Syria,

thankful to be alive and to have taken Hama and Homs and to hold Damascus and Cairo.

In theory Islam was a single religious community, the umma, a theocracy guided by the successor to the Prophet, the caliph. In reality almost since the inception of Islam the faith had been divided; there was no single umma, nor a single overarching caliphate. Instead, organisation was provided by clan or family dynasties, but dynastic legitimacy depended on identification with some fundamental aspect of Islam. Zengi showed the way when he declared jihad and his son Nur al-Din followed suit; now Saladin, who was filling the most important positions in Egypt with members of his family, also needed his religious justification and, like his predecessors, took up the banner of Holy War against his fellow Muslims.

Returning to Egypt, Saladin continued as he had done since the death of the caliph al-Adid with his programme of extirpating the Ismaili faith, which had taken root during the two centuries of Fatimid rule. The great Azhar mosque founded by the Fatimids was closed down and left to ruin, and the preaching of Ismailism, a dualistic form of Shia Islam, was everywhere proscribed. In its place Saladin worked hard to impose Sunni orthodoxy on Egypt's Muslims. As an orthodox but esoteric alternative to Ismailism, Saladin encouraged Sufism and built khanqahs – that is, Sufi hostels – and he also introduced madrasas, theological colleges that promoted the acceptable version of the faith. Numerous khanqahs and madrasas were built throughout Cairo and Egypt in Saladin's effort to combat and suppress what he regarded as the Ismaili heresy. Just as Zengi had cleansed Aleppo of Shia and Nur al-Din had done the same for Damascus, so Saladin repeated the lesson in Cairo.

Saladin's drive to orthodox conformity also had its effect on Egypt's Christians, who were still a majority of the population,[3] and also on its Jews. Notwithstanding the persecutions

of al-Hakim, Jews and Christians held positions of high responsibility under the Fatimids; now, with the dismantling of the old regime, they were increasingly marginalised and beaten down.

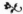

In comparison with Saladin's Sunni regime in Cairo, Outremer was a remarkably tolerant place. At Gaza, for example, which was ruinous when Baldwin III gave it to the Templars in 1149, and where they rebuilt the fortress and brought the city back to life, the bishop was Greek Orthodox. The Templars were directly subject to the pope and might have been expected to want a Latin bishop, especially as Gaza stood at the kingdom of Jerusalem's southern frontier with Egypt and the city's security and loyalty were paramount. Yet even though Gaza was resettled by Franks as much as by native Orthodox Christians, the Templars were content to have an Orthodox bishop instead of a Frank. Possibly the Templars preferred this arrangement rather than risk friction with a cleric of their own church; the Templars valued their autonomy and did not always get on with the Latin church authorities in Outremer, as illustrated by the annoyance shown towards them by the chronicler and archbishop William of Tyre. But in fact, autonomy was a pattern in Outremer; religious and ethnic groups were left to their own devices to a very high degree. As Michael the Syrian, the late twelfth-century Jacobite patriarch of Antioch, said, 'The Franks never raised any difficulty about matters of faith, or tried to reach an agreed statement of belief among Christians ethnically and linguistically separated. They regarded as Christian anybody who venerated the Cross, without further inquiry.'[4]

This spirit of tolerance in Outremer was in spite of the Great Schism of 1054 between the Eastern and Western Churches, which in any case was never a formal rupture and

was brought about more by a personal clash between two high ecclesiastics of Rome and Constantinople. Nor had it been like this during the early centuries of Christianity, when successive Church councils agreed the theological positions that became the orthodoxy of Rome and Constantinople and denounced as heresies the variations of Christian belief practiced by the Jacobites and Nestorians in Syria and Palestine and by the Copts in Egypt. But now in Outremer pragmatism, co-operation and toleration came to the fore, and both individuals and whole sections of society found ways of working together.

Sometimes, however, East and West encountered one another in unsettling ways, as at the village of Bethany, just over the Mount of Olives from Jerusalem. Bethany was a famous pilgrimage centre already at the time of Constantine because of its associations with Lazarus, whom Jesus, according to the Gospel of John 11:38–44, raised from the dead. Jesus often stayed at the house of Lazarus and knew his sisters Mary and Martha; Simon the Leper lived in Bethany too, and in his house Jesus was anointed (Mark 14:3). To Bethany, Jesus returned after his triumphal entry into Jerusalem (Mark 11:11), and near Bethany he ascended into heaven (Luke 24:50). Egeria, who travelled from Gaul, or perhaps from Galicia in the northern Iberian peninsula, visited the tomb of Lazarus in 410 on the seventh Saturday of Lent and described the scene. 'Just on one o'clock everyone arrives at the Lazarium, which is Bethany […] by the time they arrive there, so many people have collected that they fill not only the Lazarium itself, but all the fields around.'[5] At the end of the service the start of Easter was announced.

In 1143 Queen Melisende and her husband, King Fulk, rebuilt the old church at Bethany and rededicated it to Sts Mary and Martha, and they also built the church of St Lazarus above the tomb; and most splendidly they built a Benedictine convent here, also dedicated to Sts Mary and

Martha, endowed it with large estates near Jericho and forti-
fied it with a great stone tower. Not long afterwards Ioveta,
the youngest sister of Melisende, was elected abbess, making
her at the age of twenty-four the head of one of the richest
convents in the kingdom of Jerusalem and one of the most
famous in the world.

Much of Bethany's potency for Western pilgrims was its
association with Mary Magdalene, who according to tradi-
tion had fled Palestine after the crucifixion and lived and
died in France. Her relics were brought to the great abbey
church of St Mary Magdalene at Vézelay in Burgundy, where
Bernard of Clairvaux had launched the Second Crusade.

Mary Magdalene's appearances in the Gospels are brief
but telling. She is present at the most important moments of
the Jesus story – his death and his resurrection. At the cruci-
fixion of Jesus his disciples have gone into fearful hiding, but
Mary Magdalene is at both the Cross and the tomb, and it
is she who carries the news to the disbelieving disciples that
Jesus has risen (Matthew 27:56, 28:1; Mark 15:40; John 19:25,
20:1). The heirs of this great story of life and death and resur-
rection were the nuns of Bethany. Western pilgrims arriving
at Bethany had the satisfaction of entering the very landscape
of the drama that led to the salvation of mankind. Pilgrims
knew this to be true because it had been part of the tradi-
tion of the Roman Church since the time of Pope Gregory
the Great, whose Homily XXXIII, in 591, stated that Mary
Magdalene, from whom Jesus had cast out demons (Luke
8:2-3), was not only the Mary who was the disciple of Jesus
who witnessed his crucifixion and visited the empty tomb,
but was also the anonymous woman caught in adultery and
brought before Jesus by the Pharisees (John 8:3-12). Mary
Magdalene, said the pope, was 'she whom Luke calls the sin-
ful woman, whom John calls Mary', and whom 'we believe to
be the Mary from whom seven devils were ejected according
to Mark. And what did these seven devils signify, if not all

the vices?' Mary Magdalene, the pope made clear, had been a prostitute who had previously used the oils she applied to Jesus 'to perfume her flesh in forbidden acts'.[6] To which the Venerable Bede added in the next century that the sinful woman whom Jesus healed of demonic possession was one and the same as the sister of Martha and Lazarus with whom Jesus was staying in Bethany when he raised Lazarus from the dead and who also poured precious ointments over Jesus' feet and then washed them with her hair (Matthew 26:6; Mark 14:3; Luke 10:39; John 12:3) – which in turn associated Mary Magdalene with the unnamed woman who poured oil over Jesus' head in the house of Simon the Leper in Bethany. The density of associations made Bethany a prime pilgrimage site, confirmed by the naming of the church and the abbey after St Martha and after St Mary Magdalene.

But pilgrims arriving in Outremer met Jacobites and Greek Orthodox Christians who told them the story was not like that at all. All these various Marys and unnamed women were quite separate people and, apart from Mary, sister of Lazarus, and the unnamed woman at the house of Simon the Leper, had no association with Bethany. John of Würzburg was one Western pilgrim who encountered these conflicting stories when he reached Bethany and Jerusalem, and he went away entirely confused. 'If anyone wishes to know more about these things, let him come himself, and ask the more intelligent subjects of this land the sequence and truth of this story. As for me, I have not found quite enough to explain it in any of the Scriptures.'[7]

So unsettling was this confusion to pilgrims that Gerard of Nazareth, a Benedictine monk who was bishop of Latakia, on the Syrian coast, determined to put the matter straight. In his treatise written in the 1160s against the tradition of the Eastern churches he reasserted the position of the Church at Rome that Mary Magdalene was the same person as the other Marys mentioned in the Gospels, and in particular she

was the same woman as Mary, the sister of Martha. This was not a trivial issue of misidentification; great matters were at stake. Most obviously, if Mary Magdalene could no longer be associated with Bethany, then much of the appeal of its abbey would be lost and it would face financial collapse. Even worse, pilgrimages could expose people to rival views and undermine the traditions of the Roman Church – and undermine its authority in the East. If the Latin Church could get Mary Magdalene wrong, its interpretations of the Bible were open to doubt, as were the bases for so many of its rituals and practices, not to mention its arguments that had led to the Great Schism or were used to claim primacy for Rome. What authority, what ascendancy, would the Latins have left to them in the East?

Heresies have been born from less and been visited with fierce correction. But not in Outremer, where Gerard framed his argument mildly: 'There is no greatly pernicious error in this, and one can believe one or another without grave danger. But it is good, if possible, to hold to what is more truthful, not only this but in all controversy.'[8]

Behind this atmosphere of toleration was the reality that Eastern Christians felt closer ties to their fellow Christians from the West than to either the Muslim Arabs or the Turks. By the twelfth century most of the local population spoke Arabic but were not yet culturally arabised; Greek, Armenian and Syriac all survived not only as liturgical languages but also in day-to-day use. Moreover the Turks and their Kurdish allies generally did not speak Arabic, or Syriac, Armenian or Greek, whereas the Franks, who shared a common faith with the local population, also made an effort to learn the local languages. But probably the biggest factor that encouraged the Franks and the native inhabitants of Outremer to get along was that they shared a common enemy – the Turks.[9] Nor was it only Christians for whom the Turks were the enemy; they were the enemy for most Muslims too.

❧

Ibn Jubayr, a Spanish Muslim who had been on a pilgrimage to Mecca, wrote of his journey through Outremer in 1184 as he travelled between Damascus and Acre.

> We left Tibnin [Toron, within the kingdom of Jeru-
> salem] by a road running past farms where Muslims
> live who do very well under the Franks – may Allah
> preserve us from such temptation! The regulations
> imposed on them are the handing over of half of the
> grain crop at the time of harvest and the payment
> of a poll tax of one dinar and seven qirats, together
> with a light duty on their fruit trees. The Muslims
> own their own houses and rule themselves in their
> own way. This is the way the farms and big villages
> are organised in Frankish territory. Many Muslims
> are sorely tempted to settle here when they see the
> far from comfortable conditions in which their breth-
> ren live in the districts under Muslim rule. Unfortu-
> nately for the Muslims they have always reason for
> complaint about the injustices of their chiefs in the
> lands governed by their coreligionists, whereas they
> can have nothing but praise for the conduct of the
> Franks, whose justice they can always rely on.[10]

Clearly Muslim farmers had not been dispossessed of their lands by the Franks, while the tax and payment in kind were in line with amounts paid by Christian farmers too. In fact, Muslims were better off than Christians, who in addition to the payments due to their overlords were required to pay a tithe to the churches from which Muslims were exempt.

Ibn Jubayr's account is all the more striking as he was oth-erwise resolutely opposed to the Franks. But he could not deny the respect with which the Franks treated his fellow Muslims, as when he approached Acre and found Muslims

entrusted with the local administration. 'On the same Monday, we alighted at a farmstead a parasang distant from Acre. Its headman is a Muslim, appointed by the Franks to oversee the Muslim workers in it. He gave generous hospitality to all members of the caravan.'[11] In Acre itself he discovered that although two mosques had been converted to churches, Muslims were nevertheless free to use them as meeting places and to pray in them, facing towards Mecca. There was nothing unusual about this; Usamah ibn Munqidh had mentioned the hospitality he received from the Templars, who welcomed him to pray in their chapel within what had been the Aqsa mosque on Jerusalem's Temple Mount.

Although Ibn Jubayr, a Sunni Muslim himself, was full of praise for Saladin's Sunni regime in Cairo, he admitted that the majority of Muslims in Outremer and Syria were heterodox in their beliefs. 'Dissident Muslim elements, comprising Shiites, Ismailites and Nusayriyah [Alawites] [...] according to Ibn Jubayr, outnumbered the Sunnites', and also there were the Druze, an historical offshoot of the Ismailis who had separated themselves from Islam altogether, none of whom welcomed the prospect of being forced by Saladin into the Sunni mould and who therefore allied themselves as necessary with the Franks.[12]

The Ismailis, Alawites and Druze were all dualists: that is, they believed that the universe contains both good and evil because God himself is made up of good and evil. They saw evil not as the absence of good but as part of the essence of both the world and its creator, who in turn may have been an emanation of an ultimate and unknowable God. Dualism was deeply rooted in the East and penetrated Islam via Mani, a third-century Persian, who drew on Zoroastrianism, Buddhism, Babylonian Mandaeism and Christianity. In fact

the term 'Manichaean', the name some medieval French chroniclers gave to the Cathars, was used by the Byzantines to describe the dualist ideas of Mani. But the Ismailis, Alawis and Druze went beyond religious belief; they were also initiatory secret societies with political aims tending towards the apocalyptic. In rejecting Islamic orthodoxy, which teaches that God is the sole principle and is good, their enemy were the Sunnis, who under Zengi, Nur al-Din and now Saladin were determined to eradicate them; the stronghold of dualist resistance was the less accessible regions of the East, particularly the coastal mountains.

As it happens, the battle between Muslim dualists and Sunni Islam began just as the Cathars first made their appearance in France, in the 1140s. There were similarities between the two. The origins of Cathar dualism lay in the East, where it can be traced back to the Christian Gnostics, who flourished in the second and third centuries AD all round the shores of the Eastern Mediterranean, in Egypt, Syria and Palestine, and perhaps also in Asia Minor and Greece. *Gnosis* is Greek for 'knowledge', and the Gnostics believed that salvation lay in their understanding of the true nature of creation. They believed that there were two worlds: the material world of evil and decay that had been made by an evil demiurge, the enemy of man; and the world of light where the primal God resides. Mankind inhabits a catastrophe not of God's making, but the Gnostics said they knew the secret of salvation. At the moment of the cosmic blunder, sparks of the divine light, like slivers of shattered glass, became embedded in a portion of humankind. These people were the elect, and the Gnostic aim was to lead them back to God. The crucifixion and the resurrection had no place in Gnostic belief; instead, the role of Jesus was to descend from the primal God and impart to his disciples the secret tradition of the *gnosis*.

Like the Gnostics, the Ismailis believed that man possesses slivers of the divine spark which, given possession of the

secret knowledge, can reunite man with the unknown God. The Ismailis claimed to possess this knowledge. And at the opposite end of the Mediterranean, especially in Languedoc, which was a major source of Templar income and recruits, the Cathars likewise claimed knowledge of this divine secret.

During the twelfth and thirteenth centuries Languedoc, in southern France, was the centre of a rich and complex religious life in which Jews, Catholics and communities of Arian, Waldensian and Manichaean heretics lived side by side. The Arians were the survival of that 900-year-old heresy that began in Alexandria and tended towards undermining the divinity of Jesus Christ, while the Waldensians were a new twelfth-century movement that espoused poverty, called for the distribution of property to the poor, rejected the authority of the clergy and claimed that anyone could preach, saying their literal reading of the Bible was all that was needed for salvation. According to the thirteenth-century chronicler and Cistercian monk Peter of les Vaux-de-Cernay, the Waldensians 'were evil men, but very much less perverted than other heretics; they agreed with us in many matters, and differed in some'.[13] The 'other heretics' were the Manichaeans, also known as Cathars, meaning 'pure'. The Templars partly owed their great expansion in Languedoc to the support of the nobility, with whom they were in close alliance, the combination of nobles' land and Templar capital allowing the establishment of new communities and the development of previously uncultivated territories. Some of these Templar patrons were renowned Cathar supporters.

After Catharism appeared in southern France towards the middle of the twelfth century, its adherents quickly became numerous and well organised, electing bishops, collecting funds and distributing money to the poor. But they could not accept that if there was only one God, and if God was the creator, and if God was good, that there should be suffering, illness and death in his world.

The Cathars' solution to this problem of evil in the world was to say that there were really two creators and two worlds. The Cathars were dualists in that they believed in a good and an evil principle. The former was the creator of the invisible and spiritual universe; this was the celestial Christ, and his bride was Mary Magdalene. The latter was the creator of our material world; this was the terrestrial pseudo-Christ, for whom Mary Magdalene was not a wife but his concubine.[14]

All matter was evil because it was the creation of the false, terrestrial Christ, but the ideal of renouncing the world was impractical for everyone, and so while most Cathars lived outwardly normal lives, pledging to renounce the evil world only on their deathbeds, a few lived the strict life of the perfecti.

Because human and animal procreation perpetuated matter, the perfecti abstained from eggs, milk, meat and women. But both ordinary Cathars and the perfecti actively shared in their belief that the true Christ was not part of this world of evil. As the celestial Christ, he was not born of the Virgin Mary, nor had he human flesh, nor had he risen from the dead; salvation did not lie in his death and resurrection, which were merely a simulation; instead, redemption would be gained by following Jesus' teachings.

By 1200 the Cathar heresy had become so widespread that the papacy was alarmed. Pope Innocent III said that the Cathars were worse than the Saracens, for not only did Catharism challenge the Church but by condemning procreation it also threatened the very survival of the human race. In 1209 a crusade was launched against them – called the Albigensian Crusade, as so many Cathars lived around Albi – and an inquisition was introduced. In that year the core of Cathar resistance withdrew to the castle of Montségur atop a great domed hill in the eastern Pyrenees, where they withstood assaults and sieges until capitulating in 1244. Some two hundred still refused to abjure their errors; they were

bound together within a stockade below the castle and were set ablaze on a huge funeral pyre.

The Templars played no part in the Albigensian Crusade, which was bound to attack some of their own patrons, who were likewise patrons of the Cathars. Nor has it been shown that the Templars were infected by the Cathar heresy. But like the Ismailis and other Shia offshoots in the East, the charge of heresy was soon used against the Cathars for political reasons; just as Zengi, Nur al-Din and Saladin waged jihad against heterodox Muslims in order to advance their own dynastic interests, so the kings of France put their military muscle into the Albigensian Crusade and rewarded themselves by annexing Languedoc to the French crown. And in this political sense the fates of the Templars and the Cathars would be intertwined. From their inception the Templars had been protected by the pope; no church or secular authority could act against them without the pope's approval. But the machinery of the inquisition that had been used against the Cathars did not die with their destruction; instead it was resurrected and manipulated for secular purposes by King Philip IV in 1307, when he arrested the entire Templar network of France at dawn on Friday 13 October on charges of heresy and blasphemy.

As the Sunni Turks under Zengi and Nur al-Din imposed themselves more completely on Syria, the Ismailis withdrew into that region of the coastal mountains, the Jebel al-Sariya, girded by the great Templar and Hospitaller strongholds of Tortosa, Chastel Blanc, Margat and Krak des Chevaliers, where the movement assumed its militant and murderous form known as the Assassins. From such strongholds as al-Ullayqa, Qadmus, Qalaat al-Kahf and especially Masyaf, the headquarters of the Assassins' leader, the Sheikh al-Jebel, the Old Man of the Mountain, they employed a strategy of

assassination to influence and control anyone, mostly Sunni Muslims but sometimes also Christians, who might threaten their independence.

The Assassins' method of recruitment was famously described by Marco Polo, who in the latter part of the thirteenth century encountered a branch at Alamut in Persia. Referring to them as Malahida, meaning 'deviators' or 'heretics', as they were called in Persia, he said they used drugs (including hashish, from which the word 'assassin' derives) to convince novices destined to become self-destructive feddayin, 'the self-sacrificers', that they had entered a garden of delights where fountains flowed with milk, honey and wine, and where houris, those maidens of Paradise, were likewise on tap. Brought back to their normal state, the initiates were told that they had indeed visited Paradise, which would certainly be forever theirs provided they gave absolute obedience to the commands of the Assassins' imam.

A later account, published in 1307 by the Venetian historian Marino Sanudo, relates that when Count Henry of Champagne was on a visit to the Assassins he saw two young men dressed in white sitting at the top of a high tower. When asked by the Assassin leader whether he had any subjects as obedient as his own, the count had no time to reply before a sign was given to the two, who immediately leapt from the tower to their deaths. Their willingness to sacrifice their lives made the feddayins' attacks that much more disturbing; their mission was to sow fear of the sect and at the same time weaken the resolve of their enemies by the murder of key figures. The Assassins infiltrated the ranks of their adversaries, and when they had won their victim's trust they would kill him, always using a knife. These were suicide attacks, for apparently by design they themselves perished in carrying out their orders. The killers were unlikely to have dosed themselves beforehand on hashish, however, as its effect would have made them almost useless.

Among the Assassins' rare Christian victims were Raymond II, count of Tripoli, in 1152; Conrad of Montferrat, king of Jerusalem, in 1192; and another Raymond, heir to the thrones of Antioch and Tripoli, who in 1213 was stabbed to death outside the door of the Cathedral of Our Lady at Tortosa. But the Assassins' most famous attempt was against Saladin in 1176. As the champion of Sunni orthodoxy, he had already overthrown the Ismaili Fatimids in Egypt and was now at war with independent Muslims throughout the East. He entered the Jebel al-Sariya to lay siege to Masyaf, but his soldiers reported mysterious powers about, while Saladin was disturbed by terrible dreams. One night he awoke suddenly to find on his bed some hot cakes of a type that only the Assassins baked and with them a poisoned dagger and a threatening verse. Convinced that Rashid al-Din Sinan, the Old Man of the Mountain, had himself entered his tent, Saladin's nerves gave way. He sent a message to Sinan asking for forgiveness and promised not to pursue his campaign against the Assassins provided he was granted safe conduct. Saladin was pardoned and hastened back to Cairo.

The one effective organisation against the Assassins was the Templars. Being an undying corporate body, the Templars could not be intimidated by the death of one of their members. The Assassins themselves admitted that they never killed a Grand Master because they knew that someone equally good would be put in his place.

In their hatred of the Sunni, the Assassins sometimes found themselves in alliance with the Christians, and even under trying circumstances they were tolerated by the Frankish states and the Templars. After the Assassins murdered Raymond II, the count of Tripoli, in 1152 – for no reason that anyone could figure out, unless they had been hired by Raymond's wife – the Templars threatened to go after the Assassins, who readily agreed to pay an annual tribute of

2,000 gold bezants. The Assassins and the Christians shared a common enemy, and it was in their interest to keep the peace with one another.

But on one significant occasion the Templars' distrust of the Assassins led them to oppose the policy of King Amalric of Jerusalem, who had entered into talks with the Old Man of the Mountain. The Ismailis had always seen their leaders as the embodiment of emanations flowing from the unknowable God, but in 1164, in an apocalyptic moment, Rashid al-Din Sinan openly renounced Islam and declared that the resurrection had arrived. The contemporary Syrian chronicler Kamal al-Din described scenes of wild frenzy in the Jebel al-Sariya, where 'men and women mingled in drinking sessions, no man abstained from his sister or daughter, the women wore men's clothes, and one of them declared that Sinan was God'.[15] In fact, the divine status accorded to the Old Man of the Mountain was general according to the Spanish Muslim traveller Ibn Jubayr, who wrote that all his followers treated him as God.

It was nine years after these events, in 1173, that Amalric attempted to negotiate an alliance with Sinan, one of its conditions being that the Assassins would convert to Christianity while in return the Templars would forego their tribute. But as Sinan's envoy was returning from Jerusalem to Masyaf, bearing a safe-conduct from Amalric, he was ambushed and killed by some Templar knights. Only with the greatest difficulty was Amalric able to persuade Sinan that the attack was not of his doing. Meanwhile he accused the Templars of treason and of bringing the kingdom to the 'point of irrevocable ruin'[16] by destroying the chance of an advantageous alliance. The chronicler William of Tyre implied that the murder was prompted by a financial motive, for peace would have meant an end to the tribute paid by the Assassins to the Templars. Another chronicler, Walter Map, wrote that the Templars killed the envoy 'so that peace and harmony

would not come about' - in other words, war justified the existence of the Templars, who feared the outbreak of peace. Neither the patriarch nor the king, continued Map, could exact revenge on the Templars because 'Rome imposes captivity by the purse in all places; the king could not because he is smaller than their little finger'.[17]

The argument of Templar greed is typical of William of Tyre, and also it was wrong because Amalric was prepared to compensate the order from his own resources. However, the Templars were probably concerned that the king was being duped, for they understood that whatever religion the Assassins professed, it would be no more than an outer garment, just as Islam had been an outer garment, as the Assassins saw this world as mere illusion, and despite any conversion to Christianity their inner and secret beliefs would remain. The Templars controlled important castles adjacent to the Assassin enclave, castles that also controlled the passes to the yet more dangerous Sunni-held interior, and to have let their guard down on the word of such a sect would have been grossly irresponsible and would have cost the Templars their credibility in the West.

In the event, negotiations were never resumed; the next year, 1174, the able Amalric died of dysentery at the age of thirty-eight; he was succeeded by his young son Baldwin IV, who suffered from leprosy. Raymond III, count of Tripoli, was made regent, and as his own father had been murdered by the Assassins he shared the Templars' distrust, although the Assassins had been an important ally against the Sunnis. The Franks were now reaping the consequences of their failure to take Egypt, as they had earlier failed to take Damascus, and in Saladin they faced a single enemy who for the first time controlled both Cairo and Damascus and was determined to destroy all forms of Islam other than his own and then destroy Outremer as well.

18

Saladin's Jihad

BALDWIN IV was barely thirteen years old when he became king of Jerusalem in 1174; he had been nine when his father, Amalric, entrusted his education and care to William of Tyre, and it was William who discovered the symptoms of the boy's leprosy. 'It so happened', William wrote, 'that once when he was playing with some other noble boys who were with him, they began pinching one another with their fingernails on the hands and arms, as playful boys will do. The others evinced their pain with yells, but, although his playmates did not spare him, Baldwin bore the pain altogether too patiently, as if he did not feel it.' At first, William thought this pointed to the boy's endurance, but then he discovered that about half of Baldwin's right hand and arm was numb.

I reported all this to his father. Physicians were consulted and prescribed repeated fomentations, anointings, and even poisonous drugs to improve his condition, but in vain. For, as we later understood more fully as time passed, and as we made more comprehensive observations, this was the beginning of an incurable disease. I cannot keep my eyes dry while speaking of it. For as he began to reach the age

of puberty it became apparent that he was suffering from that most terrible disease, leprosy. Each day he grew more ill. The extremities and the face were most affected, so that the hearts of his faithful men were touched by compassion when they looked at him.

But Baldwin was still young and strong, he had a quick and inquiring mind, and he showed signs of having his father's abilities in the field. The secular and ecclesiastical powers in the kingdom agreed that they wanted Baldwin to succeed to the throne, and so he was 'anointed and crowned solemnly and in the usual fashion in the Church of the Lord's Sepulchre on the fifteenth of July, four days after his father's death'.[1]

Baldwin proved himself three years later, in November 1177, when the sixteen-year-old king led his outnumbered Frankish force against the army of Saladin advancing out of Egypt. The Templars summoned all their available knights to defend Gaza, but Saladin bypassed them for Ascalon. Raising what men at arms he could, Baldwin rushed to block him, and together with the True Cross and the commander of his army, Raynald of Chatillon, he managed to get inside the walls of Ascalon before Saladin arrived. But instead of attacking, Saladin left a small force to besiege Ascalon and marched towards an undefended Jersualem with about twenty-five thousand men. Sending a message to the Templars, Baldwin told them to abandon Gaza and join him. When they came near, Baldwin broke out of Ascalon and chased after Saladin, marching north along the coast and then inland. The Frankish force comprised 450 knights, 85 of them Templars, and a few thousand infantry. On 25 November Saladin's army was crossing a ravine at Montgisard, near Ramla, close by the Jaffa–Jerusalem road, when Baldwin and the Templars fell upon them, taking them by surprise. The

king himself was in the vanguard, and Raynald of Chatillon and Balian of Ibelin helped on the victory, and some saw St George himself, whose church was near by at Lydda, fighting by their side.

But the real damage to the enemy was done by the Templars. An eyewitness to the battle, apparently a pilgrim who returned to London, gave this account to Ralph of Diss, Dean of St Paul's.

> Odo the Master of the Knighthood of the Temple, like another Judas Maccabaeus, had eighty-four knights of his order with him in his personal company. He took himself into battle with his men, strengthened by the sign of the cross. Spurring all together, as one man, they made a charge, turning neither to the left nor to the right. Recognising the battalion in which Saladin commanded many knights, they manfully approached it, immediately penetrated it, incessantly knocked down, scattered, struck and crushed. Saladin was smitten with admiration, seeing his men dispersed everywhere, everywhere turned in flight, everywhere given to the mouth of the sword. He took thought for his own safety and fled, throwing off his mailshirt for speed, mounted a racing camel and barely escaped with a few of his men.[2]

In all the Franks lost about eleven hundred men. But they inflicted on Saladin's forces an overwhelming defeat, killing nine out of ten of his infantry and cavalry, about twenty-three thousand men in all. Saladin only narrowly managed to escape back to Egypt, where to cling to power he spread the lie that the Franks had lost the battle.

The battle of Montgisard was a great victory and a perfect illustration of Frankish fighting ability and the superiority they could achieve through rapid and offensive warfare, thanks especially to the Templars. But although Montgisard

saved the kingdom of Jerusalem for the moment, it did not alter the fundamental situation. Had Baldwin the forces to pursue the enemy to Cairo or to make a sudden attack on Damascus, he might have destroyed Saladin with a crushing blow. For all the magnitude of his defeat, however, Saladin still had vast resources of wealth and manpower on which he could draw in Egypt, and that was only the beginning. As his adviser Al-Qadi al-Fadil observed, Saladin would use the wealth of Egypt for the conquest of Syria, the wealth of Syria for the conquest of Mesopotamia, and the wealth of Mesopotamia for the conquest of Outremer.[3] As Saladin's wars against rival Muslims continued apace, his resources became virtually inexhaustible and his forces so overwhelming in number that in the decade after Montgisard the Franks were forced gradually to alter their strategy, at first mounting attacks on the Muslim frontier and building castles that would extend their frontier territory, but soon relying on castles for defensive purposes.

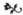

The year before Montgisard the kingdom of Jerusalem lost all chance of continuing its valuable alliance with the Byzantine Empire. Thanks to the First Crusade, the Byzantines had been able to reverse much of the damage done by the disaster at Manzikert in 1071 and had restored their authority over a large part of Asia Minor. But that was undone in 1176, when the Byzantine emperor Manuel I Comnenus led an army east with the intention of capturing Konya (Iconium), the capital of the Seljuk sultanate of Rum. Waylaid in a mountain pass through the Sultan Dagi range near the fortress of Myriokephalon, north-east of Lake Egridir, the Byzantine army suffered a fearful defeat. The emperor himself compared the battle to Manzikert, but that had been fought 800 miles to the east; the disaster at Myriokephalon,

only 200 miles from the Aegean, once again left the Byzantines clinging to no more than the coastal districts.

In the revived strength of the Seljuk sultanate of Rum, Saladin and the weakened Byzantine Empire discovered they had a common enemy, and in 1181 they entered into a peace treaty with each other. The Byzantines also adopted a policy of neutrality in the East, and their links with Outremer were dropped. The possibility of continuing the alliance against Egypt that King Amalric had enjoyed with the Byzantines was lost, leaving the Franks more exposed and more isolated than they had ever been before.

Meanwhile a century of fending off Turkish assaults had taken its toll on Byzantine trade and the state of its merchant marine, creating opportunities for Italian merchants and fleets from Pisa, Genoa, Amalfi and Venice to establish sizeable trading colonies in Constantinople. Greek resentment towards the prosperity and dominance of the Latins, who controlled almost the entire economy of the city, had been simmering for some time and came to a head after Manuel's death in 1180 introduced a period of instability at Constantinople marked by competing claims to the imperial throne. One of these claimants, Andronicus Comnenus, was known to have a hatred for the Latins, and when he entered Constantinople with his army in 1182, the Greek population turned against the foreigners. Many in the Latin community, which numbered about sixty thousand, managed to flee, but many thousands were massacred by the mob.

Greek and Arab and Frankish chroniclers described the slaughter, among them William of Tyre. 'Regardless of treaties and the many services which our people had rendered to the empire', William wrote,

> the Greeks seized all those who appeared capable of resistance, set fire to their houses, and speedily reduced the entire quarter to ashes. Women and

children, the aged and the sick, all alike perished in
the flames. [...] Monks and priests were the espe-
cial victims of their madness and were put to death
under excruciating torture. Among these latter was
a venerable man named John, a subdeacon of the
holy Roman church, whom the pope had sent to
Constantinople on business relating to the church.
They seized him and, cutting off his head, fastened
it to the tail of a filthy dog as an insult to the church.
[...] Even those who seemed to show more consid-
eration sold into perpetual slavery among the Turks
and other infidels the fugitives who had resorted to
them and to whom they had given hope of safety. It
is said that more than four thousand Latins of vari-
ous age, sex, and condition were delivered thus to
barbarous nations for a price.[4]

Apart from the effect this massacre of the Latins had on
Western opinion of Byzantium, it also drove the Italian city-
states, especially Genoa and Venice, to seek new markets in
the East, and from this time they developed a busy trade with
Egypt, so that 'Egypt was at once the most dangerous enemy
of the Crusaders and the source of the richest profits to the
Christian commercial republics of the Mediterranean'.[5]

In a self-confident mood following the Christian victory over
Saladin at Montgisard, Baldwin decided that the defences of
his kingdom should be reinforced and extended along the
Syrian frontier, and in October 1178, at the instigation of the
Templars, he commenced building the castle of Chastellet.
The castle, better known as Jacob's Ford, was deliberately
built within the Muslim frontier area – 'the Templars of the
land of Jerusalem came to the king and told him that they
should build a castle in Muslim territory', wrote the Frankish

chronicler Ernoul[6] – its purpose to control the only possible crossing of the River Jordan between the Sea of Galilee and its sources in the Golan Heights, at the spot where Jacob of the Old Testament was said to have wrestled with the angel (Genesis 32:24). But the castle was destroyed within ten months of its inception, in a disaster that has been called 'the beginning of the end' for the Templars.[7]

Jacob's Ford stood high above the Jordan in the form of a vast rectangle constructed of 20,000 enormous blocks of stone each of which was 7 feet long, its walls over 20 feet thick. This was only the first phase; the plan was to enclose the inner structure within an outer rectangle, creating a concentric castle which would have been larger than anything in Europe and the largest in the East. Saladin was alarmed at so powerful a castle at this critical spot and offered 100,000 dinars for its demolition, but Baldwin refused. And so in August 1179, before the outer defences could be built, Saladin attacked. His soldiers forced their way up the slope, digging steps with their axes, and his sappers mined the walls. With a Frankish relief force gathering at Tiberias the sappers worked unceasingly day and night, until finally at dawn on the sixth day they brought down a section of the wall, the Muslim accounts recording with amazement that the Templar commander threw himself into the smoke and flames. The garrison asked for surrender terms, but Saladin refused; eight hundred of the defenders were killed, their bodies stripped of their armour, and their corpses thrown into a cistern. Not all these victims were killed in battle, however; Saladin personally interviewed many of the captives and executed a number in cold blood, including all archers, as they had inflicted the greatest losses on the besiegers, and all Muslims who had converted to Christianity, this in accordance with Islamic law. The castle was destroyed, and its surviving seven hundred defenders, eighty of them knights, were taken captive to Damascus, along with a thousand suits

of armour belonging to knights and sergeants and a hundred thousand weapons.

For the first time Muslim sappers had shown their effectiveness against a major Frankish fortification, albeit one still under construction and incomplete; until now the Franks had always enjoyed a technological edge, but this Muslim advance in the arts of siege warfare was an ominous sign of things to come.

The story of the castle and its siege has been revealed by recent excavations conducted by Professor Ronnie Ellenblum of The Hebrew University in Jerusalem.[8] 'We are literally uncovering the beginning of the end for the Knights Templar', Ellenblum has said.

> Until the battle of Jacob's Ford in 1179, the Muslim leader Saladin saw nothing but defeat in all his efforts to push the crusaders out of the Holy Land. The battle of Jacob's Ford turned the tide. Saladin's forces not only succeeded in levelling a major castle, killing the whole garrison and carting off its wealth; they crushed an army that had been considered almost invincible.[9]

Saladin's victory at Jacob's Ford undermined Frankish self-confidence. All of Galilee and Trans-Jordan became a frontier area within range of Muslim attacks, while the Franks increasingly avoided frontal military encounters with the enemy. From the mobile and offensive strategy of the battle of Montgisard the Franks more and more retreated into a siege mentality.

Faced with an extreme drought that was threatening harvests throughout Syria and Outremer, in May 1180 Baldwin and Saladin agreed a two-year truce. But the truce did not apply

to the county of Tripoli, which Saladin invaded that summer, ravaging the bountiful agricultural land known to the Franks as La Bocquée – those rolling waves of wheat and maize, figs and prickly pears, vines and sunflowers that fill the Homs Gap, for all the world like Provence or Languedoc, and surveyed by the great Hospitaller fortress of Krak des Chevaliers and the Templars' Chastel Blanc. Saladin moved through the fields, wrote William of Tyre, 'and especially through the cultivated places and, with nobody to oppose him, wandering freely everywhere, set fire to the harvest, some of which was already gathered in for threshing, some of which was already collected in the fields in sheaves, and some of which was still standing, stole cattle as booty, and depopulated the entire region'. But the knights did not venture from their castles, not daring 'rashly to commit themselves to attacks'.[10]

For Saladin the prime value of the truce with the kingdom of Jerusalem was that it allowed him to pursue his siege of Aleppo, which was in the hands of Nur al-Din's son. For Baldwin it bought time. And for Christian and Muslim traders the truce meant that they could pass freely through each other's territory. But the treaty was broken the following year by Raynald of Chatillon, a bold and able soldier who was lord of Oultrejourdain, which lay astride Saladin's line of communication between Cairo and Damascus. From his castle of Kerak he could see the rich Muslim caravans travelling to Medina and Mecca, and falling upon one of these, he made off with all its goods. Saladin complained to Baldwin and demanded compensation, but Raynald refused to make restitution. In 1182 Raynald took matters further when he launched a fleet of ships into the Gulf of Aqaba and down the Red Sea, where they raided Egyptian and Arabian ports, including those serving Mecca and Medina, until they were driven back by a naval force under the command of Saladin's brother al-Adil. Although some Franks surrendered to al-Adil on condition that their lives were spared, Saladin insisted,

over the objections of his brother, that they be executed. The cold-blooded killing of prisoners increasingly became a policy of Saladin's, and the act was carried out by men of religion who travelled in his train. These beheadings, as the killings usually were, had the calculated purpose of publicising his jihad against the Franks, even as his primary war was against his fellow Muslims; also blood sacrifice accorded with jihad ideology, 'which maintained that the lands were made impure by the presence of the Franks and that the aim of the Holy War was to reconquer and purify these lands'.[11]

Early in 1186 Saladin fell gravely ill in Harran, not far from Edessa. Unable to sit up and barely conscious, he was not expected to live, and his devoted secretary Imad al-Din took his last will and testament. Since 1171, when he became sultan of Egypt, Saladin had spent no more than thirteen months fighting against the Franks; instead he directed his jihad almost entirely against his fellow Muslims, heterodox in many cases but most of them far from being heretics, whatever Saladin's propagandists had to say. Historians have since asked how would Saladin have been remembered, had he died at Harran. Would he have gone down in history merely as 'a moderately successful soldier, an administrator with a cavalry officer's view of economics and a dynast who used Islam for his own purposes'?[12] Would he be remembered for anything more than 'a record of unscrupulous schemes and campaigns aimed at personal and family aggrandisement'?[13]

Three years earlier, in 1183, after he had finally captured Aleppo, Saladin wrote to the caliph in Baghdad defending his years of warfare against his fellow Muslims. He had come to Syria, he said, to fight the unbelievers, to eradicate the heresy of the Assassins and to turn Muslims away from the path of wrongdoing. Matters might have gone more quickly, he said,

had Aleppo fallen into line, had Mosul recognised his suze-
rainty, had Syria not been wracked by a drought. But once
he would have Mosul in northern Iraq, this would lead to his
conquest of Georgia in the Caucasus, of the Almohades in
Morocco and Spain, of Constantinople and Jerusalem, 'until
the word of God is supreme and the Abbasid caliphate has
wiped the world clean, turning the churches into mosques'.[14]
Saladin's imperial and dynastic ambitions are written all over
this letter to the caliph, for, as it happens, the Almohades could
not be attacked without first conquering all North Africa;
Georgia and Constantinople could not be attacked without
overthrowing the Seljuk sultanate of Rum; and eventually,
last and least, having extended his authority over the entire
Muslim world, Saladin could deal with Outremer. According
to Imad al-Din, who never uttered a sceptical word about his
master, Saladin's illness was 'sent by God to turn away sins
[...] and to wake him from the sleep of forgetfulness'[15] – and
so towards his religious duty to destroy Outremer by jihad.

But Saladin was always a cautious general who relied on
overwhelming force, and he hesitated to fight the Franks as
long as his forces were dispersed. An event that helped alter
Saladin's outlook was the treaty he signed later in 1186, which
finally gave him effective control over Mosul. Freeing him
from more years of struggle east of the Euphrates, it allowed
him at last to turn his full attention to Outremer. Also he was
encouraged by the realisation that the Franks were moving
towards a strategy of passive defence, that rather than risk
battle in the field they preferred sheltering in their castles.
The Turks had meanwhile learned how to build and trans-
port large siege machines, both artillery such as catapults,
and movable towers, reducing the Franks' traditional super-
iority in military architecture and siege warfare. The tables
were turned; Saladin was prepared to fight a more mobile
and offensive warfare, and he no longer hesitated to take the
battle deep into Frankish territory.

The Franks were far from united on strategy; there was a growing division within Outremer between those who wanted to pursue an aggressive policy towards Saladin and those who sought accommodation. Among the former was Raynald of Chatillon, while among the latter were Count Raymond III of Tripoli and the slowly dying king. But Saladin had his own policy, which was to annihilate the Christian states, and their internal differences only made it easier for Saladin to destroy them. The danger became obvious in 1183, when Saladin captured Aleppo and with it gained full control of Syria. His one distraction for the moment was Mosul, but sooner or later he would turn against the Christians.

With Outremer encircled, the Templar and Hospitaller Grand Masters set sail in 1184 together with Heraclius, the patriarch of Jerusalem, to seek help from the West. The kings of France and England and the Holy Roman emperor received them with honour and discussed plans for a great crusade, but they gave pressing domestic reasons for not going to the East themselves, and instead they paid barely sufficient money to cover the cost of a few hundred knights for a year. While in London early in 1185, Heraclius consecrated the new Temple Church, the one that stands there to this day. But the Templar Grand Master did not get that far; he had fallen ill en route, and died at Verona.

At about the same time as Heraclius was consecrating the new Templar church in London, Gerard of Ridefort was elected the new Grand Master by the Templars in Jerusalem, his elevation coinciding with the culmination of factional disputes within the kingdom. Baldwin IV died in March 1185 and was buried in the Church of the Holy Sepulchre, and his successor, the child-king Baldwin V, died in 1186, not yet nine years old. Raymond III of Tripoli, leader of the party seeking accommodation with Saladin, had been the boy's regent

according to his father's will, which also stated that, if the child died before the age of ten, Raymond was to remain as regent until a new king was chosen through the arbitration of the pope, the Holy Roman emperor and the kings of France and England.

Instead the boy's mother, Sibylla, who was the sister of the leper king and the granddaughter of the formidable Melisende, claimed the throne for herself and her husband, Guy of Lusignan. Backed by the party that supported an aggressive policy towards Saladin – among them Raynald of Chatillon, the lord of Oultrejourdain, Gerard of Ridefort, the Grand Master of the Templars, and Heraclius, the patriarch of Jerusalem, who was rumoured to also have been the lover of Sibylla's mother, Agnes – Sibylla and Guy were quickly crowned at Jerusalem. All the barons of Outremer accepted what in effect was a coup d'état – all except Raymond of Tripoli, who felt he had been cheated of the kingship, and his close ally Balian of Ibelin.

Going from factional rivalry to treason, Count Raymond of Tripoli entered into a secret treaty with Saladin. It applied not only to Tripoli itself but also to his wife's principality of Galilee, even though it was part of the kingdom of Jerusalem, which might soon be at war with the Muslims. Saladin also promised his support for Raymond's aim to overthrow Sibylla and Guy of Lusignan and make himself king. In April 1187 Guy responded by summoning his loyal barons and marching north to Galilee to reduce it to submission before the expected Muslim attack began. But Balian of Ibelin, fearing the consequences of civil war, persuaded Guy to let him lead a delegation to Tiberias on the Sea of Galilee and try to negotiate a reconciliation between Raymond and the king. The delegation would include the grand masters of

the Hospitallers and the Templars, and Balian would meet them at the Templar castle of La Fève on 1 May.

Meanwhile Saladin had asked Raymond's permission to send a reconnaissance party of Mameluke slave troops through Galilee on that day, and although the timing was embarrassing, Raymond was obliged to agree under the terms of the secret treaty, stipulating only that the Muslims should traverse his territory within the day and be gone by dark, and do no harm to any town or village. Raymond broadcast the news that the Muslim party would be passing through and urged his people to stay indoors. But Balian had heard nothing of this when he arrived at La Fève in the middle of the morning on 1 May expecting to join the Grand Masters there. Instead he found the castle empty, and after waiting in the silence for an hour or two, he set out again towards Tiberias, thinking the others had gone ahead, when suddenly a bleeding Templar knight galloped by shouting out news of a great disaster.

Raymond of Tripoli's message about the Muslim party had reached La Fève in the evening of the previous day, 30 April, when Gerard of Ridefort heard the news. At once he summoned the Templars from the surrounding neighbour-hood, and by nightfall ninety had joined him there. In the morning they rode north through Nazareth, where forty sec-ular knights joined the hunt for the enemy's scouting party. But as they passed over the hill behind Nazareth what they saw was a large expedition of perhaps seven thousand elite Mameluke horsemen watering their mounts at the Springs of Cresson in the valley below. Both the Templar marshal and the Hospitaller Grand Master advised retreat, but Gerard of Ridefort, the Templar Grand Master, insisted on attack. Charging furiously down the hillside, the one hundred and thirty knights rode into the mass of the Muslim cavalry and were slaughtered almost to a man, only three Templars, Gerard among them, escaping with their lives.

That, at any rate, was the account given by an anonymous chronicler who obtained much of his information from the chronicle of Ernoul, who was a member of Balian's entourage. But neither Balian nor Ernoul was at the battle, and any account issuing from Balian's camp was likely to paint their factional opponent Gerard of Ridefort in the worst possible light. Another chronicle, the *Itinerarium Regis Ricardi*, apparently based partly on the lost journal of an English knight writing in about 1191, contradicts the story that Gerard rushed recklessly at the enemy; instead, and much more plausibly, it reports that the Templars were caught unaware and were the victims of a Muslim attack. Even so, Saladin's expedition kept to his agreement with Raymond of Tripoli, for his horsemen rode home long before nightfall, and they had not harmed a town or village in Galilee. But fixed to the lances of the Mameluke vanguard were the heads of the Templar knights.

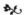

Shamed by this tragedy, which was largely his doing, Raymond of Tripoli broke his treaty with Saladin and rode to Jerusalem, where he made his peace with the king. The peril was far too great for Guy of Lusignan to do anything but welcome Raymond's renewed loyalty to the kingdom, for at that moment Saladin was gathering a great army just over the frontier. Guy called every able-bodied man to arms at Acre, emptying the cities and castles of fighting men; at about 18,000 strong, including 1,200 mounted knights, the army was all that Outremer had to give. Against this Saladin had drawn on the Turkish and Kurdish occupiers of Egypt, Iraq and Syria, along with their Mameluke slave troops and a number of volunteer jihad fighters who were ascetics and Sufis, for his invasion force of about 42,000 men, including 12,000 cavalry,[16] and on 1 July 1187 he crossed the Jordan at

Senabra, where it issues from the southern end of the fresh-water lake known as the Sea of Galilee.

On the following day, as Saladin was laying siege to Tiberias, the Frankish army settled in a good defensive position, well watered and with plenty of pasturage for the horses, 15 miles to the west at Sephoria (present-day Tzippori). The Templars and the Hospitallers were there, also Raymond, the count of Tripoli, and Raynald of Chatillon, Balian of Ibelin and many other lords with all their men, together with the bishop of Acre, who carried the True Cross. The plan they had all agreed with the king was to wait, confident that Saladin could not hold his large army together in the parched countryside for very long during the heat of summer. But that evening a message arrived from Raymond's wife, Eschiva, the countess of Tripoli, telling how she was at Tiberias holding out against Saladin's attack. King Guy held a council in his tent, where many of the knights were moved by her desperate situation and wanted the army to march to her rescue. But Raymond rose and spoke, saying it would be foolhardy to abandon their present strong position and make a hazardous march through barren country in the fierce July heat.

'Tiberias is my city and my wife is there', spoke Raymond, according to the chronicle *De Expugnatione Terrae Sanctae per Saladinum.*

> None of you is so fiercely attached, save to Christianity, as I am to the city. None of you is so desirous as I am to succour or aid Tiberias. We and the king, however, should not move away from water, food and other necessities to lead such a multitude of men to death from solitude, hunger, thirst and scorching heat. You are well aware that since the heat is searing and the number of people is large, they could not survive half a day without an abundance of water. Furthermore, they could not reach the enemy

without suffering a great shortage of water, accompanied by the destruction of men and of beasts. Stay, therefore, at this midway point, close to food and water, for certainly the Saracens have risen to such heights of pride that when they have taken the city, they will not turn aside to left or right, but will head straight through the vast solitude to us and challenge us to battle. Then our men, refreshed and filled with bread and water, will cheerfully set out from camp for the fray. We and our horses will be fresh; we will be aided and protected by the Lord's cross. Thus we will fight mightily against an unbelieving people who will be wearied by thirst and who will have no place to refresh themselves. Thus you see that if, in truth, the grace of Jesus Christ remains with us, the enemies of Christ's cross, before they can get to the sea or return to the river, will be taken captive or else killed by sword, by lance, or by thirst.[17]

By the time the council broke up at midnight it had resolved to remain at Sephoria. But Raymond's earlier treaty with Saladin had created an atmosphere of bitterness and mistrust among some, and his motives were now suspect. Later that same night the Grand Master of the Templars, Gerard of Ridefort, came to the king's tent and said that Raymond was a traitor and that to abandon Tiberias, which lay so close by, would be a stain on Guy's honour, as it would be on the Templars' own if they left unavenged the deaths of so many of their brothers at the Springs of Cresson. At this the king overturned the council's decision and announced that the army would march at dawn.

Leaving the gardens of Sephoria behind on the morning of 3 July, the Christian army marched across the barren hills towards the climbing sun. The day was hot and airless, and the men and horses suffered terribly for there was no water along the road. Guy was at the centre of the column, and

the Templars brought up the rear. As Raymond of Tripoli held Galilee in fief from the king, it was his prerogative to lead the way. This led some to find treachery in the choice of route, for the choice was his. There may have been treachery from some quarter, for Saladin quickly discovered the line of the Franks' advance, warned, it was said, by several secular knights, and sent skirmishers to harass and weary the vanguard and rearguard with flights of arrows, while he himself marched his army the 5 miles from Tiberias to Hattin, a well-watered village amid broad pastures situated where the road across the hills descended towards the lake. By the afternoon the Christian army had reached the plateau above Hattin, and here Raymond said they should camp; there was water there, he thought, but the spring turned out to be dry. According to one version, it was the Templars who said they could go no further and the king who made the decision to set up camp, causing Raymond to cry out, 'Alas, Lord God, the battle is over! We have been betrayed unto death. The Kingdom is finished!'[18] Between the Franks and the village, from where the ground fell away towards the lake, rose a hill with two summits. It was called the Horns of Hattin.

There on the waterless plateau the Christian army spent the night, their misery made worse by the smoke and flames from the dry scrub on the hillside that the Muslims had set alight. Under cover of darkness Saladin's forces crept closer; any Franks who slipped away in search of water were killed; and by dawn the Christian army was surrounded on all sides. Soon after daybreak on 4 July 1187 Saladin attacked. Against him charged the Christian infantry, desperate to break through his lines to reach water, but they were killed or driven back; so goes the account in one chronicle, but in another they simply ran away and refused to fight. In yet another version the king

gave orders for the master and the knights of the Temple to begin hostilities; some of the soldiers were

drawn up in battle order for the fight and the battle standards were entrusted to the count of Tripoli and the other leaders of the army. Attacking like strong lions, the knights of the Temple killed part of the enemy and caused the rest to retreat, but our other troops failed to obey the king's orders. They did not advance to provide back-up and, as a result, the knights of the Temple were hemmed in and slaughtered.[19]

By all accounts the knights put up a terrific fight and repeatedly checked Saladin's cavalry attacks, but their real enemy was thirst and as their strength failed them their numbers were diminished.

The Templars and the Hospitallers gathered round the king and the True Cross, where they were surrounded by the confusion and press of battle, the *Expugnatione* describing how the Christians were 'jumbled together and mingled with the Turks'. It goes on to tell how the king, seeing that all was lost, cried out that those who could escape should do so before it was too late. At this Raymond of Tripoli and Balian of Ibelin with their men charged the enemy line, hoping to break through. 'The speed of their horses in this confined space trampled down the Christians and made a kind of bridge, giving the riders a level path. In this manner they got out of that narrow place by fleeing over their own men, over the Turks, and over the cross.'[20] As they bore down on Saladin's line, it opened and let them pass through, then closed again; they were the last to get away. Soon the battle was over. The True Cross fell to Muslim hands. King Guy and those around him gave way to exhaustion and were taken.

Saladin's tent was set up on the battlefield, and here the king and his surviving barons were brought before their conqueror. Seating the king next to him, Saladin handed Guy a cup of water to slake his thirst. It also was a sign, for it was the custom that to give food or drink to a captive meant

that his life was spared. But when Guy passed the water to Raynald of Chatillon, Saladin told the king, 'You gave the man the drink, not I.' Then he turned angrily on Raynald, reminding him of his brigandage and his raids down the Red Sea coast to the ports for Medina and Mecca, and accused him of blasphemy. When Saladin offered Raynald the choice between conversion to Islam and death, Raynald replied that it was Saladin who should convert to Christianity to avoid the eternal damnation that awaited unbelievers – at which Saladin struck off his head.

Saladin's secretary Imad al-Din then surveyed the battlefield which he described in pornographic detail.

> The dead were scattered over the mountains and the valleys, lying immobile on their sides. Hattin shrugged off their carcasses, and the perfume of victory was thick with the stench of them. I passed by them and saw the limbs of the fallen cast naked on the field of battle, scattered in pieces over the site of the encounter, lacerated and disjointed, with heads cracked open, throats split, spines broken, necks shattered, feet in pieces, noses mutilated, extremities torn off, members dismembered, parts shredded, eyes gouged out, stomachs disembowelled, hair coloured with blood, the praecordium slashed, fingers sliced off, the thorax shattered, the ribs broken, the joints dislocated, the chests smashed, throats slit, bodies cut in half, arms pulverised, lips shrivelled, foreheads pierced, forelocks dyed scarlet, breasts covered with blood, ribs pierced, elbows disjointed, bones broken, tunics torn off, faces lifeless, wounds gaping, skin flayed, fragments chopped off, hair lopped, backs skinless, bodies dismembered, teeth knocked out, blood spilt, life's last breath exhaled, necks lolling, joints slackened, pupils liquefied, heads hanging, livers crushed, ribs staved in, heads shattered, breasts

flayed, spirits flown, their very ghosts crushed; like stones among stones, a lesson to the wise.

But this grisly scene in Muslim eyes was a purification.

This field of battle had become a sea of blood; the dust was stained red, rivers of blood ran freely, and the face of the true Faith was revealed free from those shadowly abominations. O sweet rivers of victory over such evil! O burning, punishing blows on those carcasses! O sweet heart's comforter against that confusion! O welcome prayers at the joyful news of such an event!

Singled out for special mention were 'the faces of the infernal Templars ground in the dust, skulls trampled underfoot, the bodies they were blessed with hewn to pieces and scattered'.[21]

Saladin reserved the final act of purification for the Templars and Hospitallers who had survived the battle. Although Gerard of Ridefort, the Templars' Grand Master, was among the prisoners taken to Damascus together with the king, the other monastic knights faced a different fate. Frankish nobles were 'irresponsible, thoughtless, petty and covetous', thought al-Hawari, who wrote a military treatise for Saladin, qualities that allowed them to be manipulated to suit Saladin's purposes; but the Templars and Hospitallers were dangerous because 'they have great fervour in religion, paying no attention to the things of this world'.[22] Two days after his victory, wrote Imad al-Din, who was an eyewitness to the event, Saladin

sought out the Templars and Hospitallers who had been captured and said: 'I shall purify the land of these two impure races.' He assigned fifty dinar to every man who had taken one of them prisoner, and

immediately the army brought forward at least a hundred of them. He ordered that they should be beheaded, choosing to have them dead rather than in prison. With him was a whole band of scholars and Sufis and a certain number of devout men and ascetics; each begged to be allowed to kill one of them, and drew his sword and rolled back his sleeve. Saladin, his face joyful, was sitting on his dais; the unbelievers showed black despair.

With Saladin's troops lined up on either side, the knights awaited their death one by one. The slash of the blade was not always cleanly done. But there was praise from Imad al-Din for the Muslim holy man he saw 'who laughed scornfully' as he slaughtered one victim after another.

How many promises he fulfilled, how much praise he won, the eternal rewards he secured with the blood he had shed, the pious works added to his account with a neck severed by him! How many blades did he stain with blood for a victory he longed for, how many lances did he brandish against the lion he captured, how many ills did he cure by the ills he brought upon a Templar. [...] I saw how he killed unbelief to give life to Islam, and destroyed polytheism to build monotheism, and drove decisions through to their conclusion to satisfy the community of the faithful, and cut down enemies in the defence of friends![23]

19

The Fall of Jerusalem to Saladin

THE TOWNS AND CITIES and castles had been emptied to defend the Holy Land against the Muslim invasion. Now, after the battle of Hattin, Outremer stood almost entirely defenceless against Saladin. Terricus, the grand preceptor of the Temple and the senior surviving knight of the order after Hattin, wrote to his brothers in the West in the latter part of July or early August 1187, telling them of the fateful battle.

> They drove us into a very rocky area where they attacked us so vigorously that they captured the Holy Cross and our king, and wiped out all our host. Two hundred and thirty of our brothers were beheaded that day, we believe, the other sixty having been killed on 1 May [at the Springs of Cresson]. It was with great difficulty that the lord count of Tripoli, lord Reynald of Sidon and lord Balian and we ourselves managed to escape from that dreadful battlefield.

Terricus then reported how the slaughter was continuing across the length and breadth of Outremer:

Intoxicated by the blood of our Christians the whole horde of pagans immediately set out for the city of Acre. They took it by force and then laid waste to the whole land. Only Jerusalem, Ascalon, Tyre and Beirut still remain in our possession for Christendom, but we will not be able to hold them unless help comes quickly from you and from above as virtually all their inhabitants are dead. At the present moment they are actively besieging Tyre, attacking day and night, and their numbers are so great that they are like a swarm of ants covering the whole face of the earth from Tyre to Jerusalem, even as far as Gaza. Find it in yourselves to come with all haste to our aid and that of Eastern Christendom which is, at present, totally lost, so that through God and with the support of your eminent brotherhood we may save the cities that remain. Farewell.[1]

Acre surrendered on 10 July, Sidon followed suit on the 29th, and Beirut capitulated on 6 August. Jaffa refused to yield; in July it was taken by storm, and its entire population were killed or sent to the slave markets and harems of Aleppo. Ascalon offered some brief resistance, but Saladin had King Guy plead to its people that his liberty could be bought by their city's surrender, and on 4 September they gave in. A few days later Saladin brought Gerard of Ridefort to the walls of Gaza and made him tell the Templars inside to surrender, which, obedient to their Grand Master, they promptly did. In the south only Tyre resisted capture; in the north there was Tripoli, Tortosa and Antioch, and they could be dealt with later – but this was a serious strategic mistake; Saladin's capture of the ports would have severed Outremer from the wider Mediterranean and from overseas aid, which would eventually come in the form of the Third Crusade; but caught up in his own jihad propaganda, Saladin turned to Jerusalem.

Refugees were flooding into Jerusalem, but there were few men of fighting age or experience among them, and for every man there were said to be fifty women and children. Heraclius, the patriarch of Jerusalem, wrote to Pope Urban III in September reporting that now only the holy city and Tyre were holding out against the onslaught. Everywhere else the Muslims had captured all the towns, 'killing almost all their inhabitants', and now Saladin was expected any day to lay siege to Jerusalem, which was 'totally lacking in men to defend it'.[2]

Queen Sibylla did what she could, together with Heraclius and various functionaries of the military orders, to prepare the city's defence, but Jerusalem lacked a leader until Balian of Ibelin appeared. After Hattin his wife and children had sought safety within its walls, and Balian had come to Jerusalem to bring them to the coast at Tyre. As Tyre was under siege, Balian was able to make this journey only with Saladin's permission, which was granted on condition that he travel unarmed and stay in Jerusalem no more than one night. But the people of Jerusalem clamoured for Balian to stay, and finally he accepted the task of readying the city against Saladin's attack. His most immediate need was to raise morale; there were only two knights left in the city, so Balian knighted every boy over sixteen of noble birth and also thirty burgesses. To fund the defence he took over the royal treasury and even stripped the silver from the dome of the Church of the Holy Sepulchre. He sent parties out into the areas all around to collect all the food before the Muslims arrived, and he gave arms to every able-bodied man.

After allowing his men to pillage and raid all along the coast, Saladin marched his army to Jerusalem, and on 20 September he was camped outside the city. He is said to have inquired about the location of the Aqsa mosque and asked the shortest route to it, saying that was also the shortest route to heaven. The story makes no sense, however, as the Temple

Mount is on the eastern side of the city and Saladin had arranged his men and his siege machines as far away as could be, opposite the western wall, which was defended by a deep ravine and ran between two formidable towers, that of David and Tancred. But the story was part of the jihad propaganda, which focused on the Temple Mount and the Night Journey and was developed by Saladin to justify the Muslim claim to Jerusalem. Likewise the siege of Jerusalem was presented by Muslim chroniclers in epic terms, with both Imad al-Din and Ibn Shaddad making the fantastical claims that the city was filled with more than sixty thousand fighting men, while Ibn al-Athir reported that the Franks had 'exactly 70,000 cavalry and infantry in Jerusalem'. But another remark by Ibn al-Athir may have been true, that as the Turks approached the walls they saw 'a terrifying crowd of men and heard an uproar of voices coming from the inhabitants behind the walls that led them to infer the number of people who must be assembled there',[3] probably a brave and orchestrated effort by the people of Jerusalem to make themselves seem defiant and intimidating.

After several days achieving nothing against the western wall Saladin moved his forces to the north, where the land is high and the city most vulnerable. There he set his sappers to work undermining that section of the northern battlements where Godfrey of Bouillon had forced his way into Jerusalem eighty-eight years earlier. By 29 September a great breach was made in the wall, which was tenaciously defended, but it was only a matter of time before the defenders would be overwhelmed by Saladin's hordes. Balian with the support of the patriarch decided to seek terms, and on 30 September he went to Saladin's tent.

Saladin was uncompromising. He had been told by his holy men, he said, that Jerusalem could only be cleansed with Christian blood, and so he had vowed to take Jerusalem by the sword; only unconditional surrender would make him

stay his hand. But Balian boldly warned that, unless they were given honourable terms, the defenders in their desperation would destroy everything in the city. Balian's words were reported by Ibn al-Athir:

> Know, O Sultan, that there are very many of us in this city, God alone knows how many. At the moment we are fighting half-heartedly in the hope of saving our lives, hoping to be spared by you as you have spared others; this is because of our horror of death and our love of life. But if we see that death is inevitable, then by God we shall kill our children and our wives, burn our possessions, so as not to leave you with a dinar or a drachma or a single man or woman to enslave. When this is done, we shall pull down the Sanctuary of the Rock and the Masjid al-Aqsa and the other sacred places, slaughtering the Muslim prisoners we hold – 5,000 of them – and killing every horse and animal we possess. Then we shall come out to fight you like men fighting for their lives, when each man, before he falls dead, kills his equals; we shall die with honour, or win a noble victory!

Whatever Balian's actual words, the essence of his threat went straight to the heart of Saladin's jihad propaganda; with considerable courage for a man who by remaining in Jerusalem and leading its defence had broken his word to Saladin, Balian was now telling the sultan to his face that, unless he swore to spare the lives of the city's population, they would reduce the Muslim holy sites – the supposed object of his jihad – to ashes. Sparing Christian lives ran against Saladin's previous determination to purify Jerusalem with Christian blood, and he felt he had to excuse himself to the caliph in Baghdad, to whom he afterwards wrote that to do otherwise meant losing Muslim lives to achieve a victory that had already been won. In the event Saladin gave in to Balian's

demand. He allowed that the Franks could leave Jerusalem if they paid a ransom of 10 dinars for each man, 5 for each female, and 1 for each boy up to seven years old; those unable to pay within forty days would be taken as slaves. As for the Eastern Christians of Jerusalem, he decreed that they could remain within the city provided first they paid the ransom and then the *jizya* too, thereby submitting to their former humiliating status as *dhimmis*.

On 2 October 1187, the twenty-seventh day of Rajab according to the Islamic calendar, Muslims gathered to watch Saladin's ceremonial entry to Jerusalem and to join in the festivities amid the misery of its Christian population. Saladin's face 'shone with joy [...] his city radiated light', wrote his secretary Imad al-Din. 'Great joy reigned for the brilliant victory won, and words of prayer and invocation to God were on every tongue.'[4] The chronicler and jurist Ibn Shaddad exulted in this felicitous timing: 'What a wonderful coincidence! God allowed the Muslims to take the city as a celebration of the anniversary of their Holy Prophet's Night Journey.'[5] But there was no coincidence about it; Saladin had waited to this date to enter Jerusalem; the story of the Night Journey had long been evolving to justify Muslim control of the holy city.

Ironically it was the Fatimids, heretics in the eyes of Nur al-Din and Saladin and against whom they had fought a jihad, who rebuilt the mosque at the southern end of the Temple Mount and added the mosaic inscription from the Koranic verse 17:1 about the Night Journey which Muslims have come to interpret as Mohammed travelling to Jerusalem and ascending from there for a glimpse of Paradise: 'Glory be to Him, who carried His servant by night from the Holy Mosque to the Further Mosque the precincts of which We

have blessed that We might show him some of Our signs.'[6]
From that moment the mosque became known as the Fur-
thest, al-Aqsa; and a century later the poet Ibn al-Qaysarani
used the image of the Aqsa mosque to promote the jihad of
Nur al-Din:

> May it, the city of Jerusalem, be purified by the
> shedding of blood
> The decision of Nur al-Din is as strong as ever and
> the iron of his lance is directed at the Aqsa.[7]

As the historian Carole Hillenbrand has written, 'Jerusa-
lem became the focus of a cleverly orchestrated ideological
campaign which played on its loss to the Crusaders. The
yearning for Jerusalem could be exploited to the full by Mus-
lim propagandists, who dwelt on the pain and humiliation of
seeing Jerusalem become a Christian city with mosques and
Muslim shrines being turned into churches or secular build-
ings.'[8] This Muslim appropriation of Jerusalem through the
story of the Night Journey was 'exploited to the full by Sala-
din's entourage and by the religious classes who gave him
their wholehearted support'.[9] Saladin's capture of the city in
1187 and his rituals of purification were meant to set the seal
on the Islamic sanctity of Jerusalem.

On entering the city Saladin observed that 'the unbelievers
had turned Jerusalem into a garden of paradise, filling the
churches and the houses of the Templars and Hospitallers
with marble'.[10] Nevertheless he wasted no time in ordering
the removal of all traces of what he called 'the filth of the
hellish Franks'.[11] Christian structures on the Temple Mount,
including the monastery of the Augustinian canons, were
dismantled. The cross erected atop the Templum Domini

– that is, the Dome of the Rock – was thrown down before the army of Saladin and in the presence of the Frankish population. A great cry went up when it fell, of anguish from the Christians, and of 'Allah is Great' from the Muslims, who dragged it round the streets of the city for two days, beating it with clubs. Also on the Temple Mount, which the Muslims called the Haram al-Sharif, the Noble Sanctuary, the Templars' headquarters at the Templum Solomonis was cleansed of Christian contamination to make it suitable for Muslim prayers. This contamination was described by Imad al-Din in the most grotesque terms. 'The Aqsa mosque', he said, 'especially its mihrab, was full of pigs and obscene language, replete with the excrement they had dropped in the building, inhabited by those who have professed unbelief, have erred and strayed, acted unjustly and perpetrated offences, overflowing with impurities.'[12] Imad al-Din's description bore no relation to the actual conditions at the Templum Solomonis; rather, it expressed the jihadist horror of any trespass in what Muslims claimed as their sacred space. Finally the Aqsa mosque and the Dome of the Rock were cleansed with rosewater and incense in preparation for Friday prayers.

Saladin joined the vast congregation that gathered for Friday prayers on 9 October at the Aqsa mosque, where Ibn Zaki, the qadi of Aleppo, gave the sermon in which he compared Saladin's victory to the caliph Umar's conquest of the city in 638 and other Muslim triumphs going back to Mohammed's battles at Badr against the Meccans and at Khaybar, which led to the expulsion of the Jews from the Arabian peninsula. Jerusalem, he continued to the Muslims, is

> the dwelling-place of your father Abraham; the spot from which your blessed Prophet Mohammed mounted to Heaven; the qibla towards which you turned to pray at the commencement of Islam; the abode of the prophets; the place visited by the saints; the cemetery of the apostles [...] it is the country

where mankind will be assembled for judgement;
the ground where the resurrection will take place.[13]

Ibn Zaki, who had been hand-picked by Saladin for this
sermon, was full of praise for the 'cleansing of His Holy
House [Bayt al-Maqdis, i.e., Jerusalem] from the filth of
polytheism and its pollutions', and he called on the faith-
ful to 'purify the rest of the land from this filth which hath
angered God and His Apostle'.[14]

By the time Ibn Zaki had delivered his sermon on the
Temple Mount the Muslims had gone round Jerusalem and
had torn down churches both within and without its walls or
stripped them of their decorations, including their wood and
iron, their doors and their marble flooring, and converted
them to mosques and madrasas. But the Church of the Holy
Sepulchre was spared. Some emirs wanted it destroyed in
order to put an end to Christian pilgrimages, fearing that
'kings bearing crosses, groups from across the sea, throngs
of different kinds of infidels' would make their way to Jeru-
salem, their aim to 'liberate the Tomb and restore the Kum-
amah', repeating the old jibe of the Holy Sepulchre being
the Church of the Kumamah – that is, the Dunghill.[15] But
others argued that what Christians came to worship was 'the
place of the Cross and the grave, not the buildings which can
be seen. They would not stop coming even if the earth [on
which it stands] were scattered to the sky.'[16]

In fact, as Saladin understood, the economy of Jerusalem
depended on the pilgrimage trade, and therefore he decided
that both the Church of the Holy Sepulchre and the Hospital
of St John should stand and pay their way. Ten Hospitaller
brothers were permitted to continue at the Hospital, caring
for the sick, and while the Latin clergy were expelled from
the city, a number of Orthodox priests were permitted to stay
at the Church of the Holy Sepulchre. But this did not stop
Saladin dismantling the aedicule over the tomb of Christ; the

Muslims 'threw down the marble framework that enclosed the Sepulchre of Our Lord and took the carved columns that stood in front of it and sent them to Muhammed at Mecca as a sign of victory'.[17] He also removed the cross from the dome of the church, broke the bells in the tower and blocked up several entrances while the aedicule was kept under lock and key by Muslims. Entrance to the church was generally forbidden to pilgrims until 1192, at which point four Latin clergy, two priests and two deacons, were also permitted to return. But between 1187 and 1192 an exception was made for pilgrims willing to pay an entrance fee of 10 bezants, a sum equal to a man's ransom at the fall of the city, a small fortune aimed at gouging the maximum price from the Christian faithful.[18]

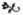

The departure of the Franks from Jerusalem was completed by 10 November. The city gates were shut, and nobody could leave without getting a receipt from a clerk for payment of the ransom and showing it to the guards. Saladin allowed Queen Sibylla to go free without payment, and he permitted the patriarch Heraclius to remove the treasures from the Church of the Holy Sepulchre. But those who tried to raise their ransom money by selling their possessions discovered that the glut of items on the market meant that what had once sold for 10 dinars now fetched only one. Imad al-Din estimated that there had been more than a hundred thousand men, women and children in the city, and he reported that people were paying bribes to the gatekeepers to go free, others were lowered from the city walls, and some were smuggled out in panniers slung over the backs of beasts of burden, while a number left disguised as Muslim soldiers. Despite Balian contributing 30,000 dinars for the poor, Imad al-Din reported fifteen thousand people who were unable to pay the ransom and were taken away as slaves.

'There were about 7,000 men', wrote Imad al-Din,

> who had to accustom themselves to an unaccus-
> tomed humiliation, and whom slavery split up and
> dispersed as their buyers scattered through the hills
> and valleys. Women and children together came to
> 8,000 and were quickly divided up among us, bring-
> ing a smile to Muslim faces at their lamentations.
> How many well-guarded women were profaned,
> how many queens were ruled, and nubile girls mar-
> ried, and noble women given away, and miserly
> women forced to yield themselves, and women who
> had been kept hidden stripped of their modesty,
> and serious women made ridiculous, and women
> kept in private now set in public, and free women
> occupied, and precious ones used for hard work,
> and pretty things put to the test, and virgins dis-
> honoured and proud women deflowered, and lovely
> women's red lips kissed, and dark women pros-
> trated, and untamed ones tamed, and happy ones
> made to weep! How many noblemen took them
> as concubines, how many ardent men blazed for
> one of them, and celibates were satisfied by them,
> and thirsty men sated by them, and turbulent men
> able to give vent to their passion. How many lovely
> women were the exclusive property of one man,
> how many great ladies were sold at low prices, and
> close ones set at a distance, and lofty ones abased,
> and savage ones captured, and those accustomed to
> thrones dragged down![19]

Two great lines of Christian refugees were led out from
Jerusalem: one bound for slavery, the other for freedom. The
ransomed refugees were assembled in three groups, Balian
and the patriarch Heraclius taking charge of one group,
another being placed in the custody of the Hospitallers, and

the third under the protection of the Templars. After one last look back at Jerusalem and the brow of the Temple Mount, the refugees were led to the coast, where they were distributed between Antioch, Tyre and Tripoli.

Saladin did not wait for the ransom period to expire; on 30 October he left the city for the coast, camping outside Acre on 4 November on his way north to attack Tyre, 'the only arrow left in the quiver of the infidels'.[20]

PART VI

The Kingdom of Acre

*I*N THE EARLY *1190s, in a remarkably short and powerfully effective
campaign, Richard the Lionheart, king of England and leader of
the Third Crusade, together with his allies the Templars, delivered a
series of powerful blows against Saladin and recovered much of Outre-
mer. In name and number the revived crusader states were as before,
but their outlines were diminished. There was the kingdom of Jerusalem,
although its capital was at Acre, which the Templars made their new
headquarters. To the north was the county of Tripoli. But the Muslims
retained control of the Syrian coast around Latakia for some time, and
so the principality of Antioch further to the north was now no longer
contiguous to the other crusader states. Nevertheless the Third Cru-
sade, in which Richard relied heavily on the Templars, had saved the
Holy Land for the Christians and went a long way towards restoring*

Frankish fortunes. In this Richard was abetted by the military orders, whose great castles stood like islands of Frankish power amid the Muslim torrent. More than ever Outremer was relying on the military orders in their castles and on the field of battle, and the power of the orders grew. In fact, at no point in their history would the Templars be more powerful than in the century to come.

Saladin died soon after the Third Crusade, and his dynastic empire dissolved, so that a quarter of a century later Frederick II, Holy Roman emperor, was able to mount an expedition against Egypt that forced Saladin's heir to cede control over Jerusalem. But the recovery of Jerusalem was brief and no more than symbolic; the life of Outremer had passed to the coast, where Acre, the new capital of the kingdom of Jerusalem, was a thriving cosmopolitan mercantile port that bore comparison to Constantinople.

When the remnants of Saladin's dynasty, the Ayyubids, were overthrown in Cairo by the militaristic Mameluke Turks in 1260, a foreboding crept across Outremer. A slave warrior elite who soon extended their control from Egypt over the whole of western Asia, the Mamelukes could call upon boundless resources and the vast manpower derived from the continuing westward migration of Turkish tribes to subject Outremer to insistent and unrelenting attack. No amount of fighting excellence by the Templars or others in Outremer was sufficient to withstand the onslaught for long.

20

Recovery

CONTROL OF THE COAST had always been essential for the security, the supply and the development of Outremer. But in its eagerness to capture Jerusalem the First Crusade marched past Acre in 1099, making no attempt to occupy the city. The conquest of the coast was left to King Baldwin I, who took the sea ports of Caesarea, Jaffa and Arsuf and in 1104 captured Acre with the help of a Genoese fleet. As other leading ports such as Tyre and Ascalon were still in Fatimid hands, Acre became the chief port of the kingdom of Jerusalem, and it attracted merchants from the great trading cities of Italy and Provence. Genoa, Pisa, Venice and Amalfi, and also Marseille, established themselves there, each community with its own quarter and piazza, with its own church, court house and warehouses, as well as its own mills, bakery and butchers. Also each community enjoyed a high degree of autonomy and was administered by its own representative; the interests and rivalries of these trading colonies would dominate the affairs of Acre throughout the two centuries to come.

Both the Templars and the Hospitallers had bases in the city. As the nearest good harbour to Jerusalem, Acre became the favoured port of disembarkation for pilgrims;

the Hospitallers gave them hospitality, and the Templars escorted them on the road. Theoderich, a German pilgrim and author of a guide to the Holy Land, described the busy pilgrim traffic when he passed through Acre in 1172:

> The Templars have built a large house of admirable workmanship by the seashore, and the Hospitallers likewise have founded a stately house there. Wherever the ships of pilgrims may have landed them, they are all obliged to repair to the harbour of this city to take them home again on their return from Jerusalem. Indeed in the year which we were there – on Wednesday in Easter week – we counted eighty ships in the port besides the ship called a 'buss', on board which we sailed thither and returned.[1]

Because of the vital commercial and pilgrim traffic that passed through Acre, not to mention the city's military importance, it was ruled directly by the king of Jerusalem through a governor, who, notwithstanding the autonomy of the trading colonies, ran the police and the justice systems and collected the port taxes which were a principal part of the royal revenue. The kings themselves often spent time at Acre enjoying the Mediterranean weather, and numbers of the barony of Outremer had properties here; both they and the Latin bishop of the city were bound by the feudal levy to raise knights for the defence of the kingdom and to provide bodies of hired troops at times of great emergency; in the fateful year of 1187 the city's manpower contribution to the kingdom was second only to that of Jerusalem itself.

Acre was no less important for Muslim trade, and the city possessed two mosques, one inside the walls and one without. Ibn Jubayr, who visited Acre in 1185, was impressed, although that did not stop him from hurling the usual imprecation at anything Frankish.

In the morning […] we arrived at the city of Acre (may God destroy it!). […] It is the base of the Frankish towns in Syria and the landing place of 'the ships carrying their sails aloft in the sea like mountains' [Koran 55:24]. The harbour of every ship, in grandeur it resembles Constantinople; the place of assembly for ships and caravans, the meeting place of Muslim and Christian merchants from all parts, its roads and streets are choked with multitudes having little room to tread.[2]

After the defeat of the Frankish army at Hattin in July 1187, Acre surrendered to Saladin without resistance. Of all the seaports of the kingdom of Jerusalem only Tyre remained in Frankish hands; it had been overlooked by Saladin in his rush to take Jerusalem, a serious strategic mistake. Terricus, formerly grand preceptor of the Temple at Jerusalem, reported the situation to King Henry II of England in January 1188, saying that Saladin had now returned to Tyre and was besieging it 'with thirteen *petrarii* launching stones nonstop, day and night', from 11 November 1187 to 1 January 1188. Conrad, the lord of Tyre, led the defence by positioning his knights and infantry on the city wall, and then,

> with the help of the house of the Hospital and the brothers of the Temple, he launched seventeen armed galleys and ten smaller boats in a successful attack against the galleys of Saladin, capturing eleven. He also captured the admiral-in-chief of Alexandria and eight other admirals. Many Saracens were killed. Saladin's remaining galleys escaped from the Christians to rejoin his army. There Saladin had them drawn up on land and burnt, reducing them to dust and ashes. He was so grief-stricken that he cut off the

ears and tail of his horse and then rode it for all his
army to see.[3]

The coastal campaign was straining Saladin's resources.
His armies had already plundered the Frankish territories
and devoured all their grain. Saladin was having to build
ships, repair fortifications and install garrisons, yet instead
of being a source of revenue the coast was becoming an
expense. And worst of all, he was being beaten.

In 1188 Saladin turned his attention to northern Syria,
where he stormed one castle after another and took the city
of Latakia. But here too he was checked, this time by the
massive castles of the military orders. He baulked at the key
Hospitaller castles of Margat and Krak des Chevaliers and at
the Templars' castle at Safita called Chastel Blanc and their
fortified city of Tortosa – though vengefully he destroyed the
church there, 'one of the largest of its kind'.[4]

As soon as the Franks recovered their morale, they made
the recapture of Acre their objective, and at the end of August
1189 King Guy advanced from Tyre to besiege the city. His
army was small and outnumbered by the Muslim garrison
within the walls, but Guy had the benefit of the newly arrived
Pisan fleet, which blocked Acre's harbour. Saladin mustered
his forces on the plain of Sephoria in Galilee and marched
to relieve his garrison on the coast; fanning out round the
city, he encircled the Frankish forces, besieging the besieg-
ers, but the Franks still maintained communication with the
Pisan fleet and would not surrender their position. 'If a ten
years' war made Troy renowned', wrote the historian Stanley
Lane-Poole, 'surely to Acre belongs eternal fame – the city
for which the whole world contended.'[5]

Perpetual skirmishing went on between the two armies,
with moments of brutality and danger, Ibn al-Athir report-
ing Bedouins falling upon Christian stragglers and bring-
ing their heads to Saladin for a reward, and women in the

Frankish camp dragging Turkish prisoners by the hair, abus-
ing them and then hacking off their heads with knives. But
then at daybreak on 4 October the Franks went into action,
the Templars on the right crashing into a Kurdish contin-
gent from Diyarbakir and scattering it to flight; the Kurds
were next heard from, crossing the Jordan below the Sea of
Galilee well on their way to Damascus. The Templar Grand
Master Gerard of Ridefort, who had been captured by Sala-
din and then released in 1187, fell in the attack and received
a last acclaim from the anonymous English knight on whose
lost journal the *Itinerarium Regis Ricardi* was based, who said
that he was crowned with the laurel of martyrdom 'which he
had merited in so many wars',[6] a washing away of any blame
he may have incurred for the disasters at the Springs of Cres-
son and the Horns of Hattin.

Saladin rallied his centre and prevented a general rout,
and the battle proved inconclusive but bloody nonetheless,
certainly for the Franks. On the Muslim side the loss was
more by flight than slaughter; the Franks estimated that
fifteen hundred of Saladin's horsemen were killed while
being secretive about their own casualties, but according to
Saladin's friend Ibn Shaddad, who saw their bodies being
carried to the river to be thrown in, the total Frankish dead
numbered over four thousand. Yet even so, the Franks held
on and persisted with their blockade of Acre through the
winter and all the following year, driving Saladin to despair
as he desperately made appeals as far away as Baghdad and
Morocco but received no fresh aid.

In the spring of 1191 the main armies of the Third Crusade
arrived. First came the forces led by King Philip II of France,
who set up his headquarters outside Acre on 20 April and
took command of the besieged and besieging Christians,
though to little effect. Meanwhile everyone waited in antici-
pation for the arrival of King Richard I of England, Coeur
de Lion, the Lionheart.

On his way to the Holy Land, Richard was distracted by a series of adventures. His mother, Eleanor of Aquitaine, had arranged that her son marry Berengaria, daughter of King Sancho VI of Navarre, and had now shipped her to Messina in Sicily, where Richard would marry her as he voyaged east and take her with him to the Holy Land. Eleanor herself had joined the Second Crusade as the young bride of Philip's father, Louis VI, and now she was stirring things up again, for Richard was already engaged to Philip's sister Alice. Philip, who likewise put in at Messina, demanded that Richard make financial restitution for breaking the engagement, which Richard did, but in contrast to Richard's large, flamboyant personality, Philip was a small and peevish man whose bitterness remained. On 30 March Philip sailed from Sicily with his fleet bound for Acre; Richard waited for Berengaria, then sailed on 10 April. Richard's passage proved tempestuous; his fleet was broken up by winds, one of his ships was lost in a storm, and another three, including the ship bearing Berengaria, were blown towards Cyprus. Berengaria's vessel managed to anchor safely off Limassol, but the other two were wrecked on the south coast of the island. The ruler of Cyprus, Isaac Ducas Comnenus, had rebelled against Byzantium and established himself locally as emperor; unpopular on the island, the appearance of Franks filled him with alarm, and he imprisoned the shipwreck survivors, confiscated their goods and tried to lure Berengaria ashore, quite likely with the intention of holding her for ransom. A week later, on 6 May, Richard sailed into view with the main fleet and was outraged at Isaac's behaviour. Writing to his chancellor back in England, Richard himself told what happened next.

> We put in at Cyprus where we were hoping that our
> men who had been shipwrecked had found shelter,
> but the tyrant who had usurped the title of emperor

and who respected neither God nor man, advanced on us with a large armed contingent to prevent us from entering the harbour. How many of our men who had suffered shipwreck he robbed and pillaged and then threw into prison to be left to die of hunger. Thoughts of revenge for this great affront were justifiably kindled, and with divine help we won a rapid victory over the said enemy in the ensuing battle. We put in irons the defeated tyrant and his only daughter, and have conquered the whole of the island's strongholds. After that we entered the port of Acre in high spirits.[7]

Richard's capture of Cyprus opened up possibilities for the Templars. Robert of Sablé became Grand Master of the Templars in 1191, almost certainly through the influence of King Richard, whose vassal he had been, and it was probably this connection that led Richard, who found he lacked the means to hold the island, to sell it to the Templars. The entire future of the Templars might have been different had they devoted more resources to the island, but they placed only twenty knights on Cyprus and another hundred men at arms, insufficient to secure it, and so they gave it back to Richard. Possessing a territory of their own, the Templars would have anticipated the achievement of the Knights Hospitaller, who established their own independent state on Rhodes in 1309. Instead Templar fortunes remained tied to the Holy Land, and when it fell, the Templars fell soon after.

As for Richard's arrival at Acre 'in high spirits' on 8 June, he entered with a bang, ramming a Muslim supply ship and sending it to the bottom of the sea; the loss of reinforcements was another blow to the defenders of the city. A month later the English and Pisans launched a fierce attack, and though failing to break through, they sufficiently terrified the weary and hungry garrison that their commanders asked for surrender terms. In return for their lives they promised Richard

that Saladin would return the True Cross, pay 200,000 dinars and release all his Christian hostages, over a thousand men. Richard agreed and the gates of the city were opened, and the English and Pisans entered. But Saladin was informed only later and was faced with honouring an agreement he may never have agreed to. Characteristically Richard wanted to talk with Saladin directly, man to man, but Saladin refused and the talks were conducted through intermediaries. Saladin was evasive, his aim, according to the author of the *Itinerarium Regis Ricardi*, to gain time: 'Meanwhile, he sent constant presents and messengers to King Richard to gain delay by artful and deceptive words, though he fulfilled none of his promises, but tried to keep the king's mind in suspense by crafty and ambiguous messages.'[8] Richard was eager to advance along the coast to liberate its ports, and when finally Saladin reneged on the agreement Richard flew into a rage. Showing that he could be as cold-bloodedly murderous as Saladin had been at Hattin and towards the Franks in the fallen cities of Outremer, and in recompense for the thousands of Franks who had been killed in the long attempts to take Acre, he ordered the 2,700 members of the garrison to be marched outside the city, where in full view of Saladin and his army he had them executed.

The object of the crusade was the recovery of Jerusalem, but Saladin controlled the interior; Richard therefore worked first to establish control all along the coast and to create secure lines of supply before pushing inland. As Richard marched south, he was shadowed by Saladin, who hoped to seize on any mischance and drive him into the sea. Richard described events: 'After the capture of Acre and the departure of the King of France who thus so cravenly abandoned his pilgrimage vow and promises against God's will - to

his eternal shame and that of his kingdom – we set out for Jaffa, but on approaching Arsuf we were met and savagely attacked by Saladin and his Saracens.'[9] Richard set out from Acre on 22 August and, as he marched south along the coast, his army was vulnerable to flank attacks by Saladin's Turkish cavalry. Ibn Shaddad described one of the more serious harassing attacks near Caesarea, remarking that the Muslim archers could do little against the armour of the Franks. 'Their infantry drawn up in front of the horsemen stood firm as a wall, and every foot-soldier wore a thick gambeson and a hawberk, so dense and strong, that our arrows took no effect, whilst their cross-bows wounded both our horses and their riders. I saw soldiers with from one to ten arrows sticking in them, still marching on.'[10] It was thanks to the Templars and the Hospitallers that the Turks were beaten off and the coherence of the Christian column was maintained – much as the Templars had done for Louis VII during his march across Asia Minor during the Second Crusade. Even greater was the debt Richard owed to the Templars when he relied on their steadiness and discipline to help him win his great victory over Saladin in the battle of Arsuf on 7 September 1191.

Arsuf lay just north of Jaffa, and here Saladin decided to abandon his harassing strikes and finally make a stand. By making repeated attacks Saladin intended to break up Richard's column, the easier to fall on its disjointed parts and destroy them. On the battlefield itself Richard placed the Templars at the front rank of his army, the Hospitallers at the rear. Richard's plan was for his army to stand firm while Saladin's forces wore themselves out in attack. And so it went, beginning with wave after wave of lightly armed black and Bedouin infantry rushing against the Christian lines, followed by charging Turkish horsemen swinging their scimitars and axes. And still the knights held their ground, Richard waiting for the moment when the Muslim charges showed signs of weakening. The Templars withstood

everything thrown at them. The Hospitallers broke ranks first; unwilling to endure the assaults any longer, they rode out against the enemy, which might have caused havoc, but Richard quickly grabbed control of the situation and sent the whole army in after them. Saladin's secretary Imad al-Din, who watched the battle from a nearby hill, gasped at the splendour of the spectacle as Richard's cavalry thundered forwards, with the king himself at the centre restoring order and taking command of the battle. The Muslims broke and fled, and seven thousand died, the Frankish losses no more than a tenth as much. Arsuf was a tremendous moral victory for the Franks and a public humiliation of Saladin, a small repayment for the Templars he slaughtered after the battle of Hattin. Acre had taught Saladin that he could not defeat the Franks when they were entrenched; now Arsuf taught him that it was dangerous to attack the Franks when they were on the move. Saladin would never again dare fight the lion-hearted English king.

Saladin's immediate response was to rush south to Ascalon, which he methodically demolished to deny Richard the value of its capture; it was the beginning of a policy by Saladin and repeated with greater ferocity by the Mamelukes of destroying everything along the coast, caring nothing for the native inhabitants, only wanting to deny purchase for any possible invasion from the West. As a leading archaeologist has written, 'It was under Ayyubid rule that the most important and dramatic transformation occurred in the settlement pattern of Palestine. Salah al-Din initiated a hitherto unknown strategy, continued by his successors: destruction of the coastal area and desolation of many of its cities.'[11] The effects of this destruction and its consequent depopulation would be felt into modern times.

'With God's grace we hope to regain the Holy City of Jeru-salem and the Sepulchre of the Lord in less than twenty days after Christmas, and then we will return home.'[12] So Richard wrote from Jaffa on 1 October, three weeks after his victory at Arsuf. Richard's advance towards Jerusalem was slow; to protect his line of supply he insisted on repairing fortifica-tions along the route, and then in January 1192, within 12 miles of the city, the weather turned, hailstones and torrential rains battering the troops. Richard stopped and took counsel with the barons and military orders. Both the Templar and the Hospitaller Grand Masters advised that, even if he took the powerfully garrisoned city, it could not be held without also controlling the hinterland, especially once his army had left Outremer. Richard took their advice and instead came to an agreement with Saladin. The Franks would demolish the walls of Ascalon, which they had only recently rebuilt, while Saladin would recognise the Christian positions along the coast; free movement would be allowed to Christians and Muslims across each other's territory; Christian pilgrims would be permitted to visit Jerusalem and the other holy places; and the extortion at the Holy Sepulchre would stop.

Accompanied by a Templar escort, Richard left the Holy Land in 1192; the Third Crusade was at an end. It had been a highly successful expedition; most of Saladin's victories in the wake of Hattin had been overturned; the Franks had regained control of the coastal cities and had secured a peace with their Muslim enemy. They failed to regain Jerusalem, but Richard had resurrected Outremer from the ashes and given it the chance to live another hundred years. Things might have been even better, had Richard stayed a bit longer; he had promised to remain in Outremer until Easter 1193, and, had he done so, he would have been there when the news came through that on 4 March 1193 Saladin had died. That was the moment when a great leader like Richard could have restored Outremer in full and might perhaps have done

far more than just that. But even as it was, peace settled over Outremer, and its immediate future looked secure.

<p style="text-align: center">⁂</p>

After the death of Saladin his empire fell apart; rival factions of his dynasty, the Ayyubids, ruled in Cairo and Damascus, but all the rest was lost. Occasional skirmishes followed between Outremer and the Muslim powers, but more often relations were regulated by repeated truces.

Acre was now the capital of the kingdom of Jerusalem and the chief city of Outremer. The king, the patriarch, the Hospitallers and the Templars all made Acre their headquarters, and various feudal lords and the survivors of monasteries who had lost all they possessed in and around Jerusalem came to Acre too, building new houses and churches. The Italian and Provençal merchants also returned to their old quarters. French and Italian were spoken throughout the town and also Syriac, Arabic and Greek; the population was very mixed and included Christians, Muslims and Jews.

After the siege of Acre, Richard had restored the city's damaged defences, but the walls were badly damaged by an earthquake in 1202 and had to be rebuilt. Acre was now enclosed within a double wall along the lines of a concentric castle, the inner wall higher than the outer; these were on the landward sides, to the north and east; the sea girded Acre and gave it protection to the south and west. The Hospitallers had their headquarters midway along the northern wall, while the Templars built their massive fortified enclosure on the sea at the south-west point of the city. But these double city walls did not yet enclose the northern suburb of Montmusart, although with the new influx of population this quarter was already growing; the double wall was extended to protect it, thanks to St Louis during his stay in Outremer in 1250–54. Acre then took on a three-cornered plan, like a

shield, two sides defended by the sea, while to landward it was defended by an extension of the double wall.

Throughout the thirteenth century every pilgrimage or crusade converged on Acre, which was also a crossroads of trade between East and West. The city prospered and grew. In 1214 the canons of the cathedral of St Cross elected James of Vitry, the most eloquent preacher of the crusade in Europe to be their bishop; and in 1219 St Francis of Assisi began his Eastern mission in Acre, sending out friars to preach; soon both the Franciscans and the Poor Clares were established in the city. The Dominicans followed in about 1228. Towards the end of the thirteenth century there were no fewer than forty churches that pilgrims would visit in the town. But overall Acre was a secular and commercial city, earning predictable imprecations in the writings of the Dominicans and of James of Vitry for being a den of vice and moral depravity; it was a wonder that any fighting or praying got done at all, one crusader happily conceding that Acre 'was delightful, with good wines and girls, some very beautiful'.[13]

What has been called the Fourth Crusade, although it was not a crusade at all, was proclaimed against Ayyubid power in Egypt with the intention of recovering Jerusalem. But a complete breakdown in organisation and indebtedness to the Venetians, who built and crewed the ships, allowed the Italians to divert the crusade to Constantinople, which in 1204 was sacked, with Latin Christians replacing the rule of the Orthodox Christian emperors until the Byzantines recovered their city in 1261. The organisational failure lay in the enthusiastic assumption that over thirty-three thousand men would take part in the crusade, requiring a fleet of five hundred major vessels, the largest assembled in Europe since ancient times. A contract was signed between the crusader

leaders and Venice, which threw everything into the task, sus-
pending its entire merchant activity to make its ships availa-
ble for the passage to Egypt, building more ships to make up
the full number, and providing the vast stores of provisions.
In the event only about eleven thousand men showed up
in Venice, and they were able to provide only a third of the
payment due. The potential loss to Venice was enormous,
possibly ruinous. Doge Dandalo proposed a solution. The
city of Zara, across the Adriatic on the Dalmatian coast, had
rebelled against Venetian rule; if the crusaders would help
take it back, then the Venetians would suspend their demand
for payment until it could be met by booty gained in Egypt.
The crusaders were uncertain; they had volunteered to fight
the infidel, and Zara was a Christian city; but in the end
they agreed. On this news members of the entire enterprise
were excommunicated by the pope; from now on this was
no crusade.

A further twist arose in Zara. Another dynastic conflict
had arisen in Constantinople, and one of the rivals, Alexius
Angelus, approached the expedition saying that in return
for placing him on the imperial throne he would submit the
Greek Church to the authority of Rome, join the crusade
with an army of ten thousand men, permanently station five
hundred knights in the Holy Land and pay the crusaders
200,000 silver marks. The offer was the answer to the cru-
saders' prayers and they eagerly accepted. But once on the
throne, Alexius Angelus failed to deliver; the Venetians were
facing bankruptcy, and also they had memories of the ter-
rible Massacre of the Latins by the Byzantines in 1182, and
working the Franks up against the Greeks they stormed the
city.

This was the event that most shaped the views of Steven
Runciman, the best known twentieth-century historian of
the crusades. Runciman felt passionately about Greece and
Byzantium, and, with all the prejudice of a lover, 1204 was

for him an unforgivable crime. His entire *History of the Crusades* is coloured by this. He repeatedly emphasised in his writings, notwithstanding all the horrors that had occurred even within his own lifetime, that 'there never was a greater crime against humanity than the Fourth Crusade'.[14] The sack of 1204 had been against a great storehouse of classical and medieval civilisation, he said, and it had wounded a great Christian power in the East that might still have ensured the survival of Outremer – although as the Byzantine scholar Professor Anthony Bryer has remarked, 'Some may argue that the Greeks asked for 1204 and got most out of it',[15] while Runciman's latter claim is doubtful given the tottering and corrupt state of the empire ever since Manzikert in 1071 and especially since its defeat at Myriokephalon in 1176. For a historian of the crusades, Runciman was bluntly hostile to the entire enterprise, saying 'To me, crusade is a dirty word'.[16] And he concluded his *History* with his famous condemnation, 'The Holy War itself was nothing more than a long act of intolerance in the name of God, which is the sin against the Holy Ghost', a remark that failed to consider the aggressions to which the crusades were a response, and as Anthony Bryer wryly observed 'proved welcome in Islamic lands'.[17]

In 1217 the papacy launched the Fifth Crusade, and again the aim was to preserve Outremer by attacking Egypt. The Templars were involved in this new crusade from the start, with the Templar treasurer at Paris overseeing the donations that were to fund the expedition. Forces under King Andrew of Hungary and Leopold, duke of Austria, were joined by men under John of Brienne, the king of Jerusalem, which included Templars, Hospitallers and Teutonic Knights – the last being a new military order founded along Templar lines by Germans who had been on the Third Crusade.

With no single outstanding leader among this mixed force, the Fifth Crusade was placed under the authority of the papal legate Pelagius, a man of no military experience. Nevertheless, early in 1219 the Crusaders captured the port of Damietta in the Nile Delta, thanks largely to the Templars, who not only fought admirably on horseback but also demonstrated a remarkable talent for innovation, adapting their engineering and tactical skills from the arid conditions of Outremer to the watery landscape of the Delta, where they commanded ships and built floating pontoons to win the victory.

The loss of Damietta so unnerved the sultan of Egypt, Saladin's nephew al-Kamil, that he offered to trade it for Jerusalem. But with similar reasoning as had been offered to Richard the Lionheart, the Templar Grand Master argued that Jerusalem could not be held without controlling the lands beyond the Jordan, and so the crusaders rejected the offer and continued their campaign in Egypt. Meanwhile they were awaiting the arrival at Damietta of another army, led by the Holy Roman emperor Frederick II. Despite its failure to appear, the papal legate Pelagius impatiently urged the crusaders to advance up the Nile towards Cairo. United under the command of an experienced leader, the Fifth Crusade might have been a success. But at Mansoura, al-Kamil cut off the crusaders' rear, opened the sluice gates of the irrigation canals and flooded the army into submission. In 1221 Pelagius agreed to give up Damietta, not in exchange for Jerusalem but to save the lives of the crusaders, who immediately evacuated Egypt and returned to Acre.

Frederick II did eventually appear in the East, but only eight years later, by when he was openly at loggerheads with the Church. Crowned Holy Roman emperor in 1212 at Frankfurt, Frederick was also king of both Germany and Sicily. He preferred to rule from Palermo, where he had been raised amid the Norman, Byzantine, Jewish and Arab influences

at the Sicilian court. He learned German, Italian, French, Latin, Greek and Arabic, and was a student of mathematics, philosophy, natural history, medicine and architecture, as well as being a talented poet. These accomplishments contributed to his broadness of outlook, his exceptionally cultivated mind and his rather idiosyncratic character, which earned him the title of Stupor Mundi, Wonder of the World. But they also engendered suspicion. It was rumoured that Frederick did not believe in God, and it was put about that he scoffed at the virgin birth of Jesus and dismissed Mohammed, Jesus and Moses as impostors and deceivers.

This may have been the black propaganda of the papacy at Rome, which was worried at being encircled by his domains and was also agitated by Frederick's claim to supreme authority and his boast that he would revive the Roman Empire, to which the papacy countered by saying the Church had a higher authority in God – it was the old dispute between the Church and secular powers that had riven eleventh-century Europe at the time of the Investiture Controversy.

Frederick had been twenty-one when he was crowned Holy Roman emperor and vowed to take the cross, but he failed to appear in Egypt during the Fifth Crusade and time and again put off his departure for the East. But in 1225, when John of Brienne, the aged king of Jerusalem, came West seeking a husband for his fourteen-year-old daughter Yolanda, whom he had crowned queen at Acre, Frederick saw his opportunity. After marrying her at Brindisi, Frederick broke his promise that John of Brienne could continue as regent; instead, Frederick claimed the right as Yolanda's husband to become king, a move that would confirm him, he imagined, as the supreme sovereign in the Christian world.

Now in 1228, at the age of thirty-six, Frederick finally set out for the Holy Land, but he fell ill en route and rested in Italy for a while before continuing his journey. Pope Gregory IX, who distrusted Frederick's imperial intentions in Italy,

excommunicated him at once, using the excuse that this was yet one more instance of the emperor's failure to fulfil his crusading vow. Then, when Frederick eventually arrived at Acre in September, the pope again asserted his authority, excommunicating him again, this time for attempting to go crusading without having first obtained papal absolution for his earlier excommunication. Frederick was not impressed, but the barons and clergy in Outremer were, as were the Templars and the Hospitallers who owed their allegiance to the pope, only the Teutonic Knights braving papal wrath to support their fellow German.

But before Frederick had even left Sicily, he and al-Kamil had been in secret negotiations over the objects of this Sixth Crusade. Frederick wanted Jerusalem, if only because it would be useful in promoting himself as the supreme power in the West. Al-Kamil was prepared to oblige, provided Frederick helped him capture Damascus. But by the time Frederick arrived in Outremer, al-Kamil had changed his mind. Determined to gain Jerusalem, Frederick now made a feint towards Egypt, in November leading his army from Acre towards Jaffa. The Templars and Hospitallers followed a day behind, not wanting to seem part of a crusade led by an excommunicant, but when Frederick placed the expedition under the nominal authority of his generals, the orders abandoned their scruples altogether and joined up with the main force. The show of unity did not last long.

Frederick's advance was enough to make al-Kamil fear that he would have to abandon his siege of Damascus, and he quickly agreed a deal with Frederick: a ten-year truce and the surrender of Jerusalem, Bethlehem, Hebron and Nablus to the Christians as well as Gaza. It was a sudden and sensational result and gave Frederick what he wanted, but it outraged the patriarch and the military orders. The walls of Jerusalem had been torn down during the Fifth Crusade; if it was going to be given to them then, the intention was that

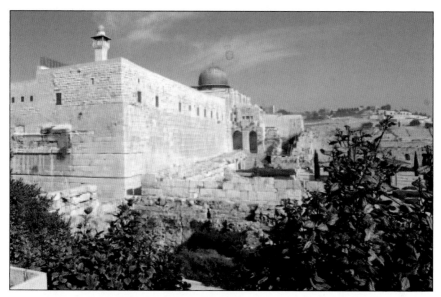

The southwest corner of the Temple Mount with the Mount of Olives in the distance. The dome marks the Aqsa mosque, known to the Franks as the Templum Solomonis, which became the headquarters of the Templars.

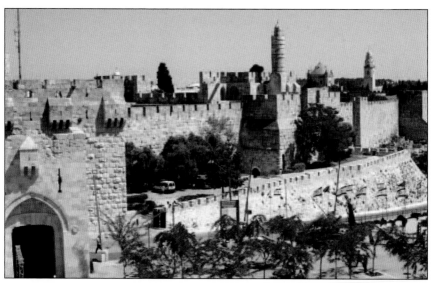

The walls of Jerusalem were rebuilt in the sixteenth century by the Ottoman sultan Suleiman the Magnficent along the lines of the walls of the crusader period. This view is along the western walls of the city looking south. David's Tower is the square bastion at the centre, surmounted by a minaret. The royal palace of the kings and queens of Jerusalem stood just beyond it.

The Rotunda, or Anastasis, of the Church of the Holy Sepulchre. The structure in the middle is the aedicule, or chapel, marking the site of Jesus' tomb and resurrection.

Muslim pilgrims queuing to enter the aedicule built over the tomb of Jesus. Islam regards Jesus as a mortal prophet and a precursor of Mohammed.

Golgotha, or Calvary, within the Church of the Holy Sepulchre has been venerated by pilgrims as the site of the Crucifixion since the time of the Emperor Constantine and his mother Helena.

The Cenacle, or Upper Room, is an elegant Gothic hall built by the Franks in the twelfth century as part of the Church of St Mary of Zion. Pilgrims have been attracted to the site, believed to be that of the Last Supper and the Pentecost, since at least the fourth century.

Queen Melisende lies in a tomb set within this alcove off the steps leading down to the Tomb of the Virgin Mary in Jerusalem's Kidron valley.

The Horns of Hattin, a strange double-peaked volcanic outcrop west of Tiberias, shrouded in a sandstorm. On 4 July 1187 the crusader army, parched with thirst, was destroyed as it advanced towards Saladin's forces which stood in the foreground. Jerusalem fell two months later.

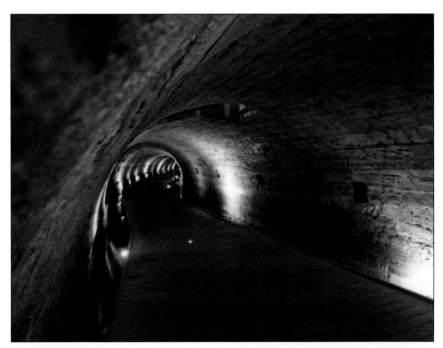

This secret Templar tunnel ran under the streets of Acre towards their fortress on the sea.

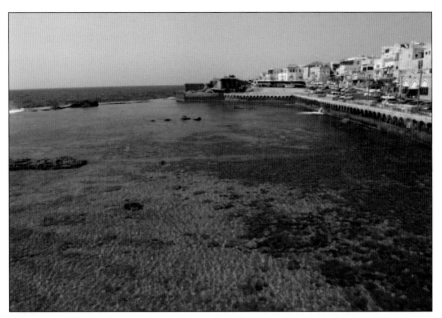

After the fall of Acre in 1291 the fortress of the Templars was destroyed; only the foundation platform survives under the Mediterranean shallows.

Foundation walls of the Templar fortress at Acre are favourite spots for fishing.

What was not destroyed at Acre was buried under earth and rubble which has recently been cleared to reveal the halls, courtyard and cloister of the Hospitallers' headquarters. This vast chamber is called the Refectory of the Knights, but it may have been a crypt and probably had another hall above it.

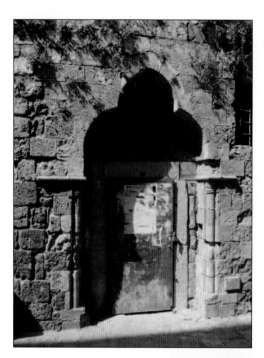

A doorway surviving from the crusader period stands along a narrow street in Acre.

This great marble Gothic arch set in the facade of the Mameluke sultan al-Nasr's madrasa in Cairo is in fact a magnificent piece of booty from the Church of St Andrew at Acre, a triumphant reminder of the conquest of Outremer.

it should not be defensible, and that remained the idea now, for part of the agreement was that the city should remain unfortified, and its only connection to the coast should be a narrow corridor of land. Moreover, the orders were forbidden to make any improvements to their great castles of Marqab and Krak des Chevaliers of the Hospitallers and Tortosa and Chastel Blanc of the Templars. And then there was the galling provision – a necessary face-saver for al-Kamil – that the Temple Mount should remain under Muslim control and that the Templars were absolutely forbidden to return to their former headquarters at the Aqsa mosque.

On 29 March 1229 Frederick was crowned king of Jerusalem at the Church of the Holy Sepulchre. The patriarch had placed an interdict on the city, forbidding church ceremonies while Frederick was in Jerusalem, and so with no priests to crown him, and with the Templars and the Hospitallers keeping away, it was left to Frederick to place the crown of Jerusalem on his own head. Calling himself God's Vicar on Earth, the title usually reserved for the pope, Frederick swore in the presence of the Teutonic Knights to defend the kingdom, the Church and his empire. He afterwards toured the city, and going to the Temple Mount he entered the Dome of the Rock through a wooden lattice door, put there, he was told, to keep the sparrows out. Venting his feelings about his papal enemies to whom he had restored the holy city, and using the vulgar Muslim term for Christians, Frederick pronounced, 'God has now sent you the pigs'.[18]

Frederick stayed in Jerusalem for only two days. It was not a prepossessing place. The Franks had turned Jerusalem into a garden of Paradise, Saladin once said, but the city had fallen into disrepair and neglect since then, so that as al-Kamil dismissively described the once beautiful city, it amounted to nothing more than 'some churches and some ruined houses'.[19] According to Al-Qadi al-Fadil, the decay had already begun during Saladin's lifetime, and al-Fadil

feared the impression it would make on Christian pilgrims and how their indignation might lead to a new crusade.[20]

In any case, Frederick had achieved what he wanted and was eager to get back to Europe and the serious business of expanding his powers there. But he also feared that the Templars might make an attempt on his life while he was in the city. Chroniclers as far apart as Sicily, Damascus and England reported this story, which if nothing else reflected the intensity of ill-feeling and suspicion between the emperor and the pope, an enmity in which the Templars had become involved. When Frederick returned to Sicily, he seized the property of the military orders there, released their Muslim slaves without paying compensation and imprisoned the Templar brothers. Yet again the pope excommunicated him, and again Frederick ignored the pope. It was a foreboding of what could happen when the Templars stood in the way of the needs and ambitions of a secular prince.

21

The Mamelukes

I N 1239 THE TEN-YEAR TRUCE made between Frederick
and al-Kamil ran out, but there was no immediate threat
to Outremer. Al-Kamil had died the year before and Egypt
was riven by factions, while the bitterness between the Cairo
and Damascus branches of the Ayyubid family had increased.
The Hospitallers favoured continuing close relations with
Egypt, but the Templars were opposed. In violation of the
truce, the Egyptians had failed to hand over Gaza, Hebron
and Nablus, and when Templar emissaries went to Cairo in
1243 they were held as virtual prisoners for six months. The
Templars saw this behaviour as a delaying tactic by the new
Egyptian sultan, al-Salih Ayyub, giving him time to over-
come Damascus and other Muslim rulers, and then to over-
whelm Outremer.

Templar policy was to favour Damascus, and this showed
some results: through negotiations adroitly handled by the
Templars, Damascus and Cairo were lured to win the sup-
port of the Christian kingdom by outbidding one another
until the Franks gained all the land west of the Jordan except
Hebron and Nablus. They were also given a free hand to
celebrate Christian services in every former church through-
out Jerusalem, and to expel the Muslims from the Temple

Mount and to reconvert to Christian use the Aqsa mosque and the Dome of the Rock. In a remarkable diplomatic triumph for the Templars they had overturned almost all that Saladin had achieved.

Templar policy against Egypt continued to prevail. When war broke out again between Cairo and Damascus in the spring of 1244, the Templars persuaded the barons of Outremer to intervene on the side of the Damascene ruler Ismail. The alliance was sealed by the visit to Acre of al-Mansur Ibrahim, a Muslim prince of Homs, who on behalf of Ismail offered the Franks a share of Egypt when al-Salih Ayyub was defeated.

The continuing factionalism in Cairo meant that al-Salih could not rely on the regular army, but he had taken steps to counter that by purchasing Mamelukes in large numbers. These military slaves were at various times Nubians, Armenians and Iranians, but Turks were preferred for their fighting qualities.

> They care only about raiding, hunting, horsemanship, skirmishing with rival chieftains, taking booty and invading other countries. Their efforts are all directed towards these activities, and they devote all their energies to these occupations. In this way they have acquired a mastery of these skills, which for them take the place of craftsmanship and commerce and constitute their only pleasure, their glory and the subject of all their conversation. Thus they have become in warfare what the Greeks are in philosophy.[1]

Turks were also preferred for their physical beauty and not infrequently served as bedfellows for their owners.

In the event the Mamelukes would be hailed as a gift from God and the saviours of Islam. 'It was God's benevolence that he rescued the faith by reviving its dying breath and restoring the unity of the Muslims in the Egyptian realms, preserving the order and defending the walls of Islam', wrote Ibn Khaldun, the fourteenth-century North African historian.

> He did this by sending to the Muslims, from this Turkish nation and from among its great and numerous tribes, rulers to defend them and utterly loyal helpers, who were brought from the House of War to the House of Islam under the rule of slavery, which hides in itself a divine blessing. By means of slavery they learn glory and blessing and are exposed to divine providence; cured by slavery, they enter the Muslim religion with the firm resolve of true believers and yet with nomadic virtues unsullied by debased nature, unadulterated with the filth of pleasure, undefiled by the ways of civilised living, and with their ardour unbroken by the profusion of luxury. The slave merchants bring them to Egypt in batches, like sandgrouse to the watering places, and government buyers have them displayed for inspection and bid for them [...] Thus, one intake comes after another and generation follows generation, and Islam rejoices in the benefit which it gains through them, and the branches of the kingdom flourish with the freshness of youth.[2]

Al-Salih Ayyub, whose great uncle was Saladin, and who was himself a Turkified Kurd, relied mostly on Kipchak Turks from the steppes of southern Russia; bought, trained and converted to Islam, they became his powerful private army. Also al-Salih bought the help of the Khorezmian Turks, ferocious mercenaries then based in Edessa, who

had been displaced from Transoxiana and parts of Iran and Afghanistan by the expansion of the Mongols. In June the Khorezmian horsemen, twelve thousand strong, swept southwards into Syria, but deterred by the formidable walls of Damascus they rode on into Galilee, captured Tiberias and on 11 July broke through the feeble defences of Jerusalem and brutally massacred everyone who could not retreat into the citadel. Six weeks later the defenders emerged, having been promised safe passage to the coast. The garrison together with the entire Christian population – six thousand men, women and children – left the city but were cut down by Khorezmian swords, only three hundred making it to Jaffa. For good measure the Khorezmians ransacked the Church of the Holy Sepulchre, tore up the bones of the kings of Jerusalem from their tombs, set the place alight and burned all the other churches of the city, pillaged its homes and shops, then left the smoking wreckage of Jerusalem to join al-Salih's Mameluke army at Gaza.

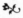

With al-Salih's army standing at Gaza, the Frankish forces which had been scattered throughout the cities and castles of Outremer gathered at Acre. Not since Hattin had such a considerable Christian army been put into the field, its numbers including over 300 knights from the Templars, at least another 300 from the Hospitallers, also some Teutonic Knights, and a further 600 secular knights, as well as a proportionate number of sergeants and foot soldiers. To these were added the yet more numerous, if more lightly armed, forces of their Damascene ally under the command of al-Mansur Ibrahim and a contingent of Bedouin cavalry.

On 17 October 1244 this Christian–Muslim army drew up before the smaller Egyptian army with its elite core of Mamelukes and the Khorezmians outside Gaza on a sandy

plain at a place called La Forbie. The Franks and their allies attacked, but the Egyptians stood firm under the command of the Mameluke general Baybars, and while the Franks were pinned in place, the Khorezmians tore into the flank of al-Mansur Ibrahim's forces. The Damascene forces turned and fled; the Franks fought on bravely, but after a few hours their entire army was destroyed. At least 5,000 Franks died in the battle, among them 260 to 300 Templars, while over 800 Christians were captured and sold into slavery in Egypt, including the Templar Grand Master, who was never seen again. Quite apart from the dreadful cost in human life, the loss represented a punishing financial blow to the defence of Outremer; the cost of maintaining 300 Templar knights for a year amounted to about a ninth of the annual income of the French monarchy. The catastrophe was comparable to Hattin, and when Damascus fell to al-Salih the following year, it looked as though time had run out for Outremer.

Relief to Outremer came in the form of the Seventh Crusade, led by King Louis IX of France, St Louis as he afterwards became thanks to his incessant warfare against enemies of the true faith, be they Muslims or Cathars – it was during Louis' reign that the Cathars were finally beaten and incinerated at the stake. Now in the summer of 1249 he landed with his French army at the Delta port of Damietta with the familiar idea of overturning the Ayyubid regime in Cairo. Al-Salih Ayyub was suffering from cancer, and when he died in November his wife, Shagarat al-Durr, hid his corpse and kept morale alive by pretending to transmit the sultan's orders to his army of Mameluke slave troops led by Baybars.

In February 1250 the French advanced through the Delta towards Cairo but owing to the impetuosity of the king's brother, the count of Artois, suffered heavy losses at

Mansoura. He had urged the crusader knights to charge into the town, where they were trapped within the narrow streets, the Templars alone losing 280 mounted knights, yet another massive blow so soon after La Forbie. A stalemate followed, and the crusaders were weakened by scurvy and plague. In April they retreated but were captured by the Mamelukes, along with King Louis himself, who was released only after a huge ransom was paid, to which the Templars, who as bankers to members of the crusade had a treasure ship offshore, refused to contribute.

That same year Shagarat al-Durr openly declared herself sultan, basing her claim to the succession on having borne al-Salih a son, although the child had predeceased the father. The Abbasid caliph refused to recognise her, so she married Aybek, one of her Mameluke slave warriors, and ruled through him instead, then murdered him in 1257, when she suspected him of turning his attentions to another woman. Purchased as a slave by al-Salih, then made one of his concubines, Shagarat al-Durr had eventually become his wife and then became the first and last female ruler of Egypt since Cleopatra. Owing to her courage and resourcefulness she had saved Egypt from the Seventh Crusade, but she proved to be the last of the Ayyubid line. Aybek's supporters killed her and threw her naked body over the wall of the Citadel at Cairo to be devoured by the dogs. The Mamelukes then made themselves the masters of Egypt in the person of their first sultan, Qutuz.

The shock of the Mongol invasion of the Middle East established the Mamelukes as the accepted defenders of Islam against the infidels of East and West. In February 1258 the Mongols, led by Hulagu, a grandson of Genghis Khan, captured Baghdad, put the Abbasid caliph to death, then

plundered and destroyed the city. In January 1260 they took
Aleppo, and in March Damascus fell. The Mongols appeared
to be unstoppable. The Franks sent urgent letters westwards
pleading for help; 'a horrible annihilation will swiftly be vis-
ited upon the world', wrote Thomas Bérard, the Templar
Grand Master, in a message carried by a brother of the order
to London.[3] But it was the Mamelukes who responded to the
threat. That summer, when Mongol ambassadors arrived in
Cairo demanding Egypt's submission, they encountered an
adversary more ferocious than themselves; Qutuz had them
killed on the spot. And in September, after being allowed
free passage through Christian lands, a Mameluke army
under Qutuz inflicted a stunning defeat on the Mongols in
the battle of Ain Jalut, south-east of Nazareth.

But among the jealous Mamelukes victory was no guaran-
tee of success, and a month later Qutuz was murdered by a
group of fellow Mamelukes, among them Baybars, al-Salih's
general at La Forbie, who then became sultan. Rejecting the
dynastic principle, Mameluke rulers would in future come to
power more by the blood on their hands than by the blood in
their veins, a practice fatalistically accepted by the religious
leadership of the Muslim community. As Baybar's panegyri-
cist Ibn Abd al-Zahir put it, 'Fortune made him king'[4] – he
ruled by the decree of fate.

Ruthless, brutal and energetic, Baybars now held Syria and
Egypt under his control. Outremer was encircled, and the
Franks were confronted by one of the most formidable fight-
ing machines in the world. Moreover Baybars and his suc-
cessors possessed overwhelming resources. 'The Mameluke
sultans were able to replenish their supplies of troops by the
import of new Turkish slaves from the Caucasus and Central
Asia along the trade routes through Anatolia. The Mameluke
state could draw on far more troops than the Franks were ever
able to do.'[5] Moreover, when the time came for the system-
atic destruction of the Frankish castles, settlements and ports,

the Mamelukes could marshal tens of thousands of auxiliary troops, Turkish, Kurdish and Mongol, to execute the task.

Just as systematically the Mamelukes devastated Christianity in the East and heterodox Islam too. Baybars forced the Alawites, mystical followers of Ali, the son-in-law of the Prophet Mohammed, to build mosques in their villages, but he could not force them to pray in them. Instead they used the buildings as stables for their cattle and their beasts of burden. But the persecution was relentless: 'In pursuit of the "scorched earth" policy Mameluke sultans methodically ravaged Lebanon.'[6] As for Christians, in 1263 Baybars announced his fanaticism by personally ordering that the Church of the Annunciation in Nazareth should be razed to the ground. Baybars well understood the importance of the church, whose origins may have gone back before the time of Constantine and stood over a grotto where, in the view of the faithful, the Christian religion had its beginning and to which Christians had been making pilgrimages since at least the fourth century. His obliteration of the church was so total and systematic that the original ground plan can be discerned only through archaeological excavation; the Mamelukes forbade Christians to rebuild on the site.

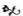

In a series of devastating campaigns Baybars captured Caesarea and Haifa in 1265, the Templar castle of Saphet in 1266, Jaffa and the Templar castle of Beaufort both in 1268, and then struck at Antioch in the north, which he captured that same year, treating its inhabitants with a murderous brutality that shocked even Muslim chroniclers. The Templar castle at Baghras in the Amanus mountains was now utterly isolated. Baghras had been their first castle, but now the Templars had no choice but to abandon it. Chastel Blanc of the Templars was surrendered in 1271 together with the Hospitallers'

great castle of Krak des Chevaliers. Baybars then marched on Montfort, between Acre and the Sea of Galilee, and that too was soon handed over to the Muslims by its garrison of Teutonic Knights.

The fall of the crusader castles to the Mamelukes needs some explanation. How could such magnificent structures, built at such vast cost and effort, incorporating the latest military design of the age and defended by men of undoubted courage, have so rapidly capitulated or been captured? There is no single answer. Several factors worked in combination.

The Templar castle of Beaufort, overlooking the southern end of the Bekaa valley in Lebanon, fell to Baybars in 1268 with the help of first-class military engineers. They assembled something like twenty-six siege engines – that is, battering rams and siege towers – as well as catapults, the wooden frames and metal parts bought from Venetian merchants sailing into Egyptian ports. In this case the Templars were overwhelmed by technology. But two years earlier, when the Templar castle of Saphet fell to Baybars, it had been down to treason.

Saphet was the castle in northern Galilee which the Templars had spent a fortune rebuilding less than thirty years earlier, a worthwhile expense as it guarded against raids of Bedouins and Turks who would formerly cross over the Jordan with impunity. Traders could safely conduct their pack animals and wagons between Acre and Galilee, farmers could cultivate their fields in security, and pilgrims could freely visit many sites associated with the ministry of Jesus. Muslim sources acknowledged its efficacy by describing Saphet as 'an obstruction in the throat of Syria and a blockage in the chest of Islam'[7] – that is until Baybars brought about its downfall in 1266. He did so not by attack – he tried three times that year and failed – but by sowing dissent between the small garrison of Templars and the much larger numbers of Syrian Christian servants and native troops inside.

He promised the latter free passage and so many wanted to defect that the defence of the castle was called into question. The Templars agreed to negotiate and a safe conduct was arranged for Templar knights and locals alike. But when the gates were opened, Baybars grabbed all the women and children and sold them into slavery and decapitated all the knights and other men.

The willingness of the Templar garrison at Saphet to negotiate points to another factor at work: a sense of isolation and of being overwhelmed, which seems to have played an important part in the fall of the Templar castle of Chastel Blanc and the Hospitallers' Krak des Chevaliers to Baybars within two months of one another in 1271. Both castles stood in the Jebel al-Sariya, that mountain range separating the interior from the sea; but both became increasingly isolated amid the Muslim advance. Perhaps also the Templar master at Tortosa thought it wiser to concentrate his forces on the coast, but whatever the reason he ordered the evacuation of Chastel Blanc.

Likewise Krak des Chevaliers was not taken but given away. The Hospitallers could no longer raise sufficient manpower to garrison the castle and for its diminished complement of Hospitaller knights the waiting became a terrible immurement. After a month's siege, Baybars delivered a forged note purportedly from their master at Tripoli, urging them to surrender. Their defences and supplies might have allowed them to hold out for years, but it must have seemed to them that Krak was drifting anchorless and rudderless on an irresistible Muslim tide. Weary, dejected and demoralised, on 8 April 1271 the Hospitallers accepted Baybars' offer of safe conduct to the sea.

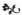

With all their great inland fortresses taken, the Franks were pinned to their remaining coastal defences, crucially Acre

and Tripoli, both powerfully fortified cities, and the Templars' stronghold of Tortosa, which had held out against Saladin, and their castle of Chastel Pelerin, south of Haifa. But meanwhile the Franks gained some relief when Prince Edward, the future Edward I of England, led a fresh crusade to the East and in 1272 persuaded Baybars to agree to a ten-year truce.

Acre, capital of the kingdom of Jerusalem and headquarters of the military orders, was the most powerfully defended city in Outremer. And according to the Templar of Tyre, who knew it well,

> The Temple was the strongest place of the city, largely situated along the seashore, like a castle. At its entrance it had a high and strong tower, the wall of which was twenty-eight feet thick. On each side of the tower was a smaller tower, and on each of these was a gilded lion passant, as large as an ox [...] On the other side, near the street of the Pisans, there was another tower, and near this tower on the Street of St Anne, was a large and noble palace, which was the Master's [...] There was another ancient tower on the seashore, which Saladin had built one hundred years before, in which the Temple kept its treasure, and it was so close to the sea that the waves washed against it. Within the Temple area there were other beautiful and noble houses, which I will not describe here.[8]

In 1273 the Templars elected a new Grand Master, William of Beaujeu, a man with considerable experience of fighting in the East and administering the order. One of his first missions was to attend the Church Council of Lyon, which was convened by the pope in 1274 for the principal purpose of launching a new crusade. At the council William spoke against a proposal to send five hundred knights and two

thousand infantry to the Holy Land as the vanguard of a mass levy like that of the First Crusade, arguing that unruly hordes of enthusiasts would not serve the needs of Outremer. Instead, a permanent garrison was required, which would be reinforced from time to time by small contingents of professional soldiers. And he also argued for an economic blockade of Egypt, the Mamelukes' power base.

Such a blockade would not be possible, however, as long as Outremer depended on the ships of the Italian maritime republics, for these were the very same merchant marines who since the Latin massacre at Constantinople had turned to trading so profitably with Egypt. The Venetians, for example, supplied Baybars with the metal and timber that he needed for his arms and siege engines, and the Genoese even provided him with Mameluke slaves. Instead, the Christians needed to gain the naval ascendancy in the Eastern Mediterranean. William's advice was accepted, and the council ordered the Templars and the Hospitallers to build their own fleets of warships.

William of Beaujeu had arrived at this plan not least because he recognised the contribution that was already being made by the French monarchy to sustaining the existence of Outremer. William's own uncle had fought with Louis IX in Egypt, and through his paternal grandmother he was related to the Capets, the French royal family. The kings of France were already paying for a permanent force of knights and crossbowmen at Acre, and the ambitious Charles of Anjou, who was king of Sicily and the younger brother of Louis IX, was helping to extend French power throughout the Mediterranean. But William's plans were overthrown by a popular uprising in 1282 known as the Sicilian Vespers, which sent Charles fleeing from the island to Naples.

Pope Martin IV, who was himself French, now declared a crusade against the Sicilian rebels and their supporters, the house of Aragon in Spain. Worse, he ordered funds held at

the Paris Temple and intended for Outremer to be diverted
to the house of Anjou in support of their war against fellow
Christians to regain control over Sicily. Christians through-
out Europe, and in particular the Templars, were outraged,
and a few years later, after the fall of Tripoli in 1289, one
Templar told Martin's successor Pope Nicholas IV, 'You
could have succoured the Holy Land with the power of kings
and the strength of the other faithful of Christ but you have
armed kings against a king, intending to attack a Christian
king and the Christian Sicilians to recover the island of Sic-
ily which, kicking against the pricks, took up just arms'[9] –
another example of the growing trend to put secular interests
over religious ideals.

Charles of Anjou's ambitions to build a Mediterranean
empire and to combine his kingdom of Sicily with the king-
dom of Jerusalem had kept Baybars' own ambitions some-
what in check. But in 1277 Baybars died, and after a brief
power struggle the most capable among the Mamelukes
was elevated to the sultanate, Baybars' brilliant commander
Qalaun. The Sicilian Vespers, followed by Charles' death
in 1285, removed any Mameluke hesitation in pursuing the
destruction of the Christian states in the East.

Within six years the few crusader possessions along the
coast would fall and the two-hundred-year struggle to defend
Christianity in the East would end.

Medieval Christians believed that God's judgement was
revealed through history, and that he often declared his
will by determining the outcome of a battle. As St Bernard
had written in his panegyric *In Praise of the New Knighthood*, a
Templar was a knight of Christ and 'the instrument of God
for the punishment of malefactors and for the defence of
the just'. A defeat in battle could mean that the Christians

were paying the price for some sin. Confession, prayers and penance would cleanse their souls and lead to ultimate victory. But what were Christians now to make of the repeated defeats in the Holy Land? After Baybars captured Caesarea and Haifa in 1265, a Provençal troubadour called Bonomel, who may have been a Templar, sang that given this, 'Then it is really foolish to fight the Turks, now that Jesus Christ no longer opposes them [...] Daily they impose new defeats on us: for God, who used to watch on our behalf, is now asleep, and Bafometz [Mohammed] puts forth his power to support the sultan.'[10] Another Provençal poet wrote that because God and Our Lady wanted Christian troops to be killed he would become a Muslim. As defeats continued, it became impossible to attribute Muslim victories to the sins of the generality of Christians, and increasingly the military orders, and especially the Templars, attracted the suspicion and resentment of a disillusioned Christian world.

22

The Fall of Acre

AT ACRE the old merchant communities of Genoa, Pisa, Venice, Amalfi and Marseille were joined by new trading colonies from Florence, Lucca and Ancona in Italy, by bankers from Siena, merchants from Montpellier and Barcelona, and by English merchants too. In turn traders from Acre were found in Egypt, Asia Minor, Constantinople, Kiev and at the great fairs of Champagne in France. The commercial interests of the city so far outweighed the religious that its coins were struck in Arabic for circulation in the surrounding Arabic-speaking countries.

According to Ludolph of Suchem, who visited Acre long after its fall but had reports from people who remembered how life had been there,

> The public squares, or streets, within the city were exceedingly neat, all the walls of the houses of like height with one another and built without exception of hewn stones, being wondrously adorned with glass windows and painting. Moreover, all the palaces and houses of the city were built not simply to serve ordinary needs but designed with a care for human comfort and enjoyment, being fitted up inside and

decorated outside with glass, painting, hangings, and other ornament, as each man was able. The public places of the city were covered over with silken sheets or other splendid stuffs for shade. [...] Not only the richest merchants but the most diverse folk dwelt there [...] all the strange and rare things which are to be found in the world were brought thither.

Ludolph, as he listened to those memories, was overcome with the sensation of a long lost world where 'all the inhabitants of the city deemed themselves like the Romans of old and carried themselves like noble lords, as indeed they were'.[1]

The ten-year truce agreed in 1272 between Baybars and the Franks had allowed the Mamelukes to direct their energy towards renewed Mongol threats, in this case directed by Baybars' successor Qalaun, who came to power in 1279. Qalaun then made fresh agreements with the Franks, in 1282 a ten-year truce with the Templars at Tortosa, and in 1283 a truce with Acre, also for ten years. Almost immediately, however, Qalaun resumed Mameluke aggression against parts of Outremer not covered in the agreements, starting with the Maronite Christian community in the Lebanese highlands, which was ravaged by a Muslim army in 1283; soon enough he found excuses to break his agreements with the Templars and Acre too. Now the coastal cities and castles began to go the way of the inland defences; in 1285 Qalaun took the Hospitaller castle of Margat, perched on a salient of the Jebel al-Sariya overlooking the sea, the Muslims celebrating the event from the heights of the citadel with the call to prayer which 'resounded with praise and thanks to God for having cast down the adorers of the Messiah';[2] and in 1287 he easily took the port city of Latakia after its walls were damaged in an earthquake.

Yet in 1286, in the midst of these campaigns and with extraordinary insouciance, the Franks celebrated the visit of King Henry II of Cyprus, who had come to assume the crown of Jerusalem. The Templar of Tyre recorded the festivities at Acre, when the king

> held a feast lasting fifteen days at the Auberge of the Hospital of Saint John. And it was the most splendid feast they had seen for a hundred years [...] They enacted the tales of the Round Table and the Queen of Femenie, which consisted of knights dressed as women jousting together. Then those who should have been dressed as monks dressed up as nuns, and they jousted together.[3]

Beyond the walls of Acre, however, the outlook was grim. In 1289 Qalaun overwhelmed Tripoli. 'The Muslim troops forced their way in and the citizens fled to the harbour. A few got to safety on ships', recorded the chronicler Abu al-Feda, who was an eyewitness to the events, 'but most of the men were killed and the children taken captive.' When the killing and looting were finished, Qalaun razed the city to the ground. But that still left a small island across the harbour, and on it the church of St Thomas. 'When Tripoli was taken a great many Franks fled with their women to the island and the church. The Muslim troops flung themselves into the sea and swam with their horses to the island, where they killed all the men and took the women, children and possessions. After the looting I went by boat to the island, and found it heaped with putrefying corpses; it was impossible to land there because of the stench.'[4]

Finally turning his attention to Acre, and vowing not to leave a single Christian alive in the city, Qalaun set out from Cairo in November 1290, but he fell ill and died along the way. His son Sultan al-Ashraf Khalil pledged to continue the war against the Franks, and in early spring 1291 his immense

forces, gathered from Syria and Egypt, converged on Acre, 'cutting down and wasting all the vineyards and fruit trees and all the gardens and orchards, which are most lovely thereabout',[5] instead planting the environs with over a hundred siege engines, including various kinds of catapults. On 5 April al-Ashraf Khalil himself arrived, and the siege began. At most the Franks were able to muster about a thousand knights or mounted sergeants and fourteen thousand foot soldiers; the civilian population of Acre was thirty to forty thousand, and every able-bodied man took his place on the ramparts. Although the Mamelukes could not blockade the town by sea, they had complete control of the land, and their numbers grew with a continuous number of recruits and volunteers who joined the regulars, so that eventually al-Ashraf Khalil's troops outnumbered the defenders by at least ten to one.

But the defenders were prepared and, confident in the strength of their fortifications and supplied by sea, they put up the most determined resistance. On 15 April, William of Beaujeu, the Templar Grand Master, led a night attack on a section of the Muslim lines. At first surprise won them the advantage, but the Christians got caught up in the enemy's tent ropes and were eventually beaten back. Under a hail of arrows and a bombardment of stones by the catapults, Mameluke engineers were able to advance close against the walls and mine the defences. In the second month of the siege breaches appeared, and fighting became incessant. On 16 May the Mamelukes pressed so heavily on St Anthony's Gate at the angle where the city walls joined those of Montmusard that the defenders made a desperate attempt to put their women and children aboard ships to safety. Ludolph of Suchem recorded how 'they fled to the sea, desiring to sail to Cyprus, and whereas at first there was no wind at all at sea, of a sudden so great a storm arose that no other ship, either great or small, could come near the shore, and many who essayed to swim off to the ships were drowned'.[6]

On 15 May, after six weeks of constant battering, the Tower of Henry II commanding the vital north-east salient of the city's walls was taken by the Mamelukes. William of Beaujeu was fatally wounded trying to force the enemy back. He was placed on a shield and carried to the Temple enclave, where he was buried before the high altar while the desperate fighting continued outside. By now townspeople were pressing onto the quays to board whatever ships they could to escape from the doomed city. Merchant captains made fortunes extorting money from the rich desperate to escape, as did also, it is thought, Roger of Flor, captain of a Templar galley called *The Falcon*, who used his profits to found his later career as a pirate. But there were also noble acts.

> I have heard from a most honourable Lord, and from other truthful men who were present, that more than five hundred most noble ladies and maidens, the daughters of kings and princes, came down to the seashore, when the city was about to fall, carrying with them all their jewels and ornaments of gold and precious stones, of priceless value, in their bosoms, and cried aloud, whether there were any sailor there who would take all their jewels and take whichever of them he chose to wife, if only he would take them, even naked, to some safe land or island. A sailor received them all into his ship, took them across to Cyprus, with all their goods, for nothing, and went his way. But who he was, whence he came, or whither he went, no man knows to this day. Very many other noble ladies and damsels were drowned or slain.[7]

On 18 May a general assault forced first St Anthony's Gate and then the Accursed Tower, the Pilgrims' Gate and finally the other gates along the eastern front of the inner wall. The survivors of the fighting and the non-combatant population were now trapped in the various strong buildings about the

town. As the Mamelukes stormed through the streets, they killed everyone in sight, including women and children. 'So many men perished on either side that they walked over their corpses as it were over a bridge.'[8] Those who hid indoors were taken captive and sold on the slave market of Damascus, where the glut of women and girls reduced their price to a single drachma.

By that evening all Acre was in the hands of the Mamelukes except for the Templar fortress built against the sea-waves at the south-western extremity of the city. Fleeing through the streets or racing through the secret Templar tunnel that ran beneath the town from the Pisan quarter, the last knights and civilians sought protection within the Templar walls. There they held out, commanded by the marshal, and were kept supplied by sea from Cyprus.

On 25 May, Peter of Sevrey, marshal of the Templars, agreed to surrender provided those inside were granted safe passage out of Acre, but as the Muslims entered they began to molest the women and boys, provoking the Templars to fight back. That night the Templar commander Theobald Gaudin was sent out of the fortress with the order's treasure and sailed up the coast to Château de Mer, the Templars' sea-castle just off the coast at Sidon.

The Templar fortress in Acre fell three days later, and at Sultan al-Ashraf Khalil's command all those left alive were led outside the walls, where their heads were cut off, and their city was smashed to pieces until almost nothing was left standing.

Forty years later Ludolph of Suchem came upon the spot and found only a few peasants living amid the desolation of what had once been the splendid capital of Outremer.

> When the glorious city of Acre thus fell, all the Eastern people sung of its fall in hymns of lamentation, such as they are wont to sing over the tombs of their dead, bewailing the beauty, the grandeur, and the

glory of Acre even to this day. Since that day all Christian women, whether gentle or simple, who dwell along the eastern shore [of the Mediterranean] dress in black garments of mourning and woe for the lost grandeur of Acre, even to this day.[9]

❦

From Sidon, Theobald Gaudin sailed to Cyprus with the Templar treasure. His intention was to bring back reinforcements. But Gaudin never returned. Instead, a message came from the Templars in Cyprus urging their brethren in Sidon to abandon their castle there, and on the night of 14 July they put to sea. Cyprus had long been a Frankish kingdom. A century earlier Richard the Lionheart had seized it from the Byzantines, and after a brief period in Templar hands, Richard sold it on again to Guy of Lusignan, the former king of Jerusalem, whose dynasty would continue to rule Cyprus for nearly three hundred years. Meanwhile the Templars and the Hospitallers had built castles in Cyprus, and now, as the Franks were being driven from the coast of Outremer, the island became a refuge for both military orders.

In the Holy Land, after the fall of Acre and Sidon, only Tortosa and Chastel Pelerin remained in Christian hands. Both were Templar strongholds, but as the Mamelukes gathered for the kill, the knights slipped away to Cyprus from Tortosa on 3 August 1291 and from Chastel Pelerin eleven days later. 'This time', wrote the Templar of Tyre, 'everything was lost, so that the Christians no longer held a palm of land in Syria.'[10] As the Templars looked back along the receding mainland, the devastation was already beginning. For some months after the fall of Tortosa in 1291, Mameluke troops laid waste to the coastal plain. As usual, the Muslims saw this as an act of sanctification, Abu al-Feda writing, 'Thus the whole

of Syria and the coastal areas were purified of the Franks.'[11] Orchards were cut down and irrigation systems wrecked, while native Christians fled into the Jebel al-Sariya. The only castles left standing were those far back from the sea, and Margat, high up on its coastal mountain, all occupied by the Muslims. Contemptuous of the lives and welfare of the local people, anything that might be of value to the Franks should they ever attempt another landing was destroyed.

Even four centuries after the Franks were driven from this coast, the devastation wrought by the Mamelukes was still apparent. In 1697 the English traveller Henry Maundrell recorded the 'many ruins of castles and houses, which testify that this country, however it be neglected at present, was once in the hands of a people that knew how to value it, and thought it worth the defending'.[12]

PART VII

Aftermath

P OWERFULLY PROTECTED *by its walls and supplied by sea, Acre had seemed invincible to attack, and the news of its fall after only forty-four days came as a terrible shock. The loss of the city also marked the end of a nation that had survived for almost two hundred years. The massive numbers and resources of the Turkish aggressors were not fully compre-hended; instead the fault was taken to lie within, and along with feelings of grief and anger there was a sense of failure. The sins of the inhabitants of Outremer were blamed, as was the failure of the leaders of European Christendom to provide ample and timely aid, and the Italian merchant states which had traded with Mameluke Egypt, and the military orders, Templars and Hospitallers alike. No one was exempt.*

But it was the Templars who felt the loss most intensely. The defence of the Holy Land and the protection of pilgrims were their raison d'être. For the Hospitallers the ethos of their charitable work took precedence; they had never abandoned their original function of caring for the sick.

But the Templars were founded as a military knighthood, their role to patrol the pilgrimage routes, to fight against the infidel and to preserve the Christian East, and in that cause they had serviced crusades and directed the finances of popes and kings. Now cast out from the Holy Land, the Templars found themselves in limbo.

23

Lost Souls

To many the fall of acre did not seem the decisive end of things, more an interlude, and there were expectations that the mainland would be regained. Certainly in the mind of Jacques de Molay, a man approaching fifty when he became the Templars' new Grand Master in 1292, the dream of recovering the Holy Land was not yet over. He had spent thirty years in the order, much of it in Outremer, and his vision for the Templars was that they should take the lead in a new crusade. The Templars had established their head-quarters in Cyprus, and later they recovered the tiny island of Ruad (Arwad) just 2 miles off the coast of Syria opposite Tortosa, and from these places Jacques de Molay envisioned that the counter-attack against the Mamelukes would begin.

Meanwhile on the mainland there were numerous local insurrections against Mameluke rule, which was brutal and repressive. Already in 1291, while Sultan al-Ashraf Khalil was busy fighting the Franks and their allies at Acre and elsewhere along the coast, Shia Muslims living in the northern part of the Bekaa valley and in the mountains north-east of Beirut had joined with Druze in an uprising against the Sunni Mamelukes. On his return from Acre, al-Ashraf Khalil had the Sunni caliph, who after the fall of Baghdad was made a

Mameluke puppet in Cairo, declare jihad against dissenting Muslims, who outnumbered Sunnis in Palestine and Syria, with the aim of breaking their resistance to Mameluke domination; they were finally crushed in 1308.

In 1293 al-Ashraf Khalil built a fleet with the intention of invading Cyprus, but he was murdered that December by another Mameluke, touching off a battle for power which after further murders, crucifixions and chopping off of hands saw al-Nasr Mohammed eventually emerge as sultan. He built himself a splendid mosque–madrasa–mausoleum in Cairo and for its entrance used the Gothic portal to the Church of St Andrew brought from Acre, an advertisement of Islam's victory over Christianity. Also during al-Nasr's reign a new emphasis was placed on Jerusalem; building on the story of the Night Journey initiated by the Umayyads, continued by the Fatimids and deployed by Saladin's jihad, the sanctity of Jerusalem was extolled, Muslims were encouraged to make pilgrimage there and were told that the Prophet Mohammed had said that a prayer at the Aqsa mosque was worth a thousand times more than one in any other, apart from at Mecca or Medina.

Under regulations imposed by al-Nasr in 1301 Christians and Jews throughout Palestine, Syria, Lebanon and Egypt were again oppressed by the old laws which reduced them to the status of *dhimmis*; among other things they were forbidden to ride horses or mules and were forced to wear distinctive clothing; al-Nasr also abolished a national Coptic feast and closed many Coptic churches in Egypt. In 1321, still during al-Nasr's long reign, fanatical Muslims looted and destroyed all the principal churches of Egypt and Christians suffered wholesale massacre, while Copts were expelled from official positions and subjected to a range of indignities. Each of these events was followed by conversions to Islam. Even so, Copts continued to outnumber Muslims in much of Egypt until a further great wave of persecution in 1354.

In Syria and Lebanon things were hardly less difficult for
the Maronites. They had been condemned by the Church
as heretics in the seventh century not for their belief in the
single nature of Christ (Monophysitism), but rather for their
belief in the single will of Christ (Monothelitism), but in
1182 the Franks helped bring them into communion with the
Catholic Church at Rome. Over fifty thousand Maronites
were said to have died fighting alongside the Franks dur-
ing the twelfth and thirteenth centuries to defend Outremer
against the Muslims. When the Franks left, some Maronites
went with them to Cyprus, where their communities con-
tinue to thrive, while those who remained never surrendered
their connection with Rome, despite persecution by the
Mameluke jihad; instead they escaped into the mountains
of northern Lebanon, which remain a Christian stronghold
to this day.

Eager to take the initiative in recovering the Holy Land, in
1294 Jacques de Molay travelled from Cyprus to the West to
promote the Templars as the vanguard of a new crusade. He
received encouragement from Pope Boniface VIII in Rome
and King Edward I in London, and practical assistance too,
with both pope and king making it easier for the Templars
to raise new funds in Europe in order to rebuild their forces
after their terrible recent losses at Acre and elsewhere in Out-
remer. Foodstuffs and treasure were shipped from European
ports to the Templars in Cyprus, and galleys were bought
from Venice, part of the war fleet that the Templars would
need to lead the attacks against the Syrian and Egyptian
coasts.

The best hope for a new crusade lay with the Mongols.
Since their defeat at the hands of the Mamelukes in 1260
the Mongols had shown an interest in forming alliances with

the Christians in the West and with the Byzantine Empire. Maria Paleologina, daughter of the Byzantine emperor Michael VIII Paleologus, who had recovered Constantinople from the Latins, was sent East in the 1260s to marry the son of the Mongol khan and to proselytise for Christianity. And when two Mongol emissaries converted to Christianity at the Council of Lyon in 1274, hopes were raised further that the Mongols might convert wholesale. Twice, in 1281 and 1299, the Mongols advanced into northern Syria; and when news came from the West in 1300 of a new crusade, the Mongols offered the Christians the Holy Land if they would help them defeat the Mamelukes.

A wave of excited anticipation swept across Europe in 1300 at the prospect of this new expedition to the East. The mood was reminiscent of those days when Pope Urban II had preached the First Crusade. Being the 1,300th anniversary of the birth of Christ, the pope declared this to be a jubilee year, promising full remission of sins to those who visited the Basilica of St Peter in Rome. Two hundred thousand pilgrims answered his call and were welcomed by a triumphant Pope Boniface sitting on the throne of Constantine the Great and holding the symbols of temporal dominion, the sword, the sceptre and the crown, and calling to the crowd, 'I am Caesar!' In the familiar battle between the Church and the secular claims of kings, no one could be left in doubt that the pope was proclaiming the universal jurisdiction of the Church over the monarchs of the West and celebrating the victory yet to come over the infidels in the East.

In the summer of 1300 the Templars, together with the Hospitallers and the king of Cyprus, launched a series of probing attacks against Alexandria and Rosetta, and at Acre, Tortosa and Maraclea. These were preliminaries to a planned joint operation with the Armenians in Cilicia and the Mongols, and they were followed up in November by a combined Templar, Hospitaller and Lusignan force from Cyprus, about

six hundred knights in all, which was landed on the island of Ruad. From there they made raids against Tortosa, waiting for the Mongols to appear.

But the Mongols failed to arrive. A year later, writing from Cyprus, Jacques de Molay gave an outline of the situation to King James II of Aragon.

> The king of Armenia sent his ambassadors to the king of Cyprus to tell him that the lord king of Armenia had learned that [the Mongol khan] Ghazan was now on the point of entering the lands of the sultan with a horde of Tartars. As we knew this we are now en route for the island of Tortosa, where our convent has maintained horses and arms the whole of this year. By pillaging, destroying their *casalia* and capturing their men our brothers have inflicted serious damage on the Saracens. We will continue to stay there until the Tartars arrive.[1]

This time, towards the end of 1301, the Templars took it upon themselves to establish a considerable force on the island and rebuild its defences. In preparation for a serious assault on the Syrian mainland, they garrisoned Ruad with 120 knights, 500 archers and 400 workers and servants, almost half the number of Templar knights and auxiliaries as would normally have defended the entire kingdom of Jerusalem in the twelfth century. Yet still the Mongols failed to arrive, but in April 1302 the Mongol Khan wrote to Pope Boniface saying they were coming soon. 'We are continuing preparations. [...] You too should prepare your troops. [...] If the heavens hear our prayers our entire effort will be directed to this great enterprise. [...] You, too, should pray to the heavens and prepare your troops.'[2]

Instead, later that year, while waiting for the Mongols, the Templars found themselves isolated on their tiny island, against which the Mamelukes sent a fleet of sixteen ships.

A prolonged siege and repeated attacks finally wore down the starving Templars, who surrendered on condition of safe conduct, a promise that was betrayed, the Templars being slaughtered or sold into slavery.

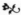

Despite this setback in the East, Pope Boniface VIII was no less adamant about his claims of papal supremacy in the West, which he reinforced with a bull in 1303 called *Unam Sanctam*. This asserted that there was only one holy (*unam sanctam*) Catholic Church, and that to attain salvation it was necessary to submit to the pope in all matters both spiritual and material. The bull was in response to various trespasses against the authority of the Church that had been committed by Philip IV of France, often known as Philip the Fair for his golden locks if nothing else, who inherited a massive debt when he became king in 1285 and was forever in need of money to finance the expansion of his kingdom and make war against Flanders and England, and who therefore imposed taxes on the clergy. To Philip this was no different to raising taxes for a crusade, for he ruled with a divine mission; in 1297 he had obtained a sainthood for his grandfather, the crusading Louis IX, and he was convinced that France was the chosen kingdom of God and his dynasty, the Capets, its chosen instrument. In effect, the conflict was between the universalist claims of the Church and the new phenomenon of nationalism as asserted by the king of France, both of which claimed to have God on their side. The pope might be the Vicar of God, but Philip, according to his admirers, was 'the most Christian king' and if not wholly divine then at least 'semi-divine'.[3]

When Philip still showed no sign of repentance or of bowing to the pope's will, Boniface prepared a bull of excommunication against the king and his minister William of Nogaret.

But before it could be published, a force of French soldiers led by William of Nogaret himself burst into the pope's summer palace at Agnani in the hills south-east of Rome with the aim of taking Boniface as prisoner back to France to stand trial on charges of heresy, sodomy and the murder of the previous pope. Boniface, who was guarded by only a handful of Templars and Hospitallers, challenged his enemies to kill him, saying, 'Here is my neck, here is my head.' But Boniface had been born at Agnani, and the townsfolk rallied to him; and before his captors could do more than slap him around and beat him up, they rushed to his defence and drove the French out. He was a broken man, however, and a month later, when he died in Rome, any serious pretension of the Catholic Church to universal dominion over spiritual and material affairs died with him. The age had truly begun of European nation-states led, whatever their religious claims, by secular leaders with secular aims.

Forty years earlier, in a dispute between the papacy and the Templars, the pope wrote to the Grand Master reminding him that it was the Church 'on whose help, after God, you are totally dependent', and that if the Church removed its hand of protection from the order 'you could not in any way subsist against [...] the force of the princes'.[4] Now that time had come.

After the death of Boniface, the College of Cardinals elected a new pope, but he died within a year. After long deliberation and pressure from Philip IV, the College produced a Frenchman, who came to the papal throne in 1305 as Clement V. Never throughout his papacy did Clement set foot in Rome or indeed Italy; instead he moved between Lyon and Poitiers until March 1309, when he set up court at Avignon in Provence, which at that time technically lay outside the

jurisdiction of the kings of France. Clement then went on to pack the College of Cardinals with Frenchmen; not surprisingly the next six popes all resided at Avignon, and all were French.

This did not mean that Clement V was a puppet of Philip IV; rather, the new pope understood that, if he was to achieve his papal ambitions, it would not be, as Boniface had insisted in *Unam Sanctam*, by trying to make Philip submit to his authority but by cultivating their relationship and securing Philip's co-operation. Clement's great ambition was a new crusade, but it would need the collaboration and leadership of the French king. The proposed venture had its difficulties, however, not least because since the fall of Ruad the Mongols had converted en masse to Islam, not to Christianity as had been hoped.

Another difficulty was presented by Philip himself. Clement succeeded in persuading the king to take the cross at the end of December 1305; he freed Philip from the distraction of local conflict by negotiating a peace between the French king and King Edward I of England; and he diverted 10 per cent of the Church's income in France to Philip's coffers to finance the new crusade. But in Philip's view a prerequisite for a successful crusade was the merging of the two military orders, the Templars and the Hospitallers. Moreover, Philip would command the new order; it would become an instrument of France, for Philip's propagandists also insisted that eventually his command should pass to one of his sons, who likewise should succeed him as king of Jerusalem. Then again, there was a large element of hypocrisy in these French plans. Recovering the Holy Land was not really Philip's priority; rather, his ambition was to conquer the Christian Byzantine Empire and to establish himself on the ancient imperial throne at Constantinople.

In May 1307 Pope Clement met with the Templar and Hospitaller Grand Masters at his court in France, where they

submitted their own views on the proposed crusade and the unification of the orders. The comments made by the Grand Master of the Hospitallers, Fulk of Villaret, about the merging of the orders do not survive, but it seems that he was opposed, as his proposal for the crusade assumed that the Hospitallers and the Templars would operate independently. Fulk favoured a small initial expedition to the East, a policy the Hospitallers in fact pursued in June of that very same year, when they seized the island of Rhodes, which had been a Byzantine possession, an enterprise that gave them a well-fortified and independent state of their own. A large crusade, went Fulk's argument, should follow only after forward bases had been secured.

But after the Templars' experience of the failure at Ruad, Jacques de Molay opposed a small-scale expedition and wanted an all-out crusade. This meant calling on the kings of Spain, Sicily, Germany, England and France to raise an army of between 12,000 and 15,000 knights and 5,000 soldiers on foot. This enormous force was to be raised secretly and transported on Venetian, Genoese and other Italian ships to Cyprus, from where it was to be launched against the coast of Palestine. Jacques de Molay's plan was based on a serious and realistic assessment of the military problems facing a crusade aimed at the recovery of the Holy Land, although he knew that this was not in line with popular opinion, which wanted the rhetoric of crusade without the effort or commitment. Moreover it flew in the face of Philip's hypocritical intentions. In the end Jacques de Molay's plan amounted to wishful thinking, but to admit that would have meant reassessing the role of the Templars in changing times, something that was not in the nature of the Grand Master to do.

On the matter of uniting the two orders, Jacques de Molay was also unaccommodating. He admitted that there could be some advantages in the merger, principally that a united order would be stronger. But he also pointed out that the

question had been raised before, only to be rejected. Competition between the Templars and the Hospitallers made the orders more effective, he said, as it provided the stimulus for each to outdo the other. Nor did one duplicate the functions of the other; rather, they were complementaries, placing different emphases on providing alms, transporting men and supplies across the sea, protecting pilgrims and crusaders, and making war against the infidel. Ultimately the great purpose of the military orders was to further the crusade, wrote Jacques de Molay to the pope, and as the Hospitallers and the Templars 'are better suited and more useful for reconquering and guarding the Holy Land than other peoples are',[5] they ought to be kept separate.

But unfortunately for the Templars there was no hope of the sort of mass crusade envisioned by Jacques de Molay. The Hospitallers had shown a keener awareness of current realities by going for the lesser option, one that all but guaranteed their survival by creating a state of their own on Rhodes. The Templars once again were left in limbo and were now increasingly the victims of attacks on their seeming idleness.

The Templars, wrote Rostan Berenguier, a poet of Marseille at around this time, 'waste this money which is intended for the recovery of the Holy Sepulchre on cutting a fine figure in the world; they deceive people with their idle trumpery, and offend God; since they and the Hospital have for so long allowed the false Turks to remain in possession of Jerusalem and Acre; since they flee faster than the holy hawk; it is a pity, in my view, that we do not rid ourselves of them for good'.[6]

After his meeting with the pope, Jacques de Molay travelled to Paris, where on 12 October 1307 his apparent intimacy with the royal family was evident for all to see when, in the presence of Philip IV himself, he walked in procession holding one of the pall cords at the funeral of the king's sister Catherine of Courtenay. Other Templar leaders, usually based in Cyprus, were also in Paris at this time.

The following day at dawn, Friday 13 October, Jacques de Molay was arrested by the king's men, led by William of Nogaret.

Philip's order for the arrest of the Templar leadership in Paris and of every Templar throughout France had been circulated secretly the month before: 'A bitter thing, a lamentable thing,' went the opening lines of the order, dated 14 September, 'a thing horrible to contemplate, terrible to hear, a heinous crime, an execrable evil, an abominable deed, a hateful disgrace, a completely inhuman thing, indeed remote from all humanity.'[7]

24

The Trial

Rumours had long been circulating of strange rituals practised by the Templars. Even Jacques de Molay, while attending a chapter meeting in Cyprus in 1291, either before or after the fall of Acre but before he became Grand Master, said that 'he wanted to eradicate from the order all things which displeased him, fearing that, if he did not do so, it would eventually harm the order'.[1] One story told of novice Templars undergoing humiliating initiation ceremonies which forced them to demonstrate their subjugation to their superiors, in some cases even kissing their behinds. At the papal coronation in late autumn 1305 King Philip repeated these rumours to Clement V, saying they were going round in both religious and secular circles, and asked him to investigate.

In May 1307, at the same time as Clement was interviewing the Templar and Hospitaller Grand Masters about uniting the two orders and their plans for a crusade, the pope heard something of these bizarre practices from Jacques de Molay himself. In the pope's words, the Grand Master told him of 'many strange and unheard-of things' which had caused Clement 'great sorrow, anxiety and upset of heart'.[2] The Grand Master feared that these initiation ceremonies, which had been going on for a century or more, were getting out of hand, and the

Pope agreed to instigate an inquiry to root out these practices before they erupted into scandal. Clement was a worldly man who came from a military family and understood well enough the sort of barrack room behaviour that took place between soldiers. But Philip had been telling him something more. For years he had been planting spies within the order, and now he was suggesting to the pope that through their practices and beliefs the Templars were undermining the very tenets of the faith. Lewd behaviour was one thing, but the Templars were a religious order on the same footing as the Benedictines, the Dominicans and the Franciscans, all directly responsible to the pope, and Clement was being confronted with the possibility that the Templars were infected with heresy.

On 24 August 1307 Clement wrote to Philip telling him that 'we could scarcely bring our mind to believe what was said at that time',[3] but there was no need for haste as he was not feeling well and would be visiting thermal baths in September to take the cure; a formal papal investigation into the order would begin in the middle of October when he returned.

Seizing the initiative, this was the moment that Philip began laying his plans for the arrest and destruction of the Templars. The middle of October was his deadline, set by Clement's cure.

The Templars were taken by surprise when Philip IV's officers came for them in the early hours of the morning of Friday 13 October 1307. They were arrested simultaneously throughout France – about two thousand men in all, from knights down to the most humble agricultural workers and household servants. There was no resistance. Most of the Templars were unarmed and many were middle aged or even elderly, and except for the Paris Temple their houses were unfortified; with their active soldiers badly needed in the East, the

Templars resident in France were no more a fighting force than the Franciscans or Cistercians. The close relationship between the French crown and the Templars probably explains why the king's officials were able to walk right in to the Temple on that Friday dawn. The keep, which had been the Templars' stronghold, immediately became their prison, and the Templars arrested throughout France were also brought here for incarceration, examination and torture.

The efficiency of the operation benefited from previous raids when King Philip struck against Italian bankers resident in France in 1291 and against Jews in 1306, in each case arresting them, throwing them out of the country and seizing their property and their money to reduce his debts. A few Templars did escape – about twenty-four, it seems – though only one of any importance, Gerard of Villiers, the master of France. Several were apprehended later, despite disguising themselves by a change of dress and shaving off their beards; some had gone to ground in the countryside, one was picked up off the streets of Paris where he was living as a beggar, and another fled to England, where he was arrested later. Some even fled to Muslim countries, or were there as prisoners at the time of the arrests; in 1323 an Irish Franciscan, Brother Simon, who came to Cairo during a pilgrimage to the Holy Land, met a man called Peter, now married but once a Templar knight. He was still looking after pilgrims, as he had always done, this time as one of three dragomen sent to interpret for the visiting Franciscan and to provide him with a pass to the Church of the Holy Sepulchre. According to Simon, all three were secret worshippers of Christ. 'All are very courteous and generous and useful to the poor and to pilgrims. They are very wealthy, possessing abundance of gold, silver and precious stones and costly garments and other wealth, and living in great pomp.'[4]

The charge against the Templars was heresy. When being inducted into the order, went the accusations, initiates were

required to deny Christ, to spit, piss or trample on the cross or images of Christ, and to kiss the receiving official on the mouth, navel, base of the spine, and sometimes on the bottom or the penis. They were also obliged to submit to homosexual practises as required within the order, which practised institutionalised sodomy. And they wore a small belt which had been consecrated by touching a strange idol which looked like a cat or a human head with a long beard called Baphomet (possibly an Old French distortion of Mohammed). Moreover the Templars held their reception ceremonies and chapter meetings in secret and at night; the brothers did not believe in the sacraments, and the Templar priests did not consecrate the host; and although not ordained by the Church, high Templar officials, including the Grand Master, absolved brothers of their sins. And drawing a contrast with the Hospitallers, the Templars were accused of failing to make charitable gifts as they were meant to do, nor did they practise hospitality.

Philip was able to arrest and charge the Templars owing to a loophole in the law going back to the time of the Cathars and their trials nearly eighty years earlier. So serious was the spread of the Cathar heresy in the early 1200s that Pope Honorius III had bestowed extraordinary powers on the Inquisition, extending its reach even to the exempt orders, the Templars, the Hospitallers and St Bernard's Cistercians, whenever there was a suspicion of heresy. After the Cathar heresy was eradicated, this grant of powers was forgotten by the papacy, but it was never revoked. This meant that the Templars, though otherwise answerable to no secular or religious authority other than the pope, were vulnerable to the charge of heresy – a discovery made by Philip IV's assiduous lawyers, who now used it to devastating effect.

As heresy was the one possible charge that the king could successfully level against the Templars, so heresy it had to be. No time was wasted in mounting a propaganda campaign against the Templars: the king's minister William of Nogaret

announced the heresy before a large crowd in Paris, and under the Inquisitor's instructions the charge was repeated from church pulpits. The mere mention of heresy had the immediate effect of blackening the order's reputation.

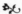

The prisoners were interrogated and tortured by royal agents under the direction of William of Nogaret, who in 1303 had taken part in the attempt to overthrow Pope Boniface VIII, since when he had remained excommunicated. William's family had suffered persecution because his grandfather had been a Cathar, but by his cleverness and cynicism he had risen in Philip's court and was ennobled in 1299, becoming the king's Keeper of the Seals and his right-hand man. These facts may have contributed to William of Nogaret's contempt for the papacy and his unscrupulous ambition to make France the greatest power in the world.

Many of those arrested were simple men, not battle-hardened Templar knights but ploughmen, artisans and servants who helped keep the order running, and these would have succumbed to torture or even the threat of torture fairly quickly. The knights themselves, however, had been long prepared for the worst in Outremer, for that day when they might be captured and thrown into a Muslim dungeon, be tortured or face execution unless they abjured their faith. And yet these too rapidly and all but unanimously confessed. The tortures could be savage: scores died undergoing what was called ecclesiastical procedure, which did not mean breaking limbs or drawing blood but which routinely included being kept chained in isolation and fed on bread and water; being drawn on the rack until the joints were dislocated, being raised over a beam by a rope tied to the wrists that had been bound behind the victim's back and sometimes with weights attached to the testicles, and having fat rubbed into the soles

of the feet, which were then placed before a fire. One tortured Templar priest was so badly burned that the bones fell out of his feet. Another of the accused said that he would have agreed 'to kill God'[5] to stop his torment.

Yet physical torture was far from the only element in the confessions. Instead, one of the worst problems for the Templars was the overturning of their spiritual and social universe. They had spent their lives in the enclosed world of a military elite to which they owed absolute loyalty and were constantly reminded of the support they in turn received from the rest of society. But now they were reviled, told that they were heretics, and no support seemed to be forthcoming from any quarter. The walls, ceiling and floor of their enclosed world had fallen away, leaving them exposed, bewildered and lost. Under these conditions it is not surprising that Jacques de Molay, the Grand Master, Geoffrey of Charney, preceptor of Normandy, and Hugh of Pairaud, whose rank of visitor of France made him the most elevated Templar in Western Christendom after Jacques de Molay, were among the near unanimity of Templars who rapidly confessed.

On 19 October 1307 the Inquisitorial hearings began at the Paris Temple. On 25 and 26 October Jacques de Molay was called to testify. His confession, made before the hearing, was recorded and sent to the pope as proof of heresy. In less than two weeks since their arrest, the Templars' honour had been stained for ever, and the news of their guilt reverberated throughout the whole of Christendom.

Jacques de Molay's confession, made on 24 October, stated that his initiation ceremony, which took place forty-two years earlier, followed the usual observances and statutes of the order, but then after the receptor placed the mantle on his shoulders he

> caused a certain bronze cross bearing the image of
> the Crucified to be brought into his presence, and

told and ordered him to deny Christ whose image was there. Against his will he did this. Then the said receiver ordered him to spit on it but he spat on the ground. Asked how many times, he said on oath that he only spat once, and he remembered this clearly. Asked if, when he vowed chastity, anything was said to him about homosexual practices with the brothers, he said on oath that this was not the case and that he had never done this. Asked on oath whether other brothers of the said order were received in this manner, he said that he believed there was no difference between his and others' receptions. [...] Asked whether he had told or included any lie or omitted any fact in his deposition because of threat, fear or torture or imprisonment or any other reason he said on his oath that he had not; indeed he told the whole truth for the salvation of his soul.[6]

Although Jacques de Molay did not admit to much, his confession acquires greater force when seen in conjunction with others made at about the same time. On 21 October, Geoffrey of Charney, preceptor of Normandy, went down the same list of offences in the same order. After the mantle was placed on his shoulders, 'there was brought to him a certain cross bearing the image of Jesus Christ, and the said receptor told him not to believe in the one whose image was portrayed there since he was a false prophet and was not God. And then the said receptor made him deny Jesus Christ three times, but he claimed to have done this only with his tongue and not with his heart'.[7] Geoffrey of Charney could not remember if he had then spat on the image, but he did recall kissing his receptor on the navel and being told it was better to have sex with brothers than with women, although he said he never did this.

The same formula – the mantle, the image, the denial, the spitting – was followed again on 9 November, when Hugh of Pairaud, Visitor of France, made his confession. 'He denied

Jesus Christ, though as he said, with his lips but not his heart.' He admitted to kissing the receptor, but only on the mouth. But when later he conducted his own initiations,

> he made them kiss him on the bottom of the dorsal spine, on the navel and on the mouth, and then had brought before them a cross and told them that the statutes of the order required them to deny the Crucified one and the cross three times, to spit upon the cross and the image of Jesus Christ, the Crucified one, although this is what he ordered them to do, he did not do this with his heart.

He also gave permission for initiates to relieve their sexual urges with their fellow brothers, 'although he did this only with his lips, not with his heart'. Asked about the head,

> he said on his oath that he had seen it, held it and stroked it at Montpellier in a chapter, and he and other brothers present had worshipped it. He said however that he had worshipped it with his lips, not with his heart, and then only in pretence; he did not know if other brothers worshipped it with their heart. [...] He said that this head had four feet, two at the front, under the face, and two behind.[8]

These confessions are significant at least as much for what has been omitted. They were crafted by William of Nogaret, who selected and extrapolated from their context those elements which could be presented as crimes against the faith. These were then put together in such a form that they created the impression of a coherent heretic creed. Quite possibly little or no torture was required to get the basic facts, but the violence came in the way they were presented.

※

It is not impossible that Philip and his government really did believe the accusations of heresy that they made against the Templars. This was an age when people believed that the devil was constantly trying to spread corruption throughout Christian society. By attacking the weak points of the social structure the devil aimed to cause the collapse of society altogether. Therefore the task of the faithful was to be vigilant, to expose evil and to cut out corruption at an early stage before the whole of society succumbed. Philip had given himself the role of a sacred king ruling over a holy country and had already shown he would not accept any challenge to his absolute sovereignty; he had not hesitated to strike against Boniface VIII and would have tried him for heretical crimes. The protection under the pope enjoyed by the Templars and their immunity from the secular law would already have been an offence in Philip's eyes; if there was anything about the Templars that smacked of heresy, the king and his supporters could easily have taken this as a danger that needed to be immediately eradicated.

But Philip's most powerful immediate motive was the desire, indeed the need, to get his hands on the wealth of the Templars. He had already stolen from the Italian bankers and the Jews, he had debased the currency, and it was his exactions from the clergy that provoked his first confrontation with Boniface VIII. His wars against England and in Flanders had cost him a great deal of money, and he had inherited a huge debt from his father's wars. The Templars were a tempting target, for unlike the Hospitallers, whose wealth was entirely in land, the Templars from their banking activities also had liquid wealth, which the king could quickly and easily grab. By accusing them of heresy Philip could turn the Templars into reprehensible religious outsiders against whom persecution was readily rationalised.

Many foreign observers, especially those in northern Italy, where there was a more complete understanding of the

power of money than anywhere else in fourteenth-century Europe, were convinced that getting his hands on the Templars' cash and precious metals was the primary motive for Philip's attack. Dante famously attacked the king's actions in *Purgatorio*, the second book of the *Divine Comedy*, written in the immediate aftermath of the Templars' arrest. Comparing Philip to Pontius Pilate, Dante wrote:

> I see the second Pilate's cruel mood
> Grow so insatiate that without decree
> His greedy sails upon the Temple intrude.[9]

Pope Clement V was stunned when, on 14 October, a messenger brought the news to his court at Poitiers that the Templars had been arrested the previous day. Although the action had been taken on the nominal authority of the French Inquisitor William of Paris, there was no doubt that the arrests represented an attack on the papacy and the Catholic Church by the secular monarchy of France. The matter concerned not the Templars only; the survival of the papacy was at stake, and Clement immediately summoned all his cardinals for an emergency meeting of the Curia, which began on 16 October and lasted three days.

Another pope at another time might have excommunicated Philip. But Clement was doubly vulnerable – after Philip's coup against Boniface in Italy, and as a resident on French soil. Instead Clement issued a bull, *Ad Preclarus Sapientie*, which gave Philip a way out: it said that the king had acted unlawfully and had tarnished the reputation of his grandfather St Louis, but he could make up for his rashness by handing the Templars and their possessions over to the Church. To achieve this, in November the pope sent two cardinals to Paris to take into custody the men and property

of the Temple. But the king had made himself absent and his counsellors refused access to the Templars, let alone handing them over to the Church, arguing that a papal intervention was superfluous as they were self-confessed heretics.

When the cardinals went back to Poitiers with the news that the French monarchy was flatly refusing to obey an express command of the pope, the Curia was plunged into crisis. According to one report, ten cardinals threatened to resign if the pope showed himself to be a puppet of the French king. Clement was faced with replacing the cardinals at the cost of causing a schism in the Church, or he could excommunicate Philip and fall victim to a royal coup.

But the pope found another way and, acting with some dexterity within the difficult constraints of his situation, he did what he could to put himself in charge of events. First on 22 November 1307 he issued a bull, *Pastoralis Praeeminentiae*, asking all the kings and princes of Christendom to arrest the Templars in their lands and to hold their property in safe keeping for the Church. In this way proceedings were initiated against the Templars in England, Germany, Portugal, Spain, Italy and Cyprus – but in the name of the Church. By doing this the pope was delivering an implied ultimatum to King Philip, that what was true in the rest of Europe must also be so in France. He praised the French king for his good faith and religious zeal, but Clement was making it clear that the case against the Templars was being removed from the king's authority and was now being taken into the hands of the papacy.

As for the crisis that had arisen when the king's officials rebuffed the two cardinals, the pope simply pretended that the incident had never happened. Instead in December he sent the two cardinals back to Paris as if for the first time. But now they brought with them the power, granted by the pope, to excommunicate Philip on the spot and to place the whole of France under an interdict if the king persisted in his

refusal to hand over the Templars. The move was effective: on 24 December 1307 Philip wrote to the pope that he would hand over the Templars.

On 27 December 1307 the cardinals met Jacques de Molay and other leading Templars, who denied everything to which they had formerly confessed. According to one source, the Grand Master said that he had confessed only under heavy torture, and he showed the wounds on his body, although it is not clear if this source can be trusted. Nevertheless, retracting the confessions was a risky move because under the rules of the Inquisition relapsed heretics were handed over to the secular authorities to be burned. That the Grand Master and others took that risk shows that they were confident that a great injustice was about to be overturned.

Although the Church was granted this brief access to the leading Templars, Philip had still not transferred any Templars to Church control. In February 1308 Pope Clement suspended the Inquisitor William of Paris and the whole French Inquisition. In reply the king's officials tried to force the pope to reopen the trial by marshalling public and theological opinion in France. The chief agent in this was William of Nogaret, who instigated a campaign of libel, slander and physical intimidation against the pope; Clement was threatened with deposition, and menaces were directed against his family. But Clement stood his ground against the king, and to settle their differences they met in May and June at Poitiers. There they agreed that the pope would set up two kinds of inquiry: one by a papal commission to look into the Templars as an institution, the other consisting of a series of provincial councils, each supervised by the bishop of a diocese, to investigate the guilt or innocence of individual Templars. For his part Philip finally consented to release a

number of Templars into the physical custody of the Church so that they could be interviewed directly by the pope.

Philip chose seventy-two Templars from among his prisoners in Paris and sent them, chained to one another and under a military escort, by wagon to Poitiers. Most of these were renegades or at best sergeants selected to make a poor impression on the pope, and with them he sent the Grand Master and four other high officers of the Templar order. But suddenly, when the convoy reached the royal castle of Chinon, the seventy-two were sent on to Poitiers; but the leaders were detained, the king claiming they were too ill to undertake the journey. This was an obvious lie, as Chinon lay not far from Poitiers. The king probably feared that if the pope interviewed the Templar leaders he would find them free of heresy and grant them absolution.

The pope ignored Philip's deceit over the Templar leaders held at Chinon. Instead of walking into a destructive confrontation with the king, Clement got on with examining those Templars who had been sent to him. From 28 June to 1 July 1308 the seventy-two Templars were heard at Poitiers by a special commission of cardinals and by the pope himself. On 2 July Clement granted absolution to the Templars, who had confessed and had asked for the forgiveness of the Church. Had the Templars been found guilty, the pope would never have forgiven them; but on the other hand, had they been innocent, he would have acquitted them without requiring any show of repentance.

The Templars were not heretics, Clement had decided. They attended Mass, they went to Holy Communion and confession, and they complied with their liturgical duties. But they also confessed to the pope that at their entrance ceremony they denied Christ and spat on the cross, although they insisted that they had never consented to this in their souls and as soon as possible had confessed to a priest and asked for absolution. The pope found these induction rituals

too confused to be taken seriously; at one moment the novice spat on the cross, but then kissed it in adoration; and the novice denied the divinity of Christ saying, 'You, who are God, I deny', which was no denial at all. If the Templars were heretics, they were the most inconsistent and unconvincing adherents any heresy could have. The Templars had fallen into peculiar ways and needed reform, but that, decided the pope, was all.

Clement's understanding of these strange Templar practices was that they were simply an entrance ritual, a custom that was common, with variations, in every military elite since early antiquity. This was a secret rite of passage after the formal ceremony, a compulsory test to which all new Templar brothers had to submit, a peculiar tradition (*modus ordinis nostri*) which demonstrated to the initiate the violence that the Templars were likely to suffer at the hands of their Muslim captors, and how they would be compelled to deny Christ and to spit on the cross. The aim of the test was to strengthen the souls of recruits, and it took the form of a very realistic performance. To this first part was added another test, that of kissing the master who had received him on the lower spine, on the navel and finally on the mouth; its purpose was to teach the novice that in all circumstances whatsoever he owed absolute obedience to his superiors. This seems to have been the original and true form of the ritual, but the local masters made changes, and in time this secret ritual became quite coarse and sometimes even violent. It could also seem preposterous; occasionally onlookers would 'erupt in laughter and inform the new Templar that it was a practical joke'.[10]

The explanation for the apparent worship of a head, the one mentioned in his confession by Hugh of Pairaud, and by others too, and which the inquisition called Baphomet, remains something of a mystery, and it is not clear if Clement was ever made aware of its meaning. Recent research by Byzantine scholars at the Pontifical Oriental Institute in Rome

has discovered a Templar rite of the Passion of Christ celebrated on the evening of Holy Thursday in commemoration of the Last Supper in which the brothers received communion only in the form of wine – that is, the blood of Christ, the drink of eternal life. The head, which was an unusual image of Christ, played a part in this mysterious cult of the sacred blood which was unknown to the Roman Catholic Church and seems to have been unique to the Templars, who may have adopted it from an ancient Christian ceremony they encountered in Jerusalem.

Having met the seventy-two Templars at Poitiers, Clement decided that they were not heretics but nor were they innocent, for they had actually denied the divinity of Christ even if it was all a pretence. Apostasy could be forgiven, but sinners had to repent and submit to harsh penance. But he could not do the same for the leaders without seeing them, and although he issued a formal summons for the appearance of Jacques de Molay and the other leading Templars, this was refused by the king with the repeated claim that they were ill.

In the summer of 1308 the pope absolved Jacques de Molay and the other Templar leaders held prisoner at Chinon. Seemingly no proper report of this hearing had survived, and until recently it was doubted that any such event had taken place – that is, until the discovery of the Chinon Parchment in the Vatican Secret Archives in 2001 and its publication by the Vatican in 2007.[11] This showed unequivocally that, despite the chief Templars being held prisoner by the king, a hearing had somehow been arranged within the royal castle at Chinon.

This was set in motion on 14 August 1308, when three cardinals left the papal court at Poitiers for an unknown destination. They were Etienne of Suisy, Landolfo Brancacci

and Bérenger Frédol, the last being one of the outstanding canon lawyers of his time and a nephew of the pope; secretly they formed a special apostolic commission of inquiry with Clement's full authority. Two or three days later the cardinals arrived at Chinon, where, in addition to the royal jailer, there were two important royal officials, identified in French records only by their initials, but who are thought to have been William of Nogaret and a lawyer who acted on his behalf called William of Plaisians.

If there were any hidden negotiations between the parties at Chinon, the fact is unknown. Instead, what followed seems to have taken place under the noses of the king's officials but without their knowledge. According to the Chinon Parchment, no royal officials attended the hearings that took place at Chinon from 17 to 20 August; they were held quickly and presumably in all secrecy to avoid the intervention of the royal officers. Apart from the three cardinals and the Templars they examined, the others at the hearing were a handful of witnesses, all clerks and humble people, none of them closely linked to King Philip. This at last was the papal trial of the Templar leaders; it was entirely a Church affair.

During the first three days of the trial the three cardinals examined Raimbald of Caron, the master of Cyprus; Geoffrey of Charney, preceptor of Normandy; Geoffrey of Gonneville, preceptor of Poitou and Aquitaine; and Hugh of Pairaud, the Visitor. On the final day, 20 August, they heard the testimony of the Grand Master, Jacques de Molay. The details varied between the testimonies, but taken all together they amounted to a restatement of the practices previously mentioned in testimony by the seventy-two Templars at Poitiers.

In essence Jacques de Molay repeated his confession of October 1307, including the assertion that he had not been tortured, although this contradicted his claim in December that year that he had been tortured. Possibly he and the other leaders had been advised that a freely given confession, one

not made under duress, would be the easiest way out of their situation; and in any case it may be that what they confessed to was true.

The following is a rough translation from the Latin of Jacques de Molay's confession at Chinon:

> Concerning the mode of his reception into the order, he said that having given him the mantle the receptor showed to him the cross and told him that he should deny the God whose image was depicted on that cross and that he should spit on the cross, which he did, though not on the cross itself, but beside it. He also said that he performed this denial by mouth, not in his heart. Of the vice of sodomy, the worshipped head and the illicit kisses, having been questioned diligently, he said that he knew nothing. Questioned whether he confessed to these things due to a request, for reward, for gratitude, for favour, through fear or hatred or at the instigation of anyone, or from the violence or fear of torture, he said no. Questioned whether after he was captured he was put to questioning or torture, he said no.[12]

When the cardinals reported back to the pope, Clement accepted the explanation of Jacques de Molay and the other Templar leaders that the charges against them of sodomy and blasphemy were due to a misunderstanding of the knighthood's arcane rituals, which had their origins in their struggle against the Muslims in Outremer. Denying Christ and spitting on the cross were understood to simulate the kind of humiliation and torture that a knight might be subjected to by the enemy if captured. They were taught to abuse their own religion 'in words only, not in spirit'.

The same confessions used by William of Nogaret to condemn the Templars were now accepted in context by the pope, who, noting that they had asked for pardon, gave

them absolution. 'We hereby decree that they are absolved by the Church and may again receive Christian sacraments.' Of Jacques de Molay in particular the pope recorded that, after hearing what he had to say,

> We have decided to extend the mercy of absolution for these acts to brother Jacques de Molay, grand master of the said order, who in the form and manner described above denounced in our presence all heresy and swore in person on the holy Gospels of God, and humbly asked for the mercy of absolution, restoring him to unity with the Church and reinstating him to the communion of the faithful and the ecclesiastical sacraments.[13]

At this point Clement was still trying to save the Templars as an order; his object was reform, and then probably to combine the Templars with the Hospitallers. But the pope failed to make the details of his absolution public because the scandal of the Templars had aroused extreme passions. Clement was still trying to avoid either a confrontation with Philip or a schism within the Church.

The Destruction of the Templars

I N MARCH 1309 THE PAPACY established itself at Avignon, which in those days was not within the kingdom of France and had the added benefit of offering the pope a quick escape over the Italian border. In November 1309 the papal commission into the order of the Templars began its sittings; this was the inquiry that Clement had agreed to establish after his meeting with Philip at Poitiers the previous year. Its concern was with the state of the order, not individual Templars, and Jacques de Molay was invited to speak. Describing himself as 'an impoverished knight who knew no Latin', he haltingly offered a defence. The Templars had the finest churches with the exception of cathedral churches, he said, and no one distributed more alms than the Templars. Most proudly he said that 'he knew of no other order or other people more prepared to expose their bodies to death in defence of the Christian faith against its enemies, nor who had shed so much blood and were more feared by the enemies of the Catholic faith'. But Jacques de Molay's defence was slapped down by a member of the commission who remarked 'that what he had said was no help for the salvation of souls'. As the Grand Master was offering this defence, the king's minister William of Nogaret strode in and told Jacques de Molay

that in the chronicles at Saint-Denis it was written that Saladin, 'on hearing of the heavy defeat the Templars had just suffered, had publicly declared that the said Templars had suffered the said defeat because they were labouring under the vice of sodomy and had violated their religion and their statutes'.[1] The chronicles said no such thing; in maintaining his slander campaign against the Templars, William of Nogaret had made it up.

Jacques de Molay was not alone in defending the order. By early May 1310 nearly six hundred Templars had spoken in support of their order before the papal commission, and they denied their previous confessions. In contrast to the Cathars, who truly were heretics and went to their deaths for what they believed, not one Templar was prepared to be martyred for the heresies that members of the order were supposed to have guarded so fiercely for so long, quite simply because there was no heresy, only the malignant interpretation put on their practices by a malignant king.

Deeply worried by this growing confidence among the Templars, Philip took drastic action and had the archbishop of Sens, a royal nominee, reopen his episcopal inquiry against individual Templars in his diocese. Obedient to his king, the archbishop found fifty-four Templars guilty as relapsed heretics – in other words guilty of having revoked their earlier confessions – and handed them over to the secular authorities. On 12 May 1310 in a field outside Paris the fifty-four Templars were burned at the stake. Yet even after these burnings not all the remaining Templars were cowed, nor was their morale completely crushed, although this intimidation by burning did have its effect, and many Templars fell silent or returned to their confessions.

Since 1308 Pope Clement had been intending to hold an ecumenical council at Vienne in the Rhone-Alps region of

France to consider three great matters: the Templars, the Holy Land and the reform of the Church. Originally scheduled for October 1310, it had to be postponed a year because the pope's contest with the king of France over the Templars was dragging on. Now in the summer of 1311 Clement had gathered information about the Templars from investigations all round France and abroad to present at the council. What he found was that only in France and in regions under French domination or influence were there substantial confessions from Templars – that is, areas where the French authorities and their collaborators had applied ferocious tortures to their victims, or where their testimony was deliberately distorted to turn admitted irregularities into heresy. Clement was becoming eager to wind up the Templar matter before its controversies caused wider and deeper troubles for the Church.

Clement had senior advisers who argued that no time should be wasted on discussion or defence, and that the pope should use his executive powers to abolish the Templars forthwith. One said that the Templars had 'already caused the Christian name to smell among unbelievers and infidels and have shaken some of the faithful in the stability of their faith'. He added that suppression of the order should take place without delay in case 'the capricious spark of this error ignites in flames, which could burn the whole world'.[2] But then in late October a dramatic event occurred which did much to counter the arguments of those in favour of swift abolition – seven Templars appeared at the council to argue for the defence of the order. The pope reacted swiftly and had them locked up.

But this was not a matter that the overwhelming majority of the clergy attending the council was prepared to overlook. As Henry Ffykeis, an Englishman attending the council, wrote home to the bishop of Norwich on 27 December 1311:

> Concerning the matter of the Templars there is great debate as to whether they ought in law to be admitted to the defence. The larger part of the prelates, indeed all of them, excepting five or six from the council of the King of France, stand on their behalf. On account of this the Pope is strongly moved against the prelates. The King of France more so; and he is coming in a rage with a great following.[3]

Indeed Philip was soon demonstrating his usual technique of intimidation by appearing at various places upriver from Vienne, creating the powerful sensation in the pope that the king was about to descend upon him. On 2 March 1312 the king sent a thinly veiled ultimatum to the pope, reminding him of the crimes and heresies of the Templars, 'Which is why, burning with zeal for the orthodox faith and in case so great an injury done to Christ should remain unpunished, we affectionately, devotedly and humbly ask Your Holiness that you should suppress the aforesaid order'.[4] Just in case Clement did not get the message, on 20 March the king with his brothers, sons and a considerable armed force arrived at Vienne.

On 3 April, having silenced the members of the council on pain of excommunication, and with the king of France sitting at his side, the pope made public his decision, already committed to writing twelve days earlier in the form of a bull, *Vox in Excelso*, dated 22 March 1312, that the Templars, though not condemned, were suppressed on the grounds that the order was too defamed to carry on.

> Considering therefore the infamy, suspicion, noisy insinuation and the other things above which have been brought against the Order, and [...] considering, moreover, the grave scandal which has arisen from these things against the Order, which it did not seem could be checked while this Order remained in being, and also the danger both to faith and souls,

and that many horrible things have been done by
very many of the brothers of this Order [...] who
have lapsed into the sin of wicked apostasy against
the Lord Jesus Christ himself, the crime of detest-
able idolatry, the execrable outrage of the Sodomites
[...] we abolish the aforesaid Order of the Temple
and its constitution, habit and name by an irrevo-
cable and perpetually valid decree, and we subject
it to perpetual prohibition with the approval of the
Holy Council, strictly forbidding anyone to presume
to enter the said Order in the future, or to receive or
wear its habit, or to act as a Templar.[5]

Under the circumstances it was probably the best that
Clement could do. Another bull, *Ad Providam*, dated 2 May,
granted the Templars' property to the Knights Hospitaller.
Soon after, Philip extracted a huge sum of money from the
Hospitallers in compensation for his costs in bringing the
Templars to trial.

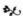

The Church had now washed its hands of the Templars. In
accordance with Church practice, once it had decided on a
defendant's fate he was handed over to the secular authori-
ties for punishment. In this case almost all the Templars in
France had been in royal hands all along, and the dispensing
of their fates did not require the transfer of their persons. The
treatment meted out by the royal authorities to individual
Templars varied. Those who had confessed were subjected
to penances, and these were sometimes heavy, including
lengthy imprisonment. Others who had confessed to noth-
ing or were otherwise of little account were sent to monaster-
ies for the rest of their lives.

The leading Templars, including the Grand Master, had
to wait until 18 March 1314 before their cases were dealt with.

They might well have expected their cases to have been disposed of long before, at Chinon, when they received papal absolution, and almost certainly they would now have been expecting to be treated accordingly. But the hearings at Chinon still remained secret, and instead Hugh of Pairaud, Geoffrey of Gonneville, Geoffrey of Charney and Jacques de Molay were brought for final judgement before a small commission of French cardinals and ecclesiastics at Paris, among them that same archbishop of Sens who had so happily for the king burned fifty-four Templars in May 1310.

The sentence was handed down. On the basis of their earlier confessions, as twisted by the crown, all four men were condemned to harsh and perpetual punishment – in effect, to starve and rot in prison until they were released by a lingering death. Hugh of Pairaud and Geoffrey of Gonneville accepted their fate in silence. 'But lo', wrote a chronicler of the time,

> when the cardinals believed that they had imposed an end to the affair, immediately and unexpectedly two of them, namely the grand master and the master of Normandy, defending themselves obstinately against the cardinal who had preached the sermon and against the archbishop of Sens, returned to the denial both of the confession as well as everything which they had confessed.[6]

Jacques de Molay was in his seventies; he and Geoffrey of Charney, the master of Normandy, had been in the king's dungeons for the last seven years. For six of those years they had lived under the expectation that their absolution by the pope would free them from their nightmare, that they would live again in sunlight among those loved by the Church and Christ. But now in the midst of betrayal and despair they refused to give themselves into perpetual incarceration in a living hell. Loudly protesting their innocence and asserting

that the order of the Templars was pure and holy, Jacques de Molay and Geoffrey of Charney put themselves into the hands of God.

At once the king ordered that they be condemned as relapsed heretics, and on that same evening, at vespers, they were taken to the Ile des Javiaux, a small island in the Seine west of Notre Dame, and bound to the stake. The chronicler described their last moments: 'They were seen to be so pre-pared to sustain the fire with easy mind and will that they brought from all those who saw them much admiration and surprise for the constancy of their death and final denial'.[7] The last of the Templars went to their deaths with courage, in the tradition of their order.

Notes

Prologue: Jerusalem 1187

1 Imad al-Din, in Gabrieli, *Arab Historians of the Crusades*, p. 163.
2 Imad al-Din, as quoted by Abu Shama in the *Recueil des Historiens des Croisades, Historiens Orientaux*, vol. IV (Paris, 1898), p. 333, and translated and reproduced in Hillenbrand, *Crusades*, p. 301.
3 Imad al-Din, in Gabrieli, *Arab Historians of the Crusades*, p. 147.
4 Saladin's extortion ceased in 1192 only when Richard the Lionheart demanded free access for pilgrims to the Holy Sepulchre.
5 Anonymous, *De Expugnatione Terrae Sanctae per Saladinum*; repr., trans. Brundage, *The Crusades: A Documentary History*, p. 163. The author of *De Expugnatione*, though anonymous, is thought to have been an Englishman in the service of Raymond of Tripoli.
6 Imad al-Din, in Gabrieli, *Arab Historians of the Crusades*, p. 156.
7 Ibn Shaddad, in Hillenbrand, *Crusades*, 189.
8 Imad al-Din, in Gabrieli, *Arab Historians of the Crusades*, p. 160.
9 Tyerman, *God's War*, p. 353.
10 Hillenbrand, *Crusades*, p. 180.
11 Lyons and Jackson, *Saladin*, p. 240.
12 Ehrenkreutz, *Saladin*, p. 237.
13 Lyons and Jackson, *Saladin*, p. 280.
14 Ibid., pp. 275–6.
15 See for example Tyerman, *God's War*, p. 52: 'The question of the extent of Arabisation and Islamicisation of conquered lands

remains obscure and vexed, but it appears that the process was slow, uneven and, by the eleventh century, still incomplete. It is not certain whether there was even a Muslim majority in Syria or Palestine when the crusaders arrived in 1097.' The evidence for a Christian majority is far greater than Tyerman admits and will be dealt with later in this book.

16 Ibid., sura 9, verse 4.

17 The Koran, trans. Dawood, sura 9, verse 14.

18 See Cyril Glassé, *The Concise Encyclopaedia of Islam*, Stacey International, London 1991.

19 Hillenbrand, *Crusades*, p. 444.

20 Ibid., p. 333.

21 Lyons and Jackson, *Saladin*, p. 276.

22 Ibid., p. 361.

23 William of Tyre, *A History of Deeds Done Beyond the Sea*, pp. 406-8.

Part I: THE MIDDLE EAST BEFORE THE CRUSADES

1: The Christian World

1 Eusebius, *Life of Constantine*, 1.28; Lactantius, *On the Deaths of the Persecutors*, 44; also see Robin Lane Fox, *Pagans and Christians*, p. 611-18.

2 Theodoret of Cyrrhus, *A History of the Monks of Syria*, p.165. Theodoret (393-466) is referring to the vast numbers of pilgrims who arrived from all over the Christian world to witness Simeon Stylites (*c.* 385-459) in northern Syria.

3 Joseph Patrich, 'Church, State and the Transformation of Palestine: The Byzantine Period', in Levy, ed., *The Archaeology of Society in the Holy Land*, pp. 470-72.

4 Leontius of Byzantium quoted in Colin Morris, *The Sepulchre of Christ and the Medieval West: From the Beginning to 1600*, p. 53.

5 The population of Palestine during the Byzantine period was about a million, a much greater population than at any time until the twentieth century. See Joseph Patrich, 'Church, State and the Transformation of Palestine: The Byzantine Period', in Levy, ed., *The Archaeology of Society in the Holy Land*, p. 473; and Gil,

History of Palestine, p. 169, and footnote 40 on that page, referring to Judaea.

6 Antiochus Strategos, 'The Capture of Jerusalem by the Persians in 614 AD', trans. Frederick C. Conybeare, *English Historical Review*, 25 (1910), pp. 502-17.

7 Sebeos, *The Armenian History*, Liverpool University Press, Liverpool, 1999; also *Sebeos' History*, trans. Robert Bedrosian, online: http://rbedrosian.com/sebtoc.html.

8 For example, the Mamilla cave discovery in 1992, a mass grave for those whose bodies were recovered from the Mamel cistern after the Persian massacre: see Ronny Reich, ' "God Knows their Names": Mass Christian Grave Revealed in Jerusalem', Biblical Archaeology Review, 22/2 (1996,), pp.26-35; also Yossi Nagar, 'Human Skeletal Remains from the Mamilla Cave, Jerusalem', Israel Antiquities Authority: http://www.antiquities. org.il/article_Item_eng.asp?sec_id=17&sub_subj_id=179; and Gideon Avni, 'The Persian Conquest of Jerusalem (641 CE): An Archaeological Assessment': http://www.bibleinterp.com/ articles/pers357904.shtml.

9 Vasiliev, *History of the Byzantine Empire*, vol. 1, p. 197.

10 Sebeos is quoted by Vasiliev in *History of the Byzantine Empire*, vol. 1, p. 198. See also Sebeos, *The Armenian History*, Liverpool University Press, Liverpool, 1999, and *Sebeos' History*, trans. Robert Bedrosian, online: http://rbedrosian.com/sebtoc.html.

2 : The Arab Conquests

1 The Koran, trans. Dawood, sura 22, verses 39-40.

2 Leoni Caetani, *Studi di Storia Orientale*, vol. 1, p. 368.

3 Dosabhai Framji Karaka, *History of the Parsis Including Their Manners, Customs, Religion and Present Position*, vol. 1, p. 15.

4 Hoyland, *Seeing Islam as Others Saw It*, p. 120. This account in the manuscript of Thomas the Presbyter is the first non-Muslim reference to Mohammed; the battle took place on 7 February 634. The Samaritans were closely related to the Jews; they claimed theirs was the true version of Judaism as practised before the Babylonian exile. Their numbers were significant in Palestine at this time, but they now number fewer than a thousand worldwide.

5 Washington Irving, *Mahomet and His Successors*, vol. 2, in *The Works of Washington Irving*, vol. 13, chapters 9-11; also Gibbon, *Decline and Fall of the Roman Empire*, chapter 51.

6 Gibbon, *Decline and Fall of the Roman Empire*, chapter 51.

7 Sophronius' sermon of 6 December 636 or 637, in Hoyland, *Seeing Islam as Others Saw It*, p. 72.

8 Some Muslim sources say Jerusalem endured a seven-month siege, but the oldest Muslim sources, and also Byzantine sources, say it lasted nearly two years. For the sufferings and deaths caused by the siege see Cline, *Jerusalem Besieged: From Ancient Canaan to Modern Israel*, pp. 149-50.

9 The Koran, trans. Dawood, sura 2, verse 137.

10 Adamnan, *The Pilgrimage of Arculfus in the Holy Land*, pp. 4-5.

11 The Koran, trans. Dawood, sura 2, verses 142-5.

12 Muhammad ibn Jarir al-Tabari, *History of the Prophets and Kings*, cited in Gil, *A History of Palestine*, p. 66.

3 : Palestine under the Umayyads and the Arab Tribes

1 Fernand Braudel, *A History of Civilizations*, Allen Lane, London, 1994, p. 335.

2 Whitcomb in Levy, ed., *The Archaeology of Society in the Holy Land*, p. 499.

3 Muqaddasi, *Description of Syria*, p. 23.

4 Ibid., p. 23, footnote 1.

5 Karsh, *Islamic Imperialism*, p. 63, citing Hamilton A. R. Gibb, *Studies on the Civilization of Islam*, Routledge & Kegan Paul, London, 1962, pp. 51-7; and Oleg Graber, 'Islamic Art and Byzantium', *Dumbarton Oaks Papers*, vol. 18 (1964), p. 88.

6 Vasiliev, *History of the Byzantine Empire*, vol. 1, p. 233.

7 Koran, trans. Arberry. Some translations of the Koran - for example, that of Dawood - refer to 'the farthest Temple', but in the original Arabic of the Koran the phrase is '*al-masjid al-aqsa*', *masjid* meaning 'mosque' and *aqsa* meaning 'farthest'.

8 For example, 'Was the Prophet Muhammad's Night Journey to Palestine or Medina?' by Ahmad Muhammad Arafa in the Egyptian Ministry of Culture publication *Al-Qahira* (5 August 2003); this can be viewed online: www.memri.org/report/en/0/0/0/0/0/0/941.htm

9 Gil, *A History of Palestine*, p. 98, footnote 22.

10 Whitcomb in Levy, ed., *The Archaeology of Society in the Holy Land,* p. 499.

11 Koran, trans. Dawood, sura 4, verse 171.

12 Muqaddasi, *Description of Syria*, p. 46.

13 The first evidence that the mosque was called al-Aqsa comes in Fatimid times, when it was yet again rebuilt and an inscription added about the 'furthest mosque' from Koran, sura 17, verse 1.

14 In the early Islamic period seafaring round the Arabian peninsula and to East Africa and India was in the hands of Persians. See George Hourani, *Arab Seafaring*, p. 79. Syrian seafarers were the descendants of the coastal Phoenicians who had competed with the Greeks in trade and colonisation throughout the ancient Mediterranean.

15 Leo I, Letter XXVIII, Tome 2, AD 449; Henry Bettenson, ed., *The Later Christian Fathers*, Oxford University Press, Oxford, 1970, p. 278.

16 Alfred J. Butler, *The Arab Conquest of Egypt*, Oxford University Press, Oxford, 1902, p. 158.

17 Gil, *A History of Palestine*, p. 141 (from Tabari, *Ta'rikh*, II, 1372).

18 Al-Maqrizi, fifteenth-century Egyptian historian, quoted in Otto Meinardus, *Monks and Monasteries of the Egyptian Deserts*, The American University in Cairo Press, Cairo, 1989, p. 55.

19 Gil, *A History of Palestine*, p. 86, citing Tabari, *Ta'rikh*, II, 1834ff.

20 Ibid., p. 86, footnote 11.

21 Theophanes, *Chronicle*, p. 112.

4 : The Abbasids and the Arab Eclipse

1 A village called Baghdad has been recorded on that spot since the eighteenth century BC; the name has been assimilated to a later but similar Persian word meaning 'Gift of God'. See Spuler, *The Muslim World*, p. 51.

2 Mansur's words as reported by the geographer and chronicler Ahmad al-Yaqubi, cited in Lewis, *The Arabs in History*, p. 82.

3 Thubron, *Mirror to Damascus*, p. 103.

4 Hourani, *Syria and Lebanon*, p. 21.

5 Whitcomb in Levy, ed., *The Archaeology of Society in the Holy Land*, p. 488.

6 Spuler, *The Muslim World*, p. 27.

7 The Koran, trans. Dawood, sura 5, verse 66; 2:62. Also sura 5, verse 69, is similar.

8 Ibid., sura 22, verse 17.

9 Frye, ed., *The Cambridge History of Iran*, vol. 4, p. 32.

10 Boyce, *Zoroastrians*, p. 147; Frye, ed., *The Cambridge History of Iran*, vol. 4, p. xii.

11 Spuler, *The Muslim World,* p. 52.

12 Frye, ed., *The Cambridge History of Iran*, vol. 4, p. xi.

13 Ibid., vol. 4, p. xi.

14 Gil, *A History of Palestine*, p. 284.

15 Ibid., pp. 171, 442.

16 Hitti, *History of Syria*, p. 543f; Gil, *A History of Palestine*, p. 159f.

17 Gil, *A History of Palestine*, p. 475.

18 Frye, ed., *The Cambridge History of Iran*, vol. 1, p. 122.

19 Carl F. Petry, ed., *The Cambridge History of Egypt*, vol. 1, *Islamic Egypt, 640–1517*, p. 83; Ye'or, *Islam and Dhimmitude*, pp. 62, 64.

20 Kennedy, *The Court of the Caliphs*, p. 264 [240 in paperback].

21 Hitti, *History of Syria*, p. 543f.; Gil, *A History of Palestine*, p. 473f; Kennedy, *The Court of the Caliphs*, p. 240.

22 Ibid., p. 278 [254 in paperback].

23 Eginhard, *Vie de Charlemagne*, Paris, 1923, chapter 16, p. 46, cited in Wilkinson, *Jerusalem Pilgrims before the Crusades*, p. 12.

24 Wilkinson, *Jerusalem Pilgrims*, p. 12; Gil, *A History of Palestine*, p. 288.

25 Bernard the Monk's account of his travels is found in Wilkinson, *Jerusalem Pilgrims*, pp. 141–5.

26 Kreutz, *Before the Normans*, p. 27.

27 Davis, *Christian Slaves, Muslim Masters: White Slavery in the Mediterranean, the Barbary Coast, and Italy, 1500–1800*. Davis does not cover slavery before the sixteenth century, but he estimates that in the hundred years from 1580 to 1680 nearly a million white Christian Europeans were captured and sent as slaves to the Barbary Coast (i.e., the Maghreb, present-day Morocco, Algeria, Tunisia and Libya) - that is, about 8,500 each year. During his brief sojourn in Taranto Bernard the Monk claims to have seen nine thousand slaves awaiting shipment to Egypt and North Africa, suggesting that the slave trade was at least as active in the

ninth century as in later centuries. Whatever the number, swathes of coastal Europe were depopulated by the Muslim raids, with devastating economic consequences: see Davis, p. 3f; also Kreutz, *Before the Normans*, p. 53.

28 Wilkinson, *Jerusalem Pilgrims*, p. 142.

29 Ibid., p. 142; Gil, *A History of Palestine*, p. 285.

30 Gil, *A History of Palestine*, p. 483.

5 : Byzantine Crusades

1 Kennedy, *The Court of the Caliphs*, p. 269, which quotes from al-Tabari's *History*.

2 Runciman, *The Emperor Romanus Lecapenus and His Reign: A Study of Tenth Century Byzantium*, p. 146.

3 Gil, *A History of Palestine*, p. 326, footnote 100, citing Dhahabi's *Tarikh al-Islam* as the Arabic source.

4 Ibid., p. 477: 'The mistreatment of the Christian population, and especially the churches of Jerusalem, was what drove the Byzantines to recruit forces for a struggle of a decidedly religious nature – namely, to free Jerusalem of the Muslims in a sort of tenth-century crusade'.

5 Vasiliev, *History of the Byzantine Empire*, vol. 1, p. 310, refers to a letter from John Tzimisces to the Armenian king Ashot III, preserved in the works of the Armenian historian Matthew of Edessa, which 'shows that the Emperor, in aiming to achieve his final goal of freeing Jerusalem from the hands of the Muslims, undertook a real crusade'.

6 Goitein, *A Mediterranean Society*, p. 403; Kennedy, *Court of the Caliphs*, p. 295; Glassé, *The Concise Encyclopaedia of Islam*, p. 323.

6 : Muslim Wars and the Destruction of Palestine

1 Lane-Poole, *A History of Egypt in the Middle Ages*, p. 101.

2 Hitti, *History of Syria*, p. 572.

3 Goitein, *A Mediterranean Society*, p. 403, quoting M. Gil, 'The Sixty Years' War (969–1029)', *Shalem*, 3 (1981), p. 1–55 (in Hebrew, with English summary). See also Bosworth, ed., *Historic Cities of the Islamic World*, p. 232, which describes the details as 'revolting'.

4 Gil, *A History of Palestine*, p. 336.

5 Hitti, *History of Syria*, p. 588.
6 In the units of measurement at the time, the cross had to weigh 5 rotls and be 1 cubit long.
7 El-Leithy, 'Coptic Culture and Conversion in Medieval Cairo'. Tamer el-Leithy is the nephew of the liberal Egyptian thinker Tarek Heggy.
8 Gil, *A History of Palestine*, pp. 222, 376f.
9 Yahya Ibn Said, *History*, cited in Wilkinson, *Jerusalem Pilgrims*, p. 14.
10 Armstrong, *Jerusalem*, p. 259.
11 Runciman, *History of the Crusades*, vol. 1, p. 35; Gil, *A History of Palestine*, pp. 376, 378.
12 Gil, *A History of Palestine*, p. 480.
13 Sir Hamilton A. R. Gibb, 'The Caliphate and the Arab States', in Setton, ed., *A History of the Crusades,* p. 90.
14 The Koran, trans. Arberry. For Fatimid policy about Jerusalem, see Hillenbrand, *Crusades*, p. 147, and S. D. Goitein and O. Grabar, 'Jerusalem', in Bosworth, ed., *Historic Cities of the Islamic World* p. 252.
15 Landes, *Relics, Apocalypse, and the Deceits of History: Ademar of Chabannes, 989–1034*, p. 41. Also Gil, *A History of Palestine*, p. 379.
16 Gil, *A History of Palestine*, p. 325.
17 Cantor, *Civilisation of the Middle Ages*, pp. 364f.
18 Cohn, *The Pursuit of the Millennium*, p. 76.

Part II: THE TURKISH INVASION AND THE FIRST CRUSADE

1 Fulcher of Chartres, in Thatcher and McNeal, ed., *A Source Book for Mediaeval History*, pp. 513-7.

7: The Turkish Invasion

1 Lang, *The Armenians: A People in Exile*, p. 37, gives the figure as 'about a million and a half'. On 23 January 2012 the French Senate followed the National Assembly in approving a bill which declares that between 600,000 and 1.5 million Armenians suffered genocide under the Ottoman Empire largely between 1915 and 1917, reported in *The Times* (24 January 2012), p. 26.

2 Gibbon, *Decline and Fall of the Roman Empire*, vol. V, chapter LVII, p. 554.

3 Norwich, *Byzantium: The Apogee*, pp. 342-3.

4 Nizam al-Mulk in his *Book of Government*, quoted in Hillenbrand, *Turkish Myth and Muslim Symbol*, p. 6.

5 Vasiliev, *History of the Byzantine Empire*, vol. 1, p. 355, citing an anonymous chronicler collected in Constantine Sathas, ed., *Bibliotheca Graeca Medii Aevi*, VII, 169, Paris 1872-94.

6 Stoneman, *Across the Hellespont: A Literary Guide to Turkey*, p. 206, quoting from Aristakes Lastivertsi, whose *History of Armenia*, written at Constantinople from 1072 to 1079, relates the fall of the Bagratid kingdom of Armenia, the destruction of Ani and the victories of the Seljuk Turks.

7 Annalist of Nieder-Altaich, *The Great German Pilgrimage of 1064-65*, in *Annales Altahenses Maiores*, in Brundage, trans. and ed., *The Crusades*.

8 Gil, *A History of Palestine*, p. 487. Sources differ about the size of the 1064-6 German pilgrimage, the Annalist of Nieder-Altaich stating 12,000 and Gil referring to sources stating 7,000; Gil also says that 'less than 2000' returned home safely.

9 Bosworth, ed., *Historic Cities of the Islamic World*, p. 233, and Richard, *The Crusades*, p. 14, are explicit that Atsiz massacred Muslims even in the Aqsa mosque.

10 Gil, *A History of Palestine*, p. 416; Montefiore, *Jerusalem*, p. 202.

11 Jacques-Paul Migne, *Patrologia Latina*, 148:329, in Thatcher and McNeal, ed., *A Source Book for Mediaeval History*, pp. 512-3.

12 Cantor, *Civilisation of the Middle Ages*, p. 246.

13 Gibbon, *Decline and Fall of the Roman Empire*, vol. 5, chapter 57, p. 554.

14 Hillenbrand, *Crusades*, p. 50; Gil, *A History of Palestine*, pp. 488-9.

15 Spuler, *The Muslim World*, p. 109.

16 Gil, *A History of Palestine*, pp. 171-2, 'As to the rural population [of Palestine], in the main it was still Christian on the eve of the Crusaders' conquest'; and 'Jerusalem was certainly inhabited mainly by Christians during the entire period [of the Muslim occupation]'. Gil's sources include al-Arabi, Muqaddasi, and the Geniza documents.

17 Ibn al-Arabi, quoted in Gil, *A History of Palestine*, p. 171.

8 : The Call

1 V. Vasilievsky, quoted in Vasiliev, *History of the Byzantine Empire*, vol. II, pp. 384, 386.

2 Anna Comnena, *The Alexiad*, Book VIII, chapter V. For the nature of Alexius' contacts with the West, see Vasiliev, *History of the Byzantine Empire*, vol. II, pp. 386-88; Erdmann, *The Origin of the Idea of Crusade*, pp. 322-3, also p. 358.

3 Somerville, *Urban II's Council of Piacenza*, p. 8.

4 Bernold of Constance quoted in Somerville, *Urban II's Council of Piacenza*, pp. 54-5.

5 Edgington, *Oxford Medieval Texts*, p. 5.

6 Ibid., p. 7.

7 Ibid., p. 5.

8 Riley-Smith, *The First Crusaders*, pp. 55-6.

9 Jotischky, 'The Christians of Jerusalem', p. 57. As Jotischky explains in his article, the reliability of Albert of Aachen's account of Peter the Hermit's visit to Jerusalem has been disputed, but recent scholarly work argues for its fundamental accuracy. See also Norman Housley, *Contesting the Crusades*, Blackwell, Oxford 2006, p. 44.

10 Chevedden, 'The View of the Crusades', pp. 307-8.

11 Fulcher of Chartres, in Thatcher and McNeal, ed., *A Source Book for Mediaeval History*, pp. 513-7.

12 Baldric of Dol in Krey, *The First Crusade*, pp. 33-6.

13 Robert the Monk, in Munro, *Urban and the Crusaders*, pp. 5-8.

14 Guibert de Nogent, in Krey, *The First Crusade*, pp. 36-40.

15 Frankopan, *The First Crusade*, p. 11.

9 : The First Crusade

1 Augustine, *City of God*, Book XIX, Chapter 7.

2 Matthew 16:24. Urban's injunction to sew a cross on one's clothing was recorded in the chronicles of Robert the Monk and Guibert de Nogent, both of whom relied heavily on the *Gesta Francorum*, an earlier anonymous account.

3 *Gesta Francorum,* in Krey, *The First Crusade*, p. 30.

4 Erdmann, *The Origin of the Idea of Crusade*, p. 346.

5 As the crow flies, the distance from the north shore of Lake
 Balkash in Kazakhstan to Jerusalem is 2,600 miles; from Paris to
 Jerusalem the distance is 2,300 miles. Likewise, the actual land
 route was longer for the Seljuks than it was for the crusaders.
 Moreover, the Seljuks started from somewhere farther north than
 Lake Balkash, while most of the crusaders set out from places
 nearer Palestine than Paris.

6 Guibert de Nogent, cited in Runciman, *History of the Crusades*,
 volume I, p. 113.

7 Simonsohn, *The Apostolic See and the Jews*, p. 13.

8 Anna Comnena, *The Alexiad*, X, ix, 323.

9 Fulcher of Chartres, in Krey, *The First Crusade*, pp. 119–20.

10 Riley-Smith, *The First Crusade and the Idea of Crusading*, p. 2.

11 France, *Victory in the East*, pp. 286–7.

12 Helen Nicholson, 'Cannibalism during the Crusades': http://
 www.crusades-encyclopedia.com/cannibalism.html .

13 Bosworth, ed., *Historic Cities of the Islamic World* p. 233.

14 Boas, *Jerusalem in the Time of the Crusades*, p. 9, has the population
 of Jerusalem during the Fatimid period as approaching 20,000;
 others estimate a population of between 20,000 and 30,000 in
 1099, when the First Crusade approached the city. See Kedar,
 'The Jerusalem Massacre of 1099', p. 74.

15 Kedar, 'The Jerusalem Massacre of 1099', p. 18.

16 Raymond of Aguilers, in Krey, *The First Crusade*, p. 261.

17 Impoverished pilgrims who died at the Hospital in Jerusalem
 in the twelfth century were deposited in free charnel pits. At
 one, the Akeldama, the dead were dropped through holes in the
 roof, where 'it was believed that the bodies decomposed within
 twenty-four hours with no smell'. Montefiore, p. 237, footnote.

18 Steven Runciman, 'The First Crusade', in Setton, *A History of the
 Crusades*, vol. 1, p. 337; Runciman, *History of the Crusades*, vol. 1, pp.
 297, 289.

19 Runciman was primarily a historian of Byzantium and its
 passionate admirer; he saw the crusades and Byzantium as in
 opposition to one another and stated plainly, 'that is why, to me,
 "Crusade" is a dirty word'; that is also why he never missed an
 opportunity to denigrate the crusaders, their characters, their

motives, their entire enterprise. See Runciman, 'Greece and the Later Crusades'.

20 Kedar, 'The Jerusalem Massacre of 1099', pp. 73–4.

21 Madden, *New Concise History*, p. 34.

22 Raymond of Aguilers, in Krey, *The First Crusade*, p. 257.

Part III: THE FOUNDING OF THE TEMPLARS AND THE CRUSADER STATES

10: The Origins of the Templars

1 Wilkinson, Hill and Ryan, *Jerusalem Pilgrimage, 1099–1185*, p. 28.

2 Saewulf in Wilkinson, Hill and Ryan, *Jerusalem Pilgrimage, 1099–1185*, p. 100.

3 Saewulf in Wilkinson, Hill and Ryan, *Jerusalem Pilgrimage, 1099–1185*, pp. 100–01.

4 Daniel the Abbot, in Wilkinson, Hill and Ryan, *Jerusalem Pilgrimage, 1099–1185*, p. 156.

5 Deuteronomy 28:47.

6 According to William of Tyre, the Hospital was at first dedicated to St John the Almsgiver, a charitable seventh-century patriarch of Alexandria. Later it was known to be dedicated to John the Baptist. But current scholarship has the Hospital dedicated to John the Baptist from the start. See Nicholson, *The Knights Hospitaller*, pp. 2–3.

7 Barber and Bate, ed. and trans., *The Templars*, p. 2.

8 Hillenbrand, *Crusades*, p. 78.

9 Ibid., p. 103.

10 Ibid., p. 45.

11 Ellenblum, *Frankish Rural Settlement*, p. 19.

12 The spot marking the centre of the world is nowadays found beneath the transept of the new basilical church built adjacent to the Rotunda by the Franks between the 1140s and the 1160s to replace Constantine's basilica, destroyed by al-Hakim.

13 The Temple Mount is 2,443 feet high; the west hill, at 2,528 feet, is higher; and higher still is the Mount of Olives, with an elevation of 2,600 feet.

14 Letter of Hugh 'Peccator' to the Templars in the East in Barber and Bate, ed. and trans., *The Templars*, pp. 54ff.

15 *The Anglo-Saxon Chronicle*, trans. D. Whitelock, Eyre and
 Spottiswoode, London, 1961, pp. 194-5. *The Anglo-Saxon Chronicle*
 was regularly updated to the 1150s, well beyond the Norman
 invasion of Anglo-Saxon England.

16 Bernard of Clairvaux, Letters, quoted in Barber, *The New
 Knighthood*, p. 13.

17 The Latin Rule of 1129 in Barber and Bate, ed. and trans., *The
 Templars*, pp. 31-54; Bernard's Rule of the Templars, in Barber,
 New Knighthood, pp. 17-18.

18 William of Tyre, *Historia rerum in partibus transmarinis gestarum*, XII,
 7; *Patrologia Latina* 201, 526-27; repr. trans. Brundage, *The Crusades:
 A Documentary History*, pp. 70-73.

11 : Outremer

1 Fulcher of Chartres is last heard of in Jerusalem in 1127. It is
 thought he died in a plague that year, but there is nothing that
 confirms his date of death.

2 Isaiah 11:7.

3 Fulcher of Chartres, in Krey, *The First Crusade*, pp. 280-81.

4 Riley-Smith, *The Atlas of the Crusades*, p. 40.

5 Boas, *Domestic Settings*, p. 72; Fulcher of Chartres, revision of 1118,
 in Wilkinson, Hill and Ryan, *Jerusalem Pilgrimage, 1099-1185*, p.
 45.

6 John of Würzburg in Wilkinson, Hill and Ryan, *Jerusalem
 Pilgrimage, 1099-1185*, p. 247.

7 Ellenblum, *Frankish Rural Settlement*, p. 32.

8 Ibid., p. 210.

9 Pringle, *Fortification and Settlement*, Addendum, p. 7.

10 Quoted from the Chronicle of Ernoul, in Forey, *The Military
 Orders*, pp. 59-60.

11 Ellenblum, *Frankish Rural Settlement*, pp. 76-7, 82-4. The list for
 Magna Mahomeria is for the year 1156; that for Bethgibelin is for
 1168.

12 Ibid., p. 79.

13 Ibid., p. 31; see also Ellenblum, 'Settlement and Society
 Formation in Crusader Palestine', in Levy, ed., *The Archaeology of
 Society in the Holy Land*, p. 504.

14 Gil, *A History of Palestine*, pp. 171-2. Gil's sources include al-Arabi, Muqaddasi, and the Geniza documents. Ellenblum, *Frankish Rural Settlement*, pp. 21-2, dismisses the assumption, made by many scholars, that the majority of the population of Palestine in the eleventh and twelfth centuries was Muslim as being without substance; he also draws attention to the varying rate of Islamisation across the Middle East, noting that as recently as 1932 Christians could still claim to be a majority in Lebanon.

15 Hillenbrand, *Crusades*, p. 331. See also Hitti, *Syria*, p. 621.

16 Hillenbrand, *Crusades*, p. 331.

17 Ibid., p. 303.

18 Fulcher of Chartres, in Krey, *The First Crusade*, p. 281.

12 : Zengi's Jihad

1 William of Tyre, *Historia rerum*, trans. Brundage, p. 79.

2 From Usamah ibn Munqidh's autobiography, in Gabrieli, *Arab Historians of the Crusades*, p. 77.

3 Usamah ibn Munqidh, *An Arab-Syrian Gentleman and Warrior in the Period of the Crusades: Memoirs of Usamah Ibn-Munqidh*, trans. Hitti, New York 2000, p. 161.

4 From Usamah ibn Munqidh's autobiography, in Gabrieli, *Arab Historians of the Crusades*, p. 79.

5 Ibid., p. 78.

6 Ibid., p. 161.

7 Robert L. Nicholson, 'The Foundation of the Latin States', in Setton, ed., vol. I, p. 429.

8 The sole source for the Templars being involved in this action is Orderic Vitalis, a twelfth-century chronicler in the West. See Orderic Vitalis, trans. and ed. Chibnall, vol. 6, pp. 496-7.

9 Hillenbrand, *Crusades*, p. 111.

10 See for example Asbridge, *The Crusades*, p. 193; Ehrenkreutz, *Saladin*, p. 236; Lyons and Jackson, *Saladin*, p. 111.

11 Hillenbrand, *Crusades*, pp. 112-3.

12 Hillenbrand, *Crusades*, p. 113, quoting Al-Bundari, *Zubdat al-nusra*, ed. M. T. Houtsma, Leiden, 1889, p. 205.

13 Hillenbrand, *Crusades*, p. 114, quoting Ibn al-Athir, *Al-tarikh al-bahir fi l'dawlat al-atabakiyya*.

14 William of Tyre, in Brundage, trans. and ed., *The Crusades: A Documentary History*, p. 80.

15 Ibid., p. 81.

16 Michael Rabo, in Moosa, *The Crusades*, p. 556.

17 Ibn al-Athir, in Moosa, *The Crusades*, p. 559.

18 The poets Ibn Munir and Ibn al-Qaysarani are quoted in Hillenbrand, *Crusades*, p. 115; Zengi's honorifics, as quoted by Ibn Wasil, are mentioned on the same page.

19 Michael Rabo, in Moosa, *The Crusades*, p. 571–2.

13 : The Second Crusade

1 Eugene III, *Quantum Praedecessores*, in Ernest F. Henderson, trans., *Select Historical Documents of the Middle Ages*, George Bell and Sons, London, 1910, p. 333.

2 Eugene III, *Quantum Praedecessores*, p. 333.

3 Bernard's actual words at Vézelay were not recorded, but he immediately followed his call for a crusade with letters which repeated his themes; for example, this letter of Bernard of Clairvaux in Riley-Smith, *The Crusades*, p. 122.

4 Letter of Bernard of Clairvaux, in Runciman, *History of the Crusades*, vol. II, p. 254.

5 Letter to England to summon the Second Crusade, 1146, in Bruno Scott James, trans., *The Letters of St. Bernard of Clairvaux*, Burns Oates, London, 1953.

6 Letter to Eastern France and Bavaria Promoting the Second Crusade, 1146, in Scott James, trans., *The Letters of St. Bernard of Clairvaux*.

7 Scott James, trans., *The Letters of St. Bernard of Clairvaux*.

8 Williams, *Saint Bernard of Clairvaux*, p. 214.

9 Chrétien de Troyes, *Arthurian Romances*, Penguin Books, London, 1991, p. 420.

10 William of Tyre, *Historia rerum*, trans. Brundage, *The Crusades*, p. 675.

11 Conrad III, king of Germany, to Wibald, abbot of Stavelot and Corvey, September–November 1148, in Barber and Bate, trans., *Letters from the East*, p. 47.

12 Ibn al-Qalanisi, in Gabrieli, *Arab Historians of the Crusades*, p. 57.

13 Ibid., p. 59.

14　Conrad III, King of Germany, to Wibald, Abbot of Stavelot and Corvey, September–November 1148, in Barber and Bate, trans., *Letters from the East*, p. 47.

15　John of Salisbury, *Memoirs of the Papal Court*, pp. 57–8.

Part IV: THE TEMPLARS AND THE DEFENCE OF OUTREMER

14: The View from the Temple Mount

1　Andrew of Montbard to Everard des Barres, late 1149 or early 1150, Barber and Bate, trans., *Letters from the East*, pp. 47f.

2　Ibn Munir, quoted in Hillenbrand, *Crusades*, p. 150.

3　In addition to sources cited earlier in this book, Steven Runciman in his *History of the Crusades*, p. 294, describes 'the vast majority of the population' of Outremer as Christian.

4　John of Würzburg in Boas, *Jerusalem in the Time of the Crusades*, p. 35.

5　William of Tyre, *A History of Deeds Done beyond the Sea,* vol. II, p. 440.

6　John of Würzburg, in Pringle, *Churches of the Crusader Kingdom of Jerusalem: The City of Jerusalem*, vol. III, p. 194.

7　Ibid.

8　Jacques de Molay, in Riley-Smith, *Templars and Hospitallers*, p. 61.

9　Theoderich's *Description of the Holy Places*, trans. Aubrey Stewart, Palestine Pilgrims' Text Society, London, 1896, pp. 30–32.

10　See Riley-Smith, *Atlas of the Crusades*, p. 36; Boas, *Archaeology of the Military Orders*, p. 4; and Barber, *New Knighthood*, pp. 93–4.

11　Barber, *New Knighthood*, p. 55.

15: The Defence of Outremer

1　Ross Burns, *Damascus: A History*, Routledge, Abingdon, 2005, p. 134.

2　Fustat, founded by the Arabs in 641, was known as Babylon in the Middle Ages after the Roman fortress of Babylon that had originally stood near by. Cairo, immediately to the north, was founded by the Fatimids in 969.

3　Barber and Bate, trans., *Letters from the East*, p. 61.

4　Asbridge, *The Crusades*, p. 266.

5 MacEvitt, *The Crusades and the Christian World of the East*, p. 218,
 footnote 12. The reference is to el-Leithy, 'Coptic Culture and
 Conversion in Medieval Cairo'.
6 William of Tyre in Barber, *New Knighthood*, p. 97.
7 Barber and Bate, trans., *Letters from the East*, p. 59.
8 Upton-Ward, trans., *The Rule of the Templars: The French Text of the
 Rule of the Order of the Knights Templar*.
9 Balzaus, better known as beauceant, was the banner carried into
 battle by the Templars; its two colours were black and white,
 arranged horizontally.
10 Psalms 115:1: 'Not unto us, O Lord, not unto us, but unto thy
 name give glory, for thy mercy, and for thy truth's sake.'
11 Anonymous Pilgrim, V.2; Stewart, trans., *Anonymous Pilgrims*, pp.
 29-30.
12 The French Rule, *c.* 1165, which supplemented the original Latin
 Rule of St Bernard, in Barber and Bate, ed. and trans., *The
 Templars*, pp. 72-3.

16 : Templar Wealth

1 Barber, *The New Knighthood*, p. 277.
2 *Gestes des Chiprois*, cited in Barber, *The New Knighthood*, pp. 241, 243.
3 Bouchard of Mount Sion, cited in Barber, *The New Knighthood*, p.
 163.

Part V : SALADIN AND THE TEMPLARS

1 For the composition of Saladin's armies see Hillenbrand,
 Crusades, p. 444.
2 Holt, Lambton and Lewis, *Cambridge History of Islam*, vol. 1A,
 p. 205.

17 : Tolerance and Intolerance

1 Lyons and Jackson, *Saladin*, p. 59.
2 Hillenbrand, *Crusades*, p. 186.
3 El-Leithy, 'Coptic Culture and Conversion in Medieval Cairo'.
4 Gervers and Powell, ed., *Tolerance and Intolerance*, p. 57.
5 Wilkinson, *Egeria's Travels*, pp. 150-51.

6 Leo the Great, Homily XXXIII, in Haskins, *Mary Magdalen*, p. 96.

7 John of Würzburg, in Gervers and Powell, ed., *Tolerance and Intolerance*, p. 108.

8 Gerard of Nazareth, in Gervers and Powell, ed., *Tolerance and Intolerance*, p. 110.

9 See Ellenblum, *Frankish Rural Settlement*, pp. 27-30.

10 Ibn Jubayr, *Travels of Ibn Jubayr*, pp. 316-7.

11 Ibid., p. 317.

12 Ibn Jubayr, in Hitti, *History of Syria*, p. 622.

13 Peter of les Vaux-de-Cernay, in Barber, *The Two Cities: Medieval Europe, 1050-1320,* p. 175.

14 Stoyanov, *The Other God*, p. 279.

15 Lewis, *The Assassins*, p. 111.

16 William of Tyre, in Barber and Bate, ed. and trans., *The Templars*, p. 76.

17 Walter Map, in Barber and Bate, ed. and trans., *The Templars*, p. 77.

18 : Saladin's Jihad

1 William of Tyre, *Historia rerum in partibus transmarinis gestarum*, XXI, 1-2, *Patrologia Latina* 201, 813-15; repr. trans. Brundage, *The Crusades: A Documentary History*, pp. 141-3.

2 Ralph of Diss, in Nicholson, *The Knights Templar*, p. 66.

3 Lyons and Jackson, *Saladin*, p. 369

4 William of Tyre, *A History of Deeds Done Beyond the Sea.*

5 Saunders, *Aspects of the Crusades*, p. 35.

6 Ernoul, in Ellenblum, *Crusader Castles*, p. 262.

7 Ronnie Ellenblum of The Hebrew University, Jerusalem, who led the excavation at Jacob's Ford, in the Arcadia Entertainment press release for their National Geographic Channel programme *Last Stand of the Templars*, 30 March 2011.

8 Ellenblum, *Crusader Castles*, chapter 16.

9 Ellenblum in the Arcadia Entertainment press release for their National Geographic Channel programme *Last Stand of the Templars*, 30 March 2011.

10 William of Tyre, quoted in Barber, *New Knighthood*, p. 98.

11 Gervers and Powell, ed., *Tolerance and Intolerance*, p. 13.

12 Lyons and Jackson, *Saladin*, p. 240.

13 Ehrenkreutz, *Saladin*, p. 237.

14 Lyons and Jackson, *Saladin*, p. 194.

15 Ibid., p. 241.

16 The sources give various figures for the two armies but generally they state that the Muslims outnumbered the Christians by two or three to one.

17 Anonymous, *De Expugnatione Terrae Sanctae per Saladinum*, pp. 155–6.

18 Ibid., p. 157.

19 Genoese consuls to Pope Urban III, late September 1187, in Barber and Bate, trans., *Letters from the East*, p. 82.

20 Anonymous, *De Expugnatione Terrae Sanctae per* Saladinum, p. 159.

21 Imad al-Din, in Gabrieli, *Arab Historians of the Crusades*, pp. 135–6.

22 Ali ibn Abi Bakr al-Harawi, quoted in William J. Hamblin, 'Saladin and Muslim Military Theory', in B. Z. Kedar, ed., *The Horns of Hattin*, proceedings of the second conference of the Society for the Study of the Crusades and the Latin East, Yad Izhak Ben-Zvi and Israel Exploration Society, London, 1992; online at www.DeReMilitari.org.

23 Imad al-Din, in Gabrieli, *Arab Historians of the Crusades*, pp. 138–9.

19 : The Fall of Jerusalem to Saladin

1 Terricus, grand preceptor of the Temple, to all preceptors and brethren of the Temple in the West, between 10 July and 6 August 1187, Barber and Bate, trans. *Letters from the East*, p. 78.

2 Heraclius, patriarch of Jerusalem to pope Urban III, September 1187, Barber and Bate, trans., *Letters from the East*, p. 81.

3 Ibn al-Athir, in Gabrieli, *Arab Historians of the* Crusades, pp. 142, 140.

4 Imad al-Din, in Gabrieli, *Arab Historians of the Crusades*, p. 160.

5 Ibn Shaddad, in Hillenbrand, *Crusades*, p. 189.

6 The Koran, trans. Arberry.

7 Ibn al-Qaysarani, in Hillenbrand, *Crusades*, p. 151.

8 Hillenbrand, *Crusades*, p. 150.

9 Ibid., p. 188.

10 Lyons and Jackson, *Saladin*, p. 276.

11 Imad al-Din, in Gabrieli, *Arab Historians of the Crusades*, p.163.

12 Imad al-Din, in Hillenbrand, *Crusades*, p. 301.

13 Ibn Zaki, in Hillenbrand, *Crusades*, pp. 189–90.

14 Ibid., p. 301.

15 Al-Qadi al-Fadil, in Hillenbrand, *Crusades*, p. 317.

16 Imad al-Din, in Lyons and Jackson, *Saladin*, p. 276.

17 *The Rothelin Continuation of William of Tyre*, in J. Shirley, *Crusader Syria in the Thirteenth Century: The Rothelin Continuation of the History of William of Tyre with part of the Eracles or Acre text*, Ashgate, Aldershot, 1999, p. 64.

18 The Frankish bezant had the same value as the Syrian gold dinar. Some sources express the ransom figure set by Saladin in dinars, others in bezants, but it amounts to the same thing. Some idea of the purchasing power of the bezant is given by Adrian Boas in *Domestic Settings*, where he states that in the twelfth and thirteenth centuries a small house could be bought for 40 bezants in Cairo, for 80 bezants in Jerusalem and for as little as 25 bezants in Acre. Therefore the charge imposed by Saladin on pilgrims wishing to visit the Church of the Holy Sepulchre amounted to anything from about half to an eighth of the value of a house. This iniquity ceased only in 1192 under terms imposed upon Saladin by Richard the Lionheart at the end of the Third Crusade.

19 Imad al-Din, in Gabrieli, *Arab Historians of the Crusades*, p. 163.

20 Imad al-Din, in Lyons and Jackson, *Saladin*, p. 277.

Part VI: THE KINGDOM OF ACRE

20: Recovery

1 Theoderich, *Description of the Holy Places*, trans Aubrey Stewart, Palestine Pilgrims' Text Society, London, 1896, vol. 5, p. 59.

2 Translated from the Arabic of De Goeje's edition of *Ibn Jubayr's Travels*, pp. 302–3, quoted in Makhouly, *Guide to Acre*, p. 24.

3 Terricus to Henry II of England, January 1188, in Barber and Bate, trans., *Letters from the East*, p. 84.

4 Al-Maqrizi, in Hillenbrand, *Crusades*, p. 380.

5 Lane-Poole, *Saladin and the Fall of Jerusalem*, p. 238.

6 *Itinerarium*, quoted in Barber, *The New Knighthood*, p. 113.

7 Richard I to William Longchamps, bishop of Ely and
 Chancellor, from Acre, 6 August 1191, in Barber and Bate, trans.,
 Letters from the East, p. 90.

8 *Itinerary of Richard I*, In Parentheses Publications, York University,
 Ontario, 2001, p. 163.

9 Richard I for general circulation, from Jaffa, 1 October 1191, in
 Barber and Bate, trans., *Letters from the East*, p. 91.

10 Ibn Shaddad, in Lane-Poole, *Saladin and the Fall of Jerusalem*, p.
 285.

11 Myriam Rosen-Ayalon, 'Between Cairo and Damascus', in Levy,
 ed., *The Archaeology of Society in the Holy Land*, p. 515.

12 Richard I for general circulation, from Jaffa, 1 October 1191, in
 Barber and Bate, trans., *Letters from the East*, p. 91.

13 Asbridge, *The Crusades*, p. 460.

14 Runciman, *History of the Crusades*, vol. 3, p. 130.

15 Anthony Bryer, 'Sir Steven Runciman: The Spider, the Owl and
 the Historian', *History Today*, vol. 51, issue 5, May 2001. Bryer is
 professor at the Centre for Byzantine, Ottoman and Modern
 Greek Studies, Birmingham University.

16 Runciman, 'Greece and the Later Crusades'.

17 Anthony Bryer, 'Sir Steven Runciman: The Spider, the Owl and
 the Historian', *History Today*, vol. 51, issue 5.

18 Runciman, *History of the Crusades*, vol. 3, p. 190.

19 Al-Kamil, quoted by the chronicler Ibn Wasil, in Gabrieli, *Arab
 Historians of the Crusades*, p. 271.

20 Lyons and Jackson, *Saladin*, p. 361.

21 : The Mamelukes

1 Al-Jahiz, *Epistle Concerning the Qualities of the Turk*, ninth century, in
 Irwin, *The Middle East in the Middle Ages*, p. 6.

2 Ibn Khaldun, in Petry, *The Cambridge History of Egypt*, p. 242.

3 Thomas Bérard, *Flores Historiarum*, in Barber, *The New Knighthood*,
 p. 157.

4 Ibn Abd al-Zahir, in Irwin, *The Middle East in the Middle Ages*, p. 42.

5 Hillenbrand, *Crusades*, p. 446.

6 Hitti, *History of Syria*, p. 622.

7 Ibn al-Furat, in Barber, *New Knighthood*, p. 167.

8 *Gestes des Chiprois*, in Barber, *The New Knighthood*, pp. 241-2.

9 Riley-Smith, *The Crusades: A History*, p. 206.

10 Partner, *The Murdered Magicians*, pp. 34-5.

22 : The Fall of Acre

1 Ludolph of Suchem, *Description of the Holy Land and of the Way Thither*, trans. Aubrey Stewart, Palestine Pilgrims' Text Society, London, 1895, XII, 54-61, repr. in Brundage, trans. and ed., *The Crusades*, pp. 266-7.

2 Ibn Abd al-Zahir, in Gabrieli, *Arab Historians of the Crusades*, p. 337.

3 The Templar of Tyre, *Gestes des Chiprois*, in Riley-Smith, ed., *The Atlas of the Crusades*, p. 102.

4 Abu al-Feda, in Gabrieli, *Arab Historians of the Crusades*, p. 342.

5 Ludolph of Suchem, *Description of the Holy Land and of the Way Thither*, repr. in Brundage, trans. and ed., *The Crusades*, p. 268.

6 Ludolph of Suchem, *Description of the Holy Land and of the Way Thither*, repr. in Brundage, trans. and ed., *The Crusades*, p. 271.

7 Ibid., p. 271.

8 Ibid.

9 Ibid., p. 272.

10 The Templar of Tyre, *Gestes des Chiprois*, in Barber, *The New Knighthood*, p. 178.

11 Abu al-Feda, in Hillenbrand, *Crusades*, p. 298.

12 Henry Maundrell, *A Journey from Aleppo to Jerusalem at Easter AD 1697*, London, 1703, p. 17.

Part VII : Aftermath

23 : Lost Souls

1 Jacques de Molay to King James II of Aragon, from Limassol, 8 November 1301, in Barber and Bate, trans., *Letters from the East*, p. 168.

2 Ghazan, Mongol Il-Khan of Persia, to Pope Boniface VIII, April 1302, in Barber and Bate, trans., *Letters from the East*, p. 168.

3 Mastnak, *Crusading Peace*, p. 244.

4 Pope Clement IV to Templar Grand Master Thomas Bérard, 1265, in Barber, *The Trial of the Templars*, p. 17.

5 Barber and Bate, ed. and trans, *The Templars*, p. 238.

6 Partner, *The Murdered Magicians*, p. 36.

7 Barber and Bate, ed. and trans, *The Templars*, p. 244.

24 : The Trial

1 Alain Demurger, *The Last Templar*, Profile Books, London, p. 62.
2 Barber, *Trial of the Templars*, p. 62.
3 Ibid.
4 *Itinerarium Symonis Semeonis ab Hybernia ad Terram Sanctam*, ed. M. Esposito, *Scriptures Latini Hiberniae*, Dublin Institute for Advanced Studies, Dublin, 1960, vol. 4, pp. 96–8; quoted in Barber and Bate, ed. and trans., *The Templars*, p. 23.
5 Partner, *The Murdered Magicians*, p. 61.
6 Deposition of Jacques de Molay, 24 October 1307, in Barber and Bate, ed. and trans., *The Templars*, pp. 252–3.
7 Deposition of Geoffrey of Charney, 21 October 1307, in Barber and Bate, ed. and trans., *The Templars*, p. 251.
8 Deposition of Hugh of Pairaud, 9 November 1307, in Barber and Bate, ed. and trans., *The Templars*, pp. 254–5.
9 *The Portable Dante*, ed. Paolo Milano, Penguin, London, 1977.
10 Frale, *The Templars*, p. 174.
11 The Chinon Parchment had been mislabelled and misplaced amid the labyrinthine files of the Vatican Secret Archive until Barbara Frale, an Italian researcher at the Vatican School of Paleography, found it and recognised its significance. She deciphered its tangled and coded writing and published her findings in the *Journal of Medieval History* in 2004. This was followed in 2007 by a facsimile publication of the parchment by the Vatican itself.
12 Rough translation from the Latin of the Chinon Parchment.
13 Ibid.

25 : The Destruction of the Templars

1 Second deposition of Jacques de Molay, 28 November 1309, in Barber and Bate, ed. and trans., *The Templars*, pp. 293–4.
2 Barber, *Trial of the Templars*, p. 262.
3 Ibid., pp. 264–5.
4 Ibid., p. 266.
5 Ibid., pp. 267–8.

6 Ibid., pp. 281-2.
7 Ibid., p. 282.

Bibliography

Books

Adamnan, *The Pilgrimage of Arculfus in the Holy Land*, trans. and ed. Rose Macpherson, Palestine Pilgrims' Text Society, London, 1895

Ahmad ibn Yahya al-Baladhuri, *The Origins of the Islamic State*, trans. Philip Hitti, Khayats, Beirut, 1966

Albert of Aachen, *Historia Ierosolimitana, History of the Journey to Jerusalem*, trans. and ed. Susan Edgington, *Oxford Medieval Texts*, Oxford University Press, Oxford, 2007

Anonymous, *De Expugnatione Terrae Sanctae per Saladinum* [The Capture of the Holy Land by Saladin], ed. Joseph Stevenson, Rolls Series, Longmans, London, 1875; repr., trans. James Brundage, *The Crusades: A Documentary History*, Marquette University Press, Milwaukee, WI, 1962

Karen Armstrong, *A History of Jerusalem: One City, Three Faiths*, HarperCollins, London, 1996

Thomas Asbridge, *The Crusades: The War for the Holy Land*, Simon and Schuster, London, 2010

Augustine, *City of God*, Penguin Books, London, 2003

Malcolm Barber, *The Two Cities: Medieval Europe, 1050-1320*, Routledge, London, 1992

Malcolm Barber, *The New Knighthood: A History of the Order of the Temple*, Cambridge University Press, Cambridge, 1995

Malcolm Barber, *The Trial of the Templars*, Cambridge University Press, Cambridge, 2012

Malcolm Barber and Keith Bate, ed. and trans., *The Templars*, Manchester University Press, Manchester, 2002

Malcolm Barber and Keith Bate, trans., *Letters from the East: Crusaders, Pilgrims and Settlers in the 12th–13th Centuries*, Ashgate, Farnham, 2010

Jonathan Porter Berkey, *The Formation of Islam: Religion and Society in the Near East, 600–1800*, Cambridge University Press, Cambridge, 2003

Bernard of Clairvaux, *The Letters of St Bernard of Clairvaux*, trans. Bruno Scott James, Burns Oates, London, 1953

Adrian J. Boas, *Crusader Archaeology: The Material Culture of the Latin East*, Routledge, London, 1999

Adrian J. Boas, *Jerusalem in the Time of the Crusades: Society, Landscape and Art in the Holy City under Frankish Rule*, Routledge, London and New York, 2001

Adrian J. Boas, *Archaeology of the Military Orders*, Routledge, London and New York, 2006

Adrian J. Boas, *Domestic Settings: Sources on Domestic Architecture and Day-to-Day Activities in the Crusader States*, Brill, Leiden, 2010

Clifford Edmund Bosworth, ed., *Historic Cities of the Islamic World*, Brill, Leiden, 2007

Mary Boyce, *Zoroastrians: Their Religious Beliefs and Practices*, 2nd edn, Routledge, London, 2000

James Brundage, trans. and ed., *The Crusades: A Documentary History*, Marquette University Press, Milwaukee, WI, 1962

Leoni Caetani, *Studi di Storia Orientale*, Ulrico Hoepli, Milan, 1911

Norman F. Cantor, *The Civilisation of the Middle Ages*, Harper Collins, New York, 1993

Eric H. Cline, *Jerusalem Besieged: From Ancient Canaan to Modern Israel*, University of Michigan Press, Ann Arbor, MI, 2004

Norman Cohn, *The Pursuit of the Millennium*, Paladin, London, 1970

Anna Comnena, *The Alexiad of Anna Comnena*, Penguin Books, Harmondsworth, 1969

Robert Davis, *Christian Slaves, Muslim Masters: White Slavery in the Mediterranean, the Barbary Coast, and Italy, 1500–1800*, Palgrave Macmillan, Basingstoke, 2003

Susan Edgington, *Oxford Medieval Texts*, Oxford University Press, Oxford, 2007

Andrew S. Ehrenkreutz, *Saladin*, State University of New York Press, Albany, NY, 1972

Ronnie Ellenblum, *The Walls of Jerusalem: A Guide to the Ramparts Walking Tour*, Yad Izhak Ben-Zvi, Jerusalem, 1995

Ronnie Ellenblum, *Frankish Rural Settlement in the Latin Kingdom of Jerusalem*, Cambridge University Press, Cambridge, 1998

Ronnie Ellenblum, *Crusader Castles and Modern Histories*, Cambridge University Press, Cambridge, 2007

Carl Erdmann, *The Origin of the Idea of Crusade*, trans. Marshall W Baldwin and Walter Goffart, Princeton University Press, Princeton, NJ, 1977

Robin Fedden, *Syria and Lebanon*, John Murray, London, 1965

Jaroslav Folda, ed., *Crusader Art in the Twelfth Century*, British School of Archaeology in Jerusalem, BAR, Oxford, 1982

Alan Forey, *The Military Orders*, Macmillan, Basingstoke, 1992

Robin Lane Fox, *Pagans and Christians*, Viking, London, 1986

Barbara Frale, *The Templars: The Secret History Revealed*, Maverick House, Dunboyne, 2009

John France, *Victory in the East: A Military History of the First Crusade*, Cambridge University Press, Cambridge, 1994

Peter Frankopan, *The First Crusade: The Call from the East*, Bodley Head, London, 2012

Charles Freeman, *Holy Bones Holy Dust: How Relics Shaped the History of Medieval Europe*, Yale University Press, New Haven, CT, and London, 2011

Richard Nelson Frye, ed., *The Cambridge History of Iran,* vol. 4, Cambridge University Press, Cambridge, 1975

Francesco Gabrieli, *Arab Historians of the Crusades*, trans. E. J. Costello, Routledge and Kegan Paul, London, 1969

Michael Gervers, ed., *The Second Crusade and the Cistercians*, St Martin's Press, New York, 1992

Michael Gervers and James M. Powell, ed., *Tolerance and Intolerance: Social Conflict in the Age of the Crusades*, Syracuse University Press, Ithaca, NY, 2001

Sir Hamilton Gibb, *The Life of Saladin fom the Works of Imad ad-Din and Baha ad-Din*, Oxford University Press, Oxford, 1973

Edward Gibbon, *The History of the Decline and Fall of the Roman Empire*, Allen Lane, London, 1994

Moshe Gil, *A History of Palestine, 634–1099*, Cambridge University Press, Cambridge, 1992

Cyril Glassé, *The Concise Encyclopaedia of Islam*, 2nd edn, Stacey International, London, 1991

S. G. Goitein, *A Mediterranean Society*, University of California Press, Berkeley, CA, 1988

Sidney H. Griffith, *The Church in the Shadow of the Mosque*, Princeton University Press, Princeton, NJ, 2007

David Grossman, *Rural Arab Demography and Early Jewish Settlement in Palestine*, Transaction Publishers, New Brunswick, NJ, 2011

A. Guillaume, *The Life of Muhammad: A Translation of Ishaq's Sirat Rasul Allah*, Oxford University Press, Oxford, 1955

Susan Haskins, *Mary Magdalen: The Essential History*, Pimlico Books, London, 2005

Carole Hillenbrand, *The Crusades: Islamic Perspectives*, Edinburgh University Press, Edinburgh, 1999

Carole Hillenbrand, *Turkish Myth and Muslim Symbol: The Battle of Manzikert*, Edinburgh University Press, Edinburgh, 2007

Philip Hitti, *History of Syria*, Macmillan, London, 1951

Philip Hitti, *History of the Arabs*, Palgrave Macmillan, Basingstoke, 2002

P. M. Holt, Ann K. S. Lambton and Bernard Lewis, ed., *The Cambridge History of Islam*, 4 vols, Cambridge University Press, Cambridge, 1977

Albert Hourani, *Syria and Lebanon: A Political Essay*, Oxford University Press, London, 1946

Albert Hourani, *A History of the Arab Peoples*, Faber and Faber, London, 2002

George Hourani, *Arab Seafaring*, Princeton University Press, Princeton, NJ, 1995

Norman Housley, ed., *Knighthoods of Christ: Essays on the History of the Crusades and the Knights Templar, Presented to Malcolm Barber*, Ashgate, Aldershot, 2007

Robert G. Hoyland, *Seeing Islam as Others Saw It: A Survey and Evaluation of Christian, Jewish and Zoroastrian Writings on Early Islam*, Darwin Press, Princeton NJ, 1997

Washington Irving, *Mahomet and His Successors*, in *The Works of Washington Irving*, George P. Putnam, New York, 1850

Robert Irwin, *The Middle East in the Middle Ages: The Early Mamluk Sultanate 1250-1382*, Croom Helm, London, 1986

John of Salisbury, *John of Salisbury's Memoirs of the Papal Court*, trans. Marjorie Chibnall, Thomas Nelson, London, 1956

Ibn Jubayr, *The Travels of Ibn Jubayr*, trans. R. J. C. Broadhurst, Jonathan Cape, London, 1952

Dosabhai Framji Karaka, *History of the Parsis Including Their Manners, Customs, Religion and Present Position*, Macmillan, London, 1884

Efraim Karsh, *Islamic Imperialism: A History*, Yale University Press, New Haven, CT, and London, 2006

Hugh Kennedy, *Crusader Castles*, Cambridge University Press, Cambridge, 1994

Hugh Kennedy, *The Court of the Caliphs*, Weidenfeld and Nicolson, London, 2004

The Koran, trans. Arthur Arberry, Allen and Unwin, London, 1955

The Koran, trans. N. J. Dawood, Penguin, London, 1990

Barbara M. Kreutz, *Before the Normans: Southern Italy in the Ninth and Tenth Centuries*, University of Pennsylvania Press, Philadelphia, PA, 1991

A. C. Krey, *The First Crusade: The Accounts of Eyewitnesses and Participants*, Princeton University Press, Princeton, NJ, 1921

Richard Landes, *Relics, Apocalypse, and the Deceits of History: Ademar of Chabannes, 989-1034*, Harvard University Press, Cambridge, MA, 1995

Stanley Lane-Poole, *Saladin and the Fall of Jerusalem*, G. P. Putnam's Sons, London, 1898

Stanley Lane-Poole, *A History of Egypt in the Middle Ages*, Frank Cass and Co., London, 1901

David Marshall Lang, *The Armenians: A People in Exile*, Unwin Hyman, London, 1988

T. E. Lawrence, *Crusader Castles*, Michael Haag, London, 1986

Thomas E. Levy, ed., *The Archaeology of Society in the Holy Land*, Leicester University Press, London, 1995

Bernard Lewis, *The Arabs in History*, Hutchinson University Library, London, 1970

Bernard Lewis, *The Assassins*, Phoenix, London, 2003

Malcolm Cameron Lyons and D. E. P. Jackson, *Saladin: The Politics of Holy War*, Cambridge University Press, Cambridge, 1982

Amin Maalouf, *The Crusades through Arab Eyes*, Saqi, London, 2006

Christopher MacEvitt, *The Crusades and the Christian World of the East: Rough Tolerance*, University of Pennsylvania Press, Philadelphia, 2008

Thomas F. Madden, *The New Concise History of the Crusades*, Rowman and Littlefield, Lanham, MD, 2006

N. Makhouly, *Guide to Acre*, Government of Palestine, Department of Antiquities, Jerusalem, 1941

Tomaz Mastnak, *Crusading Peace: Christendom, the Muslim World, and the Western Political Order*, University of California Press, Berkeley, 2002

Simon Sebag Montefiore, *Jerusalem: The Biography*, Weidenfeld and Nicolson, London, 2011

R. I. Moore, *The War on Heresy*, Profile Books, London, 2012

Matti Moosa, *The Crusades: Conflict between Christendom and Islam*, Gorgias Press, Piscataway, NJ, 2008

Colin Morris, *The Sepulchre of Christ and the Medieval West: From the Beginning to 1600*, Oxford University Press, Oxford, 2005

Dana C. Munro, *Urban and the Crusaders, Translations and Reprints from the Original Sources of European History*, vol. 1:2, University of Pennsylvania Press, Philadelphia, 1895

Muqaddasi, *Description of Syria, including Palestine*, trans. Guy Le Strange, Palestine Pilgrims' Text Society, London, 1886

Helen Nicholson, *The Knights Hospitaller*, Boydell Press, Woodbridge, 2001

Helen Nicholson, *The Knights Templar*, Sutton Publishing, Stroud, 2001

John Julius Norwich, *Byzantium: The Apogee*, Viking, New York, 1991

Orderic Vitalis, *The Ecclesiastical History of Orderic Vitalis*, trans. and ed. Marjorie Chibnall, Oxford University Press, Oxford, 1978

Peter Partner, *The Murdered Magicians: The Templars and Their Myth*, Oxford University Press, Oxford, 1981

Carl F. Petry, ed., *The Cambridge History of Egypt*, vol. 1, Cambridge University Press, Cambridge, 1998

James M. Powell, *Muslims under Latin Rule: 1100-1300*, Princeton University Press, Princeton, NJ, and London, 1990

James M. Powell, *The Crusades, the Kingdom of Sicily, and the Mediterranean*, Ashgate, Aldershot, 2007

Denys Pringle, *The Churches of the Crusader Kingdom of Jerusalem, A Corpus*, 4 vols, Cambridge University Press, Cambridge, 1993–2009

Denys Pringle, *Secular Buildings in the Crusader Kingdom of Jerusalem: An Archaeological Gazetteer*, Cambridge University Press, Cambridge, 1997

Denys Pringle, *Fortification and Settlement in Crusader Palestine*, Ashgate, Aldershot, 2000

Piers Paul Read, *The Templars*, Phoenix, London, 1999

Jean Richard, *The Crusades, c. 1071– c. 1291*, Cambridge University Press, Cambridge, 1999

Jonathan Riley-Smith, *The First Crusade and the Idea of Crusading*, Athlone Press, London, 1986

Jonathan Riley-Smith, ed., *The Atlas of the Crusades*, Times Books, London, 1991

Jonathan Riley-Smith, *The First Crusaders*, Cambridge University Press, Cambridge, 1997

Jonathan Riley-Smith, *The Crusades: A History*, 2nd edn, Continuum, London, 2005

Jonathan Riley-Smith, *Templars and Hospitallers as Professed Religious in the Holy Land*, University of Notre Dame Press, Notre Dame, IN, 2010

Steven Runciman, *The Emperor Romanus Lecapenus and His Reign: A Study of Tenth Century Byzantium*, Cambridge University Press, Cambridge, 1929

Steven Runciman, *A History of the Crusades*, 3 vols, Cambridge University Press, Cambridge, 1951-4

J. J. Saunders, *Aspects of the Crusades*, University of Canterbury Publications, Christchurch, 1962

Kenneth M. Setton, ed., *A History of the Crusades*, University of Pennsylvania Press, Philadelphia, 5 vols, 1955-85

Shlomo Simonsohn, *The Apostolic See and the Jews*, Pontifical Institute of Mediaeval Studies, Toronto, 1991

Robert Somerville, *Urban II's Council of Piacenza*, Oxford University Press, Oxford, 2011

Bertold Spuler, *The Muslim World: A Historical Survey*, part 1, *The Age of the Caliphs*, trans. F. R. C. Bagley, E. J. Brill, Leiden, 1960

Aubrey Stewart, trans., *Anonymous Pilgrims*, I–VII (11th and 12th centuries), Palestine Pilgrims' Text Society 6, London, 1894

Richard Stoneman, *Across the Hellespont: A Literary Guide to Turkey*, I. B. Tauris, London, 2010

Yuri Stoyanov, *The Other God: Dualist Religions from Antiquity to the Cathar Heresy*, Yale University Press, New Haven, CT, and London, 2000

Oliver J. Thatcher and Edgar Holmes McNeal, ed., *A Source Book for Mediaeval History*, Charles Scribner's Sons, New York, 1905

Theodoret of Cyrrhus, *A History of the Monks of Syria*, trans. R. M. Price, Cistercian Publications, Kalamazoo, MI, 1985

Theophanes, *The Chronicle of Theophanes*, ed. and trans. Harry Turtledove, University of Pennsylvania Press, Philadelphia, 1982

Colin Thubron, *Mirror to Damascus*, Vintage, London, 2008

Christopher Tyerman, *God's War: A New History of the Crusades*, Allen Lane, London, 2006

Judith Upton-Ward, trans. *The Rule of the Templars: The French Text of the Rule of the Order of the Knights Templar*, Boydell Press, Woodbridge, 1992

Usamah ibn-Munqidh, *An Arab Syrian Gentleman and Warrior in the Period of the Crusades: Memoirs of Usamah ibn-Munqidh*, trans. Philip Hitti, Columbia University Press, New York, 2000

A. A. Vasiliev, *History of the Byzantine Empire*, 2 vols, University of Wisconsin Press, Madison, WI, 1958

Bernard and Ellen M. Whishaw, *Arabic Spain*, Smith, Elder and Co., London, 1912

John Wilkinson, *Jerusalem Pilgrims before the Crusades*, Aris and Phillips, Warminster, 1977

John Wilkinson, *Egeria's Travels*, Aris and Phillips, Warminster, 1999

John Wilkinson, Joyce Hill and W. F. Ryan, *Jerusalem Pilgrimage, 1099–1185*, The Hakluyt Society, London, 1988

William of Tyre, *A History of Deeds Done beyond the Sea*, 2 vols, trans. and ed. Emily Atwater Babcock and A. C. Krey, Columbia University Press, New York, 1943

William of Tyre, *Historia rerum in partibus transmarinis gestarum*; repr. trans. James Brundage, *The Crusades: A Documentary History*, Marquette University Press, Milwaukee, 1962

Watkin Wynn Williams, *Saint Bernard of Clairvaux*, Manchester University Press, Manchester, 1935

Ehdan Yarshater, ed., *The Cambridge History of Iran*, vol. 3, Cambridge
 University Press, Cambridge, 1983
Bat Ye'or, *Islam and Dhimmitude: Where Civilisations Collide,* Fairleigh
 Dickinson University Press, Madison, NJ, 2002

Articles

Paul E. Chevedden, 'The View of the Crusades from Rome and
 Damascus: The Geo-Strategic and Historical Perspectives of Pope
 Urban II and Ali ibn Tahir al-Sulami', in *Oriens* 39 (Brill, Leiden,
 2011), pp. 257–329
Barbara Frale, 'The Chinon Chart: Papal Absolution to the Last
 Templar, Master Jacques de Molay', *The Journal of Medieval History*,
 30 (2004), pp. 109–34
Andrew Jotischky, 'The Christians of Jerusalem, the Holy Sepulchre
 and the Origins of the First Crusade', in *Crusades*, vol. 7 (Ashgate,
 Farnham, 2008), pp. 35–57
Benjamin Z. Kedar, 'The Jerusalem Massacre of 1099 in the Western
 Historiography of the Crusades', in *Crusades*, vol. 3 (Ashgate,
 Farnham, 2004), pp. 15–76

Dissertations

Tamer el-Leithy, 'Coptic Culture and Conversion in Medieval Cairo',
 PhD diss. Princeton University, NJ, 2005

Websites

Al Qahira, Egyptian weekly published by the Egyptian Ministry
 of Culture, 5 August 2003 and 19 August 2003, two articles by
 Ahmad Muhammad Arafa, arguing that Al Aqsa in Jerusalem is
 not the 'farthest mosque':
 www.memri.org/report/en/0/0/0/0/0/0/964.htm
Steven Runciman, 'Greece and the Later Crusades', a lecture given
 in Monemvasia on 31 July 1982, repr. in the *New Griffon*, Gennadius
 Library, American School of Classical Studies at Athens, ed. Haris
 A. Kalligas:
 www.myriobiblos.gr/texts/english/runciman_crusades.html

Index

BOOKS BY MICHAEL HAAG

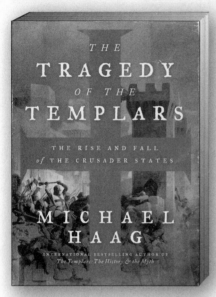

THE TRAGEDY OF THE TEMPLARS
The Rise and Fall of the Crusader States

Available in Paperback and eBook

Founded on Christmas Day 1119, the Knights Templar were a religious order of fighting knights dedicated to defending the Holy Land and Christian pilgrims in the decades after the First Crusade. They became one of the wealthiest and most powerful bodies of the medieval world. In *The Tragedy of the Templars*, historian Michael Haag explores the rise and fall of the Templars against the background story of the Crusader venture in the Holy Land which, even after four centuries of Muslim occupation, had remained a predominantly Christian community with whom settlers from the West intermarried and created a distinctive civilization. Michael Haag masterfully details the conflicts and betrayals that sent the Knights Templar spiraling from domination and power to being burnt alive at the stake.

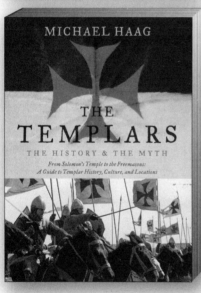

THE TEMPLARS
The History and the Myth: From Solomon's Temple to the Freemasons

Available in Paperback and eBook

Arguably one of the most provocative, puzzling, and misunderstood organizations of medieval times, the legendary Knights Templar have always been shrouded in a veil of mystery, while inspiring popular culture from Indiana Jones to Dan Brown. In *The Templars*, author Michael Haag offers a definitive history of these loyal Christian soldiers of the Crusades—sworn to defend the Holy Land and Jerusalem, but ultimately damned and destroyed by the machinations of their fellow Christians in the West. A bestseller in the United Kingdom—the first history of the enigmatic warriors to include findings from the Chinon Parchment, the long-lost Vatican document absolving the Knights of heresy.

"Haag sifts through the history and the legends to illuminate these mysterious Holy Warriors. . . . Readers of *The Da Vinci Code* and other fictions relating to the Templars will enjoy this well-written, copiously illustrated, and solidly researched book. Highly recommended." —*Library Journal*